MW00572463

THE
FAITHFUL
IMAGINATION

PAPERS FROM THE 2018 FRANCES WHITE EWBANK
COLLOQUIUM ON C. S. LEWIS & FRIENDS
TAYLOR UNIVERSITY
EDITED BY JOE RICKE AND ASHLEY CHU

The Faithful Imagination, 2018
Proceedings from the Frances White Ewbank
Colloquium on C. S. Lewis & Friends

Joe Ricke and Ashley Chu, Editors

Copyright © 2019 Taylor University

Winged Lion Press
Hamden, CT

Front Cover Image
Sasha_Kopf's_Celtic_knot_ring.jpg: Sasha Kopf derivative work:
Ninjatacoshell (talk) (https://commons.wikimedia.org/wiki/Fild: Sasha_
Kopf's_Celtic_knot_ring.svg), 11Sasha Kopf's Celtic knot ring," shades of
green by Kaylen Dwyer, https: Ucreativecommons.org/licenses/bysa/3.0/
legalcode

WINGED LION PRESS

ISBN-13 978-1-935688-30-3

This volume is dedicated to our friend and mentor:

Daryl Yost, Ed.D.

A gifted administrator and a fierce supporter of excellence in Christian higher education, Dr. Yost was not only a good friend and colleague of the Center's founder, Dr. David L. Neuhouser, but he was part of the group of forward-looking leaders who helped bring the Brown Collection to Taylor University. His years of service as Provost and Executive Vice President of Taylor were years of great growth and great challenges, and Dr. Yost built a reputation as a leader who was willing to accept any challenge presented him in the service of the university. He continues an active role in higher education and in supporting innovation initiatives in the northeastern Indiana community. He demonstrated his continued interest in the Lewis Center by speaking at the 2018 Colloquium banquet and presenting the first-ever Neuhouser Awards. His joy in seeing the work of the Center and the influence of the Brown Collection extending to a new generation of scholars was obvious and, for us, a kind of blessing.

With gratitude for his example, for his friendship, and for his service, the editors dedicate this rich volume. Every page is a testament to his vision and his commitment to scholarship.

Thank you, Dr. Yost.

TABLE OF CONTENTS

III. Essays on Inklings and Others

**VI. "Magic Moments": Reflections on the 2018 Lewis &
Friends Colloquium**

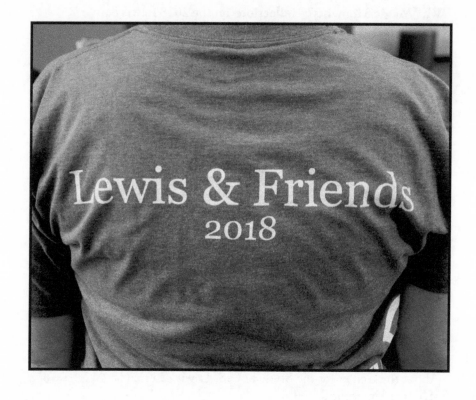

Preface: "A Balcony Perspective"

by Ashley Chu
University Archivist, Taylor University

The eleventh Biennial Lewis & Friends Colloquium at Taylor University in 2018 was one for the record books. Not only was it the largest Colloquium yet (with 150+ attendees), but it also brought the greatest number of "Young Inklings" and featured the first-ever presentations of the Neuhouser Award. Oh, and there was an awesome Saturday night concert on a balcony. We dreamed up an ambitious, scholarly, and convivial program – and it was a big dream. To see it come together (with all its flourish and haste) was incredible. And maybe somewhat miraculous. Ultimately, it was another significant step toward fulfilling the Center's mission: to support Inklings-related scholarship and to encourage and nurture the next generation of Inklings scholars.

To emphasize the Colloquium's theme, "The Faithful Imagination," artistic elements were woven throughout the program. D.S. Martin, one of our keynote speakers, became our "poet in residence," sharing his own Lewis-inspired works and hosting a late-night poetry reading by several of our attendees, sponsored by Wipf and Stock Publishers. You can read Martin's sonnet and clever limericks about the Colloquium in his reflection on page 412. In addition, two visual artists, Jeremie Riggleman and Emily Austin, exhibited and discussed their Inklings-inspired art. And, of course, we had that balcony concert. The nearly one hundred essays and creative pieces presented during those few days were both intellectual and imaginative as they explored the Inklings and Friends in relationship to the Colloquium's theme.

Our keynote presenters – Joe Christopher, Crystal Downing, Crystal Hurd, D.S. Martin, Stephen Prickett, and Charlie Starr – were insightful and invigorating. We enjoyed their scholarly presentations as well as hearing their personal stories during the keynote panel. We especially appreciated their full participation throughout the Colloquium, which enhanced the friendly, scholarly culture we strive to achieve. We also proudly presented the Neuhouser Awards to Joe Christopher and Rachel Johnson, who were recognized for their exceptional contribution to Inklings studies.

In addition to our many faithful Friends from previous colloquia, this year we welcomed quite a few newcomers as presenters and participants, specifically a sizeable group of undergraduate and graduate students. To that end, we hosted a first-ever "Young Inklings" pre-conference workshop led by Charlie Starr, utilizing some of the rare manuscripts in the Center's Brown Collection. Many students were initially attracted to the Colloquium by the undergraduate critical and creative writing competitions. In fact, several award-winning student contributions are published in this volume. Comments during the keynote panel (of which an edited transcript is included on page 364) underscored our collective delight in welcoming these new(er) scholars as new Friends.

You may have noticed that this volume is not titled *Inklings Forever*. We adopted the Colloquium theme as the title for the volume in order better to reflect its contents. In addition, we realized that a revised strategy for publishing the proceedings was necessary due to both the size and quality of the Colloquium. Our goal was to publish thirty essays that both made a valuable contribution to the field and were as representative as possible of the Colloquium's content. For the essays, please note that authors have used either MLA or Chicago Manual of Style, and while we have done our best to ensure that each essay's style and documentation is logical and consistent, we have made no attempt to normalize all essays. Thus, for example, some authors use footnotes and others use parenthetic references.

The contributions in this volume offer discerning and intriguing responses to the question moderator Joe Ricke asked the keynote panel: "What's going on today in Inklings studies?" Several essays consider C. S. Lewis in relation to other, sometimes surprising, writers. Some delve deeper than usual into the influence that individuals such as George MacDonald and Joy Davidman had on Lewis. Others consider the significance of nature, walking, family, and war related to the Faithful Imagination. As always, there are a great variety of treasures from a wide range of perspectives.

One new component included in these proceedings are the reflections, some of which we requested and others which were sent to us unprompted following the Colloquium. Whenever we would receive one, we would read it out loud and smile as we shared in the joy of others who echoed our parting sentiment, "Wow, that was amazing." We enjoyed them so much that we wanted to share some of them with you, even designating one as a foreword (Crystal Hurd) and another as an afterword (Sarah O'Dell).

Finally, many words of thanks. Planning and executing a full and vibrant program is not easy, and we happily welcome the "problem" of growth. We are very grateful for the other members on the Colloquium Planning Committee (Dan Bowell, Anne Cooper, Kaylen Dwyer, and Michael Hammond), as well as those who volunteered (or "were volunteered") to ensure that everything was ready and ran smoothly. We echo the many positive comments from participants about how welcoming and helpful our team members were. Student Kaylen Dwyer ('18) is to be especially commended for her excellent design of the Colloquium program while simultaneously completing her final semester of college. We also wish to thank the judges of our undergraduate writing competition, Julie Moore (creative writing) and Edwin Woodruff Tait (critical essay). Many other groups and individuals associated with Taylor University worked hard to make the Colloquium both enjoyable and comfortable. We are thankful for all of them.

As strange as it sounds, I must make special mention of The Balrog. You see, dear reader, The Balrog was the Celtic/classical-fusion trio that enchanted all of us during the reception on Saturday night (and following three days of very tightly packed sessions). It was a time to relax and bask in the beauty and the music and the Friends and the conversation all around us. Nearly all the responses we received remarked how meaningful and magical that evening was, especially the feeling in the presence of so many Friends singing "Come Thou Fount of Every Blessing." It was "shiny."

Finally, I want to thank my co-editor and friend, Joe Ricke. It is an honor and a joy to work and serve together in such an exciting field of study, utilizing our individual skills and experiences. When, in the bittersweet glow at the end of the Colloquium, Joe asked if I would be willing to co-edit the proceedings, I said yes without hesitation. I knew it would challenge me, but I also knew it would be fun. Professional collaboration is not necessarily an expression of friendship. Ours is.

Crystal Hurd presents her plenary lecture
"'Bookish Clever People': Exploring the Family Influences of C.S. Lewis."

Foreword: "Across the Threshold"

by Crystal Hurd

I think I understand how Lucy felt the first time she pushed those fur coats aside, felt the chill of winter on her skin, and saw that hurried faun with packages and a tiny umbrella. There is something magical about that moment. It is a moment tinged with expectation and wonder, a sliver of time in which rationality cannot satisfy one's eyes nor one's faith. Lucy passes through the veil between fantasy and fiction, and she finds on the other side a world beyond belief.

As a southerner, I always find that Indiana holds a bit of "northernness" for me, but Taylor University in particular possesses its own peculiar magic. In 2012, I attended the Lewis & Friends Colloquium as a recent graduate with an ambitious dissertation on C.S. Lewis as Transformational Leader. I stumbled onto campus a stranger, but I was soon surrounded by those who would become my dearest friends. Just as Lewis and Arthur Greeves had their "You too?" moment of mutual affection for literature, I found myself asking "You too?" to nearly everyone I encountered. In fact, I was overstimulated, exhausted, and completely exhilarated when I expressed my joy to my husband on the phone that first night. It was as if I had stepped across a threshold into a new world, one in which my Narnian nerdiness was a welcomed trait. I no longer had to conceal or suppress my enthusiasm for the author I loved; Taylor University and the Lewis Center became a place of soul nourishment for me. In the years that have passed, I have made it a priority to return to Taylor for every single Colloquium. My desire to reconnect with old friends and make new ones has not diminished at all from that first exhilarating moment.

One of the most admirable characteristics of C.S. Lewis was his seamless blend of the spiritual, the academic, and the imaginative. This can be difficult when one takes on the task of building a conference around such diverse aspects. Yet, the organizers at Taylor – the former head David Neuhouser, and now the inimitable and contagiously enthusiastic Joe Ricke – have tackled that obstacle with grace and ease. Taylor brings together scholars, writers, poets, and literary fans, and provides a place to unite under a common banner to appreciate the works of our beloved authors. It remains one of the premiere Lewis-themed events in the United States. Hence, my excitement as I prepared to attend the Colloquium once again this past spring on

Taylor's magnificent campus.

On a rainy morning in May, I packed up my clothes and my research and hit Interstate 81 heading toward Knoxville. I crossed into Tennessee, Kentucky, Ohio, and finally Indiana. Wednesday evening, I pulled into the parking lot and stared at the calm campus. The horizon was turning a bright rose. I breathed in the air, and I felt I was home again. All of a sudden, my Lewis and Friends friends and I were furiously texting each other. "I'm here. Where are you?" "Meet me at Ivanhoe's." And so began our reunion. One group was already heading to dinner at Ivanhoe's. I asked my friend and fellow Lewis scholar Charlie Starr, "Ordering a salad allows me to get ice cream, right?" As I looked along the table, I saw new and familiar faces. Sharing laughs and life updates, we spent the night reminiscing and then later recording a podcast for Starr's new book, *The Faun's Bookshelf.*

The next few days were a blur of bliss and blessing. I met fresh, young scholars from all over the country. We welcomed them with the same smile and open arms that I experienced six years ago. I shared my research on how the Lewis family shaped C.S. Lewis's works, then enjoyed the work of a wide range of scholars. Aspiring writers read their creative works in a session, and later, poet D. S. Martin read from his collection of Lewis-inspired poetry. The roundtables were fantastic and Crystal Downing's speech at the banquet was amazing. Then, on Saturday evening, we all headed to the balcony for refreshments and music. That night was one that will stay with me for the rest of my life. The music of the Celtic band *The Balrog* drifted through the air, voices saturated the second story of the science building, the conversation ebbed and flowed like the tide. Outside on the balcony, stars twinkled in the Indiana sky. I whispered to Torri Frye (a new Lewis and Friends friend) that I wished I could pause this moment. I wanted to stay suspended in the rapture of this fantastic evening – in the presence of these dear ones, in this melodic hour surrounded by such deep affection and abundance, in this shared experience. I wanted to cling to it like a cherished heirloom. That night is now tucked away in my mind: the wonderful friends, the colloquium corridor transformed as we were all transformed. Ultimately, it was a glimpse of the weight of glory that awaits us all, the delightful congress of souls that we anticipate when we pass to Aslan's Country. For a moment, all was joy.

Sunday is always a sad day for me at the Taylor Colloquium. First, we attend a worship and communion service led by Inklings scholar, writer, and Episcopal priest, Jennifer Woodruff Tait. We

contemplate together, pray together, take communion together as brothers and sisters. It is a marvelous conclusion to a magical event. We ate our lunch, gave hugs, laughed, and then . . . then it was time to leave. There was a flurry of exchanged details: email addresses, phone numbers, additions to social media accounts, "selfies." We did anything we could to capture the moment in our minds. We then left to return to our average routines, our everyday corners of the globe. But Taylor is still there in our hearts. The shared "You too?" moments are even sweeter upon reflection. As I drove away, back through the veil, I smiled at the experience. There is nothing like the Taylor University Lewis & Friends Colloquium, and it is a privilege to participate in this gathering again and again.

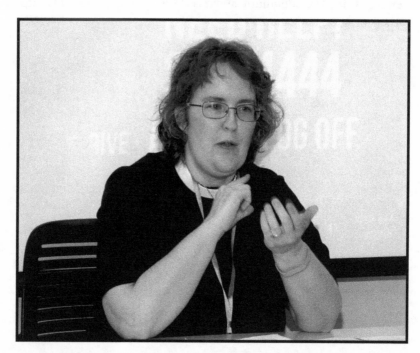

Jennifer Woodruff Tait delivers her paper, "'Is Yellow Square or Round?'
How Dead People Changed C.S. Lewis's Theology."

I. Essays on C.S. Lewis

"Bookish, Clever People":
Exploring the Family Influences of C.S. Lewis

by Crystal Hurd

Crystal Hurd is a scholar, teacher, writer, and the book review editor of *Sehnsucht*, the C.S. Lewis Journal. Some of her recent work on the Lewis family has been published in *VII: Journal of the Marion Wade Center* and *Inklings Forever X: Papers from the 10th Frances White Ewbank Colloquium on C.S. Lewis & Friends*.

In *Surprised by Joy*, C.S. Lewis declares that his penchant for writing was due to a missing joint in his thumb (12), something he inherited from his father Albert. Yet Lewis fails to mention that he was bequeathed much more than simply an absent joint. In fact, although he is undoubtedly the most famous member of the Lewis family, Clive Staples (he preferred "Jack") Lewis was only one of several members of his family to gain an audience with his quick wit and engaging writing. In the last few decades, little has been published about the artistic influence of C.S. Lewis's larger family. Although Lewis refers generously to his family in *Surprised by Joy*, other references to Lewis's family are interwoven throughout his larger body of work, especially the three volumes of Lewis's correspondence and the unpublished family papers, *The Lewis Papers*, housed at the Marion E. Wade Center at Wheaton College. *The Lewis Papers* provide much insight about the ways Lewis's family shaped him as a scholar and author. In fact, the Lewis/Hamilton families were quite accomplished in their communities and were active in labor unions and literary societies during the nineteenth century. Both of his grandfathers were writers. His father Albert was well-known for his love of literature, his mother published a short story, and his brother, who would later publish several books on French history, was the co-author of *Boxen*, a collection of stories by the brothers about Animal-Land. Clearly, a strong legacy of excellence in writing was well-established before C.S. Lewis's birth in 1898.

FLORA LEWIS

Flora Lewis was the daughter of Reverend Thomas Robert Hamilton and Mary Warren Hamilton. Reverend Hamilton kept a

diary and wrote several poems included in the family papers. Mary, his wife, is described by her grandson as "sharp-tongued, sharp-witted . . . full of heterodox opinions . . . [and] indifferent to convention as only an old Southern Irish aristocrat could be . . ." (*Surprised by Joy* 51). Like her mother, Flora was not bound by convention. Perhaps this is why she initially chose a life of academics instead of traditional husband-hunting. Flora has been called a "pioneer" for her work in mathematics (Myers 70). In 1881, she achieved a First Class Honours in Geometry and Algebra, and Lower Pass Division in French with "an unusually high score." In 1885, she received First Class Honours in Logic and Second Class Honors in Mathematics, Lower Pass Division in the Theory of Music. In 1886, she received her Bachelor of Arts degree. Warren writes that "Florence, like her brother Augustus, was a brilliant mathematician, and had her youth been lived in the period of female emancipation, would almost certainly have taken a good degree" (*The Lewis Papers* 2:329).

It is unfortunate that Flora Lewis is most famous for her untimely death from abdominal cancer when her young sons were on the cusp of adolescence. Warren was twelve and Clive only nine when Flora died after a series of unsuccessful surgeries. Her husband faithfully stayed by her bedside, recording with tenderness her last impressions and words, again reflecting the critical significance of words and writing to the Lewis family. During her short life, Flora not only influenced her sons but also the educational climate of Belfast. She was one of the few women to successfully complete a bachelor's degree in mathematics at a time when most women were not even admitted to college. In fact, it would be nearly fifty years before women received degrees at Oxford.

Flora was especially fond of writing. During a four-year stay in Italy, a young Flora wrote "The Miracle of Firenze" about a so-called miracle which occurred in a Catholic church. In another undated entry, Flora wrote an "Old Mother Hubbard" sermon (of which part is contained in Volume 1 of *The Collected Letters*). This sermon demonstrates Flora's wit and satirical genius. Flora also published a short story, pivotal to the development of her relationship with Albert, titled "The Princess Rosetta" in an issue of *The Household Journal* (now lost). After ending a five-year relationship with his brother, Flora had initially rebuffed Albert's advances. Fortunately for him, Albert chose to woo Flora by corresponding about their mutual love of literature. Upon reading "The Princess Rosetta," Albert extolled it as a fine piece of work. Shortly thereafter this exchange, their courtship emerged, quickly followed by an engagement.

Additionally, Flora encouraged her boys to have a vivid imagination. In her short life, she often took the boys to the seashores of France and Ireland. Here she taught them to play chess, allowed them to roam the landscape, took them on train rides, and taught them French and Latin. She also tutored Warren in mathematics during his time at Wynyard. Most Lewis readers can't help but think that the depiction of Digory's mother (in *The Magician's Nephew*), who falls ill and requires a magic Narnian apple to restore her health, is adapted from the real life of Flora Lewis. Perhaps this was Lewis's way of changing the ending of a very sad season of his life, what he called the "sinking of Atlantis."

ALBERT LEWIS

Unlike his wife, Albert Lewis was quite adored as the "baby" of his family and had great aspirations from a young age. His great-great-grandfather, Richard Lewis, was a Welsh farmer. His great-grandfather, Joseph Lewis, was a farmer whom Walter Hooper has called a "pious, uneducated man." Joseph later became a Primitive Methodist minister. Joseph's second son, Richard Lewis, was a "master boiler maker," originally based in Cork but later relocated to Belfast to take advantage of the seaport. Richard co-owned a boiler making company: *MacIlwaine and Lewis, Boiler Makers, Engineers, and Iron Ship Builders*. Although the pair dissolved their business partnership a few years later, Richard still became a notable and respected member of the working class. Hooper writes that Richard Lewis was a part of the "working class intelligentsia in the forefront of that artisan renaissance which gave birth to the trades union and Co-operative movements" (*The Collected Letters* 1:1014). Richard also authored essays on work and faith for the worker co-op. His youngest child (of six) was Albert Lewis. Albert had slightly different ambitions than those of his siblings. Three of Albert's brothers – Joseph, William, and Richard – performed well enough in school and went on to successful careers in industry. Joseph became a marine consulting engineer, while William "Limpopo" Lewis and Richard "Dick" Lewis formed a "Rope and Twine" business in 1883 in Glasgow, Scotland. From an early age, Albert drew attention as an orator. His father stated to others that Albert would make a wonderful politician. Albert loved literature and wished perhaps to attend college, but instead opted to become a solicitor to help the people of Belfast. He attended Lurgan School under the tutelage of his famous son's eventual tutor, William

T. Kirkpatrick. A mutual friendship would eventually develop between the student and headmaster. After his studies, Albert was "indentured" in 1879 at the Maclean, Boyle, and Maclean law firm in Dublin. Four years later, he qualified as a solicitor "with distinction." Shortly thereafter, he established a practice in Belfast.

Through it all, Albert's first love was always literature. He was thrilled to join the Belmont Literary Society in 1881. C.S. Lewis mentions the "endless books" of his childhood, books double- and triple-stacked on bookshelves throughout the home. In fact, Lewis's preface to *The Allegory of Love* admits to the overwhelming influence of Albert's bookishness: "The greatest of these debts – that which I owe to my father for the inestimable benefit of a childhood passed mostly alone in a house full of books – is now beyond repayment . . ." (xi).

Albert was indeed a promising politician in his youth. He made several stirring speeches on behalf of the Conservative Party as a young man but abandoned such prospects after he witnessed the corruption that haunts political office. He felt his talents could be put to better use as a solicitor, helping impoverished and disenfranchised people defend themselves against accusations in court. Albert used his prowess to successfully defend many unfortunate people in Belfast during his tenure. His style of loud, passionate verbosity earned him many accolades, cartoons in the local newspaper, and a long list of important clients such as Police Court prosecuting solicitor for the Belfast Corporation, Belfast City Council, Belfast and County Down Railway, Belfast Harbour Commissioners, Post Office, Ministry of Labour, and the National Society for Prevention of Cruelty to Children. Much like his father, Albert was concerned with the plight of the working man, although the family letters reveal that he was often frustrated with some aspects of his career. Through it all, Albert wrote. He penned three short stories that have survived, several poems, an unfinished (lost) novel, numerous political speeches, and lectures given to the Belmont Literary Society.

As his son mentions in the Preface to *The Allegory of Love*, Albert's influence on C.S. Lewis was inestimable. Both men enjoyed writing numerated arguments. Albert intervened on his youngest son's behalf throughout childhood and adolescence, especially concerning his schoolmaster Robert Capron and his military assignment during the Great War. Albert contributed to C.S. Lewis's intellectual development by generously financing three firsts at Oxford, even after his scholarship expired. Finally, and perhaps most importantly, Albert's ecclesiastical involvement (and his eventual death) would

catalyze his sons' conversion to Christianity.

Most readers of C. S. Lewis know Albert primarily through *Surprised by Joy*, which depicts a rather contentious relationship between Albert and his two sons. "I am sure it is not his fault, I believe much of it was ours; what is certain is that I increasingly found it oppressive to be with him" (124-25). Many biographies emphasize this strained relationship. Lewis reflects on his father with conflicting emotions:

> You will have grasped that my father was no fool. He even had a streak of genius in him. At the same time he had – when seated in his own arm chair after a heavy midday dinner on an August afternoon with all the windows shut – more power of confusing an issue or taking up a fact wrongly than any man I have ever known. As a result it was impossible to drive into his head any of the realities of our school life, after which (nevertheless) he repeatedly enquired. The first and simplest barrier to communication was that, having earnestly asked, he did not 'stay for an answer' or forgot it the moment it was uttered. Some facts must have been asked for and told him, on a moderate computation, once a week, and were received by him each time as perfect novelties. But this was the simplest barrier. Far more often he retained something, but something very unlike what you had said. His mind bubbled over with humor, sentiment, and indignation that, long before he had understood or even listened to your words, some accidental hint had set his imagination to work, he had produced his own version of the facts, and believed that he was getting it from you. . . . What are facts without interpretation? (*Surprised by Joy* 120-21)

These mixed feelings were not without emotional consequences. Later in his life, Lewis reflected with sorrow and remorse about the adolescent assessment of his father. Albert had tried to be kind and loving to his sons, but it was well known that he was more comfortable around adults than he was around children. Lewis laments,

> I should be worse than a dog if I blamed my lonely father for thus desiring the friendship of his sons; or even if the miserable return I made him did not to this day lie heavy on my conscience. . . . It was extraordinarily tiring. And in my own contributions to these endless talks – which were indeed too adult for me, too anecdotal, too prevailingly jocular – I was increasingly aware of an artificiality. The anecdotes were, indeed, admirable in their kind. . . . But I was acting when I responded to them. Drollery, whimsicality, the kind of

humor that borders on the fantastic, was my line. I had to act. My father's geniality and my own furtive disobediences both helped to drive me into hypocrisy. I could not "be myself" while he was at home. God forgive me, I thought Monday morning, when he went back to his work, the brightest jewel in the week. (125-26)

Among the traits that the Lewis brothers found repulsive were Albert's tendencies to change information he'd been told and claim that his version was correct, to eat heavy meals at mid-day (2:30 P.M.), to philosophize too loudly, to talk politics to his young sons, to use various catchphrases or "wheezes," and to strictly control the business of others. He was called a "bully" and a "snob" by some family members. Yet there are positive aspects we recognize in Albert's character, good and admirable qualities. Warren recalls that Albert would remove people from his office who would "make use of [his] legal knowledge" to "help . . . commit a swindle" (*The Lewis Papers* 2: 65). Upon reflection, C. S. Lewis admits, "With the cruelty of youth I allowed myself to be irritated by traits in my father which, in other elderly men, I have since regarded as lovable foibles. There were so many unbridgeable misunderstandings" (*Surprised by Joy* 160-61).

Albert's devotion, which appeared to be suffocating and nauseating at times, was mistook. Most scholars agree that the true stress in the relationship came from two incidents specifically: 1) Albert's refusal to see C. S. Lewis after his wounds at the Battle of Arras, and 2) the strain of concealing his relationship to Mrs. Moore during his time in Oxford. It was no secret that Albert was supporting Mrs. Moore and her daughter Maureen, as well as his son during his academic journey in Oxford. The impact of the strain in the relationship echoed in several of Lewis's works. In *The Four Loves*, Lewis writes,

> The most unlovable parent (or child) may be full of such ravenous love. But it works to their own misery and everyone else's. The situation becomes suffocating. If people are already unlovable a continual demand on their part (as of right) to be loved – their manifest sense of injury, their reproaches, whether loud and clamorous or merely implicit in every look and gesture or resentful self-pity – produce in us a sense of guilt (they are intended to do so) for a fault we could not have avoided and cannot cease to commit. (53)

Despite this, Albert's influence emerges in another one of Lewis's works: *Till We Have Faces*. The entire book is a deposition

against the gods. Certainly, this stems from the knowledge of court procedure that he absorbed in his father's presence. Such ideas are prefaced in a short essay "God in the Dock" ("in the dock" means to stand trial):

> The ancient man approached God (or even the gods) as the accused person approaches his judge. For the modern man the roles are reversed. He is the judge: God is in the dock. He is quite a kindly judge: if God should have a reasonable defence for being the god who permits war, poverty, and disease, he is ready to listen to it. The trial may even end in an acquittal. But the important thing is that Man is on the bench and God is in the dock. (244)

The first words of *Till We Have Faces* establishes the entire narrative as an indictment, shaped as much by testimony as it is by complaint. It displays the very sentiment described in "God in the Dock," the modern assumption that God is to be blamed for the misfortunes of man.

> Being, for all these reasons, free from fear, I will write in this book what no one who has happiness would dare to write. *I will accuse the gods*, especially the god who lives on the Grey Mountain. That is, *I will tell all he has done to me from the very beginning, as if I were making my complaint of him before a judge.* But there is no judge between gods and men, and the god of the mountain will not answer me. . . . Perhaps their wise men will know whether my complaint is right or whether the god could have defended himself if he had made an answer [emphasis added]" (1).

In the second section of the novel, the protagonist Orual goes to deliver her complaint to the gods. This experience of court was perhaps filtered and shaped through Albert's reflections of his career on an average day at Little Lea.

Lewis's later works demonstrate the harmonious blend of mother and father. Flora, with her passion for logic and reason, and Albert, with his wit, enthusiasm, and thirst for justice, were two prime candidates to parent a future apologist. Lewis used passion and reason and imagination to write about his faith. There is no underestimating the influence of his parents and his grandparents. As a writer and thinker, C.S. Lewis was profoundly shaped by the familial influences surrounding him as a young boy. Additionally, his reading habits, his love for writing, and his spiritual lens were all inspired by the family who loved and raised him – bookish and clever people, indeed.

WORKS CITED

Lewis, C. S. *The Allegory of Love.* Cambridge University Press, 2013.

---. *The Collected Letters of C.S. Lewis. Vol. 1: Family Letters, 1905-1931.* Edited by Walter Hooper. HarperSanFrancisco, 2004.

---. *The Collected Letters of C. S. Lewis. Vol. 2: Books, Broadcasts, and the War, 1931-1949.* Edited by Walter Hooper. HarperSanFrancisco, 2004.

---. *The Collected Letters of C.S. Lewis. Vol. 3: Narnia, Cambridge, and Joy, 1950-1963.* Edited by Walter Hooper. HarperSanFrancisco, 2007.

---. *The Four Loves.* HarperOne, 2017.

---. *God in the Dock: Essays on Theology and Ethics.* Edited by Walter Hooper. Wm. B. Eerdmans Publishing, 1979.

---. *Surprised by Joy: The Shape of My Early Life.* HarperOne, 2017.

---. *Till We Have Faces: A Myth Retold.* HarperOne, 2017.

The Lewis Family Papers or Memoirs of the Lewis Family (1850-1930) in 11 volumes. Edited by Warren Hamilton Lewis. Unpublished [Leeborough Press], 1933-1935.

Myers, Christine. "Academic Student Life." *University Coeducation in the Victorian Era: Inclusion in the United States and the United Kingdom.* Palgrave Macmillan, 2010.

When Lewis Suggests More Than He States

by Devin Brown

Dr. Devin Brown is a Lilly Scholar and a Professor of English at Asbury University. He is the author of ten books on Lewis or Tolkien. In the summer of 2008, he served as Scholar-in-Residence at the Kilns where he slept in C.S. Lewis's bed – the only thing that impressed his mother. He is currently writing *Inside the Silver Chair*.

INTRODUCTION

After the delightful dinner in chapter eight of *The Lion, the Witch, and the Wardrobe*, Mr. Beaver tells the children it is time to get down to business. When the children want to know more about Aslan, Mr. Beaver explains: "He's the King. He's the Lord of the whole wood, but not often here, you understand. Never in my time or my father's time" (78). And in his final declaration, *never in my time or my father's time*, we find the suggestion, but no more than this, that perhaps Aslan had dealings in Narnia during Mr. Beaver's grandfather's time. In Mr. Beaver's words here and in other passages like this, we find Lewis's practice of suggesting more than he states – a technique where Lewis intentionally draws only the tip of the iceberg and leaves readers to fill in the rest, a practice that creates a bridge between Lewis's imagination and our own and produces a richer reading experience with a dimension of depth it would not otherwise have.

In chapter five of *Surprised by Joy*, Lewis tells us that there came a point when, as he puts it, he learned "what writing means" (74). Among the discoveries Lewis reports he made was the fact that good writing should "not merely state but suggest." Once we begin looking for it, we can find Lewis following this principle of suggesting more than he states many times in *The Chronicles of Narnia* – particularly in the questions that Lewis raises about Aslan.

TIMES WHEN TOLKIEN SUGGESTS MORE THAN HE STATES

Before turning to Lewis, it is worth pointing out how his close friend J. R. R. Tolkien also employed this principle of suggesting more than he states – both in *The Hobbit* and *The Lord of the Rings*, particularly regarding the invisible agency of Providence that is at work behind the scenes. In one example on the very last page of *The*

Hobbit, Tolkien has Gandalf say to Bilbo, "You don't really suppose, do you, that all your adventures and escapes were managed by mere luck, just for your sole benefit?" (272).

Bilbo's response is simply to exclaim "Thank goodness!" and to hand Gandalf the tobacco jar. And with that, Tolkien ends *The Hobbit* – with the suggestion, but nothing further, that all Bilbo's adventures and escapes were, in fact, managed by something more than mere luck, by something or someone concerned for Bilbo's benefit and the benefit of Middle-earth as well.

A similar example can be found in *The Fellowship of the Ring*. On their second night out from Hobbiton, Frodo, Sam, and Pippin hear hoofs on the road behind them. Frodo creeps back to the lane where he sees a black shadow crawling towards him. Suddenly Frodo feels an irresistible desire to put on the Ring, and things might have taken a disastrous turn, but at that very moment there comes a sound like mingled song and laughter. A troupe of wandering elves just happens to be walking by, and the Black Rider is scared off. As the company approaches, Frodo recognizes they are High Elves and comments, "Few of that fairest folk are ever seen in the Shire. . . . This is indeed a strange chance" (78). Frodo's point seems to refer to the coincidence of meeting High Elves in the Shire, but readers also hear in his words a suggestion about their close escape from the Black Rider. Indeed, later Gildor, the elves' leader, tells him, "In this meeting there may be more than chance" (83), suggesting more than he actually states. Then, as if speaking for Tolkien himself, Gildor also adds, "I fear to say too much" and offers nothing further.

Two chapters later, we find a similar illustration of Tolkien suggesting more than he states when Merry and Pippin get caught by Old Man Willow and are about to be squeezed in two. Frodo, without any clear idea of why, goes running up the path crying for help, and Tom Bombadil – who, like Gildor previously, just happens to be in the area – arrives just in time to save them. At supper that night Frodo raises a question which occurs to many readers as well. He asks Tom, "Did you hear me calling, Master, or was it just chance that brought you at that moment?" Tom replies, "Just chance brought me then, if chance you call it. It was no plan of mine" (123). Although Tom had received news from Gildor's folk that the hobbits were abroad – and thus was prepared for them, in his response *if chance you call it*, we hear Tolkien's suggestion that Tom does not call it chance that brought him to the banks of the Withywindle earlier that day. Tom's statement *it was no plan of mine* hints that his providential arrival was in fact a plan

of someone else who remains unnamed.

A different sort of suggestion can be found in *The Two Towers* where Gandalf, now returned as the White Rider, tells Aragorn, "Do not regret your choice in the valley of the Emyn Muil, nor call it a vain pursuit. You chose amid doubts the path that seemed right: the choice was just, and it has been rewarded" (489). The suggestion of both Gandalf and Tolkien here is that good intentions have significance in Middle-earth. Somehow, in a way which is never fully stated, Providence honors proper intentions: if someone sets out to do the right thing, that aim will be rewarded.

A final example of Tolkien's writing suggesting more than is stated can be found six chapters later after Pippin nearly brings about the company's ruin by looking into the Palantir that Wormtongue threw down at them from Orthanc. "You have been saved," Gandalf tells the impulsive hobbit, "and all your friends too, mainly by good fortune, as it is called" (579). And in the words *as it is called*, Tolkien suggests that, like Tom, Gandalf, too, has a different name for what has saved them, but Tolkien chooses to stop there and does not have Gandalf state what that name is.

Suggestions about Aslan's Knowledge of the Future

Turning now to *The Chronicles of Narnia*, we can find a number of places where Lewis employs the principle of suggesting more than he states, particularly as related to the nature of Aslan. Some of the questions Lewis raises but chooses not to fully answer are: 1) To what extent does Aslan know, or not know, the future? 2) Might there have been other trips between Narnia and our world besides those we are told about? and 3) Might Aslan be more than a lion, and if so, what is he? As mentioned earlier, Lewis intends for these intentionally unanswered questions and others like them to engage our imaginations and, in doing so, to give our reading a dimension it would not otherwise have.

In chapter fourteen of *The Lion, the Witch, and the Wardrobe*, as Aslan moves his troops to the Fords of Beruna, he talks with Peter about plans for the upcoming battle with the Witch. "As soon as she has finished her business in these parts," Aslan tells the future high king, "the Witch and her crew will almost certainly fall back to her House and prepare for a siege. You may or may not be able to cut her off and prevent her from reaching it" (146). And then Aslan outlines two plans of battle – "one for fighting the Witch and her people in the

wood and another for assaulting her castle." When Peter points out that surely Aslan will be there himself, the great lion's only response is "I can give you no promise of that." As Paul Ford has observed:

> The fact that the Lion makes two plans with Peter for the course of the coming battle with the witch and her forces and that he cannot guarantee to Peter that he will assist Peter in the battle is an allusion to the "humanness" of the Lion. Lewis is aligning Aslan with what some Christian theologians believe of Christ in his earthly life: that he did not, as man, know the future, that he did not see the resurrection on the other side of his death, and that, therefore, he had to suffer and die like all of his fellow humans, trusting that his Father had a plan even for dying. (59)

If in *The Lion, the Witch, and the Wardrobe*, Aslan seems *not* to know the future, in chapter eleven of *The Voyage of the Dawn Treader*, Lewis suggests that Aslan *may* know the future. Just before vanishing, Aslan tells Lucy not to look so sad and promises her, "We shall meet again soon" (162). Here we find the suggestion, but again only the suggestion, that Aslan knows that in a few days the *Dawn Treader* will get lost in the inky night that surrounds Dark Island, that Lucy will call on him for help, and that he will appear in the form of an albatross and guide the ship out of danger.

In the following book, *The Silver Chair*, Lewis suggests Aslan *does* know the future – or at least the part of it revealed in the four signs he tells Jill, which are part instruction and part prediction. In the first sign Aslan tells Jill, "As soon as the boy Eustace sets foot in Narnia, he will meet an old and dear friend. He must greet that friend at once; if he does you will both have good help" (25). At the same time Lewis also suggests there are things which Aslan may not know, as illustrated by Aslan's qualifying words in the fourth sign: "You will know the lost prince (if you find him) by this, that he will be the first person you have met in your travels who will ask you to do something in my name, in the name of Aslan" (25).

SUGGESTIONS OF OTHER TRIPS BETWEEN NARNIA AND OUR WORLD

On the last page of *The Magician's Nephew*, readers are told the history of the tree that springs from a Narnian apple core that Digory has buried. After flourishing for many years, the tree is finally blown down in a great windstorm. Digory, now a middle-aged adult, cannot bear to have its trunk and branches cut up for firewood, so he uses

the timber to build a wardrobe that he keeps in his big house in the country. The narrator reports, "Though he himself did not discover the magic properties of that wardrobe, someone else did" (202). Most readers will probably just assume that this someone else is Lucy Pevensie, but in the first chapter of *The Voyage of the Dawn Treader*, Lewis provides the suggestion that the Professor or someone else not named may have made a visit to Narnia that is not told about.

As the story opens, Lucy and Edmund have been forced to stay with their Aunt Alberta and Uncle Harold. Early in chapter one we find them up in Lucy's room looking at a picture of a Narnian sailing ship. Readers are told that Aunt Alberta did not like the picture but had not gotten rid of it because "it had been a wedding present from someone she did not want to offend" (6).

Who is this person Aunt Alberta does not want to offend? Who could have had a picture of a Narnian sailing ship to give to the Scrubbs as a present? At this point in time, we know of only six people in England who have been to Narnia – Polly and Digory years earlier, and more recently Peter, Susan, Edmund, and Lucy. Given Eustace's age, we assume that the Scrubbs' wedding took place well before the Pevensies' journey in *The Lion, the Witch, and the Wardrobe*. This leaves Polly or Digory, characters who are never mentioned as knowing Eustace's parents but are older figures and perhaps the kind of people that Aunt Alberta would not wish to offend. However, in *The Magician's Nephew* Digory and Polly travel to Narnia at the time of its creation, long before it would have had sailing ships.

Through his inclusion of this painting, Lewis suggests that someone besides the four children had traveled to Narnia on a trip which is not recorded in the *Chronicles*. An additional detail supports this possibility. Lewis would later make what he called an "Outline of Narnian History." The full title Lewis gave to this list of dates and events is an "Outline of Narnian History So Far as It Is Known," and the latter part of the title suggests that there may have been more visits to Narnia than readers are told about.

SUGGESTIONS THAT ASLAN MAY BE MORE THAN A LION

In chapter eight of *The Voyage of the Dawn Treader*, the landing party is on Deathwater Island, and the gold is beginning to cast its evil spell on them. Caspian muses that "the king who owned this island would soon be the richest of all kings of the world" and commands the others to tell no one about the magical water "on pain of death" (127-

28). Edmund snaps back, "Who are you talking to? I'm no subject of yours," then goes on to say, "If anything it's the other way around" (128). Caspian puts his hand to his sword, and things are about to get out of hand when Aslan appears, this time as "the hugest lion that human eyes have ever seen." Aslan is described here as "shining as if he were in bright sunlight though the sun had in fact gone in," and oddly no one can agree on exactly how big he is. Moments later the great lion is gone and with him all memory of the incident. Some time afterwards Lucy – whose memory of the incident has been magically restored either by intention or through Lewis's mistake – cannot say whether Aslan was "the size of an elephant" or "the size of a cart-horse." In either case, the narrator comments, "It was not the size that mattered."

So what *does* matter here? Why include the discrepancy about Aslan's size? And what are we to make of the fact that Aslan seems to be in bright sunlight though it is a cloudy day?

Aslan's appearance here is more otherworldly than in the previous two stories, and in these details Lewis seems to be preparing us to revise our image of exactly who or what Aslan is. In *Prince Caspian*, the great lion made the statement to Lucy, "Every year you grow, you will find me bigger" (141). This promise seems to be holding. In *The Voyage of the Dawn Treader*, Aslan will be not merely bigger in size but larger in other ways as well. In chapter twelve Aslan will appear as an albatross and in the final chapter as a lamb.

Towards the end of *The Horse and His Boy*, Lewis continues his hints at Aslan's true nature. As Shasta spends the night near the tombs outside Tashbaan, Aslan will appear as a cat. Then later after leading him through the foggy pass to Narnia, Aslan will appear to Shasta as a lion "taller than a horse" and surrounded by a golden light – somewhat as he was on Deathwater Island. Then just for a moment before he disappears, the lion's form changes as readers are told: "Then instantly the pale brightness of the mist and the fiery brightness of the Lion rolled themselves together into a swirling glory and gathered themselves up and disappeared" (166). What exactly this swirling glory is, Lewis leaves unexplained, but there is the suggestion here that Aslan is both a lion and something more.

Some readers may take Aslan's differing appearances as simply other examples of the diverse forms the great lion temporarily chooses to appear in. Perhaps the great lion finds an albatross to be a more appropriate form for the Narnian seas, a cat more fitting for the outskirts of Tashbaan, and a lamb form more apt for the grassy plain at

the World's End. But Lewis seems to have more in mind than merely a lion who can take on other forms. After Aslan finishes speaking to the great reunion in the final paragraph of *The Last Battle*, the narrator reports that suddenly he "no longer looked to them like a lion" (210). What form does Aslan assume in the very end? The narrator will say only that "the things that began to happen after that were so great and beautiful that I cannot write them." The suggestion is that the great being who has taken on the form of a lion, an albatross, a lamb, and a cat is in reality none of these creatures but something indescribably different.

Final Thoughts from Lewis Himself

As a writer Lewis sought and was able to produce evocative passages like the ones mentioned here, phrases that suggest more than they state, because as a reader he had encountered and loved this kind of writing. In *Surprised by Joy* Lewis gives us two, now well known, examples.

The first instance occurred when Lewis was a young boy growing up at Little Lea and was reading a long work by Longfellow titled *The Saga of King Olaf*. Lewis records in *Surprised by Joy* that he was initially drawn to the work in a casual or shallow way simply because of its story and strong rhythmic verse. But then he tells us that when he turned a page and came across the opening lines from Longfellow's translation of "Tegner's Drapa," he experienced something because of what the passage suggested beyond what it stated. The lines Lewis read were: "I heard a voice that cried, / Balder the beautiful / Is dead, is dead." What was it about these lines and no others that so moved him? Lewis does not say, and perhaps did not know. He confesses that as a young boy reading the poem, he knew nothing about Balder or his death. But something about these lines suggested something sublime, for Lewis tells us he was immediately lifted up into "huge regions of northern sky" (17).

For the second example we jump to December 1911. Lewis is now in his second year at Cherbourg, and this time the experience comes not through three lines from a Longfellow poem but through the sight of a headline and a picture in a literary periodical someone had left in the schoolroom. The headline was actually for a review of a recently published translation of *Siegfried and the Twilight of the Gods*. These seven words of the title and a picture Arthur Rackham had drawn for the book – just these two things – had an immediate effect

on the thirteen-year-old Lewis. Quoting a line from the long poetic work *Taliessin through Logres* by his friend Charles Williams, Lewis tells us that in this moment, "The sky had turned round" (72).

Here we must again turn to Lewis's own account of the incident, told in his own words, to discover what the title and picture had suggested to him. Lewis writes: "'Pure Northernness' engulfed me: a vision of huge, clear spaces hanging above the Atlantic in the endless twilight of Northern summer" (73).

We conclude with a passage in which Lewis has characters of his own creation react to one of his own phrases that suggests more than it states. Early in *The Lion, the Witch, and the Wardrobe* when Peter, Susan, Edmund, and Lucy first meet Mr. Beaver, he beckons for them to come in closer so no one else will hear. Then he whispers, "They say Aslan is on the move" (67). Lewis goes on to describe the effect that Mr. Beaver's words have on the children:

> And now a very curious thing happened. None of the children knew who Aslan was any more than you do; but the moment the Beaver had spoken these words everyone felt quite different. Perhaps it has sometimes happened to you in a dream that someone says something which you don't understand but in the dream it feels as if it had some enormous meaning – either a terrifying one, which turns the whole dream into a nightmare or else a lovely meaning too lovely to put into words, which makes the dream so beautiful that you remember it all your life and are always wishing you could get into that dream again. It was like that now. (67-68)

They say Aslan is on the move. None of the children knew who Aslan was any more than you do. In the words "any more than you do," Lewis includes his readers in the experience, making it possible for us to have the same wonderful feeling of longing that sweeps over everyone except Edmund at this point. Through the phrase "They say Aslan is on the move," Lewis suggests more than he states, bridges the gap between his imagination and our own and evokes in us sensations like the ones that came over him years before at Little Lea and Cherbourg. If Lewis has, as he claims in *Surprised by Joy*, learned what writing means, he has helped us to learn this as well.

WORKS CITED

Ford, Paul. *Companion to Narnia*. HarperCollins, 2005.

Lewis, C. S. *The Last Battle*. Harper Trophy, 1994.

---. *The Lion, the Witch, and the Wardrobe*. Harper Trophy, 1994.

---. *The Magician's Nephew*. Harper Trophy, 1994.

---. *The Silver Chair*. Harper Trophy, 1994.

---. *Surprised by Joy*. Harvest, 1955.

---. *The Voyage of the Dawn Treader*. Harper Trophy, 1994.

Tolkien, J. R. R. *The Fellowship of the Ring*. Houghton Mifflin, 1994.

---. *The Hobbit*. Houghton Mifflin, 1994.

---. *The Two Towers*. Houghton Mifflin, 1994.

Lewis Underground:
Echoes of the Battle of Arras in The Narniad

by Victoria Holtz Wodzak

Victoria Holtz Wodzak earned her doctorate in medieval literature from the University of Missouri-Columbia. She teaches at Viterbo University in La Crosse, Wisconsin. Her love of C. S. Lewis dates from her earliest days as a reader when she was given her first set of his books at the age of seven. One of the very first things she learned from reading Lewis's books was that the best thing to do when you reach the end of a good book is to start over. Looking back, she recognizes the truth in Lewis's observation that one "who wishes to remain a sound Atheist cannot be too careful of [her] reading."

The Pevensie children's adventures in Narnia begin in *The Lion, the Witch, and the Wardrobe* with a wintertime visit to an underground sanctuary, where Lucy has been invited to take tea in Mr. Tumnus's carefully-concealed home:

> As soon as they were inside she found herself blinking in the light of a wood fire. Then Mr. Tumnus stooped and took a flaming piece of wood out of the fire with a neat little pair of tongs, and lit a lamp and immediately put the kettle on. Lucy thought she had never been in a nicer place. It was a little, dry, clean cave of reddish stone with a carpet on the floor and two little chairs. (LWW 19)[1]

This cozy little cave – warm, dry, and apparently safe – is mirrored by the cave in *Prince Caspian* shared by Nikabrik, Trumpkin, and Trufflehunter, which features a warm fire, a soft bed of heather, and a hot sweetened drink offered to Caspian when he wakes up with "bruised limbs and a bad headache" (PC 60). These creature comforts are followed by Caspian's introduction to the "people who lived in hiding," some of whom – the Bulgy Bears and the Dwarves of Shuddering Wood – have also chosen carefully concealed underground hiding places.

These descriptions share certain qualities with Lewis's description of his first underground bunker as a soldier in the Great War. In a letter home to his father, he writes:

1 References to specific titles from The Chronicles of Narnia in this essay are given in standard abbreviations.

> You will be anxious to hear my first impressions of trench life. This is a very quiet part of the line and the dug outs are very much more comfortable than one imagines at home. They are very deep, you go down to them by a shaft of about 20 steps; they have wire bunks where a man can sleep quite snugly, and brasiers for warmth and cooking. Indeed the chief discomfort is that they tend to get too hot, while of course the bad air makes one rather headachy. I had quite a pleasant time, and was only once in a situation of unusual danger, owing to a shell falling near the latrines while I was using them. (*Letters* 1: 352)

This letter is dated 4 January 1918, about a month after his arrival at the front. Lewis's goal, as Gilchrist points out, seems to be to reassure his father and his brother of his relative safety. They have been working to see him transferred from infantry to a gunners' unit, assuming he will be safer there. Lewis, however, is unconvinced. Writing in *Surprised by Joy* many years later, Lewis describes the conditions of war:

> The frights, the cold, the smell of [High Explosive], the horribly smashed men still moving like half-crushed beetles, the sitting or standing corpses, the landscape of sheer earth without a blade of grass, the boots worn day and night till they seem to grow to your feet. (qtd. in Gilchrist 70)

With specific reference to trench warfare, Lewis recalls "through the winter, weariness and water were our chief enemies. . . . One walked in the trenches in thigh gumboots with water above the knee, and one remembers the icy stream welling up inside the boot when you punctured it on concealed barbed wire" (*Surprised by Joy*).

As many of his contemporaries did, Lewis understates his danger; similarly, he initially understates the danger of the underground places mentioned in Narnia. Tumnus has lured Lucy into a false sense of security, planning all along to lull her to sleep with his pipes and turn her over to the Witch. Later, Tumnus's cave is raided and despoiled, its occupant taken prisoner by Her Majesty's Chief of Secret Police. One of Nikabrik's chief concerns about Caspian – other than his lineage and the fact that he's human – is that he may betray their location to Miraz. His proposed solution is to kill Caspian. This underground space may be carefully concealed, but it by no means guarantees Caspian's safety.

This attention to the importance and menace of underground spaces raises a question about the interest in underground spaces

that Lewis demonstrates. While there are, clearly, multiple potential sources or influences for such interest, primarily in classical sources such as Odysseus's trip to the Underworld, the legend of Orpheus and Eurydice, or Irish and English folk stories about Faery, my purpose here is to explore the personal and historical underpinnings located in Lewis's World War I experiences of trench warfare.

Lewis's first experience of front-line trench duty began near Monchy on 29 November 1917, his nineteenth birthday. Troops ordinarily rotated in and out of such duty, and when he was behind the lines, his records show that he was typically billeted in Schramm Barracks in Arras, or at a camp somewhat outside of Arras called Bois de Boeuf. Gilchrist notes that Lewis must have been understating his danger and discomfort in his letters to his father because, by 1 February 1918, he was out of the trenches and laid up in the military hospital in Le Treport for nearly a month, suffering from trench fever. Following his discharge, his battalion moved from Arras to Fampoux, an area north of Monchy and one which presented greater danger. Gilchrist concludes:

> [Lewis] ... endured raids, shelling, gas, mud, sleepless nights, the sight and the stench of corpses, bombs.... He experienced the daily conditions of the trenches, trench fever, hours spent making and installing wire, a collapsed dugout in which some of his battalion were buried, [and] direct hits on his line. (108)

Lewis was wounded, possibly by friendly fire, near Riez, on 15 April 1918, an incident that gave him one of the much coveted "blighty" wounds that did not kill or disable him but was still sufficiently serious to send him back to England to recover.

By the time Lewis arrived at the front lines, the engineering of underground spaces had grown increasingly sophisticated. Some of the first British recruits to the engineering companies were Manchester sewer diggers known as *clay-kickers*.[2] They were later joined by miners from various parts of England and New Zealand. Their expertise was typically sought for three purposes. First was mining, or undermining. The idea was to delve deep tunnels under enemy positions and blow them up to create vulnerable points in enemy defenses. For the allies, this began in earnest in 1914 as the stalemate on the front lines solidified. Secondly, the miners' expertise was utilized to develop shelters of increasing sophistication; Peter Barton points out that the life on the surface for either side, but especially for the Allies who

2 For further information on these specialized groups of miners, see Barton and others, *Beneath Flanders Fields*.

rarely commanded high ground, was simply impossible. Those who wanted to live had to figure out how to go underground for protection from machine gun fire, shelling, shrapnel, and air raids.[3] As these methods denuded the landscape, there was simply nowhere to go for shelter but underground.

More significant to this essay, however, is the third effort these companies undertook, particularly their efforts beneath Arras. Arras is located on a network of underground caverns that were carved out of chalk over several centuries. The chalk itself was used for building construction. In the fall of 1916, following the Somme debacle, plans were laid for the first Battle of Arras. Miners from New Zealand and Britain expanded the old chalk mines under Arras into a ten-mile long series of inter-connected caves and tunnels complete with signage, secret entrances, rail road tracks, a generator, kitchens, latrines, and a hospital.[4] In the last month leading up to the 9 April 1917 offensive, more than 20,000 British, Canadian, and New Zealand troops were successfully concealed there, underground, until their exit points were blown open in the front line trenches and the troops emerged to a successful attack on the surprised Germans. While the construction at Arras was completed and the attack deployed before Lewis arrived there, and while many of the successes of the offensive were short-lived, given his proximity during the six months of his active service in the trenches around Arras, and his billeting at Schramm Barracks in Arras proper, it's difficult to believe he knew nothing about it. Jeffrey Gusky points out that it was rare for soldiers to have spoken directly about any of the underground activity, and anything written about it in letters home would likely not have cleared the censors, since it was classified information. But it was also widely known by soldiers who participated in the original battle, as was the prevalence of underground development known by soldiers across the front who were frequently employed in lugging out and concealing the spoil of underground excavation and who were the frequent occupants of the resulting shelter.

Lewis's war record, as detailed by Gilchrist, places him, when not in the trenches, at either Schramm Barracks in Arras or at the Bois de Boeuf camp. Time at Schramm Barracks was spent in training, recreational sports, making barbed wire, and delousing.

3 For an example of the kind of engineering sophistication that developed, see the Vampire Dugout from 1918 at Barton, "Vampire."

4 For an extensive description of the underground efforts in and around Arras, see Robinson and Cave.

Soldiers were busy, but they were not under lock and key. Entrances to the cave system, while concealed, were not that difficult to identify. In fact, their rediscovery in 1990 was in part the result of a curious investigator, Alain Jacques, wanting to know why "there was all this English writing on the pillars and signs to places such as Wellington, . . . And then [he] worked out that these must be the tunnels of the Great War. . . ." (Gilchrist).

Subsequent exploration revealed large portions of the cave system, now dangerous and in disrepair, which had been sealed up and forgotten since the air raids of WWII. If Jacques could find entrances based on directional signs in 1990, it seems highly likely that, while it is nowhere explicitly documented that he was billeted or spent time under Arras, a curious and observant young Lewis could have found them as well. Rather than speak, or write, directly about all of this mostly classified information, perhaps Lewis embedded it imaginatively in his work.

Lewis's most extensive use of underground imagery is in *The Silver Chair*.[5] I would argue it is drawn from his experiences in and around (and perhaps under) Arras. By juxtaposing descriptions from the novel with pictures from the area around and under Arras, along with some of Pauline Baynes's illustrations, the close relationship between his lived experience and Lewis's descriptions become apparent.[6]

First, the trenches: Lewis arrived at the front in November 1917, during an auspiciously cold winter. Below is a diagram of the layout of a typical trench system.

5 Though not as extensive, Lewis also makes use of his experience with underground space in Aslan's How in *Prince Caspian*. As Peter, Edmund, and Trumpkin enter the How, Peter notes its cold, dank atmosphere and the writing on the walls. Graffiti is a ubiquitous feature of many of the underground spaces that sheltered World War I soldiers. For example, see the pictures at http://www. dailymail.co.uk/news/article-534236/Inside-amazing-cave-city-housed-25-000-Allied-troops-German-noses-WWI.html

6 Unfortunately, copyright precludes including Baynes's illustrations here. Where possible, I will reference them so that the reader can identify the pictures in question.

Figure 1 Typical Trench System[7]

Note the similarity between the layout of this completely typical trench, were it encountered on a miserably cold, snowy day, and the "underground lane" Puddleglum and the children encounter as described in *The Silver Chair*:

> [It was a] great, level tableland which the storm tore across without resistance . . . it was crossed and criss-crossed with curious banks or dykes, which sometimes divided it up into squares and oblongs. . . . Jill had glimpses of other odd things on that horrible tableland – things on her right that looked vaguely like factory chimneys and, on her left, a huge cliff. . . . [S]uddenly she skidded, slid about five feet, and found herself to her horror sliding down into a dark, narrow chasm which seemed that moment to have appeared in front of her. . . . She appeared to be in a kind of trench or groove only about three feet wide. . . . [A]lmost the first thing she noticed was the relief of being out of the wind; for the walls of the trench rose high above her. (SC 91-92)

On the battlefields, entrances to dugouts were carefully concealed from enemy surveillance, both because of the security they offered and because sometimes they concealed a further entrance to a mine shaft extending out into no man's land and being readied with explosives.[8]

7 Trenches were typically not laid out in straight lines to prevent an enemy from having a straight line of sight should a trench be overrun. Source of image: https://commons.wikimedia.org/wiki/File:Model_of_a_front_line_trench_system_Number_1_New_series_(HS85-10-33437)_original.tif

8 See Barrie and Barton and others for further information on underground war in World War I.

Figure 2 Entrance to a German officer's dugout[9]

In *The Silver Chair*, when Jill, Eustace and Puddleglum seek safety underground, they slip into an unobtrusive opening at the base of a step in the ruins of the old city of the giants. Baynes depicts their flight with a picture of Jill running, her cloak streaming behind her, an expression of fear on her face as she glances over her shoulder. Their flight is from hunting hounds and hungry giants; however, the sense of pursuit is urgent, and it compares well with World War I soldiers' sense of safety underground and that life on the surface was dangerous, that they were, to use Golg's words, "crawling about like flies on the top of the world!" (SC 182).

Puddleglum and the two children slide a long way down loose rock, and after a long time in darkness an "utterly strange voice" speaks to them: "What make you here, creatures of Overworld?" (SC 127). "[M]any fall down," they are told, "but few return to sunlit lands" (SC 127). Soon, a pale torch light illuminates their surroundings and reveals who has spoken to them:

> Jill found herself blinking and staring at a dense crowd. They were of all sizes, from little gnomes barely a foot high to stately figures taller than men. All carried three-pronged spears in their hands, and all were dreadfully pale, and stood as still as statues. . . . In one respect they were all alike: every face in the whole hundred was a sad as a face could be. (SC 130)

9 Knobel, Henry (Harry) Edward. Canadian official photographer. This is photograph CO 216 from the collections of the Imperial War Museums (collection no. 2600-03).

Baynes provides a picture of the Earthmen. She could easily have been depicting members of the so-called *Bantam regiments* such as the soldiers in the illustration below. They were recruited among miners and sewer diggers. Many of them did not reach military height requirements and were under 5'3". Rarely did they spend much time on the surface in either civilian or military life.

Figure 3 Somme Tunneling Group 179, Albert, 1916[10]

In Narnia, the Queen's battle plan, if not her enemy or goals, sounds virtually identical to those at Arras in 1917, as Rilian, still under enchantment describes it:

> Now the Queen's majesty knows by her art that I shall be freed from this enchantment when once she has made me king of a land in the Overworld and set its crown upon my head. The land is already chosen and the very place of our breaking out. Her Earthmen have worked day and night digging a way beneath it, and have now gone so far and so high that they tunnel not a score of feet beneath the very grass on which the Updwellers of that country walk. . . . It will be very soon now that those Uplanders' fate will come upon them. . . . Then the thin roof of earth which still keeps me from my kingdom will be broken through, and with her to guide me and a thousand Earthmen at my back, I shall ride forth in arms, fall suddenly on our enemies, slay their chief men, cast down their strong places, and doubtless be their crowned king within four and twenty hours. (SC 143)

10 http://www.laboisselleproject.com/history/9-tunnellers-of-179-tunnelling-company-albert-c-1916-courtesy-barry-maule/

Figure 4 Soldiers exit Carriere Wellington at the beginning of the Battle of Arras II, April 1917[11]

Following Rilian's liberation from his enchantment and the death of the Witch, Underworld is set free, but it also begins to fall apart. Note the description of their departure:

> Meanwhile the land was changing. The roof of Underland was so near that even by that dull light they could now see it quite distinctly and the great, rugged walls of Underland could be seen drawing closer on each side. The road, in fact, was leading them up into a steep tunnel. They began to pass picks and shovels and barrows and other signs that the diggers had recently been at work. If only one could be sure of getting out, all this was very cheering. But the thought of going on into a hole that would get narrower and narrower, and harder to turn back in, was very unpleasant. (190)

11 https://commons.wikimedia.org/wiki/File:The_British_Army_on_the_Western_Front,_1914-1918_Q4847.jpg.

Figure 5 Carriere Wellington under Arras[12]

Finally, the imagined future of Underworld sounds eerily similar to what had happened to many of the underground tunneling systems leftover from the war.

> The opening into the hillside was left open, and often in hot summer days the Narnians go in there with ships and lanterns and down to the water and sail to and fro, singing, on the cool, dark underground sea, telling each other stories of the cities that lie fathoms deep below. If ever you have the luck to go to Narnia yourself, do not forget to have a look at those caves. (SC 217)

This imagined future for the cave system seems based on experience of other underground spaces where the water table was higher than it was at Arras. Without, and sometimes even with, a sump pump, underground spaces often flooded.[13]

Today, the Arras cave system exists in two forms. Most of it is considered too unstable for routine access, although two young men recently spent a month underground exploring the caves, the artwork,

12 By Dsch67 – Own work, CC BY-SA 3.0, https://commons.wikimedia. org/w/index.php?curid=9436390.

13 For images and information on one of these flooded spaces, see http://www. dailymail.co.uk/news/article-2092768/Never-seen-images-Birdsong-tunnels-dug-British-pit-workers-undermine-German-lines-First-World-War.html. Also, Barton, *Vampire*.

and the physical artifacts the soldiers left behind. One section of the New Zealand portion, known as Carriere Wellington, has been opened to visitors as a memorial to soldiers and miners. Visitors can see drawings, graffiti, personal effects, and directional markers that still exist in a kind of ghostly tribute.

Paul Fussell, in *The Great War and Modern Memory*, points out that World War I was the most literate war in history. The young men sent out to fight, at least many of them, were well-educated scholars who both associated their experience with literary texts and re-worked those literary texts to suit their place and experience in history. It appears that Lewis does just this. In *Surprised by Joy*, Lewis recounts that "[it] was the first bullet I heard – so far from me that it whined [It created] a little whining signal that said 'This is war. This is what Homer wrote about'" (qtd. in Gilchrist 71). Here, Lewis takes his experience and looks back in time for the literary text that links his experience to what he has read. In a different context, in mingling past and present in *Prince Caspian*, he brings the four Pevensie children into Narnia's present, but their confused reality is balanced between their Narnia of about eight hundred years prior, and their twentieth-century England. One of the questions to emerge from their experience is the linkage between the children's lived experience and their remembered experience. They relive Lewis's experience of Homer:

> They were getting on at a quicker pace now. The going became easier. . . . Then – all at once – *whizz*, and a sound rather like the stroke of a woodpecker. The children were still wondering where (ages ago) they had heard a sound just like that and why they disliked it so. . . . Peter, who had been looking up to see if he could spot a squirrel, had seen what it was – a long cruel arrow had sunk into a tree trunk just above his head. (PC 118)

Memory of the past makes its way into the present. Lewis's memories refashion themselves into story, and his past becomes the ground for new story. Fussell suggests that literary past becomes current story. Lewis seems to rework it thus: historical past becomes literary present.

WORKS CITED

Barrie, Alexander. *War Underground*. Tom Donovan, 1961.

Barton, Peter. "Vampire: A Time Team Special." You Tube, www.youtube.com/watch?v=D2ppv0-A_xo>.

Barton, Peter, Peter Doyle and Johan Vandewalle. *Beneath Flanders Fields: The Tunnellers' War 1914-18*. Spellmount, 2004.

Centenary News: First World War 1914-18. 21 Aug 2015. www.centenarynews.com/article/ww1-photographer-jeff-gusky-reveals-his-new-pictures-of-the-hidden-somme->.

Fussell, Paul. *The Great War and Modern Memory*. Oxford University Press, 2013.

Gilchrist, K. J. *A Morning After War: CS Lewis & WWI*. Peter Lang Publishing, 2005.

Gusky, Jeff. "Commonwealth Underground." 2011-17. *Dr. Jeff Gusky: Doctor, Artist, Explorer*. 19 Mar 2017.

Hardman, Robert. "Inside the Amazing Cave City That Housed 25,000 Allied Troops Under German Noses in WWI." *Daily Mail*, 16 March 2008. www.dailymail.co.uk/news/article-534236/

Lewis, C.S. *Collected Letters Vol. 1: Family Letters 1905-1931*. Edited by Walter Hooper. Harper Collins, 2000.

---. *The Lion, the Witch, and the Wardrobe*. Geoffrey Bles, 1964.

---. *Prince Caspian*. Geoffrey Bles, 1964.

---. *The Silver Chair*. Geoffrey Bles, 1964.

---. *Surprised by Joy*. HarperCollins, reissue 2017. Kindle.

Robinson, Phillip and Nigel Cave. *The Underground War: Vimy Ridge to Arras*. Pen and Sword Books, 2011.

"Time Team Special 33 (2008): The Lost WWI Dugout (Flanders, Belgium)." Prod. David Brady. www.youtube.com/watch?v=usncav3TcPo>.

Walford, Charles. "Inside the Real Birdsong Tunnels: Never-Before-Seen Images of the Mines Dug by British 'Clay-

Kickers' under German Lines in First World War."
Daily Mail, 27 January 2012. www.dailymail.co.uk/
news/article-2092768/.

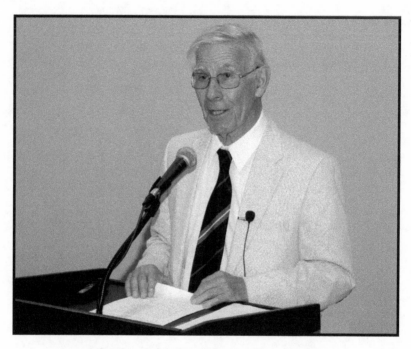

Stephen Prickett presents his keynote address
"Informing the Inklings: C.S. Lewis's Debt to George MacDonald."

C.S. Lewis's Moral Law Apologetic
and Modern Evolutionary Biology

by Daniel F. Ippolito

Dr. Daniel Ippolito received his BS in Biology from Yale
University and his PhD in Zoology from the University of
Texas. After a four-year stint teaching marine biology at the
University of New England, Dr. Ippolito took his present
position with Anderson University, where he has taught for
the past 28 years. While on the AU faculty, Dr. Ippolito
has developed interests in the fields of ecology and the
philosophy of science. He teaches an upper division seminar
on the integration of faith and science and an Honors class
on the history of scientific revolutions.

Book One of C. S. Lewis's *Mere Christianity* is entitled "Right
and Wrong as a Clue to the Meaning of the Universe." In the first
three chapters, Lewis develops his well-known apologetic argument
based on a universal Moral Law. In *The Abolition of Man* Lewis had
already pointed out the near universality across time and cultures of
a specific set of moral norms, a set which usually includes injunctions
against stealing, lying, and giving false witness, along with
commands to respect the elderly, give alms, and protect children
and the weak. In chapter two of *Mere Christianity*, Lewis rejects
the possibility that the Moral Law might simply have developed
from, or be an expression of, the herd instinct (what modern day
evolutionary psychologists call "the social instincts"), and in chapter
four of the same book, he concludes that the Moral Law must be of
Divine origin.

Lewis had previously developed the same argument in more
detail in *The Abolition of Man*, in which he had also summarized the
classic problem of deriving an *ought* from an *is*: "From the statement
about psychological fact 'I have an impulse to do so and so' we
cannot by any ingenuity derive the practical principle 'I ought to
obey this impulse.'"[1] Lewis argues "that [the claim] *This will preserve
society* cannot lead to [the imperative] *do this* except by the mediation
of [the claim] *society ought to be preserved*."[2] Talk of the preservation

1 C. S. Lewis, *The Abolition of Man, or, Reflections on Education with Special
Reference to the Teaching of English in the Upper Forms of Schools* (San Francisco:
Harper San Francisco, 2001), 35.
2 Lewis, 31.

of society, especially in the context of self-sacrificial behavior (Lewis uses the example of "Dulce et decorum est pro patria mori" [It is sweet and beautiful to die for one's fatherland]) inevitably leads to the issue of altruism, the same issue that had vexed evolutionary biologists, especially prior to the rise of sociobiology, now more commonly referred to as "evolutionary psychology." Evolutionary psychology assumes that human behaviors are heavily influenced by their genes, and therefore those behaviors which enhance the propagation of an individual's genes will be favored by natural selection and spread through the population. According to this perspective, apparently altruistic behaviors *must* have an ultimate "genetic payoff" for the altruistic individual. "Altruism" is defined as the "unselfish concern for the welfare of others."[3]

In fact, however, the annals of natural history are replete with examples of animals that act for the welfare of other animals in their social group, often at their own risk. Small social mammals such as meerkats and prairie dogs, for example, will warn other members of their colony with an alarm call when a predator approaches, even though doing so may attract the predator's attention to the individual creature making the call. Adult zebras in a herd will try to protect young zebras from lions even though the young are not their own progeny. Many other examples of apparently altruistic behaviors are known from studies of ethology, and they are usually explained in one of two ways. The first is *reciprocal altruism* (I scratch your back with the expectation that you will scratch my back at some future time), and the second is *kin selection*. Kin selection is an individual organism's predisposition (presumably a genetically-based predisposition) to behave altruistically towards close relatives who share a sizable fraction of that individual's genome. In so doing, the individual is indirectly maximizing the number of genes it contributes to the following generation.

Reciprocal altruism and kin selection still ultimately confer a "genetic payoff" on the apparently altruistic individual, and are therefore considered subtler examples of Richard Dawkins's "selfish gene." Reciprocal altruism and kin selection go a long way towards explaining altruistic behaviors in the social animals, but they fail to fully account for so-called "pure" or "universal" altruism, the kind of altruism which is directed to non-relatives who cannot reciprocate: the kind of altruism displayed by individuals like Mother Theresa,

3 *Webster's New World College Dictionary*, 3rd ed., eds. Victoria Neufeldt and David B. Guralnik (New York: Macmillan, 1997), 41.

Oskar Schindler, or Father Maximilian Kolbe. Richard Alexander has therefore proposed that the real evolutionary benefit of apparently "pure" altruism is the enhancement of the altruist's reputation. "The main reward is reputation, and all the benefits that high moral reputation may yield. Reputation as an altruist pays."[4] At the risk of engaging in the fallacy of arguing from personal incredulity, the author of this paper finds it hard to envision how a high moral reputation necessarily translates into enhanced reproductive success, which, after all, is a euphemism for "a lot of copulations." Celibate monks have historically enjoyed good moral reputations, as have orders of celibate female religious, especially those who serve in disaster zones, such as the Marianist Sisters who worked to relieve suffering in Puerto Rico after Hurricane Maria. Stephen Pope states the argument this way:

> While striving to develop, hone and deepen our evolved natural tendency to care for self, family, and friends, Christian ethics also takes deliberate steps to extend our concern beyond these spheres to encompass what sociobiologists call "non-kin" and "nonreciprocators." For its part, Christian ethics offers a helpful warning to sociobiologists that we should not confuse our natural bent to self with the full scope of our moral responsibilities to others.[5]

If straightforward selectionist arguments fail to account for human "higher morality" (especially in the case of "pure altruism"), one is left with two possibilities: human higher morality is either (1) the product of culture or (2) divinely revealed in a sort of "ontological leap." The geneticist Francisco Ayala attempted to "split the difference" between option (1) above and sociobiological evolutionary explanations. Ayala equates human "higher morality" with "ethics," which he defines as the uniquely human capacity to evaluate specific behaviors as "either right or wrong, moral or immoral."[6] This capacity is rooted in humans' disproportionately large brains and unique intellectual abilities, which include self-awareness and abstract thinking. Ayala concludes that, "these intellectual capacities are products of the evolutionary process, but they are distinctively human. Thus, I will maintain that ethical behavior is not causally related to the social behavior of

4 Richard Alexander, "Biological Considerations in the Analysis of Morality," in *Evolutionary Ethics*, eds. Matthew Nitecki and Doris Nitecki (Albany: SUNY Press. 1993), 188.

5 Stephen Pope, *Human Evolution and Christian Ethics* (Cambridge: Cambridge University Press, 2011), 72.

6 Francisco Ayala, "The Biological Roots of Morality," *Biology and Philosophy* 2, no. 3 (1987): 236.

animals, including kin and reciprocal 'altruism.'"[7] Having affirmed the evolutionary origin of the human capacity for ethical behavior, however, Ayala goes on to state unequivocally that "The moral norms according to which we decide whether a particular action is either right or wrong are not specified by biological evolution but by cultural evolution."[8] He is adamant that biology alone does not determine which specific moral norms are embraced and enforced by a particular society:

> A second observation is that some norms of morality are consistent with behaviors prompted by natural selection, but other norms are not so. The commandment of charity: "Love thy neighbor as thyself," often runs contrary to the inclusive fitness of the genes, even though it promotes social cooperation and peace of mind. If the yardstick of morality were the multiplication of genes, the supreme moral imperative would be to beget the largest possible number of children. . . . But to impregnate the most women possible is not, in the view of most people, the highest moral duty of a man.[9]

Ayala concludes that "Moral norms are not determined by biological processes, but by cultural traditions and principles that are products of human history."[10] The question left unanswered, of course, is this: if biology is not (or not always) determinative of which moral norms are embraced by a particular culture, what else determines the acceptance or rejection of those norms? For that matter, how do those norms originate if they are not determined by the genes? Ayala is ambivalent about the role of both reason and religion in establishing ethical norms:

> There is no necessary, or *logical*, connection between religious faith and moral principles, although there usually is a motivational, or psychological connection. . . . [I]n following the moral dictates of his religion, an individual is not rationally justifying the moral norms that he accepts. . . . [M]ost people, religious or not, accept a particular moral code for social reasons, without trying to justify it rationally by means of a theory from which the moral norms can be logically derived.[11]

Ayala never gives good examples of what his "social reasons" might be, and ultimately seems to be "kicking the can down the road"

7 Ayala, 236.
8 Ayala, 242.
9 Ayala, 250.
10 Ayala, 250.
11 Ayala, 242.

with regard to the actual origin of moral norms.

On the contrary, Lewis famously contends that the Moral Law has a supernatural origin. In chapter two of *Mere Christianity*, Lewis addresses and rejects both the sociobiological hypothesis and the cultural evolution hypothesis for the origin of the Moral Law (without using the same terms, however). Arguing against the biologically evolved nature of the moral code, Lewis concedes that our "herd instinct"[12] may predispose us to help our neighbor, but he also points out that our altruistic inclinations may come in conflict with other instincts, including that for self-preservation. Let us consider the classic example of having to decide whether to save a drowning man at the risk of one's own life. Evolutionary psychology argues that one is much more likely to take the risk of saving either (a) a close relative or (b) someone who can repay the kind gesture. Conversely, one should be much less likely to save a perfect stranger. At most, one might feel a very weak inclination to do so, borne out of a general sense of conspecific solidarity. Lewis acknowledges this tension:

> But at those moments when we are most conscious of the Moral Law, it usually seems to be telling us to side with the weaker of the two impulses. You probably want to be safe much more than you want to help the man who is drowning, but the Moral Law tells you to help him all the same.[13]

Lewis concludes that there is "a third thing which tells you that you ought to follow the impulse to help, and suppress the impulse to run away. Now this thing that judges between two instincts . . . cannot itself be either of them."[14] Lewis also goes to great lengths to point out that the Moral Law may encourage or suppress different instincts depending on circumstances. There are no instincts that are invariably good or bad under all conceivable circumstances. "There are also occasions on which a mother's love for her own children or a man's love for his own country have to be suppressed or they will lead to unfairness towards other people's children or countries."[15] Lewis concludes that the Moral Law cannot be simply another "instinct" (by which he means what we would now call "a biologically evolved adaptation"): "The Moral Law is not any one instinct or set of instincts: it is something which makes a kind of tune . . . by directing

12 C. S. Lewis, *Mere Christianity: A Revised and Amplified Edition* (San Francisco: Harper San Francisco, 2001), 9.

13 Lewis, 10.

14 Lewis, 10.

15 Lewis, 11.

the instincts."[16]

One might still argue, however, that the Moral Law, especially in its altruistic manifestations, might have been produced by a process of cultural evolution. Maybe people are *socialized* to believe they ought to rescue drowning men, even in the face of the instinct for self-preservation. Lewis, however, rejects the cultural evolution hypothesis by employing two different lines of reasoning. He first points out the similarities in the moral codes of cultures separated by time and space:

> Though there are differences between the moral ideas of one time or country and those of another, the differences are not really very great – not nearly so great as most people imagine – and you can recognize the same law running through them all: whereas mere conventions, like the rule of the road or the kind of clothes people wear, may differ to any extent.[17]

If moral codes were merely the products of different cultures which themselves developed in different circumstances and were subjected to different political, military, and economic pressures, what is the probability of finding such a high degree of similarity among all moral codes? Lewis is clearly implying that this probability is low indeed.

Lewis's second argument against the purely cultural origin of moral codes is based on the observation that virtually all people believe that some moralities are in some sense better than others (even moral relativists behave as if that were the case, regardless of their verbal disclaimers). For, "if no set of moral ideas were truer or better than any other, there would be no sense in preferring . . . Christian morality to Nazi morality."[18] Lewis then develops a variation of his *tertium quid* argument:

> The moment you say that one set of moral ideas can be better than another, you are, in fact, measuring them both by a standard, saying that one of them conforms to that standard more nearly than the other. But the standard that measures two things is something different from either. You are in fact, comparing them both with some Real Morality, admitting that there is such a thing as a real Right, independent of what people think, and that some people's ideas get nearer to that real Right than others.[19]

16 Lewis, 11.
17 Lewis, 12-13.
18 Lewis, 13.
19 Lewis, 13.

Lewis's argument for the supernatural origin of the Moral Law has recently been taken up by two prominent biologists, Francis Collins and Daryl Domning. Of the two, Collins is better known to the general public as the director of the National Institutes of Health and the former leader of the Human Genome Project. In his book *The Language of God*, Collins related how Lewis's Moral Law apologetics impacted his life when he was still an agnostic, and contributed to his eventual conversion to Christianity.[20] Daryl Domning is professor of anatomy at Howard University, and his specialty is the evolution of marine mammals. He also made a significant contribution to the science/religion dialogue with his 2007 book *Original Selfishness*, in which he argued for a new understanding of the traditional doctrine of Original Sin in light of our biologically evolved inclination to look after our genetic interest, along with the genetic interest of close kin.

Regarding the Moral Law, Domning goes to great lengths to point out the non-Darwinian (unevolved) nature of Christian morality. As for the "reciprocal altruism" argument, Domning claims that, "for Jesus to give such prominence to this idea – putting the interests of others on the same level as one's own self-interest, and not just from sporadic generosity but as a consistent rule – was downright novel from the Darwinian viewpoint."[21] Domning makes a second, even more radical, point, against reciprocal altruism. He argues that "throughout his teaching, Jesus made clear that this pertained especially to the despised poor; in short, to those who not only would not but could not repay. Here was something new. Here was altruism stripped of the very possibility of reciprocity."[22] Contra the kin selection argument, Domning posits the well-known parable of the Good Samaritan. "Samaritans were despised enemies of the Jews. What Jesus meant was: "Who is your neighbor? Your enemy is your neighbor. Even the one you despise most is your neighbor. It is that neighbor's interest that you are to set equal to your own."[23]

Domning finally comes to the same conclusion that Lewis had reached sixty years prior: the Moral Law in its purest (most altruistic) form must be of Divine origin. Domning is not one to invoke "miracle" at the drop of a hat or to resort to facile "God-of-

20 Francis Collins, *The Language of God: A Scientist Presents Evidence for Belief* (New York: Free Press, 2006), 22-30.
21 Daryl Domning, *Original Selfishness: Original Sin and Evil in the Light of Evolution* (London, Routledge, 2006), 122.
22 Domning, 123.
23 Domning, 123.

the-gaps" arguments. Earlier in his book he had severely criticized the Intelligent Design movement, whose proponents argue that direct Divine intervention is required to account for purportedly "irreducibly complex" structures such as the bacterial flagellum or the vertebrate eye. Domning is unequivocal in his rejection of such arguments: "In fact, natural explanations for such complexity are available."[24] When it comes to the pure altruism required by the Moral Law, however, Domning concedes that we are in the presence of an "ontological leap":

> From reciprocal altruism to pure altruism may be a small extrapolation in pure logic, but Darwin was right in sensing what an impossible leap it is in the concrete world of biology. Darwinian evolution was both necessary and sufficient to raise us to the jumping off point for such a leap, by making us the conditionally altruistic creatures that we are; but it can carry us no further.[25]

According to Domning, the same God who had worked through secondary causes (i.e., physical laws) through most of the history of the cosmos eventually had to intervene in the Incarnation to get us over this final hump:

> Why, after all, would a God who was content to let physical, biological, and cultural evolution take their course for billions of years suddenly step in with something as meddlesome as a direct revelation of the divine will? Surely not for lack of patience. If we believe that such explicit revelation has actually occurred (especially in the person of Jesus), then we can only understand it as necessitated by our own constitutional inability ever to figure out that divine will on our own.[26]

Lewis had partially foreshadowed Domning's insight that our faith (through grace) requires us to transcend our biological selfishness, which Lewis calls "natural individualism." In "Membership," Lewis wrote: "Our faith . . . sets its face relentlessly against our natural individualism; on the other hand it gives back to those who abandon individualism an eternal possession of their own personal being, even of their bodies."[27]

24 Domning, 38.
25 Domning, 127.
26 Domning, 127-28.
27 C. S. Lewis, *The Weight of Glory and Other Addresses* (San Francisco: Harper San Francisco, 1980), 172.

WORKS CITED

Alexander, Richard D. "Biological Considerations in the Analysis of Morality." In *Evolutionary Ethics*, edited by Matthew Nitecki and Doris Nitecki, 163-96. Albany: SUNY Press, 1993.

Ayala, Francisco J. "The Biological Roots of Morality." *Biology and Philosophy 2*, no. 3 (1987): 235-52.

Barkow, Jerome H., Leda Cosmides, and John Tooby. *The Adapted Mind: Evolutionary Psychology and the Generation of Culture*. New York: Oxford University Press, 1992.

Collins, Francis S. *The Language of God: A Scientist Presents Evidence for Belief*. New York: Free Press, 2006.

Dawkins, Richard. *The Selfish Gene*. Oxford: Oxford University Press, 1989.

Domning, Daryl P. *Original Selfishness: Original Sin and Evil in the Light of Evolution*. London: Routledge, 2006.

Hamilton, William D. "The Genetical Evolution of Social Behaviour." *Journal of Theoretical Biology* 7 no. 1 (1964): 1-52.

Lewis, C. S. *The Abolition of Man*. San Francisco: Harper San Francisco, 2001.

---. *Mere Christianity: A Revised and Amplified Edition*. San Francisco: Harper San Francisco, 2001.

---. *The Weight of Glory and Other Addresses*. San Francisco: Harper San Francisco, 1980.

Pope, Stephen. *Human Evolution and Christian Ethics*. Cambridge: Cambridge University Press, 2007.

Trivers, Robert L., "Parental Investment and Sexual Selection." In *Sexual Selection and the Descent of Man*, edited by Bernard Campbell, 136-179. Chicago: Aldine, 1972.

Wilson, Edward O. *Sociobiology: The New Synthesis*. Cambridge: Belknap Press of Harvard University Press, 1975

The Five Deaths of C.S. Lewis

by Jennifer Woodruff Tait

Jennifer Woodruff Tait is an Episcopal priest, the managing editor of *Christian History* magazine, and the author of *The Poisoned Chalice* and *Histories of Us* (a poetry collection). She lives in Richmond, Kentucky with her husband Edwin, daughters Catherine Elanor and Elizabeth Beatrice, in-laws, 20 goats, 10 chickens, and a laptop. She invites everyone to check out *Christian History's* 2015 issue on the Seven Sages (MacDonald, Tolkien, Lewis, Williams, Chesterton, Sayers, and Barfield).

C. S. Lewis's writings, and his life, were particularly shaped by wrestling with the problem of death. In what follows, I want to discuss the deaths of five people important to Lewis, especially the ways those deaths influenced his imagination.

FLORENCE AUGUSTA HAMILTON LEWIS (1862-1908)

Flora Lewis died in 1908, when Lewis was only nine. We have very little in the way of correspondence from Lewis's childhood, of course, and any direct reference to his mother's death at the time does not occur in extant letters. The first reference to the death of *anything* in the letters is when the eleven-year-old Lewis writes that he is not sure he wants a microscope for Christmas because studying insects would require killing them, and "to go about exterminating harmless insects, with no other motive in view than that gratification of one's own whimsical tastes does not seem to me very nice."[1]

As he grew older, Lewis seldom wrote about his mother in his letters. Other than incidental references having to do with the settling of his father's estate (more on that later), he mentions her only twice before his conversion, both in letters to Arthur Greeves. One is a memory in 1930, when he began to read Kingsley's *Water Babies*, of his mother reading it to him when he was young: "I had even a curious sense of bringing my mother to life – as if she were reading it through me. The feeling was impressive, but not entirely pleasant."[2] The second

1 Letter to Albert Lewis, December 16, 1909, in *The Collected Letters of C. S. Lewis, Volume 1* (San Francisco: HarperSanFrancisco, 2004), ed. Walter Hooper, 12-13.
2 Letter to Arthur Greeves, June 7, 1930, *Letters vol. 1*, 901. He adds that he doesn't much care for the book: "There is some fancy, and I don't object to the

is a reference in early 1931 to the fact that he is using her writing desk at the Kilns and that he wonders when she last used it.[3]

We depend, then, on the older Lewis to tell us what this experience meant to him, and he does so, famously if not always completely accurately, in *Surprised by Joy*. There, after an idyllic picture of his early childhood, he tells us how Flora became ill, how her illness removed her from the daily life of her two sons into "the hands of nurses and delirium and morphine," and how after her death he was forced to see her corpse and attend her funeral.[4]

Lewis attributes three effects to this experience which were to haunt the rest of his life. (In the text he claims he's attributing two, but, as Lewis often admitted, he had a hard time with "maths"). The first was that his mother's death made him grow farther away from his father and closer to his brother – a fact which looms large in *Surprised by Joy* and even larger in his letters. Secondly, the viewing of the body and the experience of the funeral was terrifying to him, and he attributed to it not just his later dislike of dead bodies but his later dislike of ritual and ceremony – familiar to anyone who has read his thoughts on Anglican ritual.[5]

Thirdly, he had "what some (but not I) might regard as my first religious experience" when his prayers for his mother's survival and indeed her resurrection failed to produce the desired effects. He claims the profound disappointment had no power over him, since he considered God merely as a magician who would disappear when no longer needed, and, after all, he was "used to things not working." Almost immediately in the text follows his famous statement: "It was sea and islands now: the great continent had sunk like Atlantis."[6]

Flora Lewis's death haunts the rest of *Surprised by Joy* – even to the end. Reading the famous account of Lewis's conversion to theism, if we join the scene just *before* the part that everyone loves to quote about the "most reluctant convert," we hear that one of his particular reasons for reluctance was that belief in God meant submitting to someone who would interfere with his life, reopening the vast sunken emotional continent that had vanished at her death: "I had always wanted, above all things, not to be 'interfered with.' . . . I had been

preaching, but after Macdonald [sic] it is tasteless."

3 Letter to Arthur Greeves, January 10, 1931, *Letters vol. 1*, 946.
4 *Surprised by Joy: The Shape of My Early Life* (New York: Harcourt Brace Jovanovich, 1955), 18-19.
5 *Surprised by Joy*, 20.
6 *Surprised by Joy*, 20-21.

far more anxious to avoid suffering than achieve delight."[7] A telling remark illuminating this from the young Lewis comes in a letter Lewis wrote to Greeves in 1916: "I am quite content to live without believing in a bogey who is prepared to torture me forever and ever if I should fail in coming up to an almost impossible ideal."[8]

ALBERT JAMES LEWIS (1863-1929)

Lewis's father Albert died when Lewis was in his early 30s. In *Surprised by Joy* Lewis says of Albert's death only that "My father's death, with all the fortitude (even playfulness) which he displayed in his last illness, does not really come into the story I am telling."[9] Whatever else Albert Lewis's death meant to Lewis, he did not later view it as important to the shape of his Christian journey – or, at least, to the shape of his Christian journey that he wanted to speak about in public. While Lewis gave Digory Kirke in *The Magician's Nephew* the healing miracle for his mother that the young Lewis had prayed for and did not receive, and while the living Albert Lewis is a strong presence in *Surprised by Joy*, we do not see Jack Lewis ever grieving the death of his father in published writing.

Interestingly, the death seemed to loom larger in his letters at the time. When he first hears that his father is sick, he writes to Arthur, "Isn't it all beastly. Poor, poor old Pdaitabird. I cd. cry over the whole thing."[10] Lewis went to Belfast and attended his father for a month, left briefly to return to Oxford, and then was called back to deal with Albert's death. Warnie was in Shanghai, and so there were many letters where Jack kept him up-to-date on the progress of their father's illness and death and the settling of the estate. Most of the letters to Warnie consist of reports on various relatives or on practical matters. It is to Barfield that Lewis vents his first real serious emotional reflection since the outburst to Greeves – one which also turned out to be eerily prophetic:

> I argue thus: 1. I am attending at the almost painless sickbed
> of one for whom I have little affection. . . . 2. Nevertheless
> I find it almost unendurable. 3. Then what in heavens name
> must it be like to fill the same place at the sickbed, perhaps

7 *Surprised by Joy*, 228.
8 Letter to Arthur Greeves, October 18, 1916, in *Letters, vol. 1*, 235.
9 *Surprised by Joy*, 215.
10 Letter to Arthur Greeves, July 25, 1929, in *Letters, vol. 1*, 805. Jack and Warnie commonly referred to their father as Pdaitabird because of the way he pronounced "potato."

agonized, of someone really loved, someone whose loss will be irreparable?"[11]

Finally, after the funeral, he was able to write to Warnie about his feelings regarding the death. He describes the way his feelings toward his father were so much different after his death than when he was still living; the way he kept thinking of things which he wanted to tell his father and could not; the way he was pulled up short "between wind and water" by realizing when he went to buy a tie for the funeral that "You can never put anything down to his account again"; and finally his ambiguous realization that "now you could do anything on earth you cared to in the study at midday or on Sunday, and it is beastly."[12] Six years later, he wrote to Leo Baker that "My father is dead and my brother has retired from the army and now lives with us. I have deep regrets about my relations with my father (but thank God they were best at the end)."[13]

CHARLES WALTER STANSBY WILLIAMS (1886-1945)

The next death of a person important to Lewis was Charles Williams's unexpected death when Lewis was in his late 40s. To Williams's death Lewis *did* attribute a change in his theological attitude. In his *Preface* to the festschrift prepared after Williams's death, he notes that right after he heard of the death "the very streets looked different."[14] Shortly afterward, he wrote to Barfield that this was "the first really severe loss I had suffered," which is very interesting in light of the fact that he had already lost both parents, and that *Surprised by Joy* would lay strong emphasis on how traumatic his mother's death was for him.[15] He added in his note to Barfield that Williams's death had made him sure of immortality, swept away "all my old feelings of more horror and disgust at funerals, coffins, graves,

11 Letter to Owen Barfield, September 9, 1929, in *Letters, vol. 1*, 820.

12 Letter to Warnie Lewis, October 17, 1929, in *Letters, vol. 1*, 827.

13 Letter to Leo Baker, April 28, 1935, in *The Collected Letters of C. S. Lewis, Volume 2* (San Francisco: Harper San Francisco, 2004), ed. Walter Hooper, 161. In Baker's later recollections of Lewis, he notes that they conversed about Lewis's father often, which may be why Lewis mentioned him in particular; it's interesting to compare the note with the one he sent to Belle Allen in 1950, discussed below, which erases both Albert Lewis and Janie Moore from Jack Lewis's life entirely. See Leo Baker, "Near the Beginning," in *C. S. Lewis at the Breakfast Table* (San Diego: Harvest, 1992), 5.

14 Preface to *Essays Presented to Charles Williams*, as quoted in *Letters*, vol. 2, 649.

15 Letter to Owen Barfield, May 18, 1945, in *Letters, vol. 2*, 651.

etc.," and reduced his fear of ghosts.[16] In fact, Lewis wrote to a number of correspondents that Williams's death transformed his idea of death. His letter to Williams's widow is typical: "His death has had the very unexpected effect of making death itself look quite different. I believe in the next life ten times more strongly than I did."[17]

The death of Williams, like Lewis's mother's death and unlike his father's, cast a shadow over Lewis's writing. In addition to the huge influence of Williams on *That Hideous Strength*, published in 1945, the fraught friendship between Lewis, Williams, and Tolkien makes a cameo – but telling – appearance to illustrate Friendship in *The Four Loves*: "Now that Charles is dead, I shall never again see Ronald's reaction to a specifically Caroline joke. Far from having more of Ronald, having him 'to myself' now that Charles is away, I have less of Ronald."[18] And a few months after Williams's death Lewis would publish this poem:

Your death sounds a strange bugle call, friend, and all becomes hard
To see plainly, describe truly. The new light imposes change,
Re-adjusts all a life's landscape as it thrusts down its probe from the sky
To re-arrange shadows, to change meadows, to erect hills and deepen
 vales;
I can't see the old contours. The slant alters. It's a bolder world
Than I once thought. I wince, caught in the shrill winds that dance
 on this ridge.
Is it the first sting of a world's waning, the great Winter? Or the cold
 of Spring?
I have lost now the one only friend wise enough to advise
To touch deftly such problems. I am left asking. Concerning your death
With what friend now would it help much to spend words unless it
 were you?[19]

He also wrote an epitaph to Williams that was published in 1949. Pay close attention, because it will come back later in another context:

Here lies the whole world after one
Peculiar mode; a buried sun,

16 Letter to Owen Barfield, May 18, 1945, in *Letters, vol. 2*, 651. In *Surprised by Joy*, Lewis makes the startling remark that he only began to fear being annihilated after death in 1947 – two years after he claims in his letters that Williams's death made him sure of immortality (*Surprised by Joy*, 117). Lewis's extant letters from 1947 reveal nothing about how or why he suddenly developed this fear.
17 Letter to Florence (Michal) Williams, May 22, 1945, in *Letters, vol. 2*, 653.
18 *The Four Loves* (San Diego: Harvest, HBJ, 1960), 61.
19 *The Collected Poems of C. S. Lewis: A Critical Edition* (Kent, OH: Kent State University Press), ed. Don W. King, 334. Originally published in *Britain Today* no. 12, August 1945.

Stars and immensities of sky
And cities here discarded lie.
The prince who owned them, having gone,
Left them as things not needed on
His journey; yet with hope that he,
Purged by aeonian poverty
In Lenten lands, hereafter can
Resume the robes he wore as man.[20]

Williams's death may have reflected how Lewis felt about his father's death in later life. In a letter to an American correspondent in 1951, he writes, "I feel v. strongly (and I am not alone in this) that some good comes from the dead to the living in the months or weeks after the death. I think I was much helped by my own father after his death."[21] Lewis had said nothing of the kind at the time, although as noted earlier, he suggested that he felt less resentful of Albert Lewis's eccentricities.[22]

Janie King Askins Moore (1872-1951)

The next death that had a significant influence on Lewis's life was that of Janie King Moore in 1951 when Lewis was 53. Lewis had lived with Moore from 1919 until 1950, and much ink has been spilled on their lives together. What I am interested in here is what Lewis said about her death – which turns out to be fairly minimal. Alone among these deaths, most of which were of people who died "before their time," she was very ill with dementia and her death was expected. Also alone among these deaths, she was not a Christian believer when she died. In fact, as far as is known, she retained strenuous opposition to Christianity her entire life.

Just as Lewis had experienced his father's death as a relief, so he experienced Moore's death as one. In April 1950, when Moore was taken to a nursing home, he wrote to Greeves that this would probably be a permanent arrangement:

> In one way it will be an enormous liberation for me. The other side of the picture is the crushing expense – ten guineas a week wh. is well over £500 a year (What on earth I shall do if poor Minto is still alive nine years hence when I have to retire, I can't imagine.).[23]

20 "Epitaph," in *Collected Poems*, 366.
21 Letter to Vera Mathews, in *The Collected Letters of C. S. Lewis, Volume 3* (San Francisco: Harper One, 2007), ed. Walter Hooper, 103.
22 Letter to Warnie Lewis, October 17, 1929, in *Letters, vol. 1*, 827.
23 Letter to Arthur Greeves, May 2, 1950, in *Letters, vol. 3*, 28.

Because of the expense he had to cancel a holiday in Ireland with Greeves. He concluded, "I hardly know how I feel – relief, pity, hope, terror, & bewilderment have me in a whirl. I have the jitters! God bless you. Pray for me."[24]

However, to an American correspondent in 1950, shortly after Moore had been taken to the nursing home, he described his family as if Moore had never existed: "My mother died in 1908, when I was nine and my brother thirteen; we have no sisters, and are a couple of confirmed old batchelors, sharing a rather nice house with an eight acre garden in the suburbs."[25] Though he asked several people to pray for Moore while she was sick, the only direct reference to her death in the letters is the statement to Greeves in January 1951, "Minto died a fortnight ago. Please pray for her soul."[26] Lewis later wrote Greeves in March 1951 about his planned visit now that Moore was dead: "I know now how a bottle of champagne feels while the wire is being taken off the cork. Yours, Jack! Pop!"[27]

It seems that Moore as she was in life may appear in *The Great Divorce* as a possessive wife, in *The Four Loves* as Mrs. Fidget, and in *Screwtape* as a woman enslaved by her desire for toast and tea. This is more than you can say for Lewis's father, who seems to have made no impact on his writing whatsoever. But unless you take the view – as Alan Jacobs does – that Orual is in part a portrait of Moore and that Lewis is giving her in *Till We Have Faces* the good death reconciled to God that he wished her to have, we never see Lewis specifically wrestle with Moore's death anywhere.[28]

HELEN JOY DAVIDMAN GRESHAM LEWIS (1915-1960)

The last of the five deaths is, of course, the most famous: the death of Joy Davidman. Her marriage to Lewis was brief but her impact on Lewis was tremendous. They first corresponded in 1950, met in 1952, married in 1956 civilly and in 1957 ecclesiastically, and by 1960 she was dead.

Despite Davidman's serious illness, Lewis did not find her death a release; in fact, he found it anything but. He wrote to Peter Bide, who had married them ecclesiastically, about being at Joy's deathbed. Interestingly, though he had been taken to view his mother's corpse

24 Letter to Arthur Greeves, May 2, 1950, in *Letters, vol. 3*, 28-29.
25 Letter to Belle Allen, September 5, 1950, in *Letters, vol. 3*, 51.
26 Letter to Arthur Greeves, January 31, 1951, in *Letters, vol. 3*, 90.
27 Letter to Arthur Greeves, March 23, 1951, in *Letters, vol. 3*, 98.
28 Alan Jacobs, *The Narnian* (San Francisco: Harper San Francisco, 2005), 262.

and had witnessed scenes of death in World War I, the death of his wife was the first time he had actually seen someone die naturally:

> It was far less dreadful than I had expected – indeed there's nothing to it. Pray for her soul. . . . I can't understand my loss yet and hardly (except for brief but terrible moments) feel more than a kind of bewilderment, almost a psychological paralysis. A bit like the first moments after being hit by a shell. I am – oh God that I were not – very free now. One doesn't realise in early life that the price of freedom is loneliness. To be happy one must be tied.[29]

To Mary Willis Shelburne, the "American Lady" of *Letters to An American Lady*, he wrote that his life was full of "apparent unreality" and that though Joy had died "at peace with God" he was "like a sleep-walker at the moment."[30]

In response to Davidman's death, Lewis produced the masterpiece, *A Grief Observed*, a long meditation on death, abandonment, and faith. As with *Surprised by Joy*, the book both authentically recorded Lewis's grief – as we can now see through a reading of the letters that he wrote after her death – and shaped it into a literary work.[31]

Throughout the book, Lewis referenced and linked Joy's death to his previous experiences. He noted how it was utterly unlike Williams's death: "After the death of a friend, years ago, I had for some time a most vivid feeling of certainty about his continued life. . . . I have begged to be given even one hundredth part of the same assurance about H. There is no answer."[32] Although he didn't speak of his father's death, he identified with his father's life when he read Joy's sons' reaction through the lens of his own reaction to his mother's death: "I cannot talk to the children about her. The moment I try there

29 Letter to Peter Bide, July 14, 1960, in *Letters, vol. 3*, 1169.

30 Letter to Mary Willis Shelburne, July 15, 1960, in *Letters, vol. 3*, 1171.

31 For one example of similarities between Lewis's actual letters and the book, see the letter to Katherine and Austin Farrer of July 21, 1960, in *Letters, vol. 3*, where Lewis describes grief as like being "slightly drunk" and "so like fear" (1174). The same phrases occur together on the very first page of *A Grief Observed* (New York: Bantam, 1961), 1. Lewis was unlikely to have re-read his letters to others before writing the book, but if *A Grief Observed* really originated as a kind of grief diary – as Chad Walsh describes in the book's afterword (149) – Lewis may have either told the Farrers how he felt by referring to his diary, or wrote in the diary after he wrote to the Farrers. There are a number of other occurrences like this: a letter to Chad Walsh of October 18, 1960 where Lewis says "Grief is quite unlike what I imagined. I thought of it as a state, but it is really a process. At each bend of the valley there is a new landscape" (*Letters, vol. 3*, 1198-99) makes it into the book as "Grief is like a long valley, a winding valley where any bend may reveal a totally new landscape" (69). At any rate, it's a fascinating look into his composition process.

32 *A Grief Observed*, 7.

appears upon their faces neither grief, nor love, nor fear, nor pity, but the most fatal of all non-conductors, embarrassment. . . . I felt just the same after my own mother's death after my father mentioned her."[33]

Davidman's position in Lewis's thought life as the anti-Charles Williams persists for much of the book. He expresses a belief that neither his mother nor wife exist anymore, using the metaphor of a wrecked ship when harbor was expected.[34] He says that he cannot pray for her although he is able to pray for the other dead people:

> When I try to pray for H., I halt. Bewilderment and amazement come over me. I have a ghastly sense of unreality, of speaking into a vacuum about a nonentity. The reason for the difference is plain. You never know how much you really believe anything until its truth or falsehood becomes a matter of life and death to you.[35]

This statement makes a fascinating counterpoint to his earlier description of his mother's death, which – as far as we can tell through his later representations of it – was *also* a matter of life and death to him at the time.

Eventually, *A Grief Observed* comes to an apophatic conclusion, where Lewis makes his peace with Davidman's death – not by losing his faith, as some popular portrayals would have it, but by adopting a more mystical approach to faith. He famously remarks near the end that in heaven, it is not that all problems will be subtly reconciled, but that "the notions will all be knocked from under our feet. . . . [S]ome shattering and disarming simplicity is the real answer."[36]

Letters to Malcom, published posthumously, has a great deal of speculation on death and the afterlife in a somewhat calmer mood – though not with any less literary shaping (a fact that Lewis's conversational tone in the book, so like the tone in his *actual* letters, can make the reader forget). Davidman appears briefly here, as Lewis speaks of the fact that he can recall passages of carnal love with his wife "with no re-awakening of concupiscence" and that this teaches him a lesson about the resurrection of the body: "Sown in subjectivity, it rises in objectivity."[37]

Jack's greatest commentary on Joy's death may be that his own death came so soon after hers, in 1963.[38] Given the great disparity

33 *A Grief Observed*, 8-9.
34 *A Grief Observed*, 39.
35 *A Grief Observed*, 24-25.
36 *A Grief Observed*, 83.
37 *Letters to Malcolm: Chiefly on Prayer* (San Diego: Harvest, 1964), 123.
38 Chad Walsh, in his Afterword to *A Grief Observed*, claims that Lewis

he draws between the effects of the two deaths on him in *A Grief Observed*, it is of great interest that it was a poem originally written for Williams which Lewis substantially revised and inscribed on Davidman's tombstone at the crematorium:

> Here the whole world (stars, water, air,
> And field, and forest, as they were
> Reflected in a single mind)
> Like cast-off clothes was left behind
> In ashes yet with hope that she,
> Re-born from holy poverty,
> In Lenten lands, hereafter may
> Resume them on her Easter Day.[39]

"never really recovered" from Davidman's loss (147-48). Cecil Harwood, in "A Toast to His Memory" in *C. S. Lewis at the Breakfast Table*, notes that Lewis was put "almost beside himself by his wife's death" (244). Lewis's letters by and large bear this out.

39 *Letters*, vol. 3, 1171. Published as "Epitaph for Helen Joy Davidman," in *Collected Poems*, 396-97.

Surprised by Walking:
C.S. Lewis's "Channel of Adoration"

by Kyoko Yuasa

Kyoko Yuasa is a lecturer in English Literature at Fuji Women's University, Japan. She is the author of *C.S. Lewis and Christian Postmodernism: Word, Image, and Beyond* (2016) and "C.S. Lewis and Christian Postmodernism: Jewish Laughter Reversed" in *Inklings Forever Volume X* (2017). She is the Japanese translator of Bruce L. Edwards's *A Rhetoric of Reading: C.S. Lewis's Defense of Western Literacy*. She received a BA in literature from Fuji Women's University, an MA in humanities from California University, and a PhD in literature from Hokkaido University.

C.S. Lewis was not only a writer of poetry and novels but also an avid walker. After his conversion, he was a firm believer that the natural world, what Ruskin called "the Schechinah ["God's house" in Hebrew] of the blue" (235), reflected the glory of the creation. In his book *Letters to Malcolm*, Lewis echoes this idea in his description of a man whose experiences in nature lead directly to worship.

> You first taught me the great principle, "Being where you are."
> I had thought one had to start by summoning up what we believe about the goodness and greatness of God, by thinking about creation and redemption and "all the blessings of this life." You turned to the brook and once more splashed your burning face and hands in the little waterfall and said: "Why not begin with this?" I have tried, since that moment, to make every pleasure into a channel of adoration. I don't mean simply by giving thanks for it. One must of course give thanks, but I mean something different. (88-89)

The persona "I" in *Malcolm* is an example of what I have elsewhere termed the nameless double casting of narrator and main character in Lewis's writings (Yuasa 46). This persona enjoys walking while talking with his friend Malcolm in the Forest of Dean. Doing so, he realizes that logical discussion is not the only way to access God; one may also "know" Him through sense experiences in nature.

Although the great forests of Britain were being destroyed even before the arrival of the Romans and this continued through the Anglo-Saxon period (Thomas 192-94), there were still numinous forest experiences available to C.S. Lewis in the twentieth century.

For him, the forest is a beautiful place, and this beauty inspires us to know God, the Creator of this specific beauty. The Forest of Dean is an actual place located in Gloucestershire, West England. Quoting from Thomson's "The Castle of Indolence," Lewis remembers his visit to the pleasing forest as "a pleasant land of drowsy-head" (*The Collected Letters of C. S. Lewis*; hereafter *Letters* 774).

In his early lifetime, walking for pleasure in Great Britain was still a relatively new hobby, ignited by the picturesque philosophy of the eighteenth century, which inspired the Romantic walks and writings of poets William Wordsworth and Samuel Taylor Coleridge (Solnit 96). British society did not immediately embrace this emerging practice. Lewis himself had an unwelcome experience at an inhospitable hotel during the Easter walking tour in Gloucestershire in 1928 (*Letters* 758). He seems to have mirrored this miserable experience in a reference to a hostile hotel owner who refused Ransom, the pedestrian protagonist of *Out of the Silent Planet*. However, as a response to urbanization, walking for *enjoyment* grew increasingly popular in Great Britain, and the footpaths were gradually opened to people of all social classes. The natural environment became, according to one writer, "a version of the garden . . . without walls" (Solnit 167). Among those who enjoyed this new pastime were Lewis and many of his closest companions.

Lewis loved walking in solitude in the morning and in the afternoon after tea. The present-day head of the Eastern Orthodox Church in England, Kallistos Ware, writes that, as an Oxford undergraduate, he witnessed Lewis walking alone on Addison's Walk in the mornings (53). However, walking in solitude was not always Lewis's practice. When walking on the weekend, or the Easter Tour, or in his home country of Ireland, he would often walk with friends. One of the attractions of walking for Lewis was that it is a sociable activity, an opportunity for communication with his friends.

The ultimate expression of communal human walking is a pilgrimage, a kind of group journey that allows us to move in spaces from physical and exterior to inner and invisible, from the earthly to the spiritual or heavenly dimension. In *Wanderlust: A History of Walking*, Rebecca Solnit suggests that a pilgrimage is "a form of spatial theater, but also spiritual" (68). Walter Starkie says that in *The New Life*, Dante references two kinds of pilgrimage: one for those outside their homeland, never to return, and the other for those travelling toward the great pilgrimage sites of medieval Europe – Jerusalem, Rome, and Santiago de Compostela – and returning therefrom (60). Lewis's walking, technically speaking, was neither kind of pilgrimage,

yet his walking with his friends resembled pilgrimage to the degree that these physical journeys led to inner transformation. He seemed to be spiritually touched by the Holy Spirit while walking and talking with his friends, just as the two disciples walking to Emmaus were when they encountered Jesus on the road (Luke 24:17).

Lewis's walking has been discussed previously by Lewis scholars, but the discussion has primarily focused on the different personalities of Lewis's friends or about the books and poems they discussed along the way (Glyer 138-39). Their focus is not specifically on how Lewis's physical walking influenced his spiritual life. In this essay, I want to look closely at examples of how certain walking experiences with friends became what Lewis called "a channel of adoration." And finally, I want to analyze his poem "The Future of Forestry" for its significance to this topic.

In his childhood, Lewis developed a longing for a romantic feeling he sometimes experienced when looking at the green landscape of his home country of Northern Ireland. He called this feeling "Sehnsucht," a German word often translated longing or nostalgia (*Letters* 922). Lewis himself depicts his younger self as having a rather confused worldview: his spirit longed for the fulfillment suggested by these experiences of *Sehnsucht*, but as a materialist, he insisted there was no real beauty in material nature (*Surprised by Joy* 205). However, walking with his childhood friend, Arthur Greeves, influenced Lewis's idea of nature, making him more aware of "outdoor delights" (182). He learned from Arthur how to celebrate beauty in the many faces of nature, including what Lewis calls "the Homely" (182). By "Homely," Lewis does not mean unattractive as such, but rather ordinary or unspectacular. For example, he refers to the beauty in a homely row of cabbages (182). These experiences of subtle, "homely" beauty contrast with the rather dramatic requirements of what is sometimes called "romantic" beauty.

Lewis called Greeves his "alter ego": the kind of friend who joins you like "raindrops on a window" (*Surprised by Joy* 232). On the other hand, Oxford friend Owen Barfield was the opposite: "the anti-self" who disagrees with you about everything (232). Lewis affectionately calls his walks with Barfield "a perpetual dogfight" (232). The two men continually argued while walking on the hills for many days without giving "a glance" (232) at the natural beauty. In *Letters to Malcolm*, the narrator tells us that he comes to know the Creator and the creation while walking with his friend, (the fictional) Barfield (73-74). Similarly, in real life, Lewis and Barfield often discussed

the lifelong topic of "God and creature" (Barfield 219). Barfield remembers his walking tour with Lewis in the Thames Valley, saying that Lewis "emphasized the chasm between Creator and creature" (219). Apparently, his walking tours with Barfield helped narrow the chasm.

In a different way, Lewis came to understand creation and Creator when walking with his scholar friends Tolkien and Dyson. Lewis claims that two kinds of wind were blowing on them on the famous night of 20 September 1931, as they walked along Addison's Walk, a riverside footpath in Magdalen College. The first wind was a natural one, blowing on them as Lewis and his friends were in the middle of a discussion of myth and Christianity. They were "interrupted by a rush of wind which came so suddenly on the still, warm evening and sent so many leaves pattering down that we thought it was raining. We all held our breath, the other two appreciating the ecstasy of such a thing almost as you [Greeves] would" (*Letters* 970).

Tolkien and Dyson relished "the ecstasy from the wind;" since he doesn't mention himself, we may infer that Lewis did not, at least to the same degree. At this stage, however, Lewis did not share the same views on myth and Christianity as his friends. In fact, that was the main discussion topic of their famous long night walk. Still, even if Lewis was not as ecstatic as the other two, he must have been moved by the experience for he, like his friends, held his breath. For Lewis, such experiences link with what he eventually came to call "the Numinous," a word coined by German philosopher Rudolph Otto that means a feeling of holy awe mixed with fear (Otto 151). The rush of wind in Addison's Walk was perhaps a numinous experience planting a spiritual seed in Lewis's materialist mind, ready to bloom into "a channel of adoration."

From this seed, another wind may have been generated. After returning to his apartment from the night walk, as is well known, Lewis heard from his friends about the one great myth transcending human myths. This began a process of coming to believe that the myth of a god who dies and rises again was historically completed in the gospel – the story of Jesus Christ (*Letters* 970). Through walking then, Lewis came to access a "channel of adoration," a means of grace that he develops further in his later works.

Malcolm Guite calls Lewis's poem "The Future of Forestry" "an early voice of ecological protest" by a "contemporary exponent of 'deep ecology'" (304-5). In this light, the poem has been read as an ecological song that warns of the destruction of the environment and

humanity. King agrees with Guite on the ecological critique of the contemporary city, but he also emphasizes the importance of "faery" in the world of the poem, not simply "the natural world" (187). I suggest that, although "ecology" is commonly used to refer to material nature, Lewis suggests not only a material but also an imaginative and spiritual dimension of ecology through this poem, especially in its concluding image of "tree-delighted Eden."

"The Future of Forestry" is comprised of three verse paragraphs, each lamenting the loss of one of the sensitive faculties – touching, hearing, and seeing. The poet feels grief at his inability to touch trees because the forest has been ruined by urbanization and civilization. Sadness or nostalgia at the felling of trees was not a widespread emotion in Britain until the concept of forests changed in the eighteenth century (Thomas 214). Cowper's "The Poplar-Field" and Hopkin's "Binsey Poplars" are elegies about the felling of trees. Lewis follows their legacy after witnessing a giant elm tree cut down by storms, describing the damage as "lying dead" (*Letters* 250). This emotion is reproduced in the poem and in *The Chronicles of Narnia*. Similarly, the crash of a falling tree is expressed as "a disastrous noise" of sin in *The Magician's Nephew* (59).

The first paragraph of "The Future of Forestry" warns of the ecological crisis faced by modern civilization: the felling of the last tree, the barren farm soil, and the restless country polluted with light and noise. Surprisingly, the narrator attributes the cause of the ecological crisis to the lack of storytelling about trees at home and school. This has resulted in the children's loss of memory of trees, especially chestnuts and elms. Chestnut trees in Narnia are associated with the memory of humanity in two young men, Shasta and Emeth, in Calormen. A chestnut tree is included among the trees of the first forest Shasta sees (*The Horse and His Boy* 149), and Emeth is seen to be sitting under a chestnut tree by the Narnian friends (*The Last Battle* 200). Trees, therefore, are an important part of human culture, part of the human story. They in a sense shelter and nurture human flourishing. If they are lost, so will much of the good of human life.

In 1938, when "The Future of Forestry" was published, the elm tree was already faced with extinction, as Dutch elm disease was spreading all over Britain (Gibbs 1). The children depicted in "The Future of Forestry" have no memory of elm trees nor do they notice the extinction crisis.

> Simplest tales will then bewilder
> The questioning children, "What was a chestnut?

Say what it means to climb a Beanstalk,
Tell me, grandfather, what an elm is.
What was Autumn? They never taught us."

In *Prince Caspian*, as the natural environment is damaged by a kind of Narnian modernization, the tree-fairies of the elm fall asleep, symbolically suggesting that the world has gone into a spiritual sleep or apostasy (166).

In "The Future of Forestry," Lewis reminds us that memory loss can lead to ecological crisis. Or put another way, that healthy human memory is always partly at least a memory of trees. By losing legends about trees, we will forget the sense of the numinous so that we may finally lose the power to imagine the living forest. "Beanstalk" refers to "Jack and the Beanstalk," a well-known fairy tale from folklore that combines the fear and longing of the numinous. Joy Alexander, a Lewis scholar in Ireland, admires Lewis's reference to the beanstalk in "The Future of the Forestry." She states that modern children's alienation from the natural world "will cut them off from their cultural heritage of fairy-stories." Through Eustace, a thoroughly modernist boy, Lewis cautions us that, with no imagination, we will lose our humanity, which may lead to a loss of faith in God (*The Voyage of the Dawn Treader* 89, 107).

The poet of "The Future of Forestry" tells another horror story, that of losing the knowledge of autumn. Autumn is Lewis's favorite season, as the fallen leaves remind him of a spiritual resurrection from death: "In autumn I get the sense, just as the mere nature and voluptuous life of the world is dying, of something else coming awake" (*Letters* 832). From the physical phenomenon of autumn, Lewis receives a spiritual message of the soul, dead and risen. *The Silver Chair* is a story, not of autumn leaves, but of humanity falling and rising in autumn. The main characters are painfully aware of their sins of having wrongly followed the cannibal giants when they have eaten a talking stag without knowing (132). The children in "The Future of the Forestry" are a good warning of what not to do. To forget autumn is to lose the physical and spiritual delight it embodies and symbolizes.

Lewis advocates for the restoration of the forest, as it is directly and indirectly connected with the restoration of humanity. Milton fancifully suggests a common destiny of trees being felled and fairies becoming extinct in *II Penseroso*: "To arched walks of twilight groves, / And shadows brown that *Sylvan* loves / Of Pine, or monumental Oake, / Where the rude axe with heaved stroke, / Was never heard the Nymphs to daunt, / Or fright them from their hallow'd haunt"

(133-38). Lewis inherits Milton's legacy and sees the wood fairy (or at least the enchanted meanings of trees) disappearing because of an ecological crisis. Like Milton's, Lewis's "deep ecology" includes both the woods and the fairy. His ecological stance is shared by Tolkien, who similarly sees "a real (not metaphorical) connection between them ['nymphs and dryads'] and the countryside." (*Letters* 909).

Lewis's imaginative vision re-enchants the world with legends of "fancy" and "romances" that allow him to see a vivid picture of trees and fairies walking in the wood. In *The Discarded Image*, a book about the medieval worldview, Lewis includes the dwarf, the faery, and the giant in the same group of "longlivers," explaining that they are so "because their place of residence is ambiguous between air and Earth" (122). He points to the four characters of "fairy" according to Paracelsus's "A Book of Nymphs": 1) a third rational species distinct from angels and mankind; 2) angels demoted; 3) some special class of the dead; and 4) fallen angels (134-37).

The poet of "The Future of Forestry" sees fairies and a natural creature, a tree, as inhabiting the same world – a birch-girl is the alter-ego for the hawthorn. In Irish mythology, white hawthorn is associated with the fairy realm underground (Briggs 159) and traditional May celebrations in pre-Christian days (Hooke 37). Nowadays, May Day is grafted onto a Christian setting in Oxford and celebrated with a May choir in Magdalen, where Lewis was a fellow. Stories of fairies were familiar to Lewis, who was brought up by an Irish nanny (*Surprised by Joy* 127). He states how he once met a dwarf in the garden and describes "a fear that guarded the road to Faerie" (*Surprised by Joy* 61).

Hawthorn trees in Narnia are associated with salvation and eschatology. When walking in the forest of Narnia, the sweet fragrance of the hawthorn blossoms makes Lucy and the Beavers feel the reality of salvation (*The Lion, the Witch, and the Wardrobe* 135-36). In *Prince Caspian*, when mythological characters, including Bacchus, splash into the water to stop excessive civilization, ivy on the Beruna Bridge transforms into hawthorn but eschatologically disappears and collapses into the water (212). Lewis's poem concludes:

> Fancy will tint their wonder-paintings
> Trees as men walking wood-romances
> Of goblins stalking in silky green,
> Collar, pallor in the face of birchgirl
> So shall a homeless time, though dimly
> Catch from afar (for soul is watchful)
> A sight of tree-delighted Eden.

The story ultimately points towards a glimpse of something hopeful: "A sight of tree-delighted Eden." As predicted in *Prince Caspian*, the whole forest of Narnia is to be destroyed outside the stable on the hill, but inside the stable, all kinds of trees themselves are delighted in the ending of *The Last Battle*: "Lucy looked hard at the garden and saw that it was not really a garden at all but a whole world, with its own rivers and woods and sea and mountains" (*The Last Battle* 224). The story of the trees and fairies, dead and risen, is completely fulfilled inside the stable in Narnia, which echoes how Lewis came to believe in Christ after walking with the wind blowing both naturally and spiritually.

If Lewis were to encounter us walking, he perhaps might ask us the same question Jesus asked his disciples on the road to Emmaus: "What are you discussing together as you walk along?" (Luke 24:17). Our walking will perhaps say more than our words about the love of a God who created all living things and who speaks to us through the numinous experiences His creation affords us in nature.

WORKS CITED

Alexander, Joy. "Re: Beanstalk." Email received by Kyoko Yuasa, 25 April 2018.

Barfield, Owen. "Lewis and/or Barfield." *C. S. Lewis and his Circle: Essays and Memoirs from the Oxford C. S. Lewis Society*, edited by Roger White, Judith Wolfe, and Brendan N. Wolfe, Oxford UP, 2015, 214-22.

Briggs, Katharine. *An Encyclopedia of Fairies: Hobgoblins, Brownies, Bogies, and Other Supernatural Creatures*. Pantheon Books, 1976.

Cowper, William. "The Poplar-Field," *PoemHunter.com*, 12 Aug. 2018, www.poemhunter.com/poem/the-poplar-field/.

Dickerson, Matthew T., and David O'Hara. *Narnia and the Fields of Arbol: The Environmental Vision of C. S. Lewis*. UP of Kentucky, 2009.

Gibbs, John. "Dutch Elm Disease in Britain." *The Forestry Authority*, 27 March 2018, www.forestresearch.gov.uk/documents/2346/.

Glyer, Diana Pavlac. *The Company They Keep: C. S. Lewis and J. R. R. Tolkien as Writers in Community*. Kent State UP, 2008.

Guite, Malcolm. "Poet." *The Cambridge Companion to C. S. Lewis*, edited by Robert MacSwain and Michael Ward, Cambridge UP, 2010, pp. 294-310.

Hooke, Della. *Trees in Anglo-Saxon England: Literature, Lore and Landscape*. Boydell Press, 2013.

Hopkins Gerald Manley. "Binsey Poplars," *PoemHunter.com*, 12 Aug. 2018, www.poemhunter.com/poem/binsey-poplars/.

Jacob, Joseph. "Jack the Giant-Killer," *The Project Gutenberg EBook of English Fairy Tales*, 12 Aug. 2018, www.gutenberg.org/files/7439/

King, Don W. *C. S. Lewis, Poet: The Legacy of His Poetic Impulse*. The Kent State UP 2001.

Lewis, C. S. *The Collected Letters of C. S. Lewis Volume I: Family Letters 1905-1931.* Edited by Walter Hooper. Harper, 2004.

---. "The Future of Forestry." *Poems*, edited by Walter Hooper, Bles, 1964, p. 61.

---. *The Great Divorce: A Dream.* Bles, 1945.

---. *The Horse and His Boy.* Harper, 1954.

---. "Is Theology Poetry?" *C. S. Lewis: Essay Collection & Other Short Pieces*, edited by Lesley Walmsley, HarperCollins, 2000, pp. 10-21.

---. *The Last Battle.* Harper, 1984.

---. *Letters to Malcolm Chiefly on Prayer: Reflections on the Intimate Dialogue between Man and God.* Harcourt, 1992.

---. *The Lion, the Witch, and the Wardrobe.* Harper, 1980.

---. *The Magician's Nephew.* Harper, 1955.

---. *Mere Christianity.* Harcourt, 1992.

---. "Myth Became Fact." *God in the Dock*, edited by Walter Hooper, Eerdmans, 1972, pp. 30-33.

---. "On Living in an Atomic Age." *C. S. Lewis: Essays Collection and Other*, edited by Lesley Walmsley, Harper, 2000, pp. 361-66.

---. "On Three Ways of Writing for Children." *On Stories*, edited by Walter Hooper, Harcourt, 1982, pp. 31-48.

---. *Out of the Silent Planet.* Bles, 1938.

---. *Prince Caspian.* Harper, 1980.

---. *The Silver Chair.* Harper, 1981.

---. *The Screwtape Letters.* Bles, 1955.

---. *Surprised by Joy.* Bles, 1955.

---. *The Voyage of the Dawn Treader.* Harper, 1980.

Milton, John. *L'Allegro, Il Penseroso, Comus, and Lycidas*, 18 May 2018, archive.org/details/miltonslallegroi00miltrich.

Neuhouser, David. "Nature as 'God's Imagination': The Environmental Vision of George MacDonald."

Exploring the Eternal Goodness, edited by Joe Ricke and Lisa Ritchie, Winged Lion Press, 2016, pp. 143-56.

The Ramblers' Association 2010. "Walking Facts and Figures 2: Participation in Walking," 14 March 2018, www.ramblers.org.uk/advice/facts-and-stats-about-walking/social-and-community-benefits-of-walking

Ruskin, John. *Modern Painters. Volume 2*. Edited by E.T. Cook and Alexander Wedderburn, Hon-No-Tomosha, 1990.

Starkie, Walter. *The Road to Santiago: Pilgrims of St. James*. U. of California P, 1965.

Solnit, Rebecca. *Wanderlust: A History of Walking*. Penguin Books, 2001.

Thomas, Keith. *Man and the Natural World: Changing Attitudes in England, 1500-1800*. Penguin, 1984.

Tolkien, J.R.R. "Mythopoeia." *Tree and Leaf*. Houghton, 1989, pp. 97-101.

Ware, Kallistos. "Sacramentalism in C.S. Lewis and Charles Williams." *C.S. Lewis and his Circle: Essays and Memoirs from the Oxford C.S. Lewis Society*, edited by Roger White, et al. Oxford UP, 2015.

Wheeler, Michael. *Ruskin's God*. Cambridge UP, 1999.

Yuasa, Kyoko. *C.S. Lewis and Christian Postmodernism: Word, Image, and Beyond*. Wipf and Stock, 2016.

Faith Awakened in the Woods of Narnia

by Jim Stockton

Jim Stockton is a Lecturer in Philosophy at Boise State University. His research interests include medieval philosophy, Inklings studies, and philosophy and film. His most recent publications include "C. S. Lewis and the Oxford Philosophers," "Chaplain Stella Aldwinckle: A Biographical Sketch of the Spiritual Foundation of the Oxford University Socratic Club," and "The Libraries of Narnia." He is currently working on a history of the Oxford University Socratic Club.

C. S. Lewis's Narnia is a magical world wherein natural entities (particularly trees) are often portrayed as harbingers of faith. Although sacred trees and forests are common to fairyland and the epic fantasy genre, the woods of Narnia are unique in that they play a subtle but significant role in enhancing the relationship between Aslan and many of the other characters in the storyline. To bring this point forward I will offer a brief analysis of five examples wherein the characterization and interaction of a tree, or trees, helps develop a sense of virtue and/ or religiosity. In chronological order the five examples are: 1) the Tree of Protection in *The Magician's Nephew*, 2) the Awakened Trees of Aslan's in *Prince Caspian*, 3) the cedar forests of Dragon Island in *The Voyage of The Dawn Treader*, 4) the "park-like country"[1] of Archenland and the promise it holds for Shasta and Aravis of *The Horse and His Boy*, and 5) the murder of the Dryads and other living trees in *The Last Battle*.[2] Collectively, these five instances of Narnian tree lore remind us, as Mr. Beaver tells the Pevensie children, that Aslan is "The Lord of the whole wood,"[3] and the woods answer to his roar.

One of the finest examples of faith being awakened, as well as faith being challenged, within the woods of Narnia occurs when the Pevensie children first meet Mr. Beaver in *The Lion, the Witch, and the Wardrobe*. Having seen the beaver pop his head out of the trees, and having been cheered on by Lucy's comment that she thought it was a nice beaver, "the children all got close together and walked up to the tree and in behind it, and there, sure enough, they found

1 C. S. Lewis, *The Horse and His Boy* (New York: HarperCollins, 1994), 149.
2 The capitalization of 'Dryad' (and other characters referred to in this paper) follows the use given in the Chronicles.
3 C. S. Lewis, *The Lion, the Witch, and the Wardrobe* (New York: HarperCollins, 1994), 85.

the Beaver; but it still drew back, saying to them in a hoarse throaty whisper, 'Further in, come further in. Right in here. We're not safe in the open!'"[4] The "here" our good Mr. Beaver is referring to is a safe but "dark spot where four trees grew so close together that the boughs met and the brown earth and pine needles could be seen underfoot because no snow had fallen there."[5] In his "cathedralesque" shelter, Mr. Beaver asks the children, "Are you the Sons of Adam and Daughters of Eve?" When Peter replies with, "We're some of them," Mr. Beaver quiets Peter with a cautious "S-s-sh!" and a polite "not so loud please. We're not safe even here."[6] Showing little surprise in engaging in a conversation with an animal, an imaginative act of faith in its own regard, Peter, quite naturally, asks, "Why? Who are you afraid of? . . . There's no one here but ourselves."[7] Mr. Beaver corrects him by pointing out that "There are the trees. . . . They're always listening. Most of them are on our side, but there *are* trees that would betray us to *her*; you know who I mean."[8] Lewis's choice to italicize the verb *are* and the pronoun *her* brings to our attention the trees' capability to "betray" other sentient beings of Narnia by serving the White Witch. Moreover, as we later learn (particularly so in *Prince Caspian*) not only do many of the trees of Narnia speak, they also exercise a free will and are capable of moral discernment. However, it is Mr. Beaver's whispered comment, "They say Aslan is on the move – perhaps has already landed," that brings about "a very curious thing."[9]

> None of the children knew who Aslan was any more than you do; but the moment the Beaver had spoken these words everyone felt quite different. . . . At the name Aslan each one of the children felt something jump in its inside. Edmund felt a sensation of mysterious horror. Peter felt suddenly brave and adventurous. Susan felt as if some delicious smell or some delightful strain of music had just floated by her. And Lucy got the feeling you have when you wake up in the morning and realize that it is the beginning of the holidays or the beginning of summer.[10]

For three of the children, the mere mention of Aslan's name brings about joyful thoughts, and a deeply felt desire to learn more

4 Lewis, 72.
5 Lewis, 72-73.
6 Lewis, 73.
7 Lewis, 73.
8 Lewis, 73
9 Lewis, 74.
10 Lewis, 74.

about Narnia's most noble beast. Their faith has been awakened, and their hopes have been elevated; however, with malice and betrayal on his mind, Edmund cannot, for the time being, share in his siblings' sense of joy. His faith has been challenged, and his moment with joy will occur later in the story, and, rooted in redemption, will be much different than that of his siblings. As unique as each experience of facing Aslan might be, it is obvious that to hear of, to speak of, and most of all to see and sense Aslan is to experience a stirring within one's soul.

One of the most picturesque awakenings in all of the Chronicles is the *creatio ex nihilo* of Narnia, as it occurs in *The Magician's Nephew*. Standing in the utter darkness and nothingness of "an empty world," Digory, Polly, Frank the Cabby, Uncle Andrew, Jadis the Witch, and Strawberry the Horse witness the birth of a world when "A voice had begun to sing."[11] In the words of Frank the Cabby, it was a voice "beyond comparison, the most beautiful noise . . . ever heard."[12] This "First Voice,"[13] Aslan, will be joined by many other celestial voices, and, in unison, this divine choir will sing all of Narnia into existence. As the world around them comes into existence, it is little more than a "valley of mere earth, rock and water," but it will quickly be filled with grass and heather, and in a miraculous moment "a little, spiky thing . . . threw out dozens of arms and covered these arms with green and grew larger at the rate of about an inch every two seconds," giving rise (literally) to Narnia's first trees.[14] The first tree to be identified is a "full-grown beech whose branches swayed above [Digory's] head."[15] What follows next is the further creation of Narnia, and Jadis the Witch's repulsion of Aslan's glorious magic. As the green and beautiful world around her takes shape, a horrified and angry Jadis tosses the iron bar of a London streetlamp at Aslan, hitting him square in the head, flying off to the side, and having no effect. However, the children and Uncle Andrew soon notice that where the iron bar had landed, a "young lamp-post" grew out of the soil, prompting the greedy Uncle to proclaim that "the commercial possibilities of this country are unbounded," and leading Polly to reply, "You're just like the Witch. . . . All you think of is killing things."[16]

11 C. S. Lewis, *The Magician's Nephew* (New York: HarperCollins, 1994), 116.
12 Lewis, 116.
13 Lewis, 117.
14 Lewis, 124.
15 Lewis, 126.
16 Lewis, 132.

The birth of the lamp-post not only reaches back to *The Lion, the Witch, and the Wardrobe*, it suggests that what is magical, or miraculous, in the world of Narnia, might very well occur in our world. With the reader having been assured that Narnian magic has the potential to run concurrently between all worlds, the animals arise from the earth. The moles come first, followed by dogs, stags, frogs, panthers, leopards, showers of birds, butterflies, bees, and an elephant. As the animals arise, Aslan "would go up to two of them (always two at a time) and touch their nose with his. . . . At last he stood still and all the creatures he had touched came and stood in a wide circle around him. The others he had not touched began to wander away."[17] It is at this moment in the story that faith in Aslan, as well as faith in his creation, is first awakened, witnessed, and accepted. It is also the first time that Aslan speaks to his creation in "the deepest, wildest voice they had ever heard . . . saying: 'Narnia, Narnia, Narnia, awake. Love. Think. Speak. Be walking trees. Be talking beasts. Be divine waters.'"[18] The Trinitarian imagery is hard to ignore, just as it difficult to dismiss the revered status given to "walking trees."

With Narnia awakened, "Out of the trees wild people stepped forth, gods and goddesses of the wood; with them came Fauns and Satyrs and Dwarfs."[19] Shortly after Aslan decrees that all of Narnia is given freely to those he has gathered, he also calls the "chief Dwarf, and you the River-god, and you Oak and the He-Owl, and both the Ravens and the Bull-Elephant,"[20] together for a council to deal with the evil that the witch Jadis has brought to Narnia. Shortly afterwards, Digory will confess to Aslan that he brought Jadis out of Charn, into the streets of London, and eventually into Narnia. Aslan sends Digory on a redemptive quest beyond the "big snowy mountains" of the Western Wild, where he will "find a green valley with a blue lake in it, walled round by mountains of ice. At the end of the lake there is a steep green hill. On the top of that hill is a garden. In the center of that garden is a tree. Pluck an apple from that tree and bring it back to me."[21]

When Digory reaches the garden, he recognizes the object of his quest without hesitation. Not only did it sit in the center of the garden, it also bore "great silver apples" that "shone so and cast a light of their

17 Lewis, 136.
18 Lewis, 138.
19 Lewis, 139.
20 Lewis, 142.
21 Lewis, 169-70.

own down on shadowy places where the sunshine did not reach."[22] Putting a silver apple in his jacket, Digory is tempted to keep the apple for himself, only to be confronted by the arrival of Jadis, who does her wicked best to convince Digory to forget Aslan's command, to return to his world, and to share the magic apple with his ailing mother. It is here that Digory's faith is further awakened and tested. Seeing through Jadis's cruel temptations, Digory returns to Aslan, apple in hand. Standing before everyone, Aslan tells Digory, "For this fruit you have hungered and thirsted and wept. No hand but yours shall sow the seed of the Tree that is to be the protection of Narnia. Throw the apple toward the river bank where the ground is soft."[23] Digory follows Aslan's command, fully aware that he is throwing away a chance to cure his mother, thus demonstrating the sincerity of his faith in Aslan.

A new tree arises where the silver apple landed, and Aslan tells the creatures of Narnia, "let it be your first care to guard this Tree, for it is your Shield. The Witch of whom I told you has fled far away into the North of the world; she will live on there, growing stronger in dark Magic. But while that tree flourishes, she will never come down into Narnia."[24] Digory's faith is rewarded when Aslan tells him to "Pluck her [his mother] an apple from the tree"[25] and take it back to London. As those of us who have read the Chronicles well know, Digory's mother is cured by the magic apple, and the "tree which sprang from the Apple that Digory planted in the back garden, lived and grew into a fine tree."[26] In later years, when Digory is a middle-aged Professor, a heavy wind blows down the tree and Digory uses the wood to build a "wardrobe, which he put in his big house in the country."[27]

As an anthropomorphized species, Narnian trees prove to be a very lively lot, and while there are many wondrous trees in the Chronicles, it is in *Prince Caspian* that the Trees of Narnia rise to occasion in what many would say is their finest hour. However, prior to

22 Lewis, 188.

23 Lewis, 198.

24 Lewis, 206.

25 Lewis, 209.

26 Lewis, 219-20. In the same passage, the narrator continues to explain the quasi-magical nature of this particular tree with, "Growing in the soil of our world, far out of the sound of Aslan's voice and far from the young air of Narnia, it did not bear apples that would revive a dying woman as Digory's mother had been revived, though it did bear apples more beautiful than any others in England, and they were extremely good for you, though not fully magical. But inside itself, in the very sap of it, the tree (so to speak) never forgot that other tree in Narnia to which it belonged. Sometimes it would move mysteriously when there was no wind blowing."

27 Lewis, 220.

the famous Battle of Aslan's How, the Pevensie children must get their bearings straight, because the Narnia they have returned to is much different than the one they left behind (at the end of their first visit). The landscape is unfamiliar, there are no talking animals or magical creatures to greet them, and, as they soon learn, they have arrived in a *new* Narnia that for a thousand years since their last adventure has been ruled by a brutal race of men, the Telmarines. As the children venture further and learn more about the current state of affairs, they soon realize that many of the animals have grown "dumb" and have lost their ability to speak. This change is depicted when Lucy crosses the path of a "grim-looking gray bear,"[28] who is immediately shot dead by Trumpkin the Dwarf. To the shocked children, Trumpkin explains: "That's the trouble of it. . . . [M]ost of the beasts have gone enemy and gone dumb, but there are still some of the other kind left. You never know, and daren't wait and see."[29] The Telmarine tyranny of Narnia has tossed Aslan's world into an unnatural state in which no one knows what to expect and whom to trust. Aslan had warned the Talking Beasts of Narnia about this very fate shortly after their creation in *The Magician's Nephew*:

> Creatures, I give you yourselves. . . . I give you forever this land of Narnia. I give you the woods, the fruits, the rivers. I give you the stars and I give you myself. The Dumb Beast whom I have not chosen are yours also. Treat them gently and cherish them but do not go back to their ways lest you cease to be Talking Beasts. For out of them you were taken and into them you can return. Do not so.[30]

The significance of Aslan's proclamation is that all of Narnian Nature is for the balanced benefit of the Talking Beasts, the mythical creatures, and those humans who visit or inhabit Aslan's world. Pragmatically speaking this allows Narnians to have a carnivorous diet, firewood, and forded waterways without being accused of cannibalism, murder, or slavery. Spiritually, this makes the blessed creatures of Narnia the stewards of Aslan's creation – and by extension we can identify a clear tie to the Augustinian doctrine that interprets Genesis 1:29-30[31] as granting humans dominion over all of nature.

28 C.S. Lewis, *Prince Caspian* (New York: HarperCollins, 1998), 126.
29 Lewis, 127.
30 Lewis, *Magician's Nephew*, 140.
31 "Then God said, 'I give you every seed-bearing plant on the face of the whole earth and every tree that has fruit with seed in it. They will be yours for food. And to all the beasts of the earth and all the birds in the sky and all the creatures that move along the ground – everything that has the breath of life in it – I give every

In both Narnia and our world alike, this view of natural dominion includes "the woods, the fruits, the rivers."[32] Nor is it just the animals that have grown dumb and brute. Earlier in the novel, Trufflehunter the Badger explains to Caspian that he cannot call upon the spirits of trees and water to help them in their rebellion against the Telmarines:

> "We have no power over them. Since the Humans came into the land, felling forests and defiling streams, the Dryads and Naiads have sunk into a deep sleep. Who knows if they will ever stir again? And that is a great loss to our side. The Telmarines are horribly afraid of the woods, and once the Trees moved in anger, our enemies would go mad with fright and be chased out of Narnia as quick as their legs can carry them."[33]

Upon hearing this, Trumpkin, the *doubting Thomas* figure in the story, is quick to reply, "What imaginations you Animals have! ... Why stop at Trees and Waters? Wouldn't it be nicer if the stones started throwing themselves at old Miraz?"[34]

Being the embodiment of faith, and closest to Aslan, Lucy will have nothing to do with Trumpkin's skepticism. As the rest of the children and Trumpkin lie asleep, a restless Lucy arises and walks into the woods trying to settle her worries over "how a handful of Dwarfs and woodland creatures could defeat an army of grown-up Humans."[35] Finding comfort in the beauty of the Narnian woods, Lucy begins to feel "A great longing for the old days when the trees could talk."[36] Here Lewis give us perhaps the finest single account of Narnian tree lore.

> She looked at a silver birch: it would have a soft, showery voice and would look like a slender girl, with hair blown all about her face, and fond of dancing. She looked at the oak: he would be a wizened, but hearty old man with a frizzled beard and warts on his face and hands, and hair growing out of the warts. She looked at the beech under which she was standing. Ah! – she would be the best of all. She would be a gracious goddess, smooth and stately, the lady of the wood.[37]

Moved by the beauty of the woods, and a longing to be closer

green plant for food.' And it was so."

32 Lewis, *Magician's Nephew*, 140.
33 Lewis, *Prince Caspian*, 84.
34 Lewis, 85.
35 Lewis, 120.
36 Lewis, 122.
37 Lewis, 122-23.

to the trees, Lucy cries aloud, "'Oh Trees, wake, wake, wake. Don't you remember it? Don't you remember *me*? Dryads and Hamadryads, come out, come to me.'"[38] Lewis's (italicized) emphasis on the first "me", followed by the imperative in the final sentence, is one of many indicators that Queen Lucy the Valiant[39] is not only closest to Aslan, she is also closest to Narnian Nature. She is, by her love for the sublime and her profoundly evident innate faith in Aslan and the Greater Good, a Wordsworthian child of Nature. Shortly thereafter, when Aslan awakens the sleeping Trees of Narnia, Lucy once again awakens in the middle of the night, "with the feeling that the voice she liked best in the world had been calling her name." Upon hearing the voice, Lucy walks into the woods and begins to notice that "the trees were really moving – moving in and out through one another as if in a complicated country dance. ('And I suppose,' thought Lucy, 'when trees dance, it must be a very, very country dance indeed.')".[40] As Lucy looks closer at the trees around her, she observes that one can't see a walking tree's "feet or roots, of course, because when trees move they don't walk on the surface of the earth; they wade in it as we do in water."[41] Within minutes Lucy is dancing amongst the trees, in what is referred to as the "Great Chain,"[42] and is immediately united with Aslan in "A circle of grass, smooth as lawn . . . with dark trees dancing all around."[43]

Having awakened the woods of Narnia, Aslan will soon "Romp" through the countryside, with Lucy and Susan riding upon his back, calling upon all of Narnian Nature to arise against the Telmarines. As the Romp continues, we are told, "All of the trees of the world appeared to be rushing toward Aslan. But as they drew nearer they looked less like trees," making up "a crowd of a hundred human shapes."[44] The "birch-girls" and "shaggy oak-men" are now joined by "willow-women [that] pushed back their hair from their brooding faces to gaze on Aslan," and "shock-headed hollies (dark themselves, but their wives all bright with berries), and gay rowans."[45] As a wild dance ensues, vines appear upon the trunks of the trees, the finest grapes miraculously appear, and the pagan gods Bacchus and Silenus arrive to announce the re-birth of Old Narnia. Readied for battle, Aslan and all who

38 Lewis, 123.
39 Lewis, *Lion, the Witch, and the Wardrobe*, 201.
40 Lewis, *Prince Caspian*, 145.
41 Lewis, *Prince*, 145.
42 Lewis, 146.
43 Lewis, 146, 148.
44 Lewis, 166.
45 Lewis, 166.

joined him in the Romp ascend upon the battlefield of Aslan's How where Peter and Miraz are engaged in one-on-one combat. Just as Peter begins to gain an advantage over the more seasoned Miraz, the King of the Telmarines is stabbed by his own counselor, Glozelle. Full battle ensues, with the odds very much in the Telmarines' favor. However, "almost before the Old Narnians were really warmed to their work they found the enemy giving away. Tough-looking warriors turned white, gazed in terror not on the Old Narnians but on something behind them. . . . The Wood! The Wood!"[46] Lewis describes the advance of "the Awakened Tress" by asking his reader to "imagine that the wood, instead of being fixed to one place, was rushing at you; and was no longer trees but huge people; yet still like trees because their long arms waved like branches and their heads tossed and leaves fell round them in showers."[47] As the Telmarines race to "the Great River in hope of crossing the bridge to the town of Beruna and there defending themselves behind ramparts and closed gates,"[48] they are shocked to learn that the Bridge of Beruna had been washed away by the river god, who had been released, on Aslan's command, by Bacchus.[49] With that the Telmarines are defeated, and Old Narnia and Narnian Nature are restored.

With much of the action taking place on the sea, *The Voyage of the Dawn Treader* has fewer woodland references; nevertheless several "island" passages prove to be most interesting. As the crew of the Dawn Treader first approaches what will later be christened Dragon Island, they drop anchor in the bay of a "mountainous island," in the early evening and waited until morning before exploring the unknown land. What they first saw was, "a bay encircled by cliffs and crags that it was like a Norwegian fjord. In front of them, at the head of the bay, there was some level land heavily overgrown with trees that appeared to be cedars. . . ."[50] We are also told that "the whole place was entirely silent," and that the scene before them "would have been pretty in a picture but was rather oppressive in real life. It was not a country that welcomed visitors."[51] Although the harsh depiction of the island primarily foreshadows Eustace's metamorphosis into a dragon, the inclusion of the cedars is curious on two accounts. First,

46 Lewis, 209.
47 Lewis, 210.
48 Lewis, 210.
49 Lewis, 211.
50 C. S. Lewis, *The Voyage of the Dawn Treader* (New York: HarperCollins, 1994), 79.
51 Lewis, *Dawn Treader*, 79.

compared to the many mentions of firs, beeches, oaks, and flowering trees, cedars are rarely mentioned in the Chronicles. The text offers no hint or complementary imagery to suggest why cedars grow on this island, but we can speculate that a source for this woodland reference might be other literary classics. In the *Epic of Gilgamesh*, for example, the hero Gilgamesh journeys into the sacred cedar grove to kill the demonic demi-god, Humbaba, and harvest the great trees. Perhaps the two stories share a common mythic setting in which passing through a cedar grove is the start of their respective tests of courage and humility.

One of the more compelling aspects of *The Horse and His Boy* is the starting point of its physical and cultural sense of place – the desert lands of Calormen, a country that stands in political, theological, and moral conflict with Narnia and its staunch ally Archenland. One of the most prominent themes in the novel is that of freedom: Shasta escapes a life of slavery, Avaris escapes from an arranged marriage to a beastly partner, and two talking horses escape to Narnia and their kin (talking beasts). For all four of them, the quest for freedom is tied to their hope of reaching Narnia, and the geographical differences between the countries of Calormen and Narnia play a significant role in bringing this ideal forward. Having escaped Calormen, the four protagonists begin to ascend the "pine-clad slopes"[52] of Archenland:

> It was all open, park-like country with no roads or houses in sight. Scattered trees, never thick enough to be a forest, were everywhere. Shasta, who had lived all his life in an almost treeless grassland had never seen so many or so many kinds. If you had been there you would probably have known (he didn't) that he was seeing oaks, beeches, silver birches, rowans, and sweet chestnuts.[53]

In response, Aravis exclaims, "Isn't it simply glorious!" Nor is it coincidental that as they approach the high country of Archenland's Southern March (with the malicious Calormene Prince Rabadash and his soldiers close behind them) that a wild lion (Aslan) pushes them ahead, assuring that they reach the sanctuary of the Hermit's "perfectly circular enclosure, protected by a high wall of green turf."[54] The Hermit's home is a calm and serene retreat, including "a pool of perfectly still water. . . . At one end of the pool, completely overshadowing it with branches, there grew the hugest and most

52 Lewis, *The Horse and His Boy*, 147.
53 Lewis, *Horse*, 149.
54 Lewis, 155.

beautiful tree that Shasta had ever seen."[55]

Unfortunately, there is little time for Shasta to take in the serenity of the Hermit's marsh, as he is instructed to quickly run through a back gate and warn King Lune of Archenland of the Calormene advance. Shasta will reach King Lune in time, and when he does so he will learn that he is King Lune's long-lost son and accept his destiny as a Prince of Archenland. Meanwhile, Avaris, Bree, and Hwin will spend part of their time with the Hermit reflecting on who they are and what they hold dear before rejoining Shasta and his father's royal court. In sum, for both the children and their horses, their "homecoming" begins as they ride through the "glorious" trees of Archenland.

I will close with one of the more tragic moments in the Chronicles, the slaughter of Dryads in the second chapter of *The Last Battle*. As King Tirian and his good friends Jewel the Unicorn and Roonwit the Centaur discuss the sad state of Narnia, and the rumors that Aslan has been seen, they are silenced by the wailing cry, "Woe, woe, woe. . . . Woe for my brothers and sisters! Woe for the holy trees! The woods are laid waste. The axe is loosed against us. We are being felled. Great trees are falling, falling, falling."[56] The slaughter of the sacred trees in the second chapter of *The Last Battle* acts as a prophetic foreshadowing of what lies ahead – the end of Narnia.[57]

And yet, the end of Narnia is not the end of life, nor the end of beautiful, numinous trees. As the story ends, the friends of Narnia and all who stood alongside Aslan leave the shadowlands behind and enter Aslan's country. Upon hearing King Frank's horn beckon them forward, all of the good characters form a "bright procession" that will join Aslan, in his country, where there are "forests and green slopes and sweet orchards."[58] And it is here that we note that throughout it all, the trees of Narnia quite often offer much more than a foreshadowing of faithful events – they give hope to both the characters and readers of Narnia alike.

55 Lewis, 155. The description of the Hermit's pool is slightly reminiscent of the pools and trees in Chapter 3, "The Wood Between the Worlds," in *The Magician's Nephew*.

56 C. S. Lewis, *The Last Battle* (New York: HarperCollins, 1994), 20.

57 It is interesting that this is one of the few times that we hear a Dryad speak. Although we are told that the trees are speaking and/or singing as they dance in several of the novels, just as we are told that a dryad had prophesized, in *The Voyage of the Dawn Treader*, that Reepicheep would seek the "utter east" (Aslan's country), these are typically reported by the narrator or other characters.

58 Lewis, *The Last Battle*, 227.

WORKS CITED

Lewis, C. S. *The Horse and His Boy*. New York: HarperCollins, 1998.

---. *The Last Battle*. New York: HarperCollins, 1998.

---. *The Lion, the Witch, and the Wardrobe*. New York: HarperCollins, 1998.

---. *The Magician's Nephew*. New York: HarperCollins, 1998.

---. *Prince Caspian*. New York: HarperCollins, 1998.

--- . *The Voyage of the Dawn Treader*. New York: HarperCollins, 1998.

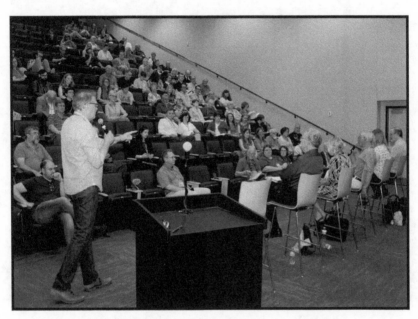

Joe Ricke moderates the keynote panel discussion.

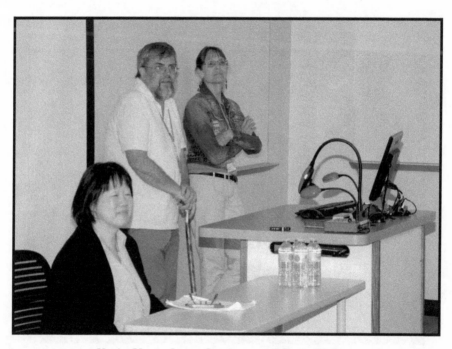

Kyoko Yuasa, James Stockton, and Grace Tiffany
respond to audience questions during "The Green Imagination" paper session.

II. Lewis and . . .

C.S. Lewis's Assessment of
George MacDonald's Writings

Marsha Daigle-Williamson taught in the English Department at Spring Arbor University for twenty-five years. She has translated books on Christian spirituality from Italian and French into English for several publishers. Her book *Reflecting the Eternal* (2016) explicates C.S. Lewis's use of the *Divine Comedy* in his novels. She is a frequent participant in the "Lewis and the Middle Ages" sessions at the International Congress on Medieval Studies (sponsored by Taylor University's Center for the Study of C.S. Lewis & Friends).

Lewis readers are familiar with the fact that Lewis first encountered the writing of the nineteenth-century Scottish minister George MacDonald[1] when he was seventeen and picked up a copy of *Phantastes* (1858) in February 1916 at a station bookstore. It was in fact very much by accident since he says, "I had bought [*Phantastes*] almost unwillingly, for I had looked at the volume on that bookstall and rejected it on a dozen previous occasions."[2] After reading it, he quickly wrote to his friend and fellow bibliophile Arthur Greeves, "You simply MUST get this at once."[3] Within two weeks Greeves read it and began his own journey of reading and collecting MacDonald's works – to the point that Lewis says in 1930, "I envy you your shelf of MacDonalds and long to look over them wth [sic] your guidance."[4] The letters between Lewis and Greeves continued into the 1960s and often included discussion about MacDonald and his works.

Most readers are aware of Lewis's expressed admiration for MacDonald in his most well-known and most cited words from the preface to his 1946 *Anthology* of MacDonald's writings: "I have never concealed the fact that I regard him as my master. Indeed I fancy I have never written a book in which I did not quote from him."[5] In addition to publishing this *Anthology*, he also makes MacDonald

1 The editors have corrected Lewis's spelling ("Macdonald") throughout.

2 C.S. Lewis, "Preface," *George MacDonald: An Anthology*, ed. C.S. Lewis (1946; repr. ed., Garden City, NY: Dolphin, 1962), 25.

3 Letter to Arthur Greeves, March 7, 1916, *The Collected Letters of C.S. Lewis*, ed. Walter Hooper (New York: HarperCollins, 2004), vol. 1, 170.

4 Letter to Arthur Greeves, June 15, 1930, *Letters*, vol. 1, 905.

5 Lewis, "Preface," *Anthology*, 25.

a major character as the narrator's guide in the *Great Divorce* (also 1946), which one of his former students describes as "Jack's tribute to his master."[6]

It was an auspicious beginning for Lewis with *Phantastes*. In November of that same year, he read MacDonald's short fairy tale "The Golden Key" and told Greeves that "To me it was absolute heaven."[7] Even as late as 1956, he still calls it MacDonald's "best short fairy tale."[8] Earlier, in 1918, he tells Greeves, "Few things have pleased me more than MacDonald's *The Goblin and the Princess* [sic]."[9]

Despite this delightful initial excitement about MacDonald's writings and despite Lewis's famous comment in the *Anthology* about MacDonald's influence, the list of Lewis's severe criticism of MacDonald's writing is long and specific. By 1930, now having read as many works by MacDonald as he could, Lewis writes to Greeves, "His novels have great and almost intolerable faults. . . . The plot is usually improbable, obscure, and melodramatic." Lewis points to a lack of variety in MacDonald's writing, noting, "his only real form is the symbolic fantasy. . . . That is what he always writes."[10] In the fall of that year Lewis writes again to Arthur Greeves, "*Adela* I'm afraid I think definitely bad, tho it began well: and the *Seaboard Parish* the same,"[11] and he refers to that latter novel again three months later, saying he was "badly shaken by an unsuccessful attempt to read the *Seaboard Parish*."[12] In 1939, in his first letter to Sister Penelope, an Anglican nun who had studied theology at Oxford and was an author in her own right, he says that "all his [MacDonald's] novels [are] amateurish."[13]

As for MacDonald's poetry, Lewis, commenting on *Phantastes* to Greeves about his first reading of it, says, "there are one or two poems

6 George Sayer, *Jack: A Life of C. S. Lewis* (Wheaton, IL: Crossway, 1988), 305.

7 Letter to Arthur Greeves, November 15, 1916, *Letters*, vol. 1, 254.

8 Letter to Mrs. Johnson, December 3, 1956, *The Collected Letters of C. S. Lewis*, ed. Walter Hooper (New York: HarperCollins, 2007), vol. 3, 814.

9 Letter to Arthur Greeves, August 7, 1918, vol. 1, 393. By 1930, Lewis, the consummate "re-reader," says he has read that 1871 book for "the third time" (Letter to Arthur Greeves, June 15, 1930, vol. 1, 906).

10 Letter to Arthur Greeves, August 31, 1930, vol. 1, 935.

11 Letter to Arthur Greeves, October 29, 1930, vol. 1, 941.

12 Letter to Arthur Greeves, December 24, 1930, vol. 1, 944. Fortunately, however, he says his reading of *Annals of a Quiet Neighbourhood* soon after "went far to restore my faith in him."

13 Letter to Sister Penelope, August [misdated by Lewis as July] 9, 1939, *The Collected Letters of C. S. Lewis*, ed. Walter Hooper (New York: HarperCollins, 2004), vol. 2, 263.

in the tale . . . which are shockingly bad."[14] Thirty years later Lewis continues to maintain to Greeves, "His verse . . . I still consider inferior to his prose."[15] He repeats the same thing later to Sister Penelope: "My love for G. MacDonald has not extended to most of his poetry [although] I have naturally made several attempts to like it."[16]

In the preface to his MacDonald *Anthology*, Lewis repeats and elaborates the overall assessment of MacDonald's writings that is found sprinkled throughout his early diary and letters. He states, "If we define Literature as an art whose medium is words, then certainly MacDonald has no place in its first rank – perhaps not even in its second."[17] Lewis in fact goes on to say, "The texture of his writing as a whole is undistinguished, at times fumbling. Bad pulpit traditions cling to it; there is sometimes a nonconformist verbosity, sometimes . . . florid ornament, . . . sometimes an over-sweetness."[18] In addition, he states, "Few of his novels are good and none is very good."[19] Explaining his particular selection of quotes in the anthology, Lewis says, "Some of [MacDonald's] best things are . . . hidden in his dullest books: my task here has been almost one of exhumation."[20] Not exactly high praise.

With such a negative literary assessment of his novels and his poetry, how on earth could Lewis call MacDonald his "master" and why did he bother quoting from him since he found his writing so flawed? There are two reasons: MacDonald's handling of fantasy and myth and the spiritual content of his writings.

In the *Anthology's* preface, which incorporates the bulk of Lewis's assessment of MacDonald, Lewis states, "What he does best is fantasy . . . and the mythopoeic. And this, in my opinion, he does better than any man."[21] In 1931, Lewis had already expressed his predilection for myth to Greeves, saying, "More and more the value of plays and novels becomes for me dependent on the moments when . . . they succeed in expressing the great *myths* [italics original]."[22] In the *Anthology's* preface Lewis defines myth as "a story where the mere pattern of events is all that matters,"[23] and in which "the words are going to be forgotten

14 Letter to Arthur Greeves, March 7, 1916, vol. 1, 170.
15 Letter to Arthur Greeves, May 13, 1946, vol. 2, 709.
16 Letter to Sister Penelope, May 6, 1951, vol. 3, 123.
17 Lewis, "Preface," 18.
18 Lewis, 18.
19 Lewis, 21.
20 Lewis, 22.
21 Lewis, 18.
22 Letter to Arthur Greeves, September 5, 1931, vol. 1, 968.
23 Lewis, "Preface," 19.

as soon as you have mastered the Myth."[24] Since no particular iteration of a myth is what counts, then the words are not of primary import. According to this approach, MacDonald's words would not necessarily matter that much because "it was in this mythopoeic art that MacDonald excelled."[25] Lewis goes even further when he says, "every now and then there occurs in the modern world a genius . . . who can make such a story [myth]. MacDonald is the greatest genius of this kind whom I know."[26] This is not to say, however, that this makes MacDonald a great writer, for Lewis goes on to say, "To call it *literary* genius seems unsatisfactory since it can co-exist with great inferiority in the art of words [italics added]."[27]

Nevertheless, Lewis does make some positive comments in the *Anthology's* preface about MacDonald's style. He notes that one admirable feature of his novels is the "rare, and all but unique merit" that MacDonald's "'good' characters are always the best and most convincing."[28] In addition, MacDonald's "psychology also is worth noticing: he is quite as well aware as the moderns that the conscious self, the thing revealed by introspection, is a superficies."[29] Perhaps the most significant factor for Lewis, however, was that "the quality which had enchanted me in his imaginative works turned out to be the quality of the real universe, the divine, magical, terrifying and ecstatic reality in which we all live."[30]

The same year the *Anthology* appeared, Lewis listed in a letter to Arthur Greeves what he considered three positive elements in MacDonald's novels: "(a) the parts that have something of a fairy tale quality . . . (b) the melodrama . . . (c) the direct preaching."[31]

The last item listed here points to the second – and perhaps most important–reason MacDonald appealed to Lewis: the spiritual content of his writing. Although he classifies his first reading of *Phantastes* as "a great *literary* experience [italics added],"[32] Lewis writes the following in his diary entry for January 11, 1923 – many years *before* his conversion to Christianity: "I have read [it] many times and . . . I really believe [it] fills for me the place of a *devotional book*. It tuned me

24 Lewis, 20.
25 Lewis, 21.
26 Lewis, 20.
27 Lewis, 20.
28 Lewis, 22.
29 Lewis, 24.
30 Lewis, 26-27.
31 Letter to Arthur Greeves, May 13, 1946, vol. 2, 709.
32 Letter to Arthur Greeves, March 7, 1916, vol. 1, 170.

up to a higher pitch and delighted me [italics added]."[33] Seven years later, *after* his conversion, he tells Greeves, "I know of nothing that gives me such a feeling of spiritual healing, of being washed, as to read G. MacDonald."[34] He later clarifies this same assessment to Sister Penelope in discussing *Phantastes*: "I found it endlessly attractive, and full of what I felt to be holiness before I really knew that it was,"[35] and the following year, he remarks to her that *Phantastes* "did a lot for me years before I became a Christian, when I had no idea what was behind it. This has always made it easier for me to understand how the better elements in mythology can be a real *praeparatio evangelica* for people who do not yet know whither they are being led."[36] His clearest and most well-known statement about the impact of this book is found in the *Anthology's* preface: "I knew that I had crossed a great frontier. . . . What it actually did to me was to convert, even to baptise . . . my imagination. It did nothing to my intellect nor (at that time) to my conscience."[37] His statement here actually points to more of a spiritual impact by this book than a literary one.

In fact, according to Lewis, the purpose of the *Anthology* he published "was . . . not to revive MacDonald's literary reputation but to spread his religious teaching."[38] Ever since encouraging Greeves to read MacDonald back in 1916, Lewis had been recommending MacDonald to others. In 1940 he asks Sister Penelope, "Dare I hope that my frequent quotations from Geo. MacDonald will lead you to read him? He deserves to be better known."[39] He tells Greeves in 1942, "I have introduced such a lot of people to MacDonald this year: in nearly every case with success."[40] After publishing the *Anthology*, he writes to J. S. Goodridge "about the value of MacDonald. . . . I keep on getting letters from people who have found him as helpful as you and I do."[41]

Lewis selected quotes from MacDonald for the *Anthology* primarily from *Lilith*, *Phantastes*, *The Princess and the Goblin*, and the three volumes of *Unspoken Sermons*. Some 75 percent of the extracts in the book are from MacDonald's sermons and religious writings

33 C. S. Lewis, *All My Road Before Me*, ed. Walter Hooper (New York: Harcourt, Brace Jovanovich, 1991), 177.
34 Letter to Arthur Greeves, August 31, 1930, vol. 1, 936.
35 Letter to Sister Penelope July 9, 1939, vol. 2, 263.
36 Letter to Sister Penelope, November 4, 1940, vol. 2, 453.
37 Lewis, "Preface," 26.
38 Lewis, 22.
39 Letter to Sister Penelope, October 24, 1940, vol. 2, 451.
40 Letter to Arthur Greeves, December 10, 1942, vol. 2, 539.
41 Letter to J. S. Goodridge, April 26, 1949, vol. 2, 936-37.

rather than from his literary works. This is partly the case because, as he says in the preface, "The author, though a poor novelist, is a supreme preacher."[42] And of the religious extracts, most are from *Unspoken Sermons* – the book about which Lewis says, "My debt to this book is almost as great as one man can owe to another."[43]

Throughout his life, as Lewis continued to recommend MacDonald's books to others, it was mainly because of their spiritual content, and quite often with caveat about his style. Although he tells Mrs. Harold Steed that "the most generally useful of G. M.'s works is the 3 vols of *Unspoken Sermons*,"[44] when he recommends those volumes to Mary Neylan, he cautions, "if you can stand serious faults of style."[45] Nevertheless, the epigraph for Lewis's *Problem of Pain* is a quote from this work, and he often quotes from these sermons in his letters.[46]

In commenting on *What's Mine's Mine* (1886), Lewis tells Greeves, "It has very little of the bad plot interest, and quite frankly subordinates story to doctrine. But such doctrine."[47] One month later he admits to Greeves, "It has not the fantastic charm of *Phantastes*. . . . It is just the spiritual quality with some beautiful landscape – nothing more."[48] His following letter to Greeves on the book elaborates, "You are right in saying that it is good not despite, but because of, its preaching – or rather . . . its spiritual knowledge. So many cleverer writers strike one as quite *childish* after MacDonald [italics original]."[49]

Despite not liking MacDonald's poetry in general, Lewis tells Sister Penelope he makes an exception for *The Diary of an Old Soul* (1880).[50] This book consists of 366 seven-line poems for devotional reflection, one for each day of the year with an extra one in February for leap year (1880 was, in fact a leap year; Lewis followed MacDonald's own format for his *Anthology*, but perhaps since 1946 was not a leap year, he included only 365 entries.) Lewis writes to Greeves in October 1929 that in this book MacDonald "seems to know everything . . . and I find my own experience in it constantly. As regards the literary

42 Lewis, "Preface," 22.
43 Lewis, 23.
44 Letter to Mrs. Harold Steed, June 6, 1956, vol. 3, 760.
45 Letter to Mary Neylan, March 26, 1940, vol. 2, 375-76.
46 See, for example, Letter to Sheldon Vanauken, January 8, 1951, vol. 3, 84; Letter to Mary Van Deusen, May 25, 1951, vol. 3, 118; Letter to Mary Margaret McCaslin, November 15, 1956, vol. 3, 806.
47 Letter to Arthur Greeves, January 17, 1931, vol. 1, 950.
48 Letter to Arthur Greeves, February 1, 1931, vol. 1, 953.
49 Letter to Arthur Greeves, February 23, 1931, vol. 1, 955.
50 Letter to Sister Penelope, May 6, 1951, vol. 3, 123.

quality, I am coming to like even his clumsiness."[51] Lewis was clearly reading from this book every day because three months later he tells Greeves, "20 minutes before bed . . . I . . . try to wash the day off with MacDonalds *Diary of an Old Soul*."[52] In 1952 Lewis gave Joy Davidman a copy of this book for Christmas.[53] One of the things he always appreciated about the book was what he called the "delicious home-spun, earthy flavor about it,"[54] and he quotes from it in some of his letters.[55]

In general, although acknowledging all of MacDonald's literary faults, Lewis felt they could be overlooked. In 1930 he tells Greeves, "There is no need to urge me to read any [MacDonald] books I can get a hold of. The faults are obvious but somehow they don't seem to matter."[56] Later that year he expressed the same sentiment to his friend again: "The gold is so good that it carries off the dross."[57] In the *Anthology*'s preface he phrases that sentiment this way: "Even in the worst of them [MacDonald's books] [there is] something that disarms criticism . . . and [the reader] will come to feel a queer, awkward charm in their very faults."[58]

To summarize, Lewis appreciated and was inspired by the features of fantasy and myth in MacDonald's writings, just as Tolkien did, whom Lewis says "grew up on MacDonald,"[59] and just as Joy Davidman did, who, according to Lyle Dorsett, "was captivated [by MacDonald stories] . . . during childhood."[60] However, it seems perhaps that MacDonald's primary impact and significance for Lewis was spiritual. As he says in the *Anthology*'s preface, "I know hardly any other writer who seems to be closer, or more continually close, to the spirit of Christ himself."[61] Given all of the above, it seems that when Lewis called MacDonald "my master," he was referring to him far more as a spiritual master than as a literary one.

51 Letter to Arthur Greeves, October 10, 1929, vol. 1, 834.
52 Letter to Arthur Greeves, January 26, 1930, vol. 1, 872.
53 See Lyle Dorsett, *And God Came In* (Wheaton, IL: Crossway, 1991), 89.
54 Letter to Arthur Greeves, October 10, 1929, vol. 1, 834.
55 See, for example, Letter to Mrs. D. Jessup, November 13, 1952, vol. 3, 250, and Letter to Mary Willis Shelbourne, March 19, 1956, vol. 3, 721.
56 Letter to Arthur Greeves, February 27 1930, vol. 1, 885.
57 Letter to Arthur Greeves, August 31, 1930, vol. 1, 935.
58 Lewis, "Preface," 22.
59 Letter to Arthur Greeves, March 25, 1933, vol. 2, 103.
60 Dorsett, *And God Came In*, 15.
61 Lewis, "Preface," 23.

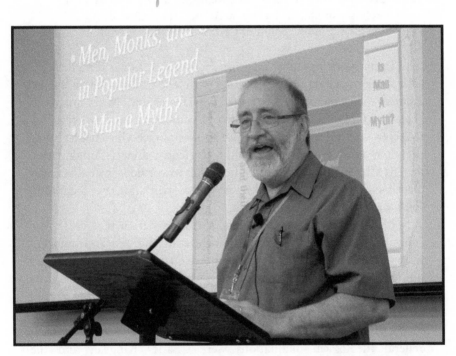

Charlie Starr gives his keynote address, "From the Faun's Bookshelf."

"Good Death":
What C.S. Lewis Learned from *Phantastes*

by Edwin Woodruff Tait

Edwin Woodruff Tait earned his PhD from Duke University, specializing in sixteenth-century church history. In addition, he has actually read C.S. Lewis's *English Literature in the Sixteenth Century Excluding Drama*. More than once. He is currently a homeschooling parent, homesteader, organist, and freelance writer in Richmond, Kentucky, as well as an adjunct professor of church history at Asbury Theological Seminary and a contributing editor to *Christian History* magazine.

In his autobiography *Surprised by Joy*, C. S. Lewis described the transformative effect of his encounter with George MacDonald's novel *Phantastes* as a teenager. The book, Lewis later said, had a quality of "Death, *good* Death."[1] This baptism of the imagination was, according to Lewis, central in preparing him to re-embrace Christianity more than ten years later.[2] MacDonald reoriented Lewis's imagination toward Christianity long before he began to consider it intellectually plausible. And, according to Lewis, this reorientation was focused in some way on the concept of death.

It's no secret to any reader of Victorian fiction that death is a constant presence, particularly the deaths of children and innocent young women. This reflects both the reality of nineteenth-century life, with its frequent outbreaks of acute infectious disease, and its sentimental love of pathos. But death is also often treated as a kind of penitential, purifying crisis, particularly in authors with religious concerns. Two novelists particularly akin to MacDonald in their general theological inclinations were Charles Kingsley and the

1 C. S. Lewis, "Introduction," in *Phantastes: A Faerie Romance* (Grand Rapids: Eerdmans, 1981) by George MacDonald, xi.

2 Lewis, *Surprised by Joy: The Shape of My Early Life* (New York: Harcourt Brace Jovanovich, 1955), 181. In *Surprised by Joy*, Lewis wrote, "That night my imagination was, in a certain sense, baptized; the rest of me, not surprisingly, took longer." In his Preface to an anthology of MacDonald's writings published in 1946, he had described the experience at more length: "What it actually did to me was to convert even to baptise (that is where the Death came in) my imagination. It did nothing to my intellect nor (at that time) to my conscience" ("Introduction," xi). Lewis goes on to note that when his conscience was ready to receive, he found that he was at last "ready to hear from [MacDonald] much that he could not have told me at that first meeting. But . . . what he was now telling me was the very same that he had told me from the beginning" (xi).

lesser known F. W. Farrar. Farrar is better known today as a biblical scholar than as a novelist, but he wrote two school stories, *Eric* and *St. Winifred's*, as well as a book of *Allegories*.[3] In *Eric*, the hero succumbs to various temptations at school, culminating in an accusation of theft (he has actually attempted to return the money) which leads to his expulsion from school and a harrowing experience as a sailor under a sadistic captain. At the end of the book, he is spiritually redeemed and undergoes a typically Victorian sentimental death. By killing him off, Farrar avoids any suggestion that sin has no consequences.

In his *Allegories*, Farrar is able to carry the story beyond death. Most of the short works included in that volume contain some description of the post-mortem fates of the characters. Farrar was slightly more conservative than MacDonald on the question of what happened to the wicked after death, believing that it was likely that a few would eventually refuse to be redeemed, while a few on the other end of the scale would not need any postmortem purification. For most, however, death would lead to an extended period of purgatorial suffering ending in eventual redemption.

Phantastes is the story of a young man named Anodos, which means both "lost/without a way" and "on the way upwards." As his twenty-first birthday approaches, on which he will enter into possession of his family's estate, he is visited by a fairy ancestor who gives him the gift of entering Fairy Land.[4] There he undergoes a number of adventures culminating in his heroic death fighting a monster. But the story does not end here. He becomes part of nature, finally turning into a cloud, and then wakes up back at home on his birthday. Death in Fairy Land, as it turns out, is a kind of coming-of-age ritual. His entire experience in Fairy Land has been a course of preparation for his duties as an adult in the non-fairy world.

Besides Anodos's own death, the other obvious example of "good death" in *Phantastes* is the story of two royal brothers who have taken it upon themselves to deliver their land from three giants. Anodos joins them and works with them to forge the armor that they will use to fight the giants as well as to forge a brotherly bond among themselves. Ironically, the giants catch them by surprise and they have no time to put the armor on. All three giants are killed, but only Anodos survives from those who fought the giants, and is able to bring the brothers' bodies back to their father. On the most basic level, then, "good death"

3 F. W. Farrar, *Eric; or, Little by Little* (Edinburgh: A. and C. Black, 1858); *St. Winifred's; or the World of School* (Edinburgh: A. and C. Black, 1862); *Allegories* (London: Longmans, Green and Co., 1898).

4 George MacDonald, *Phantastes*, 9.

in *Phantastes* is heroic, self-sacrificing death fighting against evil.

I doubt, however, that Lewis had no more than this in mind. On a deeper level, the entire novel (like most of MacDonald's work) is a commentary on the traditional Christian concept of the "death of the old man." Like many other Victorian writers, MacDonald returns repeatedly to the theme that life springs out of death and so that the willing acceptance of some kind of death is the only path to a truer and fuller life – the false self must die so that the true self may be born.[5]

One of the central metaphors of the book is Anodos's "shadow," which he acquires in the house of an ogre. Even though he has been warned to stay away from the ogre and has been shown a path that will supposedly take him far away from her house, he somehow finds himself there anyway. She is reading a book affirming the eternality of darkness and its fundamental priority over light.

Opening a door in the house, Anodos is confronted with his own shadow, which leaps out of the door and attaches itself to him. This shadow accompanies him for most of the book. It blights everything it rests on, killing flowers and causing Anodos to view people he meets with cynicism and disenchantment. He meets a young girl (described as childlike but "almost a woman") who has a magnificent crystal globe which makes music.[6] She is nervous about Anodos touching the globe, first warning him to do so gently and then, when he touches it too eagerly, telling him not to touch it at all. But the shadow grows and wraps itself around the girl, leading Anodos to feel an overwhelming desire to "know about the globe."[7] He grabs the globe, which shatters, leaving the girl desolate.

The shadow recedes in prominence as a narrative element after that, though MacDonald continues to refer to it occasionally. It becomes an important part of the story after the heroic fight with the giants which leaves Anodos as the sole survivor. The king and his court honor him, but Anodos continues to be troubled by the shadow and takes his leave. As he rides through the forest, he feels confident and happy, thinking of himself as a great hero. He meets a larger and more powerful version of himself, a knight who orders him to follow

5 In Novalis's *Henry of Ofterdingen* (Berlin: Tieck and Schlegel, 1802), the hero has a dream in chapter one which includes death and a return again to life casually in its early stages, followed, significantly, by love and separation from the beloved, and only then, toward morning when his dreams are calmer, by the key dream of the blue flower.

6 MacDonald, *Phantastes*, 61.

7 MacDonald, 62.

and whom he is powerless to fight. This evil doppelgänger forces him into a tower in the heart of the forest, and Anodos becomes convinced that the knight is a manifestation of the shadow.[8]

Anodos is imprisoned in the tower, alternately tormented by the sun and consoled by the moon, until he is unexpectedly delivered by the song of a woman, who turns out to be the young girl whose globe he had broken. (His inability to leave the tower, like his inability to resist the doppelgänger knight, appears to be psychological rather than physical.) She explains that the Fairy Queen had taken the fragments of the globe and put her to sleep "in a great hall of white, with black pillars, and many red curtains."[9] She expected to receive the globe back, but instead received the gift of song herself, without any need for the globe.

Anodos, humbled by this encounter and his failure, takes off his armor and resolves not to act as a knight any longer until he has earned the right to do so. "'I have failed,' I said. 'I have lost myself; would it had been my shadow.'"[10]

In that moment he looks around and realizes that the *shadow* has vanished, and Anodos feels reborn:

> Another self seemed to rise, like a white spirit from a dead man, from the dumb and trampled self of the past. Doubtless this self must again die and be buried, and again, from its tomb, spring a winged child, but of this my history as yet bears not the record. Self will come to life even in the slaying of self, but is there ever something deeper and stronger than it, which will emerge at last from the unknown abysses of the soul: will it be as a solemn gloom, burning with eyes? Or a clear morning after the rain? Or a smiling child, that finds itself everywhere, and nowhere?[11]

This leads into Anodos's final adventure as a squire serving the noble knight who has interacted with his story several times before, followed by his fairyland "death" and return to "normal" life.

This passage clearly struck deep roots in Lewis, with echoes in the layers of dragon skin Eustace tears off in *The Voyage of the Dawn Treader*, and the anguished confession in *A Grief Observed* that what he called his faith after the crisis of Joy's death may simply be a new "house of cards" God has to knock down.[12] "Good death" in this case,

8 MacDonald, 161.
9 MacDonald, 164.
10 MacDonald, 166.
11 MacDonald, 166.
12 Lewis, *A Grief Observed*, (New York: Bantam, 1961), 42.

then, refers not to literal death but to deliverance from one's "shadow self," here identified with arrogance and an ideal vision of oneself that is not grounded in reality (the evil knight who enslaves Anodos is a reflection of his self-complacent image of himself as comparable to Sir Galahad). But in other parts of the book, the concept of dying to live or (in the language of my own Wesleyan Holiness tradition) "dying to self" is given a context with clear romantic/sexual overtones, in which the false self is specifically identified with a self-centered, predatory approach to love and sexuality.

This context is clearest in the story of Cosmo told about halfway through the book, comprising the entirety of chapter thirteen. This comes as part of a longer section describing Anodos's sojourn in a fairy palace, where he learns a great deal about the nature of Fairy Land. While there, he finds himself taking the part of the chief actor in every story he reads, including the story of Cosmo. In this story, the student Cosmo acquires a magic mirror in which he sees a beautiful woman with whom he falls in love, and, as MacDonald puts it, "his love – shall I call it *ripened*, or – *withered*, into passion?"[13]

He cannot reach his beloved physically, but he comes to think of her as a "secret treasure," like a miser's hoard.[14] He believes that he would be content if he could kiss one of her feet: "Alas! He deceived himself, for passion is never content. Nor did he know that there are two ways out of her enchanted house."[15] He becomes convinced that the woman has another lover, and this drives him to desperation; he uses magic spells to force the real woman represented in the mirror to come to his apartment. She explains that she is a "slave of the mirror" and cannot freely love him as long as the mirror exists. But if he breaks the mirror, it is possible he will never see her again.[16]

Cosmo hesitates, reluctant to give up the certainty of being able to see her for the chance of a freely chosen relationship with her. The woman wails that he does not truly love her, and Cosmo belatedly attempts to break the mirror, but fails. He comes down with that convenient disease of Victorian characters, brain fever, and by the time he recovers, the mirror – not to mention the lady – has vanished. He becomes intent on freeing her from the mirror, whether or not he ever sees her again, and discovers that the mirror has been bought by a villainous nobleman named Von Steinwald. Cosmo manages to

13 MacDonald, *Phantastes*, 94.
14 MacDonald, 93.
15 MacDonald, 95-96.
16 MacDonald, 99.

break into Von Steinwald's house and steal the mirror, but apparently is mortally wounded by Von Steinwald in the process. The lady finds him as he is in the process of dying, and he tells her, "Death made me bold. . . . Have I atoned at all? Do I love you a little – truly?"[17] In the middle of this story (which is presented in fragmentary form), MacDonald inserts the motto, "Who lives, he dies; who dies, he is alive."[18]

In *this* story, then, "good death" turns out to be identified with the renunciation of sexual control over another human being. In a typically melodramatic nineteenth-century fashion, MacDonald presents death as the way in which Cosmo frees the lady from both his own control and that of the more overtly villainous Von Steinwald, and also frees himself from the "passion" into which his love for the lady has "withered."

A second story presented within the text, driving home the same point, is the "Ballad of Sir Aglovaile," which is sung to Anodos by an old woman in a cottage on an island. In this story, Sir Aglovaile encounters the ghost of a woman with whom he has had a child out of wedlock, now also dead. She is more beautiful than ever as a ghost, telling him "Thou seest that Death for a woman can / Do more than knighthood for a man," and she offers him love if he will agree not to touch her.[19] Eventually he is unable to keep this condition and "clasps to his bosom the radiant ghost," upon which she turns into a corpse and he loses her forever.[20]

These stories about possessive sexual passion and the necessity of overcoming it through death to self are illustrative foils for the central quest that (loosely) unifies the narrative of *Phantastes*: Anodos's pursuit of a marble lady. He first encounters her in chapter five, as a marble statue in a cave, whom he brings to life by song. The song describes her "sleeping in the very death of dreams," and affirms that her smile has emboldened Anodos "with primal Death to cope."[21] Later he wonders if she is in fact Death: "Yea, I am dead, for thou hast drawn / My life all downward unto thee. / Dead moon of love! Let twilight dawn: / Awake! And let the darkness flee."[22] This song awakens the lady, who rushes out of the cave: "found, freed, lost!"[23] Seeking her, Anodos

17 MacDonald, 104.
18 MacDonald, 95.
19 MacDonald, 132.
20 MacDonald, 134.
21 MacDonald, 38.
22 MacDonald, 39.
23 MacDonald, 40.

first discovers a knight with rusted armor who has been seduced by the Maiden of the Alder-tree, and then the Maiden herself, whom Anodos mistakes for the marble lady, and who seduces him in order to make him the prey of the spirit of the Ash tree. The Ash is about to seize Anodos when he vanishes, because – as Anodos discovers later – the knight with rusted armor has started chopping down the tree on which the spirit depends.

Anodos encounters the image of the marble lady again in the palace of Fairy Land, immediately after reading the story of Cosmo. Once again he brings her to life by song, but in spite of an inscription warning him not to do so he (like Sir Aglovaile) grabs her in his arms to lift her down from the pedestal. (Digory Kirke would repeat a similar mistake in *The Magician's Nephew*.) She runs away, crying "You should not have touched me!"[24]

Pursuing her, Anodos finds himself outside the palace in a wasteland with a chasm leading into the earth. Thinking that the lady may have gone into it, he descends, only to find himself in an underground country inhabited by goblins, who mock his love for the lady and tell him that "she's for a better man, how he'll kiss her!"[25] Anodos accepts the possibility that the lady may wind up as the bride of a nobler man, which does, in fact, happen. He later discovers that she has married the knight of the rusted armor, who has meanwhile cleansed his armor through noble deeds. The culmination of the story is Anodos's service to this very knight as a squire and his death – fighting a monster whose evil the nobler knight is paradoxically unable to recognize because of his purity of soul.[26]

The entire novel is a *Bildungsroman* describing Anodos's journey to moral and spiritual maturity. For MacDonald, this process of gaining maturity is a process of dying to one's false, egotistical self. This of course has deep biblical resonances as well as recalling the Platonic maxim that to be a philosopher is to learn to die. But the specifics of MacDonald's novel point to a particular kind of egotism that needs to be killed, one associated with a kind of false or decadent romanticism.

Rolland Hein, in his perceptive analysis of *Phantastes* in *The Harmony Within*, points to elements in the story where MacDonald criticizes rationalism, and it's true that Anodos's immediate response

24 MacDonald, 117.
25 MacDonald, 120.
26 MacDonald, 177.

to his fairy ancestor at the beginning of the novel is skeptical.[27] But this skepticism quickly passes. For most of the novel, Anodos's response to Fairy Land is a romantic one – he is delighted and fascinated by it (with some exceptions later on, perhaps due to the shadow). His problems in Fairy Land arise primarily from his immature romanticism – his immediate imaginative and emotional response to the stimuli of Fairy Land is undisciplined by the long obedience of moral and spiritual effort.

Over and over again, Anodos gets in trouble by responding too quickly and rashly to the phenomena he encounters – for instance, by rushing through the "door of the Timeless" in the cottage of the old woman on the island.[28] He is endlessly curious, but this curiosity seems to be more an imaginative hunger for experience than an analytical curiosity. And on several occasions, as we have seen above, this immature imaginative response takes an erotic form, expressed through the act of seizing a female form. Even the incident of the girl with the crystal globe, which Hein interprets as representing Anodos's analytical destruction of the girl's childlike imagination, can be read in a disturbingly sexual way. The girl has a precious possession which is a source of beauty and is attractive to Anodos, which she tells him either not to touch or to touch gently; he seizes it and thus breaks it, which causes her intense distress but also transforms her into a woman.

Sexual and imaginative response are intimately connected in *Phantastes*. Anodos is characterized, above all, by his talent for song. He basically pays his way into the company of the two princes preparing to fight the giants by offering to sing to them, since his fighting ability is well behind theirs. His singing is the thing that wins him acceptance among the inhabitants of Fairy Land, and it is above all the means by which he twice transforms a statue into (the same) living woman.

Yet this aesthetic and imaginative response frequently slips into an immature and predatory sexual response – the attempt to "seize" the female object of his imaginative desire. Anodos early on proves unable to distinguish between the marble lady and the "Maiden of the Alder" – between a virtuous, Platonic love interest and a sexual, destructive one. Both the marble lady (speaking to the knight whom she has chosen as a more worthy partner) and Anodos himself, in

27 Rolland Hein, *The Harmony Within: The Spiritual Vision of George MacDonald* (Grand Rapids: Christian University Press, 1982), 54-84; see MacDonald, 7.
28 MacDonald, 143-44.

THE FAITHFUL IMAGINATION

his repentant self-realization after liberation from the tower, criticize Anodos for being content with a nobleness of thought rather than of action, a purely ideal image of beauty. But in fact Anodos doesn't just dream about ideal beauty; he repeatedly tries to "grasp" it prematurely and selfishly.

"Good Death" in *Phantastes*, then, involves above all the renunciation of this desire to "grasp" the object of imaginative and erotic desire. The final stage in Anodos's journey consists of his acceptance of the role of squire to the man who has won the love of the marble lady. Ironically, Anodos develops far more of an actual relationship with the knight than he ever has with the lady. His love for the lady finds expression in service to the man whom she has found worthy of her love.

And yet Anodos's tendency to rash response to the stimuli of Fairy Land, now purified through humble service, stands him in good stead in the climactic episode. Anodos intuits that there is something wrong with the solemn ritual he and the knight are observing, and he rashly probes the mystery, revealing that the initiates are being fed to a wolf-like monster. Anodos kills the monster at the cost of his own life, achieving a "good death" in the literal sense as the climax of his learning "good death" in the more metaphorical and spiritual sense.

Why was this so significant to the adolescent Lewis? Lewis read *Phantastes* at a time when his primary interests were aesthetic. He was drunk on Romanticism, particularly William Morris, in whom, as he noted in a letter to Arthur Greeves, he found food for his sado-masochistic sexual fantasies.[29] His claim of a real sexual encounter with a Belgian girl was, by his later admission, a lie, but it's clear from passages in his letters (recovered by Walter Hooper in what I consider an ethically dubious way) that sexual fantasy was a consuming part of his life in this period.[30] In later reflections on his state of mind at this time and MacDonald's effect on him, as well as in his early allegorical work *The Pilgrim's Regress*, Lewis expressed a fear that he was on a path "South" toward a decadent kind of Romanticism identified both with sexual license and with an interest in the occult.[31]

In *Pilgrim's Regress*, the opposite of these "Southern" tendencies

29 Letter to Arthur Greeves, June 3, 1917, in *The Collected Letters of C. S. Lewis, Volume 1* (San Francisco: HarperSanFrancisco, 2004), ed. Walter Hooper, 313.

30 Letter to Arthur Greeves, Oct. 1, 1931, in *Letters, vol. 1*, 973, referring to previous letters on 104-5, 108-9, and 114-15 from February and March 1915.

31 Lewis, *Surprised by Joy*, 175-78; *The Pilgrim's Regress* (London: Bles, 1943), 5-14.

⌘ 102 ⌘

is the "Northern" error of denying Romanticism, or the lure of the otherworldly, altogether. John, the protagonist, finds that whenever he experiences the vision of the Island beyond the world, it tends to transform itself into lust. He is therefore tempted (in the person of his alter ego "Vertue") to renounce these longings altogether, but John, the imaginative and primary self, finds nothing appealing in this stark "Northern" path and helps the weakened Vertue back toward the center.

Eventually John is confronted by a personification of Death and finally surrenders to the prospect of crossing the "Grand Canyon" under the guidance of "Mother Kirk." Death tells him that he has chosen well: the only way to escape death is by dying. John throws himself into the water at the bottom of the canyon and comes up in the heart of the mountain on the other side. He is eventually told that crossing the canyon "is called Death in the Mountain language" and that he will have to experience it many times:

> It is too tough a morsel to eat at one bite. You will meet that brook more often than you think: and each time you will suppose that you have done with it for good. But someday you really will.[32]

This language of complete self-abandonment, clearly influenced by MacDonald, recurs throughout Lewis's work, from Eustace in *The Voyage of the Dawn Treader* to Jane Studdock in *That Hideous Strength* to the ghosts in *The Great Divorce*. I suggest that when Lewis says that one of the things he learned from MacDonald was "good Death," he is speaking primarily of what could be called MacDonald's ascetic Romanticism: his affirmation of imaginative and even erotic desire within the framework of self-abandonment to God and renunciation of the possessive, predatory impulses that pervade sinful human affectivity, including but not limited to sexuality. MacDonald offered Lewis a way out of the prison of disordered desire, not through the renunciation of desire itself but through its purification; and this became central to Lewis's later imaginative as well as apologetic work.

32 Lewis, *Pilgrim's Regress*, 173.

C.S. Lewis and Joy Davidman
Disagree about a Phoenix

by Joe R. Christopher

Joe R. Christopher, Professor Emeritus of English at Tarleton State University, is a distinguished teacher/scholar, a prolific poet, and a foundational figure in the field of Inklings Studies. His early book, *C.S. Lewis* (1978), and his bibliographic study (with Joan Ostling), *C.S. Lewis: Writings about Him and His Works* (1974) helped set the stage for the explosion of work on Lewis and the Inklings in the years since. Joe publishes regularly about Lewis, including over twenty essays on Lewis's often-neglected poetry. He serves on the Executive Board of the C.S. Lewis and Inklings Society.

An entire book could be written about the love of C. S. Lewis and Joy Davidman, and in one sense a very good book *was* written about their love – Lewis's own *A Grief Observed* (1961). But their connection is more complicated than his book indicates. Anyone who has read Davidman's sonnets to and about Lewis from 1951 through 1954 knows that their path to marriage had many sizable, roughly-shaped stones in it (Davidman, "Love Sonnets to C. S. Lewis"). I contend that the three sonnets to be considered in this essay, one dated and two undated, come from the 1953-1954 period. These sonnets are numbered XIX, XX and XXI in the sonnet sequence. One poem by Lewis, also undated, is part of the same period. Because of its close relation to "XIX" and "XXI," it will be considered first. For reasons based on its relationship to the two Davidman poems and on what is known of Lewis's and Davidman's lives during the period, Lewis's poem was probably written in 1953.

Joy Davidman, with her two young sons, moved to England permanently in 1953, her ship docking in Liverpool on 13 November (Santamaria 258). She had been corresponding with Lewis since 1949 (Santamaria 193-94), and she had made a four-and-a-half-month trip to England in 1952, being in England again from 13 August to 3 January 1953. She met Lewis in September for the first time and stayed in Oxford for ten days at that period, seeing him on several occasions, but Lewis was treating her as a friend, nothing more (Santamaria 229, 232-33). Davidman dates sonnet "VI," describing their first meeting on 10 December 1952, three months after the actual meeting, revealing

that the sonnets were not necessarily written immediately after the event described. The sonnet itself, in line 5, declares the occasion to be in "September," so there is no confusion about the time being described. I know of no reason to doubt Davidman's dating of either the meetings or the poems.

Davidman's first visit to England ended with her being invited to the Kilns, the Lewis home outside Oxford, for a week at Christmas, beginning 15 December (Santamaria 245). Lewis, in letters, refers to her staying three weeks after being invited for one, and talking all the time (Santamaria 247-48; Lewis, *Collected Letters* 269, also 267, 268, 271, 285). Davidman wrote "VII," a "Sonnet of Misunderstanding," afterward on the boat trip back to America (Santamaria 248). According to the sonnet, "[H]e sent me and my empty soul away, / Saying I must not love him any more" ("Love Sonnets" 287). This suggests she had been clear about her desire for something more than friendship (*Philia*) – something more like *Eros*. In her letter to Chad Walsh about this time, Davidman did not indicate any problems about her Christmas stay for a "fortnight" (interesting math) with the Lewises, but that is to be expected in the equivalent of friendly chitchat (*Out of My Bone*, 138-39). Davidman was still, in fact, married to William Gresham at this time, as she was when she returned to England with her two children at the end of 1953. Lewis's rejection of *Eros* at this point is also clear in his poem to be considered in this essay – and, in fact, the 1952 Christmas episode presumably inspired his poem.

Obviously, at this point, the poems and the narrative of Davidman's life have begun to mesh. She arrived back in England on 13 November 1953; she and the boys went to visit the Lewis brothers in Oxford, from December 17 to 21 (Santamaria, 263-64). She and her sons then celebrated Christmas in the London apartment house where they were living (265); and she sent them off to boarding school "in the second week of January" (268). Apparently, she did not see Lewis again until "mid-April" when she took her sons (during a school vacation) for a visit to the Kilns (272). Of course, she probably wrote Lewis or possibly phoned him to set up the April meeting, and she did get an agreement in March from Lewis to write an introduction to the British edition of *Smoke on the Mountain*, which implies some communication to arrange (272). This means that, if the second sonnet ("XX") really imitates an actual conversation in person, that conversation almost necessarily took place during the December visit. Santamaria also assumes the conversation took place during those five days, claiming that Davidman's "sonnets indicate that she had again

professed her feelings, and he had again declined her advances – if gently and with regret" (265). To support this, Santamaria quotes from the first part of "XX" omitting the devastating close (265).

One cannot determine anything about the date of the conversation in "XX" from Lewis's letters to Davidman (only three of which survive), for his letter to her after the December meeting, 22 December 1953, is taken up discussing a book she lent or gave him, Arthur C. Clarke's *Childhood's End* (*Letters* 390-92). His letter does not mention her feelings for him and his refusal, but it may suggest that Lewis is avoiding the fraught topic of love and sticking to a neutral, if enthusiastically engaged, common interest.

One final comment about Davidman's placement of "XX" in the sequence. Davidman provided section titles for her "Love Sonnets," giving country and year for the various sub-sequences. The meeting with Lewis occurred in December 1953 in Oxford. Davidman's section of her sonnet sequence titled "America, 1953" consists of six sonnets all dated before December and one sonnet, "IV," that begins with nine lines Davidman recycled from an earlier poem, "Notes on an Obsession," which King dates "1938?" (*A Naked Tree* 78-80, "Love Sonnets" 284). Interestingly, "XX" from December 1953 has been shifted to the fourth place in the "England, 1954" section. Of course, since Davidman felt free to insert some earlier lines (from 1938?) into the 1953 section, she probably felt free to shift a December 1953 occurrence into 1954 for the sake of keeping the countries straight.

If "XX" is based on a 1953 conversation poetically placed by Joy Davidman in 1954, what can be said about "XXI"? It appears to be a reaction both to Lewis's poem and to the conversation in "XX." It is certainly later than the December 1953 conversation reported in "XX." It is probably, but not necessarily, later than "XX" in composition. On a different basis, one may say it probably was not written the same day as "XX" since "XXIII" is dated by Davidman as being written on the same day as "XX." If she dated two sonnets January 22, she probably would have dated "XXI" the same if it had been written on that day. Since it is the best artistically of the three sonnets being analyzed in this essay, it may well have been worked on over a period of days. Don W. King's approximate date ("1938?") in the case of "XXI" is misleading. He claims that Davidman's style in "XXI" is much like that of the poems from that earlier period (King, email of 3 February 2018). He may have been misled, however, by Davidman's working harder on this sonnet than she did on others.

So, these are the background dates and events as best as we

understand from the available evidence. The first poem of concern to this essay is C. S. Lewis's "The Phoenix Flew into My Garden." Lewis's poem at twenty-two unrhymed lines is unlike Davidman's sonnets, of course, but no evidence suggests that he had ever seen them. In fact, her introductory implies that she did not show them to him until sometime after the sequence was complete. Lewis's poem seems to be written in the tradition of the classical form called the elegiac distich (or elegiac couplet). The classical form consists of a dactylic hexameter line followed by a dactylic pentameter line, both unrhymed. Classical rules about versification, with, for example, the use of long and short syllables and the possible substitution of two short syllables for one long in certain positions, are occasionally attempted in English. John Milton wrote several elegiac distiches in Latin (the seven poems titled "Elegia" in his 1645 collection provide examples), but since the English language basically works, as do all Germanic tongues, on the basis of accents, not of duration, it is not surprising that the classical model is usually transposed into some general equivalent. Lewis's long lines in each distich are iambic heptameters and the shorter lines are iambic hexameters. (Of course, Lewis sometimes has substitutions in his meters to allow for rhetorical emphases).

The verse form could be used for several kinds of content, classically speaking – sometimes for poems about *Eros* as in Ovid's *Amores*. Lewis is using it for a fairly short supernatural narrative, a sort of anti-*Eros* poem. Here is the first sentence of Lewis's poem:

> The Phoenix flew into my garden and stood perched upon
> A sycamore; the feathered flame with dazzling eyes
> Lit up the whole lawn like a bonfire on midsummer's eve.

The content of Lewis's poem begins with the action: the solitary Phoenix has flown into the speaker's garden and perched on a sycamore tree.

Lewis did not pick the sycamore for symbolic or mythic purposes. Since it was an introduced species in the United Kingdom, it has no mythic episodes. The Phoenix is, of course, mythic. Lewis may have had a specific source in mind, but the traditional interpretation can be found in T. H. White's translation of a twelfth-century Latin bestiary.

> FENIX the Bird of Arabia . . . lives beyond five hundred years. When it notices that it is growing old, it builds itself a funeral pyre, after collecting some spice branches, and on this, turning its body toward the rays of the sun and flapping its wings, it sets fire to itself of its own accord until it burns

itself up. Then verily, on the ninth day afterward, it rises from its own ashes! (*Book of Beasts* 125)

The bestiary goes on to make a popular religious analogy:

> Now our Lord Jesus Christ exhibits the character of this bird, who says: "I have the power to lay down my life and to take it up again." If the Phoenix has the power to die and rise again, why, silly man, are you scandalized at the Word of God – who is the true Son of God – when he says that he came down from heaven for men and for our salvation, and who filled his wings with the odours of sweetness from the New and Old Testament, and who offered himself on the altar of the cross to suffer for us and on the third day to rise again? (126)

Having established the identification of two of the characters, one may consider Lewis's narrative in the first stanza as allegorical. In 1930, Lewis became a Christian – that is, he accepts that Jesus is God the Son: that is, *the Phoenix appears*. Lewis began to announce his conversion in *The Pilgrim's Regress* and continued in other books. "The Sole Bird is not fabulous! Look! Look!" Joy Davidman reads *Mere Christianity* and other works. The dark girl heard him. They both are converts, believing in Christ. "We went [. . .] towards the Wonder." Then, Lewis realizes that Joy was more interested in him than in Christ. "[H]er eyes / Had all along been fixed on me." Obviously, this narrative takes on its allegorical nature mainly because the Phoenix appears in the poem, instead of Jesus in risen human form. The latter would still be a religious poem, but not an allegorical one. Although it has not been given emphasis in this allegorical reading, the light associated with the Phoenix is also beyond realistic light.

The second stanza, two lines shorter than the first, is mostly variations of the theme of not having succeeded in bringing Davidman to God. It begins with a traditional flattery ("thrice-honored lady") and then offers an argument by analogy: "make not your spoon your meat," for the eating instrument does not give nourishment. Here, Lewis is the spoon. Next, a rather vague promise, in a statement that he will be all things to her except a substitute for God. Perhaps Lewis means he offers *Storge*, *Philia*, but not *Eros* as a substitute for *Agape*.

The next seven lines start from the assumption that both their hearts will break if Lewis failed to reveal Jesus to her, if Lewis mistakenly was in the way of her perceiving Christ. And then Lewis does something odd. He says that he had dreamed he had brought her to Christ, but he uses the image of him as a fisherman, Davidman as a fish – "a silver, shining fish" – to be fed to the Phoenix. The source

of the image may be Jesus's call to fishermen to become fishers of men (Mark 1:17-18, Matthew 4:19-20, Luke 5:10-11), but it is an odd image, nevertheless. What convert wants to be devoured by a large, supernatural bird? Or by any large predator? It might be considered more a Metaphysical image of wit than an authentic religious invitation. Probably Lewis thought he was symbolizing the Christian convert giving up herself for God's will.

Continuing the imagery, Lewis writes of the conversion of Davidman as being "a miraculous draught" – an echo of New Testament accounts of fishing miracles, as described in John 21:4-14 or Luke 5:4-7. Davidman by herself would be a great catch, but Lewis indicates he has little to show for his efforts without Davidman being converted. That is a good argument to present, to indicate how precious she was, and it may have indicated (not intentionally) Lewis's humility about his efforts. "If the line breaks," Lewis writes, "Oh with what empty hands you send me back to Him!" Why is Davidman such a great catch? Partly, no doubt, this is simply rhetorical – Lewis is writing to her, and every soul is precious to God. But she is also a great catch in more worldly terms. She has shown her lively intellect in her letters; she is of Jewish background and is a former Communist; she has the potential for being a good Christian writer, as shown by her "Longest Way Round" in 1951.

As indicated, this whole rhetorical development of Davidman as a fish to be eaten by God the Son seems very odd. Probably the original rhetorical choice of the Phoenix as an image for God (or Jesus) has led to this choice of the image of a fish/soul being fed to the Phoenix, since many birds do feed on fish – but it will prove, in two of Davidman's sonnets, to produce a strong reaction by Davidman against the imagery.

Lewis's sophisticated use of meter and couplet-form is extremely unlike the modern age in poetry, of course. Perhaps he can be compared to Ben Jonson in Jonson's writing of his longer epigrams and miscellaneous poems (although Jonson is writing in *rhymed* couplets) – and the comparison even works, in a general way, to one or more of Jonson's masques in Lewis's choice of imagery. Finally, "The Phoenix Flew into My Garden" is an amazingly polished work to have been written to respond to just one person's misplaced (or certainly ill-timed) affection.

One further thing in Lewis's poem became very important to Davidman and her responses. In the sixth line when Davidman is introduced, the narrator says, "The dark girl, passing in the road,

heard me." In a later poem, Davidman will note the fact that she is called "dark." From Davidman's black-and-white photographs in Santamaria's biography, it is clear that Davidman had dark hair. Santamaria says only that her hair was "dark" (9). The Wade Center has a rather faded June 1958 color photo which shows her hair as either very dark brown or black, and streaked, by that time, with grey (Laura Schmidt, email). Don W. King states definitively that Davidman was a brunette in a footnote to "XII" (289). Davidman's complexion in the biography's pictures seems lighter in some and slightly darker in others.

Davidman's Sonnet "XIX" starts with three birds captured in a trap:

> Here are three pairs of wings caught in one net,
> Three sets of silken feathers.

She clarifies the image with a comparison: "as the bird / Stoops to the fowler's lure, and [is] most ill met." And then she ends the quatrain with a further clarification of what three birds she is writing about: "My love and I, with Christ to make the third." Lewis is her love in the sense that she loves him. Christ being a bird is one of the ties of this sonnet to Lewis's poem.

The second quatrain describes the three birds further:

> And one of us has mud-bedabbled wings,
> And one of us has wings washed clean as [the] sun,
> And one of us planned this and other things
> Before the howling planets were begun.

Davidman describing herself as mud-bedabbled presumably means, in Christian terms, she is sin-bedabbled because of her numerous earlier love affairs and her long-time atheism, etc. And it is she who apparently desires a love affair while she is still married. In this sonnet, Davidman seems to have read Lewis's reference to her as a "dark girl" as being a moral judgment, not a physical description. The bird with wings washed clean is Lewis, who is not tempted by the offer of an affair. He is presumably washed (as by baptism) by his faith, and by his moral certitude in Christ. And, of course, the bird who controls all events in this world and thus is responsible for the three birds caught in this situation is Christ – for the fourth Gospel says that "all things were made by him [the Word, Christ]; and without him was not anything made that was made" (John 1:3) and who, the Epistle to the Hebrews says, is "upholding all things by the word of his power" (Hebrews 1:3), thus expanding the idea of creation to include

Providence's sustaining work. The worlds howl in the eighth line perhaps because they are filled with people or their science-fictional equivalents caught in like moral impasses. All the universe, it seems, is fallen, not – as in the Ransom Trilogy – just the Earth. (Otherwise, the "howling" of the planets seems inexplicable).

So far there is little clearly based on Lewis's "Phoenix" poem. The Phoenix as an image of Christ and the third bird identified as Christ (as was suggested above) is an obvious parallel; the mud-bedabbled bird may suggest the dark girl, but the next quatrain goes further about darkness:

> Here are three unlikely birds indeed!
> A jackdaw in a peacock company
> I strut, until they peck me and I bleed,
> Since I am black and they are bright to see.

A jackdaw is, as King says in a footnote, a small crow (293, note 34). Davidman's identification of herself as black as a crow may well develop (taking "mud-bedabbled" further) from Lewis's reference to her as a "dark girl," although she is exaggerating the image in her jackdaw blackness (from mere darkness to blackness).

The identification of both Lewis and Christ as peacocks in the third quatrain is interesting. The peacock is sometimes a Christian symbol of immortality. But the peacock is also sometimes a symbol of pride, no doubt because of its colorful display. The ambiguity for Lewis and Christ is surely deliberate. And peacocks are known to sometimes attack various small animals. Davidman's strutting suggests a self-assertion, with Lewis and Jesus attacking her to deny the assertion. The blackness/darkness of Davidman and the light/brightness connected with the Jesus bird (Phoenix or peacock) come from Lewis's poem. Lewis's identification with Jesus's attitudes (regarding sexual morality, for example) makes Lewis a peacock. Finally, the pecked-until-bleeding may be the equivalent to this sonnet to the fish being eaten in Lewis's poem.

Davidman flips the conclusion:

> Yet I've a fire at heart [which] shall make me shine
> Fit for my human love – or my divine.

Davidman has picked up the emphasis on light in Lewis's poem – the "flame" that was quoted, but also "golden rays" which "flood-lit" the scene (line 7). Here, in the final couplet, it is Davidman who shines, not the Phoenix (as in Lewis), not the Christ-Peacock. She also neatly brings the final couplet back to the "three unlikely birds,"

now phrased as Davidman herself, her human love (Lewis), and her divine love (Christ).

Some brief comments about the artistry of this sonnet at this point. Although clever, this is not one of Davidman's best works. In the first sonnet of her sequence – before her numbering of sonnets begins (282) – Davidman tells Lewis that she writes sonnets too hastily because she finds them easy – she says, amazingly enough, that she can write an acceptable sonnet in fifteen seconds. Probably this speed explains three omitted words in order to keep the meter: "the bird / Stoops [. . .] and [is?] most ill met" ll. 2-3), "one of us has wings washed clean as [the?] sun" (l. 6) and "I've a fire at heart [which?] shall make me shine" (l. 13). Also, the sonnet tends to break into separate topics: three birds in a net (first quatrain), birds' wings (first two lines of the second quatrain), Christ's control of the world (next two lines), jackdaw and peacocks (third quatrain), and a conclusion without the bird metaphor (final couplet). Acceptable but not much more than that. Still, the conceit of the three birds is clever, especially as a response to Lewis.

Davidman, in the next sonnet in her sequence, "XX," retells a conversation with Lewis. She dates the composition of the poem "January 22, 1954," and the conversation has been argued here as having occurred in the meeting in December 1953. This poem is an English sonnet in form: three quatrains and a couplet.

Davidman begins with three uses of the word *love* in the first two lines:

> My love who does not love me but is kind,
> Lately apologized for lack of love[.]

She continues about what he said, running over the end of the first quatrain into the second; Lewis was

> Praising the fire and glitter of my mind,
> The valour of my heart, and speaking of
> Affection, admiration[.]

One notices that Davidman, in her enjambment, uses *of* at the end of the fourth line. English is rhyme weak on the word *love* – *of, glove, dove, above, shove* – that is about the limit of English rhymes. Here *of* certainly keeps the sentence moving from the first quatrain into the second.

In the second quatrain, Davidman develops an image of a begging woman:

> Affection, admiration, bitter scraps

Men fling the begging woman at the door
When hunger lends her courage and she raps
Loud at their consciences.

So Davidman, wanting to be given *Eros*, is like the physically hungry woman who gathers her courage to knock, to "rap," at a wealthy man's door to ask for food. She is likely, Davidman says, to get only "bitter scraps" of food to eat.

Again, Davidman enjambs the movement from one quatrain to the next. She begins at the end of the second quatrain: "Why, there was more;"[.] One might be surprised that she used a semi-colon, not a colon; but the idea goes on: "He [that is, Lewis] said that I had beauty of a sort / Might do for other men, but not for him." Davidman injects the image of demons to symbolize the psychological pain the coming words caused her: "At which the grinning devils had their sport / And tore me shrieking, limb from bleeding limb[.]" One doubts that she literally shrieked, or that it really felt like she had an arm or leg pulled off. But she does get across the idea that Lewis's words pained her. The comparison to being tortured in Hell is quite effective.

At this point Davidman has finished the three quatrains of the English sonnet. The final couplet in this form of sonnet is usually spent on an epigrammatic conclusion. The present writer must admit he does not find her finale effective. She writes:

To be rejected, O this worst of wounds,
Not for love of God, but love of blondes!

Was Lewis really attracted to blondes? Who knows? But we do know that he was trying to discourage Davidman's obvious attraction to him. He seems to be saying, "I'm sorry, but I'm just not attracted to your type."

According to the body of the sonnet, Lewis led up to the rejection with praise for Davidman's other traits, trying to soften the rejection. Davidman sees the praise merely as a rhetorical device. Of course, the reader of the sonnet cannot judge Lewis's sincerity in the praise of many traits or in the attraction to blondes or even if he really said it. Obviously, he later married Davidman and loved her dearly.

At the end of the sonnet, Davidman's final couplet is not a complete disaster, of course – she was a better writer than that – but it is not ideal. Isn't the exclamation "O this worst of wounds[!]" a touch of stereotyped tragedy? The actor strikes his chest while declaiming it. The alliteration on *w*, in other circumstances, might be effective, but here it reinforces the stereotyping. The parallelism of the last line,

however, is effective: Not for *blank* but *blank*. The two terms in the structure, each introduced by "love of," end with two one-syllable words: "God" and "blondes," all in one headless iambic pentameter line: "Not for love of God, but love of blondes!" Since Lewis was known as a religious writer, the irony of his rejecting a woman not because of religious principles but because she was not a blonde adds an extra piquancy to the use of "God" in this contrast.

The first two sonnets considered have been English sonnets. The third sonnet, "XXI," is a mixture. It begins with two quatrains in the English rhyme scheme, ABAB CDCD. The last six lines start with four lines in what seems still part of an English sonnet, EFEF, but then Davidman turns it into a sestet by rhyming the last two lines FE.

However, "XXI" does not use an organization into two quatrains and a sestet rhetorically. "XXI" is written in three sentences, and the first two end interiorly. These are dramatic speeches, not lyric ones. Here is the first sentence:

> This that was a woman in its time
> Loved you before you pulled its long hair out
> By the blood roots, punctured its eyes to slime
> With sharp contempt, and neatly cut its throat
>
> And hung the carcass downward by its heels
> To drain, and fed it to a bird you kept
> Tame and call a phoenix.

Several aspects of this beginning are interesting. First, in the preceding sonnet, Davidman wrote about Lewis in the third person, "My love, who does not love me but is kind [. . .]." Here she shifts to the second person, to *you*: "you pulled its long hair out / By the blood roots." The accusation is much more direct.

Second, she refers to herself as *it*: "This that was a woman in *its* time," "pulled *its* long hair out," "punctured *its* eyes to slime." Of course, this is a claim that Lewis has dehumanized her: that is, he refuses to treat her as a woman, but as an *it*. Only one of the actions Davidman accuses Lewis of – pulling her hair out by its roots – has been seen in the poems this essay is concerned with. Davidman's previous sonnet said he preferred blondes and was not attracted to her dark hair; thus he has (she reports) rejected her hair, denies the value of her hair. In this twenty-first sonnet, the image becomes that of tearing out her hair.

Third, Davidman has so organized this first sentence that it reaches a rhetorical climax. The final word is *phoenix*. This is another

clue that this sonnet is a reply to Lewis's poem and belongs in the four-poem sequence. Davidman does not elsewhere mention the phoenix in her sonnets to Lewis. One should notice that she says Lewis "fed" her carcass to the phoenix. Lewis's poem says he wanted to give her, as a silver-colored fish, to the Phoenix to eat. The Bestiary does not mention what a Phoenix eats, so two poems mentioning a person as a meal for the Phoenix/phoenix in one way or another seem likely to be related.

One other comment about that phoenix. Davidman is not simply missing the religious meaning of Lewis's Phoenix when she turns the bird's eating into something unpleasant. Don W. King has a copy of a paper she wrote as a student, a translation into the alliterative meter of "about seventy lines" of the 677-line Old English poem *Phoenix* (email of 28 July 2018). Although the Anglo-Saxon poem takes the legendary bird mainly as a symbol of the Christian's death and resurrection, nonetheless, in the last lines the Phoenix is treated as an image of Christ. Davidman understood Lewis's point, if there were any doubt. She simply is rejecting it.

The second sentence in her sonnet is this:

> Pleasant meals
> The feathered creature had before it slept
> And left the tattered ribs to fill with air,
> The shattered brain to light the naked skull
> With a last mockery of life.

In other words, the phoenix has eaten most of the human meat and left the scarred bones to provide a skeletal suggestion of life. Also, Davidman indicates some of the brain still exists; she calls it "shattered." (Normally a fragmented skull – being bone – is described as "shattered," but here the brain is mostly eaten, and "shattered" in the sense that bits of the brain are left.) The brain provides "light" not in the physical sense of illumination but in the intellectual sense of some thought processes. The remaining thoughts are referred to "a last mockery of life," "mockery" being used in its sense of a false imitation.

One example of Davidman's artistry in this sentence is the off-rhyme and then pure rhyme in the middle of lines of "feathered" (line 8), "tattered" (10), and "shattered" (11). Perhaps an earlier, even further "off-rhyme," might be considered: "punctured" (3). With or without this last example, these echoes increase the aural density of the poem. This second sentence is basically transitional, supplying details about the leavings of the nearly insatiable bird and the suggestion of some

life remaining.

The third sentence builds to a second climax:

> Despair
> Might think your leavings fit for burial;
> And yet the horror is a woman still;
> It grieves because it cannot stroke your hair.

The first clause of this compound sentence does two things of rhetorical interest. *Despair* is obviously a personification. However, the use of the subjunctive *might* suggest despair is not certain. When the second clause denies that Davidman despairs – "And yet" it begins – then the personification is left as a rhetorical device without actual manifestation.

The second point of interest in the first clause is the word *your*. "Your leavings" would suggest it refers to the phoenix, but *you* in this poem has, hitherto, referred to Lewis. Thus, the figures seem to merge: Lewis is responsible for Davidman's feelings of being devoured, of having her outward appearance and her inward ego destroyed by Lewis's treatment of her. He is the hungry phoenix.

The last two lines of the sonnet use a very Gothic image to conclude. The nearly-dead skeleton, all that remains of Davidman, still wishes to stroke Lewis's hair. Gothicism is part of the American literary tradition through Poe and Hawthorne, and both serious and popular forms have appeared throughout American culture. A skeleton reaching toward a person, whether to stroke his hair or for another reason, suggests a cover painting for something like *Weird Tales*. The combination, in various ways, of *Thanatos* and *Eros* is an ancient macabre motif, and it was Poe's mainstay.

What then can be said about this sonnet more generally? Certainly it is more vivid in its use of *you* for Lewis, instead of the *he* of the previous sonnet. The imagery given in the first ten lines involve sadistic torture in the attack on the woman; the phrasing is very specific: hair, eyes, throat, carcass, ribs, skull. It is a powerful reply to Lewis's image of feeding "a silver, shining fish" to the Phoenix.

No doubt other details are also important. In the last six lines, for example, the F's are off-rhymes – "Skull," "burial," and "still" – while the E's are pure rhymes – "air," "Despair," and "hair." Because of the reversal in the rhyme pattern in the last two lines – not EF.EF.EF but EF.EF.FE – the sonnet ends strongly with a pure rhyme. Simply another detail which supports the thesis that this is the best of the

three sonnets analyzed.

That having been said, one may return to the sequence of Lewis's "The Phoenix Flew into My Garden" and Davidman's "XIX," "XX," and "XXI." King also points to the sonnets that later refer to Lewis's preference for blondes: "XXII" and "XXXI." He ties these to an earlier sonnet, "XII," in which Davidman does refer to herself as not having golden hair, but which is basically about her face getting older. The hair reference is part of a contrast of herself with Helen of Troy ("Love Sonnets to C. S. Lewis" 289, n. 27). In short, Davidman's sonnets are available for various patterns of study. The virtue to the present approach is that it combines poems by Lewis and by Davidman; it shows the eventual lovers in dialogue, both between poems and, to a degree, within "XX." This dialogue, except in the final couplet of "XIX," is not upbeat, but perhaps more interesting for that.

Obviously, this dialogue seems to reflect on the real relationship of Lewis and Davidman; perhaps this understanding extends, to some degree, to other lovers (or frustrated lovers). Is this understanding important? It may be important to the student of Lewis and/or Davidman. It may be interesting to ask why Lewis and Davidman (and others like them) need to write of their views, rather than thrash out their problems in person. One reason might be that neither Davidman nor Lewis seems to succeed telling the other how they felt in person. The poems are a way of thoughtfully and emotionally and formally stating their positions. And perhaps the poems help us understand the lives of poets (and/or human beings generally). If the lives of Lewis and Davidman are important, if their poetry is important, at least this essay may help to clarify something they have written. Some later critic may work it into a larger study of them. That is as it should be.

THREE NOTES

(1) C. S. Lewis's poem "The Phoenix Flew into My Garden" is placed in Don W. King's *Collected Poems of C. S. Lewis* into an "Undated Poems" section (420). Charlie Starr, however, working from his study of the details of C. S. Lewis's handwriting, has placed it in the 1950-1956 period (Starr). If the preceding essay is correct, it was written after Joy Davidman's "three-week" Christmas visit to Lewis, ending on 2 or 3 January 1953; Lewis was irritated both by how long Davidman stayed and by her trying to turn into a romance what he considered a friendship; thus, his poem. He may have started it soon after the visit or later that year, when he learned that she was moving to

England. In short, sometime after 3 January 1953 and certainly before 17 December 1953 (the date of her next visit to Oxford), Davidman had to have time to write "XIX" as a response to "The Phoenix Flew into My Garden" before the visit with the discussion of blondes. Lewis presumably mailed his poem to her soon after finishing it.

(2) The present author published a previous essay on "The Phoenix Flew into My Garden" in 1992, "No Fish for the Phoenix." Don W. King found it "frustrating," in part because it had a very New Critical approach which limited identifications to what was revealed in the words of the poem (King, *C. S. Lewis, Poet*, note 68, 357). The present identifications of the speaker as Lewis and the "dark girl" as Davidman remedy the earlier limits. The treatment of the metrics of the poem is also briefer here.

(3) Here, I give, in list form, an updated account of the dating of the poems in question. In "Love Sonnets to C. S. Lewis" (*A Naked Tree* 282-307), Don W. King provides a date in parenthesis after each poem; some are dates that Davidman included on the typescripts, some are dates (usually approximate) that King provides; as listed, it is impossible to be certain which is which. But in *Yet One More Spring* (169-88), King indicates in footnotes whether the dates are hers or his. The following chart gives the sources by the authors' initials (D for Davidman, K for King). The centered place and time divisions are Davidman's. The bracketed numbers indicating repetition of full dates (that is, more than one sonnet written on the same date) are mine. In addition, an asterisk before a sonnet number indicates that Davidman's sonnet in the sequence has a reference to the blonde/brunette, fair/dark distinction.

"Dear Jack" (prefatory sonnet) K 1954-1955

AMERICA, 1951

I	D 8 April 1951
II	D 1948 or 1949
III	D March 1940
IV	K September 1938

ENGLAND, 1952

| V | K 1940 |
| VI | D 10 December 1952 |

| VII | D Christmas 1952 |
| VIII | D S. S. Franconia, January 1953 |

AMERICA, 1953

IX	D 11 February 1953
X	D 14 February 1953 [King points out this is Valentine's Day]
XI	D 14 February 1953 [King points out this also is Valentine's Day]
*XII	D 1 August 1953 [King considers this the first of the sub-series about blondes]
XIII	D 20 March 1953
XIV	D 22 February 1953
XV	D 8 January 1953
XVI	K September 1938

ENGLAND, 1954

XVII	K 1938
XVIII	D 23 February 1954
*XIX	K 1954 or 1955 [JRC 1953 – see Note 1]
*XX	D 22 January 1954 [1]
XXI	K 1938 [JRC 1953 or 1954 – most probably the latter]
*XXII	K 1954 or 1955
XXIII	D 22 January 1954 [2]
XXIV	D 16 January 1954
XXV	D 2 February 2954
XXVI	D 31 January 1954
XXVII	D 18 February 1954 [1]
XXVIII	D 18 February 1954 [2]
XXIX	K 1954 or 1955
XXX	D 1 March 1954
*XXXI	D 9 May 1954 [1]

XXXII	K 1954 or 1955
XXXIII	K 1954 or 1955
XXXIV	D 10 March 1954
XXXV	D 9 May 1954 [2]
XXXVI	D 9 May 1954 [3]
XXXVII	D 9 May 1954 [4]
XXXVIII	K 1954 or 1955
XXXIX	K 1954 or 1955
XL	D 30 March 1954
XLI	D May 1954
XLII	D May 1954
XLIII	K 1954 or 1955
XLIV	D November 1939

WORKS CITED

The Book of Beasts, being a Translation from a Latin Bestiary of the Twelfth Century. Made and edited by T. H. White. G. P. Putnam's Sons, 1954.

Christopher, Joe R. "No Fish for the Phoenix." *The Bulletin of the New York C. S. Lewis Society,* no. 23, July 1992, pp. 1-7.

Davidman, Joy. "The Longest Way Round." *These Found the Way: Thirteen Converts to Protestant Christianity,* edited by David Wesley Soper, Westminster Press, 1951.

---. "Love Sonnets to C. S. Lewis." *A Naked Tree: Love Sonnets to C. S. Lewis and Other Poems,* edited by Don W. King. Michigan: William B. Eerdmans, 2015. 282-307.

---. *Out of My Bone: The Letters of Joy Davidman.* Edited by Don W. King. William B. Eerdmans, 2009.

Heck, Joel. "Chronologically Lewis." Website.

King, Don W. *C. S. Lewis, Poet: The Legacy of His Poetic Impulse.* Kent State University Press, 2001.

---. *Yet Once More Spring: A Critical Study of Joy Davidman.* Michigan: William B. Eerdmans, 2015.

---. Emails to Joe R. Christopher, 3 February 2018, 28 July 2018.

Lewis, C. S. *Collected Letters, Volume III, Narnia, Cambridge and Joy 1950-1963.* Edited by Walter Hooper. Harper Collins, 2006.

---. "The Phoenix." *Poems,* edited by Walter Hooper. Geoffrey Bles, 1964, p. 121.

---. "The Phoenix Flew into My Garden." *The Collected Poems of C. S. Lewis: A Critical Edition,* edited by Don W. King. Kent State University Press, 2015, p. 420.

Santamaria, Abigail. *Joy: Poet, Seeker, and the Woman Who Captivated C. S. Lewis.* Houghton Mifflin Harcourt, 2015.

Schmidt, Laura (Archivist, Marion E. Wade Center). E-mail to Joe R. Christopher, 27 July 2018.

Starr, Charlie W. [with Don W. King and Andrew Lazo].

"Date Corrections, Confirmations or Narrowings, and Dates for Undated Poems in Don King's *Collected Poems of C. S. Lewis: A Critical Edition* (as of October 2017)." Unpublished typescript.

A Difference of Degree:
Sayers and Lewis on the Creative Imagination

by Gary L. Tandy

Gary L. Tandy is Professor of English and Chair of the
English and Theatre Department at George Fox University
where he teaches a class on C. S. Lewis and Friends. His
book, *The Rhetoric of Certitude: C. S. Lewis's Nonfiction Prose*,
was published by Kent State University Press in 2009, and he
frequently publishes about Lewis and the Inklings.

Dorothy L. Sayers and C. S. Lewis were writers who thought
deeply about the creative imagination, the creative process, and the
relation of these to their Christian faith. Both were practitioners, as well
as theorists, producing multiple works of fiction, drama, apologetics,
and poetry. Both wrote for a variety of audiences including scholarly
and popular and believed that literary works could be entertaining
as well as edifying, could both delight and teach, as the classical and
renaissance writers put it. Finally, both authors addressed the creative
imagination in their essays, books, and letters. While a comprehensive
treatment of their respective theories of the creative imagination
would require a book-length study, my aim is to describe each writer's
theoretical view and to explore one particular disagreement that arose
between the two in response to Sayers's book, *The Mind of the Maker*.[1]
Finally, I hope to provide some explanation for the different views by
looking at two addresses, one by Lewis and one by Sayers, in which
each author attempts to formulate a Christian aesthetic.

In *The Mind of the Maker* (1941), Sayers writes that "the
characteristic common to God and man is . . . the desire and the ability
to make things."[2] Sayers arrives at this conclusion from her reading
of Genesis, noting that in the beginning God created man in His
own image. Sayers admits that the expression "in His own image" has
occasioned a good deal of controversy[3] but then goes on to contribute
to the controversy herself by giving her interpretation, pointing out
that whatever the meaning of image it is something shared by male
and female alike. After asking the question, "How can he [man] be
said to resemble God?" Sayers asserts:

1 Dorothy L. Sayers, *The Mind of the Maker* (New York: Harper & Row,
1987).

2 Sayers, *The Mind of the Maker*, 22.

3 Sayers, 21.

> Looking at man, he [the Genesis author] sees in him something essentially Divine, but when we turn back to see what he says about the original upon which the "image of God" was modeled, we find only the single assertion, "God Created." The characteristic common to God and man is apparently that: the desire and the ability to make things.[4]

For Sayers, then, God and humans are both creators. As she states, "God is the archetype of the creator; the artist is a type. . . . The mind of the maker and the mind of the Maker are formed of the same pattern, and all their works are made in their own image."[5] This may seem a bold statement (as we shall see later, C. S. Lewis thought it much too bold), but Sayers goes on to make an even bolder claim: "It is the artist who, more than other men, is able to create something out of nothing."[6] Sayers expands on this idea, noting that artistic creation is not simply a rearrangement of what already exists, a rearrangement of "matter" as she calls it, because the amount of matter in the universe and its possible rearrangements are limited. On the other hand, Sayers suggests:

> But no such limitation of numbers applies to the creation of works of art. The poet is not obliged, as it were, to destroy the material of Hamlet in order to create a Falstaff, as a carpenter must destroy a tree-form to create a table form. The components of the material world are fixed; those of the world of imagination increase by a continuous and irreversible process, without any destruction or rearrangement of what went before. This represents the nearest approach we experience to "creation out of nothing," and we conceive of the act of absolute creation as being an act analogous to that of the creative artist. Thus Berdyaev is able to say: "God created the world by imagination."[7]

Continuing the analogy, Sayers suggests that poets are known through their work as God is known through His creation. The minds of poets are revealed through their poems, which communicate the content of their minds and of their experiences to readers and evoke a response from them. This is analogous to the workings of the Trinitarian Godhead. The Father is the idea, the generative form of the poem; the Son is the Energy by which the idea is incarnated in a work of art; the Spirit is the Power responsible for the communion

4 Sayers, 22.
5 Sayers, 182.
6 Sayers, 28.
7 Sayers, 29.

between the poet's mind, the poem, and the audience.[8] For Sayers, it is this Trinitarian analogy that is most significant, and she spends the rest of *The Mind of the Maker* exploring the many ways in which the creative imagination and artistic process reflect the Trinity.

In a review of *The Mind of the Maker,*[9] C. S. Lewis praises Sayers's book, noting that it is the first "little book on religion" he has read in a long time in which "every sentence is intelligible and every page advances the argument." But he also registers a serious dissatisfaction with that argument. Lewis's complaint focuses on his fear that Sayers has granted the artist too high a position as creator. He wishes that Sayers had stressed throughout the book that the analogy between God as creator and Author as creator is merely an analogy. He makes clear that his concern stems from his view that the current age has idolized human genius, calling this one of our most insidious dangers. Lewis states:

> I am afraid that some vainglorious writers may be encouraged to forget that they are called "creative" only by a metaphor – that an unbridgeable gulf yawns between the human activity of recombining elements from a pre-existing world and the Divine activity of first inventing, and then endowing with substantial existence, the elements themselves. All the "creative" artists of the human race cannot so much as summon up the phantasm of a single new primary colour or a single new dimension.[10]

Lewis takes particular issue with Sayers's assertion that "between the mind of the maker and the Mind of his Maker" there is "a difference, not of category, but only of quality or degree."[11] "On my view," Lewis says, "there is a greater, far greater, difference between the two than between playing with a doll and suckling a child."[12]

So how should we understand this serious disagreement between two Christian authors who shared many, if not most, other views in common? What made their views of the creative imagination and the artist as creator diverge so widely? Lewis's disagreement seems to arise from his theological views and cultural perspectives, some of which he

8 Richard L. Harp, "The Mind of the Maker: The Theological Aesthetic of Dorothy Sayers and its Application to Poetry," in *As Her Whimsey Took Her: Critical Essays on the Work of Dorothy L. Sayers*, ed. Margaret P. Hannay (Kent, OH: Kent State University Press, 1979), 176.

9 C. S. Lewis, review of *The Mind of the Maker, Theology*, 43 (October 1941): 248-49.

10 Lewis, 248.

11 Lewis, 249.

12 Lewis, 249.

states in his address "Christianity and Literature."[13] Lewis begins by noting that he finds a "disquieting contrast" between the ideas used in modern criticism and ideas found in the New Testament.[14] The key words in modern criticism, according to Lewis, are "Creative" with its opposite "derivative." Therefore, according to the modern mindset, great authors are innovators and pioneers while bad authors "bunch in schools and follow models."[15] While admitting that the New Testament says nothing about literature, Lewis suggests that what it says about other subjects can be applied to formulate a Christian view of literature.[16] Lewis notes passages like "we are of Christ and Christ is of God," imagery which emphasizes ideas of imitation, reflection, and assimilation. St. Paul, for example, tells the Corinthians to imitate him as he imitates Christ and that a Christian is to Christ as a mirror is to an object (II Cor. 3:18). Since in the New Testament the art of life is the art of imitation, can we, Lewis asks, believe that literature, which must derive from real life, is to aim at being "creative, original, spontaneous"?[17] Lewis continues:

> "Originality" in the New Testament is quite plainly the prerogative of God alone; even with the triune being of God it seems to be confined to the Father. . . . Applying this principle to literature . . . we should get as the basis of all critical theory the maxim that an author should never conceive himself as bringing into existence beauty or wisdom which did not exist before, but simply and solely as trying to embody in terms of his own art some reflection of eternal Beauty and Wisdom.[18]

In "Christianity and Literature," it is easy to hear echoes of Lewis's critique of Sayers's argument in *The Mind of the Maker*, especially in his assertion that the author cannot bring into existence beauty or wisdom which did not exist before, or, in Sayers's terms, the human author cannot "create something out of nothing." Lewis seems to identify this concept of art as imitative as the fundamental difference between the Christian and the unbeliever in their approach to literature. He gives us further insight into the roots of his perspective when he states that "the unbeliever is more apt to make a kind of religion out of aesthetic experience while the Christian knows from the outset that

13 C.S. Lewis, "Christianity and Literature," in *Christian Reflections*, ed. Walter Hooper (Grand Rapids, MI, 1980), 1-11.
14 Lewis, "Christianity and Literature," 3.
15 Lewis, 3.
16 Lewis, 4.
17 Lewis, 6.
18 Lewis, 7.

the salvation of a single soul is more important than the production or preservation of all the epics and tragedies in the world."[19]

But Sayers was a Christian, too, sharing Lewis's Anglican faith. What led her to adopt such a dangerously different view of the creative imagination and, in Lewis's opinion, to elevate the role of the creative artist out of its proper sphere? I suggest the major difference lies in Sayers's incarnational theology, which led her to choose a different word than Lewis when describing the activity of the creative artist. While Lewis chose the word "imitate," Sayers chose the word "image." Sayers's clearest exploration of the word and her theology occurs in her address "Toward a Christian Esthetic."[20] This address, much like Lewis's "Christianity and Literature" address, proposes a Christian philosophy of the arts in general and of literature in particular.

Sayers begins her address claiming that "The church as a body has never made up her mind about the arts."[21] Sayers deplores this fact and suggests the idea of art as Creation is the one important contribution Christianity has made to aesthetics. Noting that the Greeks saw art as a kind of *techne* and that they did not have a word for creation in their theology or view of history, Sayers suggests that Christian theology gives us the word "image," which is better than "copy," "imitation," or "representation."[22] In Sayers's view, what the artist does in creating is to image forth. In Christian theology, the Son, who is the express image, is not a copy, or imitation, or representation of the Father, nor yet inferior or subsequent to the Father in any way. In other words, the unimaginable and the image are one and the same.[23] Just as the Son and Father are one, so the poet himself did not know what his experience was until he created the poem, which revealed his own experience to himself. Sayers states: "What the poet does for himself he can also do for us. When he has imaged forth his experience, he can incarnate it, so to speak, in a material body – words, music, painting – the thing we know as a work of art."[24]

But to return to Lewis's critical view of originality in favor of imitation: is what the artist images forth really new? Sayers states: "The recognition of the truth we get in the artist's work comes to us as

19 Lewis, 10.
20 Dorothy L. Sayers, "Toward a Christian Esthetic," in *The Whimsical Christian: 18 Essays by Dorothy L. Sayers*, ed. William Griffin (New York: Macmillan, 1978), 73-91.
21 Sayers, "Toward a Christian Esthetic," 74.
22 Sayers, 84.
23 Sayers, 84.
24 Sayers, 86-87.

a revelation of new truth. It is new, startling, and perhaps shattering, and yet it comes to us with a sense of familiarity. We did not know it before, but the moment the poet has shown it to us, we know that somehow or other, we had always really known it."[25] So for Sayers, what is original about the artist's imaging forth is her experience; yet in another way, she seems to be saying it is not entirely new because it strikes a familiar chord in the heart of the reader, thus the power that comes through the literary experience and the interaction of text, author, and reader. Near the end of her address, Sayers almost seems to be responding to Lewis's concern in "Christianity and Literature" that art will become a substitute for religion:

> Art is not He – we must not substitute art for God; yet this also is He for it is one of His images and therefore reveals His nature. Here we see in a mirror darkly – we behold only the images; elsewhere we shall see face to face, in the place where image and reality are one.[26]

Peter Schakel, in his study of Lewis and imagination, notes that in his preconversion years, Lewis held a high, Coleridgean view of poetic and romantic imagination, but that after his conversion he scaled back his high view, coming to regard the imagination as a lower faculty, able to reflect spiritual values, but not actually *spiritual* itself.[27] Imagination for Lewis became not the source of truth but the source of meaning. In what has become an oft-repeated phrase, Lewis stated: "Reason is the natural organ of truth; but imagination is the organ of meaning."[28] While Lewis's reading of the New Testament and his opposition to the theory of genius led him to adopt this lower or modest view of the artist as creator, Sayers's view of the Trinity and her incarnational theology led her to adopt a high view of the creative artist whose creation in the image of God makes him a creator able to image forth new and startling truths. Whereas Lewis's theology caused him to emphasize the gulf between God and man when it comes to creativity, Sayers's theology caused her to stress what God and man shared in common. For her, "between the mind of the maker and the Mind of his Maker" there is "a difference, not of category, but only of quality or degree."

25 Sayers, 87.
26 Sayers, 91.
27 Peter J. Schakel, *Imagination and the Arts in C. S. Lewis* (Columbia, MO: University of Missouri Press, 2002), 10.
28 C. S. Lewis, "Bluspels and Flalansferes," in *Selected Literary Essays*, ed. Walter Hooper (Cambridge: Cambridge University Press, 1979), 265.

Lessons from Venus:
Lewis's *Perelandra* and Barlow's
History of a World of Immortals Without a God

by Kristine Larsen

Kristine Larsen is Professor of Astronomy at Central Connecticut State University where her research and teaching focus on the intersections between science and society, including science in the works of the Inklings. Her most recent book is *The Women Who Popularized Geology in the Nineteenth Century* (Springer, 2017).

A trip to a cloud-shrouded, watery Venus without a normal spacecraft; mentally and ethically "bent" scientists; discussions of sin, morality, and a world's relationship with God; the unnaturalness of immortality outside of Christianity and the Resurrection. A reasonable summary of C.S. Lewis's Space Trilogy? Perhaps. However, in this case it is the plot summary of the now largely forgotten Victorian science fiction tale, *History of a World of Immortals without a God*, originally published in 1891 and reissued in 1909 by Irish cleric, author, and educator James William Barlow. Barlow's story follows the normal tropes of the late nineteenth and early twentieth centuries, as seen in works by Olaf Stapledon, C.S. Lewis, and others, depicting Venus as eternally cloud shrouded, warm but not lethally hot, and hosting a large ocean. While Barlow's science accurately reflects the time of his writing (and is interesting in itself), this analysis will instead focus on the society of the Venusians (here called Hesperians) and draw parallels (and in some cases perpendiculars) with Lewis's Space Trilogy and other writings.

James William Barlow was born in Dublin in 1826, the son of Reverend William Barlow and his wife Catherine Disney. He married Mary Louisa Barlow, and their daughter Jane became a "well-known writer of Irish stories and poems" ("Dublin" 149). Educated at Trinity College, Dublin, Barlow became a Junior Fellow and Tutor at his alma mater in 1850, Erasmus Smith Professor of Modern History at Dublin University in 1860, and Senior Fellow at Trinity College in 1893, dying in Dublin in 1913. His teaching-related publications include *Lectures on the History of Italy during the Middle Ages (A.D. 1100- A.D. 1329)* [1862] and *A Short History of the Normans in South*

Europe [1886] (Black and Black 95; *Dublin University Calendar* 521). In the 1860s Barlow became infamous in Irish theological circles for his writings on eternal damnation.

Trinity graduate and British Army Chaplain Charles Henry Hamilton Wright wrote in his 1867 work *The Fatherhood of God*, "The subject of eternal torment has been one much discussed of late" (86). Geoffrey Rowell's 1974 study, *Hell and the Victorians: A Study of the Nineteenth-Century Theological Controversies*, details the breadth and depth of this long-term debate, including its connections to wider issues of Anglican Evangelicalism and Tractarianism, Darwinism, and the general distancing of an increasingly impersonal God from daily life. Secularists co-opted the doctrine of eternal damnation as an argument against Christian dogma, and even devout Christians voiced unease at the thought of a benevolent, loving deity condemning the majority of humanity to everlasting torture. For example, the 1864 pamphlet *Eternal Punishment* (published under the pseudonym Presbyter Anglicanus) argues that "it is better to say at once that the dogma must be rejected with a deeper and more vehement indignation than that with which Teutonic Christendom rose up against the worst abuses and superstitions of Latin Christianity" (52).

In the 1860s there were three general theological positions among Christian commentators in the British Isles. The orthodox view supported eternal damnation for those sinners who had not repented at the time of their deaths. Some who found the orthodox position in conflict with their personal view of God espoused a belief in the annihilation of the sinner, perhaps on Judgement Day or after some period of punishment determined by the weight of their sins. Alternately, some held that humans as a species are not in general immortal; rather, the immortality of the soul was seen as a gift given by Christ to "the righteous, even as, by the self-same Saviour's gift, their bodies shall put on immortality in the resurrection day" ("The Doctrine of Eternal Punishment" 434).

These debates were certainly not resolved by the middle of the twentieth century, as noted by C. S. Lewis in *The Problem of Pain* (1940). He said of the doctrine of eternal punishment "it is *not* tolerable. But I think the doctrine can be shown to be moral, by a critique of the objections ordinarily made, or felt, against it" (76). Lewis posits "the conception of Hell as a positive retributive punishment inflicted by God" (78) and adds: "Finality must come some time, and it does not require a very robust faith to believe that omniscience knows when" (79). Lewis also argues that souls cannot be "destroyed;" rather, "What

is cast (or casts itself) into hell is not a man: it is 'remains' (like the remains of a burnt log) that cannot have the consciousness of a man" (80).

Barlow's role in this significant theological debate is an interesting one. After graduating from Trinity College, he had become a clergyman as well as an academic, as was common for his time. In 1859 he was chastised by Richard Whately, the Archbishop of Dublin, for his views on eternal punishment and ceased officiating as a member of the clergy (van Weerden 314). In response to the ongoing debate within Irish theological circles concerning the doctrine, Barlow published *Eternal Punishment and Eternal Death: An Essay* in early 1865. He was particularly replying to the sermons "The Eternity of Future Punishment" and "The Place which this Doctrine ought to hold in Christian Preaching" delivered in Trinity College's Chapel (and afterwards published) by his colleague George Salmon in 1864.

It was Barlow's opinion that "this doctrine of Eternal Punishment is now actively at work in undermining Christianity itself" and had "given a more deadly wound to the Christian faith, than all the rancorous hostility of the infidels of the last century" (*Eternal Punishment* iv). In particular, Barlow argues it has had the effect of "driving out thousands from us into infidelity; and it is, beyond all question, THE great repulsive force which prevents the alien from entering within the Christian Pale" (*Eternal Punishment* v; emphasis original). As for his personal beliefs, Barlow echoes the concerns of many Christians of the time:

> The assertion that endless torments will be inflicted upon a creature, by the Being of Infinite Love and Justice who made him, involves, to my mind, a contradiction in terms. It contradicts my notion of Love, and I can no more admit the Love of God to cease, than I can admit His Life, or His Intelligence to cease. (34-35)

Barlow instead argues that for some "punishment may be followed by restoration" (114), while those who are irredeemable are doomed for annihilation.

As noted by a contemporary reviewer, Barlow's essay "has aroused some interest in England, and still more discussion on the Irish side of the channel. . . . [It] has created the more surprise in some quarters, and alarm in others, as the University of Dublin has always been noted for its conservative tendencies" ("The Doctrine of Eternal Punishment" 435). Inflammatory comments from Barlow such as "Few educated and intelligent laymen believe in an everlasting

life of torture" certainly ruffled a few feathers (*Eternal Punishment* 141). Clearly, Barlow's essay hit a nerve in the Trinity community and precipitated a flurry of published rebuttals, not the least reason being his perceived open attack on George Salmon, the Irish mathematician and theologian who at that time had held lectureships in both Mathematics and Divinity at Trinity for nearly 20 years (and was therefore Barlow's academic senior). Salmon's criticism of Roman Catholic beliefs in the infallibility of the Church and the Papacy (in his 1888 book, *The Infallibility of the Church*), are familiar to Lewis scholars. Michael Edwards, who wrote Lewis for advice about whether to convert to Roman Catholicism, notes that, in a 1959 letter, "Lewis recommended I should read 'The infallibility of the Church' [1888] by [George] Salmon" (Lewis, *Letters* 1133).

In response to his critics, Barlow issued the pamphlet, *Remarks on Some Recent Publications Concerning Future Punishment*, in late 1865. An 1866 article in *The Contemporary Review* summarizes Barlow's essay as "vigorously but not temperately written; the sympathy which he excites by his generous feeling for ethical rectitude being checked by a treatment of his opponents which is certainly not generous" (Alford 494). Barlow continued to write on ethical and theological issues, including *De Origine Mali: An Essay Concerning Modern Scientific Atheism* (1872) and *The Ultimatum of Pessimism: An Ethical Study* (1882). Despite the criticism it received, Barlow's original essay remained influential in some circles, as it was quoted by Irish Universalist clergyman and Trinity graduate Thomas Allin in his 1885 work *Christ Triumphant* (57). It is Barlow's ruminations on eternal damnation, scientific atheism, and pessimism that came together to form the foundation of his Venus-centric science fiction tale.

George Salmon was named Provost at Trinity College in 1888, a position he retained until his death in 1904, and it is perhaps for this reason (plus the fact that Barlow was still a Junior Fellow at the time) that *History of a World of Immortals without a God* was initially published in 1891 under the pseudonym Antares Skorpios. Interestingly, Barlow was named Vice-Provost of Trinity in 1899, six years after attaining the rank of Senior Fellow, and resigned from the college in 1908. The following year his novel was republished with the new title *The Immortals' Great Quest* under his own name, the title page listing his affiliation as "Ex-Senior Fellow and Vice-Provost, Trinity College, Dublin."

The structure of the book is a "found" manuscript, the century and a half-old diary of one Gervaas Van Varken of Rotterdam,

stumbled upon in a university library by the translator (Skorpius in the first edition, Barlow in the second). The later edition includes a preface calling the work "not a sensational novel, but a History. How the manuscript . . . came into a University Library, is wholly unknown," with Barlow offering that "Of the substantial truth of the narrative there can be no good reason to doubt" (*Immortals' Great Quest* v). A similar literary device is used in Lewis's *Out of the Silent Planet* and *Perelandra*, as both tales are said to be written down and published by Lewis on behalf of his friend "Dr. Ransom . . . not his real name" (*Out of the Silent Planet* 150). Barlow bolsters his fictional claim of the veracity of his tale by stating, "Had Bishop Butler, who maintains that the doctrine of Future Life is not necessarily connected with any System of Theism, been aware of these extraordinary adventures, he would have found a singular corroboration of his views in the history of the race endowed with Life Immortal, and groping after an Unknown God" (*Immortals' Great Quest* vi). The reference is to the novel's opening quotation, taken from Bishop Joseph Butler's famous work *The Analogy of Religion*: "That we are to live hereafter, is just as reconcilable with the scheme of atheism, and as well to be accounted for by it, as that we are now alive is; and therefore nothing can be more absurd than to argue from that scheme, that there can be no future state" (Butler 73).

The central theme of Barlow's novel is encapsulated in the lines immediately following in Butler's original (but not included in the novel):

> That which makes the question concerning a future life to be of so great importance to us, is our capacity of happiness and misery. And that which makes the consideration of it to be of so great importance to us, is the supposition of our happiness and misery hereafter depending upon our actions here. (Butler 73)

Bishop Joseph Butler was a prominent eighteenth-century cleric whose writings on moral philosophy greatly influenced David Hume and were widely read throughout the nineteenth century. Like Salmon, Butler's name is familiar to Lewis scholars, as Lewis mentions Butler several times in his various essays and other theological works. For example, in "On the Reading of Old Books," he complains "Wherever you find a little study circle of Christian laity you can be almost certain that they are studying not St. Luke or St. Paul or St. Augustine or Thomas Aquinas or Hooker, or Butler, but M. Berdyaev or M. Maritain or Mr. Niebuhr or Miss Sayers or even myself" (21).

Barlow had himself earlier referenced Butler's view on immortality in *De Originale Mali*, observing:

> Atheism does not necessarily exterminate the hope of immortality; for, as Butler says, if our present life be reconcilable with the scheme of atheism, so may a future life. But I greatly doubt that any atheist has really a serious belief that his existence will survive the shock of death – practically speaking, all hopes of immortality are grounded on a system of Theism at the least. (30)

The novel thus became Barlow's thought experiment as to what immortality would be like, not for atheists, but for theoretical theists who have no personal knowledge of, or experience with, God.

Within the body of Barlow's novel, the translator first summarizes Van Varken's biographical information, then presents diary entries detailing his main adventure. The later entries are described as fragmentary and are only presented in summary. Van Varken is painted as a hopeless misanthrope who had been abused by both of his harshly disciplinarian parents (including his Calvinistic mother) as well as a schoolmaster, becoming a doctor only because his father had destined him for it. In this depiction Barlow continues the trend he started in *Eternal Punishment and Eternal Death* of condemning the "hard-hearted and selfish Calvinist" (137), a viewpoint that branded him as "a strong anti-Calvinist" by his critics ("The Doctrine of Eternal Punishment" 435). Van Varken is greatly influenced by Swift's *Gulliver's Travels* and begins referring to fellow humans as "Yahoos." After the death of his parents, he collects his inheritance and moves to the Far East, seeking knowledge from a Tibetan master as to how to change his species. He is instead given instruction on how to instantaneously teleport from place to place. Desirous of putting as many miles between himself and the Yahoos as possible, Van Varken teleports to Venus (called Hesperos in the novel) but is disturbed to find that this planet is also inhabited by creatures that appear physically identical to humans.

The Hesperians are shocked to see a stranger in their land because every Hesperian is known to every other. This is because in the Earth year 18,270 BC, all one hundred million Hesperians "simultaneously awoke into conscious life" on a landmass in the northern hemisphere of the planet (Barlow, *History* 48). Equally distributed between male and female, the apparent ages of the Hesperians range between 20 and 60 years. Their origin is unknown because for "twenty thousand years the Unknown Power which called them into being has preserved a

rigid and unbroken silence" (Barlow, *History* 48). While this creation myth has some similarities with that of Middle-earth, as the deity Ilúvatar is largely removed from the world and only intervenes in extreme circumstances (such as the Atlantis-like destruction of Númenor), Tolkien's demi-gods, the Valar, are very much an influence in the world (at least until the very same cataclysm). The Higher Power of Hesperos is utterly silent. This is apparently a very different kind of silence than we find in Lewis's Space Trilogy, as there is no evidence that the Higher Power of Hesperos is evil.

The Hesperians cannot reproduce, so their population remains constant, except for those who "evanesce" – instantaneously disappear. This is accidentally discovered when a man unintentionally bludgeons another to death. When it is much later decided to condemn one particular murderer to life (eternity) in prison, he suddenly evanesces for no visible reason after only three and a half years. The Hesperians thus learn that both emotional and physical pain can cause evanescence. This is like the immortality of Tolkien's Elves, who "die not till the world dies, unless they are slain or waste in grief (and to both these seeming deaths they are subject)" (42). In *The Problem of Pain*, Lewis discusses how all pains, both physical and emotional/mental, can be classified as "suffering" (56); it is therefore more correct to say that the Hesperians evanesce when they have reached some level of suffering, regardless of the source.

In response to this discovery, the Hesperians build a special "metronome" that measures the balance of pleasure and pain in an individual's life, and it is found that when an individual's total suffering exceeds the accumulated amount of pleasure by ten million units, instantaneous evanescence results. As Van Varken notes in his diary, it is this natural law that prevents a Hesperian court from "sentencing a prisoner to eternal punishment" (Barlow, *History* 61). Instead, murderers are themselves forced to evanesce by being whipped. While the parallels with Barlow's beliefs concerning the impossibility of eternal damnation are obvious, there is another connection to his earlier philosophical writings. In *The Ultimatum of Pessimism*, Barlow describes the modern pessimistic philosophy through a physics analogy, using a series of vectors (having both magnitude and direction) that are perpendicular to the lifeline of an individual. At any moment these vectors point in either the "positive or negative eudemonistic" direction and have lengths proportional to "the instantaneous intensities of these predominating pleasures or pains" (4). Barlow then criticizes this model for its lack of a scientifically

defined unit, noting that the relativity of the *"subjective time* and *intensity of feeling* [emphasis original]" perceived by each individual make this ultimately impossible (9). He had made a similar point a decade before, in *De Origine Mali*, where he notes:

> No standard of comparison for our pains and griefs has yet been discovered, or is likely to be discovered. Intensity and duration are the variable elements – a good clock or watch will determine the latter, but what instrument could we suggest to appraise the former, or translate into aggregations of units of the same denomination the suffering from a tooth-ache or the gout, and the grief arising from the loss of a much loved friend? (9-10)

Both the attempt to measure pain and the comparison to a toothache are interesting, especially when compared with Lewis's *The Problem of Pain*. He argues that while we can "have a toothache of intensity x," we should not make the mistake of trying to measure a universal "sum of suffering, for no one suffers it" (73). Instead, we should discuss only "the maximum that a single person can suffer . . . something very horrible" (73). For the sake of the storyline Barlow sets aside his skepticism of the possibility of such scientific measurements and ponders their potential ramifications.

Despite the lack of any personal communication or experience with the Creator, the increasingly technological Hesperians do not doubt that such a Power exists. This parallels an argument in Barlow's *The Ultimatum of Pessimism*, in which he opines that while in modern physics "Heat, light, sound, electricity, sensation, thought, emotion – all are reduced to the swinging of infinitesimal atoms," the laws of physics cannot lead us to an explanation of consciousness. Instead, Barlow argues, "we are at once led on to the belief in Something beyond; Something which has not been reached" (99-100). The concept that there is something beyond the mechanistic universe of modern science is central to Lewis's thought experiments in *The Discarded Image*, in which the reader is urged to walk under the night sky and experience it through a medieval rather than modern lens. A similar viewpoint is espoused by Ransom on his trip to Mars in *Out of the Silent Planet*: "'Space' seemed a blasphemous libel for this empyrean ocean of radiance in which they swam. He could not call it 'dead'; he felt life pouring into him from it every moment. . . . Older thinkers had been wiser when they named it simply the heavens – the heavens which declared the glory" (34).

The Hesperians were convinced of the existence of their Creator,

but simultaneously deeply troubled by their lack of contact with Him. They raise temples to the "Unknown God" and carry out ceremonies devoted to Him, but "that the Something either could not or would not speak to them, or hold any sort of communication with them was a patent fact, and this caused unutterable sorrow to the Hesperian mind" (Barlow, *History* 80). The sorrow caused by a lack of connection with God is tasted, albeit briefly, by Ransom in *Perelandra*. While trying to keep Weston from leading the Green Lady into sin, "Not for the first time he found himself questioning Divine Justice. He could not understand why Maleldil should remain absent when the Enemy was there in person" (119). But Ransom soon feels the presence of Maleldil and understands that, while Maleldil may not be actively intervening in the battle for the souls of Perelandra, by selecting Ransom as His champion, He has already intervened in a meaningful way.

It is a thirst to know their Creator that drives the Hesperians to pass north beyond the Eden-like plains where they had initially come into consciousness. First, they use their technology to conquer the natural fencing of the glacier and precipice-topped mountains by tunneling through their interiors and then braving extreme mountain climbing to the summits in order to see through the permanent shroud of the clouds to the sun, stars, and other planets for the very first time. For comparison, in *Perelandra*, Ransom fights Weston in an undersea cave and must save himself from the Campbellian belly of the whale by climbing upward through darkness from cliff to cliff, eventually emerging on a tall mountaintop where the "golden sky-roof" of the clouds looked to only be a few feet above (160).

Above the clouds the Hesperians build large observatories, using the science of astronomy, to study the earth from afar. Yet, rather than bringing them closer to their Creator, it merely distresses them further, leading to "world-weariness" (Barlow, *History* 113).

> The brilliant discoveries of the astronomers had failed to throw the faintest glimmer of light on the question of questions – Who was their Maker? – was a fact which could not be disguised. An Answer to this was as far off as ever – further off, even. They had learned the enormous extent of the universe, and, as a consequence, that the Hesperians, so far from exhausting its contents, were not more than insignificant specks in its unfathomed deeps. In the vast profusion of worlds they felt themselves lost. (Barlow, *History* 114)

To the Hesperians, the universe seems cold and distant, in Lewis's terms, merely *Space*. Their Creator had blocked their view of

the heavens, but the Hesperians defy this apparent prohibition. As in the case of Adam and Eve, reaching for forbidden fruit leads to knowledge, but also great sorrow. In contrast, in *Perelandra* Ransom is amazed that the Green Lady knows of other worlds despite the permanent cloud cover. Unlike Barlow's Hesperians, the Green Lady is granted knowledge of what lies beyond by the Powers themselves, and it is enough for her to believe that it is true instead of seeing it for herself. She notes "Your world has no roof. You look right out into the high place and see the great dance with your own eyes. You live always in that terror and that delight, and what we must only believe you can behold. Is not this a wonderful invention of Maleldil's?" (53)

Speaking of the unknown Power that lies beyond the probing lens of science, Barlow notes in *The Ultimatum of Pessimism*, "Between us and this Something – awful in mystery and in power – stands an impassable barrier, called by some the Veil of Isis. . . . The barrier is impassable. Yet, from the first dawn of reflection, men have never ceased to fight; and it would be evil for humanity if they gave up the battle in despair" (100). In the seventeenth through nineteenth centuries, the metaphor of lifting of the Veil of Isis – the unveiling of nature's secrets – was used to represent the Scientific Revolution and Enlightenment (Smith 169). Lewis's Green Lady is granted knowledge of what lies beyond the veil without the violence of piercing through it, thanks to the grace of Maleldil, whereas the Hesperians use technology to force their way through a literal veil of Venusian clouds. Similar knowledge (the existence of the earth and the greater cosmos beyond) brings joy to the Green Lady (she appreciates the beauty of God's plan) but only pain to the Hesperians.

The consequence of these investigations causes some Hesperians to question: "If their Maker had charge of that vast universe, he might well have forgotten them altogether. Why, then, should they not depart from life?" (Barlow, *History* 114). This leads some individuals to throw themselves from the precipices in order to evanesce and escape their world-weariness. But a horrifying discovery ends this practice. Their creator had set another boundary in their world – another veil, if you will – a permanent, cataclysmic storm that rings the equator and prevents them from sailing to the southern half of their planet. Undeterred, they build submarines, and travel under the storms to the southern hemisphere, where they discover that all those who had previously evanesced had simply reincarnated into their physical forms. The Hesperians are therefore trapped, not in the fires of damnation, but in a kind of limbo. They had thought that upon death they were

to be truly annihilated into nothingness (Barlow notes in *Eternal Punishment* that this is the expectation of atheists). However, the Hesperians are not actually atheists, but rather, the bearers of a kind of curse. They are the creation of a seemingly impersonal, uncaring, and perhaps even miserable God. In *The Ultimatum of Pessimism* Barlow defines the "Pessimistic Justification of Life" as the "duty to remain in life ourselves, and to continue the human species, in order, by our suffering, to alleviate the Divine (which is also our own) misery. . . . Therefore develop culture, and endure your sorrow. This is the Ultimatum of Pessimism" (82-83). In the Hesperians we see the wretched result of having a pessimistic viewpoint seemingly thrust upon them through the absence of this fictional deity. Barlow's fiction once again illustrates the more theoretical points of his nonfiction.

The positive effect of the Hesperians' painful epiphany is an improvement in the overall ethics of their society; they realize that no individual can divorce themselves from the others and they must therefore all act towards the greater good. They are all, in a very real way, in this together. But this is not the transcendent moral law of Lewis. Instead, one could argue that each individual is selfishly acting in a moral manner simply because it is in their own best interest. In contrast, in Lewis's sermon "The Weight of Glory," he claims that "all day long we are, in some degree, helping each other to one or other of these destinations," meaning salvation or damnation, the pinnacle of morality (45-46).

Van Varken's arrival only adds to the Hesperians' feelings of despair, especially after a devastating public lecture that the terrestrial gives concerning his home planet. Although the Hesperians hope that he might shed light on the power and majesty of their Unknown Maker, the misanthropic and anti-religious Van Varken utterly dashes their hopes. He describes the religious beliefs of different cultures (although not named, easily recognizable to the reader as pagans, Muslims, and Hindus/Buddhists), falling into common stereotypes. It is interesting that Van Varken's knowledge of teleportation is received in Tibet because the world weariness of immortality experienced by the Hesperians is reminiscent of the concept of *samsara* – the endless cycle of reincarnation – that a Tibetan Buddhist seeks to end. As Lewis notes in "Religion without Dogma?," in Buddhism "a doctrine of immortality is central, while there is nothing specifically religious. Salvation from immortality, deliverance from reincarnation, is the very core of its message" (130). Of course, Tibetan Buddhists don't acknowledge the existence of a Divine Creator, so the Hesperians

should not be seen as Buddhists.

Van Varken informs the Hesperians that Christians, whom he calls the "most highly civilized types of humanity," believe "that the Maker designed the greater part of the human race to live everlastingly in excruciating torture by fire" (Barlow, *History* 166-67). At this point the Hesperians walk out of the lecture, like Barlow himself, rejecting the possibility of a benevolent God who damns His creations to eternal pain. Some Hesperians entreat Van Varken to teach them, against his better judgement, how to teleport in order that they might learn about Earth on their own. Instead of traveling to Earth, they only find themselves evanescing and reconstituting on the southern continent. There is no way out of their Limbo – what seems to some of them to be utterly Hell, despite the lack of fire and brimstone. The novel ends with the statement that Van Varken transports home and nothing further is known about the "Godless Immortals. It is not likely that their additional existence of one hundred and sixty years have lightened the World-Weariness and Sorrow which was plainly settling down upon them like a heavy pall" (*History* 177). Van Varken is reminiscent of Tolkien's humans, for whom, unlike the Elves, escape from the world is possible, because "Death is their fate, the gift of Ilúvatar, which as Time wears on even the Powers shall envy" (Tolkien 42).

In *De Originale Mali*, James Barlow argues:

> Altogether, it must be admitted that, once rationality is joined to sensitive existence, a prospect of immortality is essential for true happiness. And the more favourable are the conditions of life, the more indispensable does this become. May we not say with truth that our modern atheistico-scientific theories destroy not only the life to come, but even the life that now is they strip of all its charms? (29)

But clearly not all forms of immortality bring happiness. For example, one of the themes of Lewis's Space Trilogy is the vain search for such an unnatural "atheistico-scientific" immortality. In *Out of the Silent Planet*, Weston is working toward the immortality of the human species by breaking through God's quarantine (the vast interplanetary distances) and spreading their seed among the stars. In Weston's inept Malacandrian speech, "Me die. Man live" (136). In *That Hideous Strength*, the nefarious plot of the NICE conspirators is revealed by Ransom to be "a way of making themselves immortal. . . . It is the beginning of what is really a new species – the Chosen Heads who never die. They will call it the next step in evolution" (194). In the plight of the Hesperians we witness the painful results of unnatural

(i.e. non-Christian) immortality.

Several years after its initial publication, Barlow's novel was reflected upon by Scottish Free Church minister William Robertson Nicoll in his book-length consideration of death and grief, *The Key of the Grave*. Nicoll asks of the increasingly popular idea of a distant and impersonal God, "Will the various and complex desire of humanity be satisfied by a new heaven and a new earth lighted only by the love of God? . . . We have come on a book, published some time ago in Dublin, which suggests these questions" (155). Clearly the lesson of Barlow's novel is a resounding "No." In Nicoll's words, the Hesperians "had no hope – no light. The Maker of the Universe did not answer them; they concluded at last that they were forgotten among His myriad worlds" (160). It is not enough that the Deity exists – it is the personal relationship with Him that not only makes Immortality possible, but truly desirable. In this way Barlow demonstrates that it is indeed possible to contemplate immortality without a relationship with God, but he also proves that, in many ways, it is empty of meaning. Barlow clearly believes in a personal relationship with a caring God, a deity who, he also believes, is incapable of damning His beloved creations to everlasting torture and damnation. For his part, Lewis might have said of the Hesperians that they were "both banished from the presence of Him who is present everywhere and erased from the knowledge of Him who knows all. . . . left utterly and absolutely *outside* – repelled, exiled, estranged, finally and unspeakably ignored" ("The Weight of Glory" 41; emphasis original). As a result, the Hesperians, like terrestrial Christians, have a "longing to be reunited with something in the universe from which we now feel cut off, to be on the inside of some door which we have always seen from the outside" ("The Weight of Glory" 42). Thus Barlow, like Lewis, utilized his science fiction as a vehicle through which to explore his theological and philosophical viewpoints.

Barlow once mused that the "speculation that this earth is the only planet in creation which has been invaded by sin and sorrow" should be considered "an idle dream" (*De Originale Mali* 22-23). It is unknown if Lewis ever read Barlow's works, but as previously explained, they were both well-read in the same theological traditions. It can be argued that if Barlow had been able to read Lewis's Space Trilogy, he would have understood the literary power of such an "idle dream," even one written by an "educated and intelligent laymen" (*Eternal Punishment* 141) who clearly disagreed with him on the issue of eternal damnation.

WORKS CITED

Alford, Henry. "Notes from Ireland: Theological Literature." *The Contemporary Review*, vol. 1, 1866, pp. 493-94.

Allin, Thomas. *Christ Triumphant.* Annotated and edited by Robin Parry. Wipf and Stock, 2015.

Anglicanus, Presbyter. *Eternal Punishment.* Charles W. Reynell, 1864.

Barlow, James William. *De Origine Mali: An Essay Concerning Modern Scientific Atheism.* Hodges, Foster, and Co., 1872.

---. *Eternal Punishment and Eternal Death: An Essay.* Longman, Green, Roberts, and Green, 1865.

---. *History of a World of Immortals without a God.* William McGee, 1891.

---. *The Immortals' Great Quest.* Smith, Elder and Co., 1909.

---. *Remarks on Some Recent Publications Concerning Future Punishment.* William McGee, 1865.

---. *The Ultimatum of Pessimism: An Ethical Study.* Kegan Paul, Trench, and Co., 1882.

Black, Adam and Charles Black. *Who's Who.* Macmillan, 1910.

Butler, Joseph. *The Analogy of Religion.* 1736. Robert Carter, 1846.

"The Doctrine of Eternal Punishment and Immortality." *The Journal of Sacred Literature and Biblical Record,* vol. 8, 1866, pp. 433-46.

"Dublin." *The University Review,* vol. 7, 1908, pp. 148-49.

The Dublin University Calendar for the Year 1897. Hodges, Figgis, and Co., 1897.

Lewis, C.S. *The Collected Letters of C. S. Lewis, Vol II.* Edited by Walter Hooper. Harper San Francisco, 2004.

---. *Mere Christianity.* 1952. Zondervan, 2001.

---. On the Reading of Old Books." *God in the Dock,* edited by Walter Hooper, William B. Eerdsman, 1970, pp. 200-207.

---. *Out of the Silent Planet*. 1938. Scribner, 2003.

---. *Perelandra*. 1943. Scribner, 2003.

---. *The Problem of Pain*. 1940. Samizdat University Press, 2016.

---. "Religion without Dogma?" *God in the Dock*, edited by Walter Hooper, William B. Eerdmans, 1970, pp. 129-46.

---. *That Hideous Strength*. 1945. Scribner, 2003.

---. "The Weight of Glory." *The Weight of Glory and Other Addresses,* Harper Collins, 2001, pp. 25-63.

Nicoll, W. Robertson. *The Key of the Grave, 4th ed.* Hodder and Stoughton, 1897.

Rowell, Geoffrey. *Hell and the Victorians: A Study of the Nineteenth-Century Theological Controversies.* Oxford UP, 1974.

Smith, Philip. *The Student's Ancient History. The Ancient History of the East.* John Murray, 1871.

Tolkien, J.R.R. *The Silmarillion*. 1977. Houghton Mifflin, 2001.

van Weerden, Anne. *A Victorian Marriage: Sir William Rowan Hamilton.* J. Fransje van Weerden, 2017.

Wright, Charles Henry Hamilton. *The Fatherhood of God.* T. and T. Clark, 1867.

C.S. Lewis's *Sehnsucht* and L.M. Montgomery's *Flash*: Vocation and the Numinous

by Brenton Dickieson

Brenton Dickieson is a faculty member at Signum University and the University of Prince Edward Island. He does freelance speaking and writing and is the author of the popular Faith and Fiction blog, A Pilgrim In Narnia. He is a PhD candidate at the University of Chester, where he is writing a dissertation on the spiritual theology of C.S. Lewis.

INTRODUCTION: C.S. LEWIS AND L.M. MONTGOMERY AS UNMET CONVERSATION PARTNERS

At the very first glance, a side-by-side consideration of C.S. Lewis and L.M. Montgomery seems a peculiar choice. Montgomery was a consummate short-story writer, with more than 530 stories placed in Canadian and American women's magazines. Montgomery's work mostly featured young women as striking protagonists in rural Canadian towns within a largely realistic novel style. Following the success of *Anne of Green Gables* (1908), the bestselling author lived her life as a Presbyterian clergyman's wife. An expert in the short story even when writing her twenty novels, Montgomery's stories have a very rooted sense of place, often with named houses – New Moon, Green Gables, the House of Dreams, Ingleside, etc. – and often, but not always, situated in Prince Edward Island, giving the tiny Canadian province an unusual global status.

C.S. Lewis's experience and style are strikingly different. To the degree to which Montgomery's work fits a very narrow and focused stylistic band,[1] Lewis's published work includes literary history, literary criticism, theory, philology, lecture, debate, letter, memoir, anthology, festschrift, epistolary fiction, philosophical novella, Christian teaching, biblical commentary, classic science fiction, space fantasy, dystopia, fairy-tale, myth retelling, narrative and lyric

1 Perhaps her most distinctive departure in terms of form and style is *The Blythes are Quoted*, mysteriously submitted to the publisher on the day of her death and not published in its entirety until 2009. The book is cast as a fireside reading session with 41 poems interspersed among fifteen short stories. After each cluster of poems there is a family vignette drawing out the Anne-Gilbert love story, happy memories of home and childhood, deep grief at the loss of Walter, the haunting nature of the world wars, or moments of wonder. This book departs from the 1930s Anne books, where the characters are protected from almost all harm.

poetry, apologetics, and popular philosophical theology – and this list itself is a narrow description of Lewis's play in form, idea, and story. Montgomery wrote realistic home novels; Lewis wrote primarily in speculative genres of science fiction, fantasy, allegory, and myth. Montgomery instituted a classic sense of home and place, while Lewis created varied mythic, interstellar, transdimensional, and aeon-bending locales. Montgomery set her publishing life in New York and excelled in the genre that Lewis slighted (he once remarked that if the unliterary person "reads anything it is more likely to be the Women's Magazines"[2]) while Lewis's work appeared in the mainstream publishing world and was encountered first by the Oxbridge literati.

Beyond contextual and stylistic differences, they were completely unknown to each other. Montgomery died in 1942 before Lewis became popular and there is no known evidence that Lewis ever read anything by Montgomery. Still, I believe there is value in considering the two authors in conversation.[3] From the perspective of reception, they were each unusually prolific authors with very large, global audiences.[4] Both produced popular genre literature that was initially ignored by the academic world. Anne of Green Gables and Lucy of Narnia remain two of the most endearing and enduring characters of the twentieth century. Neither Lewis nor Montgomery are famous for their poetry though each deeply desired to be poets as children. If we consider how their poetry fits within their corpus and their literary and cultural worlds, however, we discover that their poems resonate with classical and naturalistic imagery, unlike literary modernism that was in fashion during their careers.[5] To greater and lesser

2 Lewis, *Collected Letters* 3, 881. (Hereafter, *Letters*) Note that part of Lewis's project in *An Experiment in Criticism* (1961) is to reverse expectations of what we assume to be good literature. Though he places "short stories in the women's magazines" next to "'commercial trash,' thrillers, pornography" and the like (107), he also places the women's magazines in conversation with Dante (1). Still, when giving advice, Lewis probably would have repeated this advice about writing: "Read all the good books you can, and avoid nearly all magazines," *Letters* 3, 1108.

3 Although there is as yet no critical comparison of Lewis and Montgomery, Julie Rae Golding Page's 1998 MA Thesis on the Christian imagination in Montgomery leans heavily on the Inklings, and Lewis scholar Monika B. Hilder published work on Montgomery that references Lewis, "Unholy Tendency," 50, 53.

4 The Wikipedia page "List of best-selling books" has *Narnia* at 120,000,000 copies alone, not including his other works. Montgomery is undoubtedly Canada's bestselling author, ahead of Margaret Atwood and Robert Munsch, with estimated sales of *Anne of Green Gables* alone at 50,000,000 copies. *Narnia* and *Anne* are each consistently in print in dozens of languages.

5 Lewis is commemorated in Poet's Corner at Westminster Abbey, while Montgomery was the first Canadian woman to be named a Fellow of the Royal Society of Arts in England.

degrees, they were shaped by some of the same authors, including John Bunyan, Charlotte Brontë, Walter Scott, George MacDonald, Alfred Lord Tennyson, and the romantic and Arthurian traditions. Both Montgomery and Lewis were early orphans who had to care for aging adoptive mothers whose tyranny intensified with illness. Yet each wrote rapidly and prolifically even through periods of adversity. Both were shaped deeply by the Great War, both were islanders, and both Montgomery and Lewis had profound experiences of grief.

The most resonant link between Lewis and Montgomery, however, is that they were both publicly Christian authors whose fiction reached widespread mainstream audiences. Their Christian pathways were, however, quite different: Montgomery was a Prince Edward Island Scotch-Presbyterian who served as a minister's wife and host in their small-town parsonages and who gave Christian lectures and wrote Christian stories and essays, but whose journals identify her difficulty with some specific doctrinal issues; Lewis was a reverted Anglican layman who worked evangelistically as a cultural critic and used his status as a leading Christian public intellectual to problematize social expectations and invite people to what he called "mere Christianity." Despite doubts and struggles and variances in context and taste, however, both Montgomery and Lewis produced their fiction projects with a definite sense of Christian vocation.

More specifically, just as C.S. Lewis's *Surprised by Joy* (1955) is a philosophical treatise on longing (*Sehnsucht*), L.M. Montgomery's autobiography, *The Alpine Path* (1917), is a reflection on her experience of what she calls "*the Flash*." As Lewis's *Sehnsucht* weaves through his entire corpus, so Montgomery uses the Emily series to invite her reader into the complex and nuanced experience of *the Flash*. Admittedly autobiographical, Emily's *Flash* is a "moment of joy, of pure recognition."[6] Using C.S. Lewis's philosophy of *Sehnsucht* to explore the spiritual, relational, and imaginative dynamics of *the Flash*, this essay suggests that Lewis's philosophical approach could have helped Montgomery see her experience more deeply and that Montgomery could have helped Lewis reconsider his experience of *Sehnsucht* in terms that were more vocationally relevant.

THE FLASH IN EMILY OF NEW MOON

Emily of New Moon begins, typically for Montgomery, with a picture of Emily's earliest home, "the house in the hollow" nestled

6 Munro, "Afterword," 359.

into "a grassy little dale" that was "a mile from anywhere."[7] Emily's
life is filled with her dear Father, her cats, the trees she has named,
and the "Wind Woman" – an ambivalent personification of the wind
that brings stability and change. "And there was 'the flash,' too,"[8] the
narrator adds. This mercurial experience, unpredictable in its coming
yet always welcome, is woven into the first pages of *Emily of New Moon*
as her father's imminent death shatters Emily's settled happiness. In
addition to the homey, naturalistic, artistic images that Montgomery
uses to introduce Emily, there are other types of references: biblical
(Adam and Eve), religious and literary (the Tree of Knowledge from a
book; *The Pilgrim's Progress*[9]), as well as faërie, elemental, classical, and
magical. A single extended passage will show how Emily's imagination
enchants her mundane beautiful world:

> She loved the spruce barrens, away at the further end of the
> long, sloping pasture. That was a place where magic was made.
> She came more fully into her fairy birthright there than in
> any other place. Nobody who saw Emily skimming over the
> bare field would have envied her. She was little and pale and
> poorly clad; sometimes she shivered in her thin jacket; yet a
> queen might have gladly given a crown for her visions – her
> dreams of wonder. The brown, frosted grasses under her feet
> were velvet piles. The old mossy, gnarled half-dead spruce-
> tree, under which she paused for a moment to look up into
> the sky, was a marble column in a palace of the gods; the far
> dusky hills were the ramparts of a city of wonder. And for
> companions she had all the fairies of the country-side – for she
> could believe in them here – the fairies of the white clover and
> satin catkins, the little green folk of the grass, the elves of the
> young fir-trees, sprites of wind and wild fern and thistledown.
> Anything might happen there – everything might come true.
>
> And the barrens were such a splendid place in which to play
> hide and seek with the Wind Woman. She was so very *real*
> there; if you could just spring quickly enough around a little
> cluster of spruces – only you never could – you would see her
> as well as feel her and hear her. There she was – that *was* the
> sweep of her grey cloak – no, she was laughing up in the very
> top of the taller trees – and the chase was on again – till, all at
> once, it seemed as if the Wind Woman were gone – and the

7 Montgomery, *Emily of New Moon*, 1.
8 Montgomery, 1.
9 "Many a time had she walked the straight and narrow path with Christian
and Christiana – although she never liked Christiana's adventures half as well as
Christian's," Montgomery, 3.

evening was bathed in a wonderful silence – and there was a sudden rift in the curdled clouds westward, and a lovely, pale, pinky-green lake of sky with a new moon in it.[10]

In this event, all the images of Emily's literary, religious, and mystical imagination come together in her natural and familiar environment. It is no accident, then, that the next moment is literary: Emily "must go home and write."[11] Indeed, she knew that it "would hurt her with its beauty until she wrote it down."[12] The pain-like sensation of beauty is striking for a child; immediately following it is *the Flash*: "And then, for one glorious, supreme moment, came 'the flash.'"[13] After several such references, Montgomery invites the reader into the experience:

> Emily called it that, although she felt that the name didn't exactly describe it. It couldn't be described – not even to Father, who always seemed a little puzzled by it. Emily never spoke of it to anyone else.

> It had always seemed to Emily, ever since she could remember, that she was very, very near to a world of wonderful beauty. Between it and herself hung only a thin curtain; she could never draw the curtain aside – but sometimes, just for a moment, a wind fluttered it and then it was as if she caught a glimpse of the enchanting realm beyond – only a glimpse – and heard a note of unearthly music.

> This moment came rarely – went swiftly, leaving her breathless with the inexpressible delight of it. She could never recall it – never summon it – never pretend it; but the wonder of it stayed with her for days. It never came twice with the same thing. To-night the dark boughs against that far-off sky had given it. It had come with a high, wild note of wind in the night, with a shadow wave over a ripe field, with a greybird lighting on her window-sill in a storm, with the singing of "Holy, holy, holy" in church, with a glimpse of the kitchen fire when she had come home on a dark autumn night, with the spirit-like blue of ice palms on a twilit pane, with a felicitous new word when she was writing down a "description" of something. And always when the flash came to her Emily felt that life was a wonderful, mysterious thing of persistent beauty.[14]

The phrase "a world of wonderful beauty" and the passage that

10 Montgomery, 6.
11 Montgomery, 6.
12 Montgomery, 7.
13 Montgomery, 7.
14 Montgomery, 7.

surrounds it is as close as Montgomery gets to a full revelation of what *the Flash* truly is. It cannot be summoned or repeated but is triggered by beauty (chapter 1; hereafter just the chapter number); the need to write (3); Emily's first view of New Moon and feelings of home (6); the composition of poetry (15); reading the book of Revelation (19) or thinking about a hymn (1); ancient symbols (26) or things connected to her deceased mother (26). *The Flash* can come in the midst of tension or conflict (3, 8), but it can also arise when Emily feels the connection of family, especially when combined with natural beauty (6, 19, 26). At the climactic moment of the novel, *the Flash* is also associated with Emily's vocation as a writer (26). *The Flash* appears variously and contains several recurring features: aesthetic (1); mystical and religious (1, 14, 19); literary (3, 8); familial (6); vocational (8, 26); nostalgic or mythical (19, 26); relational (19); and elemental (1, 3, 13, 19). It is sometimes a rare occurrence, as we see at the beginning of *Emily of New Moon* and in the other two books of the trilogy, but it is also sometimes frequent: "The flash came almost every evening over something or other."[15]

We already know that *the Flash* invites Emily into an enchanting realm of unearthly beauty, but it also provides glimpses of heaven (2), the reality of God's great realm of love (2), and has resonant connections to "home" (6, 19). Intriguingly, *the Flash* in *Emily of New Moon* is not merely an experience of beauty or joy or heaven in her hard world, but is causative, producing emotional, vocational, and ethical responses in Emily. All throughout the Emily trilogy, *the Flash* spurs her on to creativity and writing. But it also provides courage and hope as she must face the death of her father and the development of her craft in a hostile family that initially rejects her and her calling (3). When she experiences *the Flash*, she tingles all over (6), becomes lost in "rapture and delight" (8), and is filled with a feeling of longing or homesickness (26) that can be so lovely and overwhelming that it brings a physical sensation of pain (1, 19). Moreover, the experience has a lasting effect after the feeling is gone: "The flash was gone, but its uplift remained,"[16] and Emily would bask in "the afterglow of the flash."[17]

THE FLASH AND MONTGOMERY'S AUTOBIOGRAPHY

Intriguingly, there is an intimate link between Montgomery's

15 Montgomery, 143.
16 Montgomery, 80.
17 Montgomery, 81.

own story and her fictional Emily. In a letter to Ephraim Weber, Montgomery comments on the link herself: "'Emily' will be, in a sense, more autobiographical than any of my other books. People were never right in saying I was 'Anne,' but, *in some respects*, they will be right if they write me down as *Emily*."[18] Scholars agree with Montgomery that *Emily of New Moon* is "literary autobiography" and Emily a stand-in for Maud.[19] The poem "The Alpine Path" is both the central organizing poem in *Emily of New Moon* and the name given to Montgomery's autobiography.[20] In her autobiography, Montgomery tells of how she found a poem and pasted it in her portfolio as "the key-note of my every aim and ambition."[21] In *Emily of New Moon*, the poem is sent to Emily and includes the same stanza as the autobiography:

> Then whisper, blossom, in thy sleep
> How I may upward climb
> The Alpine Path, so hard, so steep,
> That leads to heights sublime.
> How I may reach that far-off goal
> Of true and honoured fame
> And write upon its shining scroll
> A woman's humble name.[22]

This poetic discovery triggers *the Flash* in both Emily and her author, a mystical moment of thrilling clarity where her everyday life connects to an immortal or heavenly beauty, which she then works out as a vocation of writing: "When I read that *the Flash* came, and I took a sheet of paper . . . and I wrote on it: I, Emily Byrd Starr, do solemnly vow this day that I will climb the Alpine Path and write my name on the scroll of fame."[23] As Emily voiced her desire to be a poet, *the Flash* was attended by a "queer unreasonable conviction" as well as the rapturous "moment when soul seemed to cast aside the bonds of flesh and spring upward to the stars."[24] Emily experiences *the Flash* in composing poetry,[25] in receiving criticism of her writing,[26] and as

18 L. M. Montgomery, *After Green Gables*, 88.

19 Epperly, *Fragrance of Sweet-Grass*, 144; see also 144-46, 151, 222; see also Cowan, "Lucy Maud and Emily Byrd," 44; Whitaker, "Queer Children," 55.

20 *The Alpine Path* (1974) was originally published serially in *Everywoman's World*, June to November 1917.

21 Montgomery, *Alpine Path*, 10. The second volume, *Emily Climbs*, is a titular reference to the poem, which is referenced throughout the trilogy.

22 Montgomery, *Emily of New Moon*, 290; Montgomery, *Alpine Path*, 10.

23 Montgomery, *Emily of New Moon*, 290.

24 Montgomery, 80.

25 Montgomery, 173.

26 Montgomery, 333.

an impetus to write when the writing is hard.[27] "The Alpine Path" and its attendant experience of awe shapes both ambition and courage in Montgomery and Emily, providing hope and strength when perseverance is needed in a community where Emily's vocation as a writer is devalued and misunderstood – a parallel to Montgomery's experience growing up in Prince Edward Island.

The poem and the sense of awe and delight in writing clearly links the author with her fictional work; it is less clear to what degree Montgomery herself experienced *the Flash* or something like it. Explorations of Montgomery's religion or spirituality[28] are broad and varied, producing readings of Montgomery as a "romantic pantheist,"[29] a nature worshipper,[30] or an "iconoclastic but ultimately orthodox" Christian.[31] Using her own words, we see that Montgomery had experiences that integrated her religious and literary feelings. Montgomery remembers the thrill in her very soul when reciting Sunday School hymns that combined with her vivid imagination, which she called:

> [A] passport to the geography of Fairyland. In a twinkling I could – and did – whisk myself into regions of wonderful adventures, unhampered by any restrictions of time or place. Everything was invested with a kind of fairy grace and charm, emanating from my own fancy, the trees that whispered nightly around the old house where I slept, the woodsy nooks

27 Montgomery, *Emily's Quest*, 102.

28 John Sorfleet sees pagan resonances in Montgomery, "From Pagan to Christian," 175-83. Elizabeth Epperly writes about "Anne's struggle with romanticism," *Fragrance of Sweet-Grass*, 73. Simone Nelles and Gavin White talk about Montgomery's searching for mature faith while preserving tenderness of spirit, Nelles, "Pilgrimages," 105; White, "Religious Thought," 84. Blair and Thompson explore Montgomery's ecotheology in its time and place and today, "Mood of the Golden Age," 131-57. Julie Rae Golding Page develops Montgomery's "Christian understanding of the sacramental imagination," "Kindred to The Spirit," iii; cf. 30-33; 120-34. Deirdre Kessler writes about Montgomery's "numinous, profoundly spiritual dimension" in "Montgomery and the Creation of Prince Edward Island," 234. Mary Henley Rubio addresses the tensions that arise in Montgomery's Scotch Presbyterian roots, "Scottish-Presbyterian Agency," 89-105. Monika B. Hilder demonstrates that Montgomery's "subversion of conventional religion" is a conventional and imaginative exploration of faith, "Unholy Tendency to Laughter," 34. In dialogue with Rubio, Hilder suggests that "Like Anne's Romantic view of nature, Montgomery offers a dream of faith 'where we could drink of the wine of God's sunshine in his eternal communion that knows no restrictions or creeds,'" "Unholy Tendency," 40. More recent studies seek to resolve the tensions by shifting the conversation away from belief about doctrine or theological messaging in a didactic kind of way, to the question of spirituality.

29 Waterston, "Lucy Maud Montgomery," 15.

30 Blair and Thompson, "Mood of the Golden Age," 134.

31 Hilder, "Unholy Tendency," 34.

I explored, the homestead fields, each individualized by some oddity of fence or shape, the sea whose murmur was never out of my ears – all were radiant with "the glory and the dream." I had always a deep love of nature. A little fern growing in the woods, a shallow sheet of June-bells under the firs, moonlight falling on the ivory column of a tall birch, an evening star over the old tamarack on the dyke, shadow-waves rolling over a field of ripe wheat – all gave me "thoughts that lay too deep for tears" and feelings which I had then no vocabulary to express. . . . It goes without saying that I was passionately fond of reading.[32]

This sounds a great deal like *the Flash*: a version of Wordsworthian nature religion, fairyland, and spirituality used to describe bare glimpses behind a veil that separates our beautiful commonplace world and an enchanted realm beyond. At times, Montgomery's journal describes a *Flash*-like mysticism that likewise combines the natural, the literary, and the spiritual: "Then I came in, still tingling with the strange, wild, sweet life of the spirit, and wrote a chapter of my new serial – wrote it easily and pleasureably, with no flagging or halting. Oh, it is good to feel well and vivid and interesting and all alive!"[33]

Nearly twenty years later Montgomery repeats this final experiential description in *Emily Climbs* (1925) with "once more" added to the sentence, emphasizing a recovery from loss.[34] As time went on, after losing all of her friends and one child, and after the harrowing experiences of a decade-long publisher lawsuit and her husband's mental illness, these sorts of experiences would become rarer for Montgomery. There is one journal entry in 1933 that shows the religious dimensions of her experiences:

I dared to feel a little happy again – not only with outward happiness but with inward – my own strange happiness, as if I were drinking from some deep, still, lucent pool in my own soul. I don't know exactly what Jesus meant when he said, "The kingdom of heaven is within you," but I know what I mean by it – that very experience I had today – that realization of a life apart from this harried life of death – that sense of being One with Eternal Beauty itself. It is so long since I experienced it – and it was once a daily, hourly thing. I won courage from it – "the fountain of perpetual peace flows there."[35]

32 Montgomery, *Alpine Path*, 46-47.
33 20 Nov 1906 entry in Rubio and Waterston, *Selected Journals* 1: 324.
34 Montgomery, *Emily Climbs*, 151.
35 8 Nov 1933 entry in Rubio and Waterston, *Selected Journals* 4: 232.

As the Emily series progresses, so too the experiences of *the Flash* become rarer, to the point that Emily calls it a "miracle" when it happens. *The Flash*, "after these long months of absence" returned with her "old, inexpressible glimpse of eternity."[36] Suddenly, after a long spell of drought, Emily lifts up her heart and seizes her pen, knowing she can write and experience joy again. It is evident that *the Flash* is a rich and imaginative tool for structuring Emily's life as she is caught between cruelty and beauty, persecution and vocation. This dialectical, evasive, mercurial, almost fantastic experience of oneness with Eternal Beauty is an integrated view of the literary, the vocational, the natural, and the spiritual for Montgomery.[37] Deeply entrenched in natural and literary beauty, Montgomery notes that these moments are meant to be special:

> Such moments come rarely in any life, but when they do come they are inexpressibly wonderful – as if the finite were for a second infinity – as if humanity were for a space uplifted into divinity – as if all ugliness had vanished, leaving only flawless beauty. Oh – beauty – Emily shivered with the pure ecstasy of it. She loved it – it filled her being to-night as never before. She was afraid to move or breathe lest she break the current of beauty that was flowing through her. Life seemed like a wonderful instrument on which to play supernal harmonies.[38]

From this nighttime rapture Emily turns to prayer, "Oh, God, make me worthy of it – oh, make me worthy of it."[39] Her hope and prayer is that as a writer she could "dare try to carry some of the loveliness of that 'dialogue divine' back to the everyday world of sordid market-place and clamorous street," being to the world a kind of "high priestess of beauty."[40] In the character of Emily, Montgomery integrates the "mystic flash"[41] with the consecration of Emily's poetry,[42] communicating an authentic vision of how these glimpses of eternity provide deep sight for everyday life in the vocation of a writer. More than this important vocation, however, this experience

36 Montgomery, *Emily's Quest*, 102.

37 Montgomery scholarship has not treated *the Flash* as extensively as one might imagine. For exemplary work, see Epperly's *Fragrance of Sweet-Grass*, 151-66. See also Tausky, "L.M. Montgomery," 5-20; Klempa, "Passionate Blood," esp. 35-48; Gammel, "The Eros of Childhood," 97-118; Epperly, "Natural Bridge," 89-111, esp. 91; Munro, "Afterword," 357-61.

38 Montgomery, *Emily Climbs*, 177.

39 Montgomery, 177.

40 Montgomery, 177.

41 Montgomery, 54.

42 Epperly, *Fragrance of Sweet-Grass*, 151.

would be critical to what follows for Emily. After this "Sign of the Haystack" vision, Emily has an experience of miraculous second sight that, if she is faithful to it, could save a young boy's life. And as her tale continues, she will need the memory of these experiences and how they are implicated with her vocation as a writer to persevere through great trials and spiritual drought as she endeavors to climb the Alpine Path.

C.S. LEWIS AND *SEHNSUCHT*

A perceptive reader of C.S. Lewis will immediately see connections between Montgomery's idea of *the Flash* and Lewis's concept of *Sehnsucht*, which is worth briefly reviewing by considering Lewis's description of the phenomenon.

More than strict autobiography or life writing for the sake of the story, *Surprised by Joy* is a veritable autoethnographic philosophical treatment of the concept of *Sehnsucht*, or Joy. For Lewis, his experience of *Sehnsucht* "must have the stab, the pang, the inconsolable longing."[43] Resonant of Emily's experience of *the Flash*, Lewis talks of "longing,"[44] "stabs of Joy,"[45] and "the old thrill."[46] Though Lewis and Montgomery both use religious, mystical, and romantic terms to refer to *Sehnsucht/ the Flash*, Lewis does not connect it to his own religious experiences until much later in his life.[47] For Lewis, however, experiences of *Sehnsucht* came, as for Emily, in the experience of nature,[48] nostalgic beauty,[49] and literature[50] – and often in combination and experienced with physiological sensations such as tingling.[51] Like Montgomery, Lewis viewed the longing in Wordsworthian terms, each referring to Wordsworth's bittersweet lyric, "the Glory and the Dream."[52] Like Montgomery, Lewis found the experience somewhat elusive and untamable. The "stab of Joy" could not be summoned, and even

43 Lewis, *Surprised by Joy*, 72.

44 Lewis, 7, 16, 72, 166.

45 Lewis, 21, 72, 78, 130-1, 166-67, 228.

46 Lewis, 166-68.

47 Lewis spoke of MacDonald's *Phantastes* drawing him into an experience of holiness and baptizing his imagination, though he did not recognize it at the time; see *Surprised by Joy*, 179-81; *Great Divorce*, 66-67; *George MacDonald*, 33-34.

48 Lewis, *Surprised by Joy*, 7, 152-58, 166-68.

49 Lewis, 16.

50 Lewis, 16-18, 150-52, 163-64, 166-68.

51 "I accepted the invitation – threw myself open to this feathery, impalpable, tingling invitation. The rest of the journey I passed in a state which can be described only as joy," Lewis, "Hedonics," 53.

52 Montgomery, *Alpine Path*, 47; Lewis, *Surprised by Joy*, 166.

the name *Sehnsucht* was inadequate and was conceived late in Lewis's development. The early fragment now called "Early Prose Joy"[53] is, like its later published Christian version, an exploration of joy and longing, but Lewis does not yet use the word *Sehnsucht*[54] to describe the experience in technical ways. Indeed, Lewis does not even use "Joy" in that capitalized sense, but uses "longing" or, especially, "It." Even in *Surprised by Joy*, when Lewis casts his mind back to previous longings for *this* longing, he skirts around names at times: "Nature and the books now became equal reminders, joint reminders, of – well, of whatever it is."[55] And, as for both Emily and Montgomery, though foundational to his spiritual experience, the stabs of Joy would gradually become less central for Lewis.[56] In considering a Lewis-informed critique of Montgomery's *Flash* in the next section, we shall see that this decentering is essential to the ultimate fulfillment of the experience.

THINKING OF MONTGOMERY'S *FLASH* WITH LEWIS'S *SEHNSUCHT*

Though Montgomery's experience occurs largely in a fictional environment and, unlike Lewis, she does not critically or philosophically explore the implications of this experience, the parallels are obvious. Ultimately, however, Lewis came to believe that the point of his experience of Joy was never the experience itself, but that he was being drawn to the thing – the One – to which the experience pointed. This signpost nature of *Sehnsucht* is emphasized by many scholars[57] and is, in many ways, the critical thrust of *Surprised by*

53 Wade archive CSL MS-116 X. This copy of a handwritten manuscript is 62 pages. It was published in 2013; see Lewis and Lazo, "Early Prose Joy," 13-49. See also Lazo's "Introduction" in the same issue.

54 The first instance of Lewis's use of *Sehnsucht* is in his series of 1940 essays, "Christianity and Culture," 16, 21-23, and it is here that Lewis connects the historical experience of romantic longing with his own formation: "I have not (or not yet) reached a point at which I can honestly repent of my early experiences of romantic *Sehnsucht*. That they were occasions to much that I do repent, is clear; but I still cannot help thinking that this was my abuse of them, and that the experiences themselves contained, from the very first, a wholly good element. Without them my conversion would have been more difficult," 23. He returned to a use of *Sehnsucht* in a 10 Jun 1952 letter to Mary Van Deusen, in response to photos of vast American landscapes, *Letters* 3, 199.

55 Lewis, *Surprised by Joy*, 78. See Montgomery's 2 Jan 1905 journal entry, "two great refuges and consolations – the world of nature and the world of books," Rubio and Waterson, *Selected Journals* 1:301.

56 Lewis, *Surprised by Joy*, 78, 238.

57 See Kilby, *Christian World*, 18-19; Brown, *A Life Observed*, 129; Downing,

Joy. Although Lewis's philosophical arguments can be complex, there is an elegant set of narrative arcs in his conversion narrative. First, Lewis develops the theme of Joy-*Sehnsucht*-Longing in his childhood and young adulthood. As the experiences of Joy begin to fade as they also do in Emily's story, the narrative moves to his intellectual struggle toward theism and finally to the relational, philosophical, and self-reflective nature of his conversion to Christianity. Although he returns to themes of Joy, the centrality of that idea lessens as, indeed, the importance of his own self in the journey lessens. In the end, he describes his final conversion to Christianity rather briefly, almost as an afterthought, much like his final conversation on Joy. Lewis has already been devastated by Alexander's philosophy about two ways of seeing: "This discovery flashed a new light back on my whole life."[58] In his memoir, Lewis acknowledges that all his attending to the experience of Joy was a heuristic error. The idea is not to seek the longing or the stabs of Joy for their own sake. Instead, these physiological experiences were the "mental track left by the passage of Joy" – not the "wave but the wave's imprint on the sand."[59] The experiences of Joy were signposts to something greater – to Someone greater – which is why the experiences, when focused upon idolatrously, were inadequate:

> But what, in conclusion, of Joy? for that, after all, is what the story has mainly been about. To tell you the truth, the subject has lost nearly all interest for me since I became a Christian. I cannot, indeed, complain, like Wordsworth, that the visionary gleam has passed away. I believe (if the thing were at all worth recording) that the old stab, the old bittersweet, has come to me as often and as sharply since my conversion as at any time of my life whatever. But I now know that the experience, considered as a state of my own mind, had never had the kind of importance I once gave it. It was valuable only as a pointer to something other and outer.[60]

As the experiences of longing were essential to his conversion, Lewis is not denigrating them. Despite the similarities between the two, Montgomery lacks a similar clarity about the signpost role of *the Flash* in her experience. As noted, Montgomery felt a definite sense of relief when something of her old feelings returned to her. Emily,

Most Reluctant Convert, 131-33; Downing, *Region of Awe*, 33-35.

58 Lewis, *Surprised by Joy*, 219. See also, Lewis, "Meditation in a Toolshed," 212-15.

59 Lewis, *Surprised by Joy*, 219.

60 Lewis, 238.

too, experiences increasing desperation as the experience of *the Flash* is withdrawn from her. The second book, *Emily Climbs*, registers a kind of clinging to the experience: "that stab of poignant rapture she called 'the flash' – her priceless thing whose flitting, uncalculated moments were worth cycles of mere existence."[61] Though there are other moments of rapture, there is no record of *the Flash* returning after this midway point of the novel. Indeed, her gift of writing threatens to disappear as *the Flash* has, linked as they are in Emily's mind:

> There were no more jottings in her Jimmy-book, no further entries in her journal, no new stories or poems. The flash never came now – never would come again. There would never again be wonderful little secret raptures of insight and creation which no one could share. Life had grown thin and poor, tarnished and unlovely. There was no beauty in anything.[62]

The final book of the trilogy, *Emily's Quest* (1927), begins with the same sentiment of loss. Later, Emily is relieved to experience the miraculous return of *the Flash*. Sensing that she will again lose *the Flash* as she grows old, Emily mourns and turns to Wordsworth for hope: "Nature never did betray the heart that loved her."[63] Gaining perspective from the poetic promise, Emily "felt suddenly that some old gladness was yet waiting for me, just around the curve of the hill."[64]

Ultimately, Emily finds her authorial voice again and rediscovers her place within the world she inhabits. The lesson that Lewis learned, however – the discovery that *the Flash*/*Sehnsucht* is a bittersweet signpost to something greater – is never explicitly clear to Emily. Although Emily in some sense knows that *the Flash* is "a pointer to something other and outer," her focus is on the vocational and existential result and numinous experience. Emily wants *the Flash* so that she can write and so she can feel that supernal moment of the poignant rapture. In longing for the experience of *the Flash*, however, Emily misses the critical lesson before her. *The Flash* has, from the beginning, pointed elsewhere, to eternity, to life beyond her existence, to a world of wondrous beauty, to an enchanted realm beyond, and "inexpressible glimpse of eternity"[65] and a "tantalizing glimpse of a world beyond."[66] Moreover, according to her father's early lesson, *the Flash* points to a God who is all love as well as to the realm where

61 Montgomery, *Emily Climbs*, 173.
62 Montgomery, 279.
63 Montgomery, *Emily's Quest*, 158.
64 Montgomery, 158.
65 Montgomery, 102.
66 Epperly, *Fragrance of Sweet-Grass*, 151.

she believes her father dwells, "just beyond that wavering curtain."[67] Confirming that *the Flash* is meant to take Emily out of herself, it is when she is attending to other things – the Wind Woman, nature, lines of poetry, evocative words – that *the Flash* comes upon her. Anyone who has experienced separation, writer's block, or a spiritual desert can empathize with Emily's loss of experience and the heartbreaking dryness it brings. However, at least from a Lewisian perspective, for her to focus on her experience of *the Flash* is a critical error – the wrong way of seeing, the confusion of the signpost for the city, the temple for the god.

While Emily never comes to understand this lesson fully, it appears to be embedded in the narrative, suggesting that Montgomery herself does understand it. Perhaps *the Flash* fades in the story not because Emily is aging but because she is attending to the wrong thing, wanting *the Flash* for its own sake. In any case, if Emily's *Flash* is the deep, resonant, "mental tracks" of the Creator drawing people to God – as the text suggests it is and as Lewis discovered was the nature of his *Sehnsucht* – Emily would have ultimately found that *the Flash* was more important for where it led her than for the rapture of the experience itself. To the degree that the resolution of the series is a restoration of Emily's vocation as a writer rather than as a mystic, Montgomery implicitly confirms this principle that is central to Lewis's philosophy.

CONCLUSION: A LIMITATION IN C.S. LEWIS'S UNDERSTANDING OF *SEHNSUCHT*

Though there are no historical links between their work, the resonances between Montgomery's "Flash" and Lewis's "Joy" are striking. The source of *the Flash/Sehnsucht* with its stabs of Joy and rapturous longing may be different for each author. However, the experiences overlap to a remarkable degree, particularly in areas of literature, nature, nostalgia, and a connection to the divine. Lewis's philosophical journey of *Sehnsucht* offers structured ways of thinking about Montgomery's *Flash*, suggesting that Emily needed to experience a loss of *the Flash* – in the pattern of *The Great Divorce*[68] and Lewis's experience of *Sehnsucht* – for its mystical-relational-vocational aspects to be reborn in her. As Lewis's structured thinking about *Sehnsucht* suggests greater potential depth for Montgomery, so, too,

67 Montgomery, *Emily of New Moon*, 18.
68 See Dickieson, "Die Before You Die," 32-45.

Montgomery's narratives of *the Flash* suggest possibilities that may have filled out Lewis's sometimes mercurial philosophy of *Sehnsucht*.

In conclusion, I would like to suggest one way Emily's experience of *the Flash* could have enhanced Lewis's self-understanding and clarified his literary impact. In particular, Montgomery was much more in tune with the effective as well as the affective aspect of the numinous experience. For her it was not simply the physiological/emotional experience of Joy and longing or an encounter with the sublime, but it had the effect of leading Emily to pick up her pen and write. If there is one area that is unsatisfying in Lewis's memoir, it is his insufficient attention to telling the story of his own discovery of his gifts as a writer, his development as a writer, and the degree to which that was seen by him as a Christian vocation.

Following Narnia, Lewis provided some essays about the impetus behind his creative project,[69] but he does not provide the kind of sophisticated consideration about the writing vocation of which he was obviously capable. In the memoir that the Narnian himself put before the public to describe "The Shape of My Early Life," he claims that the literary career that ultimately produced about 20,000 pages developed in his childhood because he could not bend the upper joint on his thumb. Being clumsy, he naturally turned to literature.[70] Does any reader find this a sufficient or even credible snapshot of what was Lewis's lifelong dream and fulfilled vocation? In a late-in-life interview, Lewis admitted that a writer must be strongly moved to write well. Indeed, the need to write is like a lust waiting to be fulfilled or a scratch that needs to be itched.[71] "Writing," Lewis said, "comes as a result of a very strong impulse, and when it does come, I, for one, must get it out."[72] I don't doubt that Lewis is telling the truth of his own experience, but was there really no connection between this strong impulse and his spirituality or sense of vocation?

Granted Lewis's humility often caused him to undervalue his skills as a writer. Still we must recognize the greatness of his literary achievement in multiple genres. He wrote importantly and

69 E.g., the numerous essays in Lewis, *Of Other Worlds*, including "On Three Ways of Writing for Children," 22-34; "Sometimes Fairy Stories May Say Best What's to be Said," 35-38; "It All Began With a Picture," 42; "A Reply to Professor Haldane," 74-85; and parts of "Unreal Estates," 86-96 and "On Stories," 3-21.

70 Lewis, *Surprised by Joy*, 12. Lewis continues to give this explanation of his vocation in letters, e.g., the 6 Dec 1960 letter to a Miss Lee, *Letters* 3, 1213-14.

71 Montgomery uses similar language: "The 'itch for writing' – I forget how it is spelled or I would write it in Latin – is upon me to-night," Rubio and Waterston, *Selected Journals* 1: 155.

72 Lewis, "Cross-Examination," 258.

metacritically about literary history, literary criticism, apologetics, reading, teaching, the task of culture formation, and many other topics. As someone who appreciates Lewis's skill with the pen and is pursuing a theologically coherent understanding of my own vocation as writer and scholar, I find it puzzling that Lewis did not spend more time reflecting on his literary formation as a Christian vocation and the degree to which his experience of *Sehnsucht*[73] formed his ethical response to the numinous. This integration of the numinous and the vocational is Emily Byrd Starr's strength. Though she could not fully visualize the signpost experience of *the Flash* as it pointed to otherness, she knew that it was bound up with the subcreative act, with the project of poetic and imaginative literature, a particular application to the poignant rapture that was her rare gift – and a gift she shared with C.S. Lewis. Though unmet conversational partners, Montgomery strengthens our understanding of Lewis as he sharpens our vision of Montgomery.

73 Lewis, *Surprised by Joy*, 130.

WORKS CITED

Blair, Kirstie, with William V. Thompson. "The Mood of the Golden Age: Paganism, Ecotheology and the Wild Woods in L.M. Montgomery's Anne and Emily Series." *Literature and Theology* 30, no. 2 (2016): 131-47.

Brown, Devin. *A Life Observed: A Spiritual Biography of C. S. Lewis.* Grand Rapids: Brazos Press, 2013.

Cowan, Ann S. "Canadian Writers: Lucy Maud and Emily Byrd." In *L.M. Montgomery: An Assessment*, edited by John Robert Sorfleet, 42-49. Guelph, ON: Canadian Children's Press, 1976.

Dickieson, Brenton D.G. "'Die Before You Die': St. Paul's Cruciformity in C.S. Lewis's Narrative Spirituality." In *Both Sides of the Wardrobe: C.S. Lewis, Theological Imagination, and Everyday Discipleship*, 32-45. Eugene OR: Resource Publications, 2015.

Downing, David C. *Into the Region of Awe: Mysticism in C. S. Lewis.* Downers Grove, IL: IVP, 2005.

---. *The Most Reluctant Convert: C. S. Lewis's Journey to Faith.* Downers Grove, IL: IVP, 2002.

Epperly, Elizabeth R. *The Fragrance of Sweet-Grass.* Toronto: University of Toronto Press, 1992.

---. "Natural Bridge: L.M. Montgomery and the Architecture of Imaginative Landscapes." In *L.M. Montgomery and the Matter of Nature(s)*, edited by Rita Bode and Jean Mitchell, 89-111. Kingston, ON: McGill-Queen's University Press, 2018.

Gammel, Irene. "The Eros of Childhood and Early Adolescence in Girl Series: L.M. Montgomery's Emily Trilogy." In *Windows and Words: A Look at Canadian Children's Literature in English*, edited by Aïda Hudson and Susan-Ann Cooper, 97-118. Ottawa: University of Ottawa Press, 2003.

Golding Page, Julie Rae. Kindred to The Spirit: A Christian Perspective on The Imagination as Portrayed in L.M. Montgomery's 'Anne of Green Gables' Series. M.A. Thesis, Regent College, Vancouver, 2000.

Hilder, Monika B. "'That Unholy Tendency to Laughter': L.M. Montgomery's Iconoclastic Affirmation of Faith in *Anne of Green Gables.*" *Canadian Children's Literature/ Littérature Canadienne pour la Jeunesse* 113-14 (2004): 34-55.

Hooper, Walter, ed. *The Collected Letters of C.S. Lewis: Vol. 3. Narnia, Cambridge, and Joy 1950-1963.* Edited by Walter Hooper. New York: HarperSanFrancisco, 2007.

Kessler, Deirdre. "L.M. Montgomery and the Creation of Prince Edward Island." In *L.M. Montgomery and Canadian Culture*, edited by Irene Gammel and Elizabeth Epperly, 229-34. Toronto: University of Toronto Press, 1999.

Kilby, Clyde S. *The Christian World of C. S. Lewis.* Grand Rapids: Eerdmans, 1964.

Klempa, Mary-Margaret. "Passionate Blood, Puritan Conscience: An Intertextual Study of the Private and Public Works of L.M. Montgomery." MA Thesis, Concordia University, Montreal, 1998.

Lazo, Andrew. "'Early Prose Joy': A Brief Introduction." *SEVEN* 30 (2013): 5-12.

Lewis, C.S. *The Abolition of Man, or Reflections on Education with Special Reference to the Teaching of English in the Upper Forms of Schools.* New York, Touchstone, 1996.

---. *The Allegory of Love: A Study in the Medieval Tradition.* Oxford: Oxford University Press, 1958.

---. "Christianity and Culture." In *Christian Reflections*, 12-36. Edited by Walter Hooper. Grand Rapids: Eerdmans, 1967.

---. "Cross-Examination." In *God in the Dock: Essays on Theology and Ethics*, 258-67. Edited by Walter Hooper. Grand Rapids: Eerdmans, 1970.

---. "*De Audiendis Poetis.*" In *Studies in Medieval and Renaissance Literature*, 1-17. Edited by Walter Hooper. Cambridge: Canto, 1998.

---. "*De Descriptione Temporum.*" In *Selected Literary Essays*, 1-14. Edited by Walter Hooper. Cambridge: Canto

Classics, 2013.

---. "Democratic Education." In *Present Concerns*, 32-36. Edited by Walter Hooper. New York: A Harvest Book, 1986.

---. *An Experiment in Criticism*. Cambridge: Canto Classics, 2013.

---. "The Genesis of a Medieval Book." In *Studies in Medieval and Renaissance Literature*, 18-40. Edited by Walter Hooper. Cambridge: Canto, 1998.

---. *The Great Divorce: A Dream*. London: Geoffrey Bles, 1945.

---. "Hedonics." In *Present Concerns*, 50-55. Edited by Walter Hooper. New York: A Harvest Book, 1986.

---. "The Idea of an 'English School.'" *Image and Imagination: Essays and Reviews*, 3-20. Edited by Walter Hooper. Cambridge: Cambridge University Press, 2013.

---. "Interim Report." In *Present Concerns*, 92-99. Edited by Walter Hooper. New York: A Harvest Book, 1986.

---. "Is English Doomed?" In *Present Concerns*, 27-31. Edited by Walter Hooper. New York: A Harvest Book, 1986.

---. "Learning in War-Time." In *Fern-seed and Elephants, And Other Essays on Christianity*, 26-38. Edited by Walter Hooper. New York: Fontana, 1975.

---. "Meditation in a Toolshed." In *God in the Dock: Essays on Theology and Ethics*, 212-15. Edited by Walter Hooper. Grand Rapids: Eerdmans, 1970.

---. *Of Other Worlds: Essays and Stories*. Edited by Walter Hooper; New York: Harcourt, 1994.

---. "On Reading 'The Faerie Queene." In *Studies in Medieval and Renaissance Literature*, 146-48. Edited by Walter Hooper. Cambridge: Canto, 1998.

---. "On the Reading Old Books." In *God in the Dock: Essays on Theology and Ethics*, 200-7. Edited by Walter Hooper. Grand Rapids: Eerdmans, 1970.

---. "Our English Syllabus." *Image and Imagination: Essays and Reviews*, 21-33. Edited by Walter Hooper. Cambridge:

Cambridge University Press, 2013.

---. *Perelandra*. New York: Macmillan, 1965.

---. *Selected Literary Essays*. Edited by Walter Hooper. Cambridge: Canto Classics, 2013.

---. *Surprised by Joy: The Shape of My Early Life*. New York: Harcourt, Brace and Co., 1956.

---. *That Hideous Strength*. New York: Collier Books, 1965.

Lewis, C.S., ed. *George MacDonald: An Anthology*. London: Fount, 1983.

Lewis, C.S. and Andrew Lazo, ed. "'Early Prose Joy': C.S. Lewis's Early Draft of an Autobiographical Manuscript." *SEVEN* 30 (2013): 13-49.

Lewis, C.S. and E.M.W. Tillyard. *The Personal Heresy: A Controversy*. New York: HarperOne, 2017.

Montgomery, L.M. *After Green Gables: L.M. Montgomery's Letters to Ephraim Weber, 1916-1941*. Edited by Hilda Froeses Tiessen and Paul Gerard Tiessen. Toronto: University of Toronto Press, 2006.

---. *The Alpine Path: The Story of My Career*. Don Mills, ON: Fitzhenry & Whiteside, 1974.

---. *Anne of Avonlea*. Toronto: Seal Books, 1908.

---. *Anne of Green Gables*. Toronto: Seal Books, 1909.

---. *Anne of Ingleside*. Toronto: Seal Books, 1939.

---. *Anne of the Island*. Toronto: Seal Books, 1915.

---. *The Blythes are Quoted*. Toronto: Viking Canada, 2009.

---. *Emily Climbs*. Toronto: Seal Books, 1983.

---. *Emily of New Moon*. Toronto: Seal Books, 1983.

---. *Emily's Quest*. Toronto: Seal Books, 1983.

Montgomery, Lucy Maud. *My Dear Mr. M: Letters to G.B. MacMillan from L.M. Montgomery*. Edited by Francis W.P. Bolger and Elizabeth R. Epperly. Oxford University Press, 1992.

Munro, Alice. Afterword to *Emily of New Moon* by L.M. Montgomery, 357-61. Toronto: McClelland and

Stewart, 2007.

Nelles, Simone. "Pilgrimages in a Land of Penumbra: A Critical Reading of the Religious Theme and Its Complex Variations in Lucy Maud Montgomery's Approaches toward Faith." M.A. Thesis, Johannes Gutenberg University of Mainz, Germany, 1998.

Rubio, Mary Henley. "L.M. Montgomery: Scottish-Presbyterian Agency in Canadian Culture." In *L.M. Montgomery and Canadian Culture*, edited by Irene Gammel and Elizabeth Epperly, 89-105. Toronto: University of Toronto Press, 1999.

Rubio, Mary and Elizabeth Waterston, eds. *Selected Journals of L.M. Montgomery: Volume I: 1889-1910*. Toronto: Oxford University Press, 1985.

---. *Selected Journals of L.M. Montgomery: Volume IV: 1929-1935*. Toronto: Oxford University Press, 1998.

Sorfleet, John. "From Pagan to Christian: The Symbolic Journey of Anne of Green Gables." In *Windows and Words: A Look at Canadian Children's Literature in English*, edited by Aïda Hudson and Susan-Ann Cooper, 175-83. Ottawa: University of Ottawa Press, 2003.

Tausky, Thomas E. "'L.M. Montgomery and 'The Alpine Path, so hard, so steep,'" *Canadian Children's Literature/ Littérature canadienne pour la jeunesse* 30 (1983): 5-20.

Waterston, Elizabeth "Lucy Maud Montgomery: 1874-1942." In *L.M. Montgomery: An Assessment*, edited by John Robert Sorfleet, 9-26. Guelph, ON: Canadian Children's Press, 1976.

Whitaker, Muriel A. "'Queer Children': L.M. Montgomery's Heroines." In *L.M. Montgomery: An Assessment*, edited by John Robert Sorfleet, 50-59. Guelph, ON: Canadian Children's Press, 1976.

White, Gavin. "The Religious Thought of L.M. Montgomery." In *Harvesting Thistles: The Textual Garden of L.M. Montgomery: Essays on Her Novels and Journals*, edited by Mary Henley Rubio, 84-88. Guelph: Canadian Children's Press, 1994.

Cosmic Horror vs. Cosmic Redemption: C.S. Lewis and H.P. Lovecraft

by John Stanifer

John is an unabashed geek who enjoys the smell of books and coffee, preferably both at the same time. He obtained his BA in English from Indiana University and his MA in the same field from Morehead State University. John discovered the work of C.S. Lewis as a fourth grader when he inherited his dad's Collier paperback edition of the Narnia books. It would be another seven years or so, with the release of Peter Jackson's adaptation of *The Fellowship of the Ring*, before he found Tolkien.

In *The Magician's Nephew*, C.S. Lewis describes the origin of the White Witch, Jadis. In what is arguably one of the darkest sections of the Narnia stories, Digory and Polly visit the dead city of Charn and are exposed not only to its disturbing air but also to its dark history. In turn, readers learn just enough to give them an idea of the destruction Charn and its inhabitants, especially Jadis, are capable of producing.

Readers of influential horror writer H.P. Lovecraft will find that a close examination of Lewis's descriptions in *The Magician's Nephew* reveals several intriguing similarities between Charn and the city of R'lyeh, which is described in Lovecraft's popular short story "The Call of Cthulhu." R'lyeh, like Charn, is home to a slumbering power just waiting for some hapless soul to wake up said power and unleash its reign of terror.

From this initial similarity between the works of two major figures in speculative fiction, it is tempting to wonder what other comparisons and contrasts between the two writers might be significant. Most readers are familiar with C.S. Lewis, the intellectual atheist who became one of the foremost apologists for popular Christianity during World War II and has since inspired millions with his stories of a land of talking animals under the benign lordship of Aslan, the thinly-veiled Christ figure. Lovecraft, on the other hand, was a lifelong atheist credited for popularizing the peculiar sub-genre called "cosmic horror," in which humanity is depicted as the victim of an indifferent and frequently hostile universe peopled by a bizarre array of "elder gods" and monstrous abominations.

Lewis left readers of his Narnia books with a hopeful vision of

the afterlife in which Aslan the lion leads his people into "the Great Story, which no one on earth has read: which goes on forever: in which every chapter is better than the one before" (*The Last Battle* 184). In the end, all the malice of Jadis and her evil allies fails to keep humanity and its fantastic friends from their final redemption. Lovecraft left readers with a far bleaker vision of the future, one that often ended with his characters driven to madness or suicide, as with the narrator of "Dagon," an early story penned during the Great War: "I cannot think of the deep sea without shuddering at the nameless things that may at this very moment be crawling and floundering on its slimy bed. . . . I dream of a day when they may rise above the billows to drag down in their reeking talons the remnants of puny, war-exhausted mankind" (8-9).

These two passages illustrate a fundamental difference between the worldviews of the two writers. One left the world a frightening body of work that often envisions the eventual enslavement and likely destruction of the human race at the hands of ancient entities from distant corners of the known universe. The other left a picture of hope for the renewal of creation and the healing of the corruption in the hearts of fallen creatures. Through a brief look at the life and fiction of Lewis and Lovecraft, focusing specifically on the Narnia books and the stories of the "Cthulhu Mythos," it will become clear that although both authors dealt with similar themes using similar imagery, the tone and narrative arc of their respective fictions gave voice for two very different, ultimately irreconcilable, worldviews.

While individual detailed studies of Lewis and Lovecraft are everywhere, and while each author has inspired conferences throughout the globe, comparative studies of these two fantasists are rare. One exception is Dale Nelson's essay featured in the July/August 2017 edition of *CSL: The Bulletin of the New York C.S. Lewis Society*. Although not a detailed study, Nelson's article suggests some of the possibilities that a comparative study might offer. Nelson summarizes two Lovecraft stories, "At the Mountains of Madness" and "The Shadow Out of Time," noting that both present pessimistic versions of the distant past and distant future of the human race, with the protagonist of the latter story discovering that "human beings are fated to be supplanted by a 'mighty beetle civilisation'" (Nelson 9). According to Nelson, "Both of these stories are presented as true accounts that effect a radical reassessment of human nature and our place in the universe" (9). Lewis, Nelson argues, takes a different approach in *Out of the Silent Planet* and his incomplete story, *Dark*

Tower. "In contrast to the Lovecraftian outlook, the ancient records and the scholar-protagonist's experiences make manifest a glorious creation – if, also, a dreadful peril" (9). Where Lovecraft's characters see only inevitable doom, Lewis's see the splendor of a creation which, though full of danger, is ultimately good and fated for redemption rather than destruction.

There is little question that both Lewis and Lovecraft expressed sentiments in their literary creations that reflected their actual beliefs. In 1922, Lovecraft published "A Confession of Unfaith," an essay in which he described in detail his spiritual and philosophical journey. He says that his skepticism began to manifest itself at around the age of five when he questioned whether, if Santa Claus was a myth, why God couldn't "equally [be] a myth" (2). Though he attended the children's Sunday School at the First Baptist Church in Providence, Rhode Island, he raised so many doubts and asked so many questions in class that he was finally "permitted to discontinue attendance" (2). He concludes the essay by summarizing the core of his present philosophy: "I can at last concede willingly that the wishes, hopes, and values of humanity are matters of total indifference to the blind cosmic mechanism. Happiness I recognise as an ethical phantom whose simulacrum comes fully to none and even partially to but few, and whose position as the goal of all human striving is a grotesque mixture of farce and tragedy" (7).

Readers familiar with Lewis's spiritual journey might be tempted to call "A Confession of Unfaith" an anti-*Surprised by Joy*, since both works suggest deep similarities between the two authors but end with very different outcomes. Throughout *Surprised by Joy*, Lewis alludes to his love of northern myth. His early exposure to stories of Balder and the other Norse deities gave him a sense of spiritual longing that would be fulfilled in a robust Christian faith later in life (18-19). To a point, Lovecraft had a similar experience with the gods of Greece and Rome: "When about seven or eight I was a genuine pagan, so intoxicated with the beauty of Greece that I acquired a half-sincere belief in the old gods and Nature-spirits" ("Confession" 3). He even once convinced himself he had spotted dryads and satyrs dancing in the woods and remembered the moment as "a kind of 'religious experience' as true in its way as the subjective ecstasies of any Christian" (3). While Lovecraft's childlike faith in these classical myths would evolve into the materialism he asserts at the end of the essay, he continued to use supernaturalism as a storytelling device in his adult writings, including demons, gods, and monsters of various

sorts in his stories.

Before his conversion, the agnostic C. S. Lewis would tell his friend J.R.R. Tolkien that he believed myths were "lies and therefore worthless, even though breathed through silver" (Carpenter 42-43). This is comparable to the sentiment expressed by Lovecraft in a 1932 letter to Robert E. Howard, creator of *Conan the Barbarian*: "The myths, conclusively, are false – being natural products of known forms of illusion" (37). However, although Lovecraft would never recant his skepticism of Christianity and held a lifelong belief that myths are necessarily false in any historical sense, Lewis – through the intervention of Tolkien and other friends from his Oxford circle – came to believe that myths are a vehicle to reality, and at least in the case of Christ, can also be verified in history (*Letters* 976-77). He states this most profoundly in his essay "Myth Became Fact":

> The heart of Christianity is a myth which is also a fact. The old myth of the Dying God, *without ceasing to be myth,* comes down from the heaven of legend and imagination to the earth of history. It *happens* – at a particular date, in a particular place, followed by definable historical consequences. We pass from a Balder or an Osiris, dying nobody knows when or where, to a historical Person crucified (it is all in order) *under Pontius Pilate.* By becoming fact it does not cease to be myth: that is the miracle. (66-67)

Here, Lewis celebrates all the other systems of "myth" as signs pointing to what he saw as their final historical fulfillment in Christ. This could not be further from what Lovecraft would argue in 1931, just a few years before his untimely passing:

> To think clearly about the cosmos in the light of contemporary information is to abandon any possibility of believing in the fantastic and capricious orthodoxies of yesterday – be they Buddhistic, Judaic, Christian, Hindoo, Mahometan, or any other brand. More liberal wish-delusions . . . will undoubtedly last for several generations more – or until the race has lost that emotional dependence on mythic values . . . which the earlier centuries of primitive ignorance and fanciful speculation have bred into it. (qtd. in Joshi, *Against Religion* 40)

How then did Lewis and Lovecraft, who shared a mutual interest in myth as children but adopted such opposing perspectives as adults, communicate the fruit of their reflections in their respective fictions? It is curious to note that both Lewis and Lovecraft attributed the genesis of their most significant literary works to recurring dreams. In

1896, the year he turned six, Lovecraft began to be troubled by what he referred to as "night-gaunts," dreams of grotesque creatures that he would describe years later as "black, lean rubbery things with bared, barbed tails, bat-wings, and *no faces at all*" (qtd. in Joshi, *H.P. Lovecraft* 20-21). As W. Scott Poole has noted, Lovecraft's monsters are not at all like what came before: "Lovecraft created horror tales without precedent and monsters without antecedent. . . . These Things came to him in dreams just as now – after we've read him – they come to us in ours" (*In the Mountains of Madness* 8). Lovecraft biographer S.T. Joshi adds, "It is already evident that [Lovecraft's] boyhood dreams contain many conceptual and imagistic kernels of his mature tales: the cosmic backdrop; the utterly outré nature of his malignant entities . . . and the helpless passivity of the protagonist-victim, at the mercy of forces infinitely more powerful than himself" (*H.P. Lovecraft* 21).

Just as the creatures in Lovecraft's childhood nightmares were a foreshadowing of Cthulhu and the other monstrosities he would invent to embody the existential despair of his protagonists, so Lewis claimed that some of the key figures of his mythology – including the Christ-lion Aslan himself – appeared to him in a series of dreams or "pictures." Lewis said his method of storytelling was to "assemble the pictures that appeared in his mind" (Sayer 311). He carried an image of "a faun carrying parcels and an umbrella in a snowy forest" in his imagination for over thirty years before he started writing down the story that would become *The Lion, the Witch, and the Wardrobe* (Sayer 312). Sayer writes, "After [Lewis] had written a good deal of the book, he got the idea of the lion Aslan, who 'came bounding into it.' [Lewis] had been 'having a good many dreams of lions about that time . . . [and] once he [Aslan] was there he pulled the whole story together, and soon he pulled the other six stories in after him'" (312).

Leslie Klinger notes that "Dagon" is the "earliest [Lovecraft story] to contain any elements of what eventually became known as the Cthulhu Mythos" (3). This makes "Dagon" a significant starting point for understanding Lovecraft's worldview and his contribution to the modernist mindset that followed the devastation of the Great War. The second paragraph of this story, written in 1917, makes the setting clear: "The great war was then at its very beginning, and the ocean forces of the Hun had not completely sunk to their later degradation" (3). While the war serves mainly as a backdrop to the events of the story, it is still a crucial factor in the mood Lovecraft builds. W. Scott Poole laments that critics have failed to consider Lovecraft's "willingness to engage directly with the destructive and horrific possibilities of the

twentieth century presaged by World War I and [fail] to see that his deep pessimism emerged from historical concerns blended with his sense of 'cosmic dread'" ("Historicizing Lovecraft" 38). The sense of dread that Poole identifies is powerfully felt in the previously-cited passage from "Dagon," in which the narrator anticipates a day when "nameless things" that lie at the bottom of the ocean "may rise above the billows to drag down in their reeking talons the remnants of puny, war-exhausted mankind" ("Dagon" 8-9). Poole suggests, "We are given little reason . . . to care for 'war-exhausted mankind' and its fate and it's suggested that such dread in the face of ultimate human extinction is both appropriate and simply realistic. Human history stands as an ongoing monument to its own end" ("Historicizing Lovecraft" 44).

Another story, "The Call of Cthulhu" (1928), develops these themes more fully. Its narrator describes his attempts to trace the origins of the mysterious Cthulhu cult using notes left behind by his great-uncle, a professor of Semitic Languages. What is most compelling is the story's description of the city of R'lyeh, buried beneath the Pacific Ocean. It is a "Cyclopean" city, a city "of titan blocks and sky-flung monoliths, all dripping with green ooze and sinister with latent horror" (128). R'lyeh is where the so-called "Great Old Ones" are said to "lay in stone houses . . . preserved by the spells of mighty Cthulhu for a glorious resurrection when the stars and the earth might once more be ready for them" (142). The catch is that these Great Old Ones have no power to restore themselves but are forced to depend on others: "But at that time some force from outside must serve to liberate Their bodies. The spells that preserved Them intact likewise prevented Them from making an initial move, and They could only lie awake in the dark and think whilst uncounted millions of years rolled by" (142).

In *The Magician's Nephew*, C.S. Lewis provides Jadis (known in *The Lion, the Witch, and the Wardrobe* as the White Witch) with an origin story that is eerily similar to Cthulhu's. Cthulhu's race is said to have once "ruled on the earth" from "great cities" but "[t]hey all died vast epochs of time before men came" (141). When Digory and Polly arrive in Charn, everything they see is colored by the light of a dying red sun (58-59), suggesting that the world Jadis inhabits is probably billions of years old, a timeframe reminiscent of the "uncounted millions of years" referenced by Lovecraft's narrator and the suggestion that the Great Old Ones have their own history that vastly predates their arrival on Earth. Digory and Polly, the children in Lewis's story, are both impressed and frightened by the evidence of the once-great civilization around them. When Jadis finally enters

the picture, she speaks of "the creaking of wheels, the cracking of the whips and the groaning of slaves, the thunder of chariots, and the sacrificial drums beating in the temples" (59). Her words evoke a civilization based on oppression and human sacrifice, qualities very much like that of Lovecraft's Great Old Ones, whose followers will happily slaughter innocent people if it serves the whims of their tyrannical masters (139-40).

Both Jadis and Cthulhu are asleep in their respective city-tombs, unable to carry out their plans for conquest until stirred into life by blundering outsiders. Digory, so curious to see what will happen when he strikes the bell hanging from the pillar in front of Jadis, winds up waking her and unwillingly leading her back to London. Eventually, Lovecraft's narrator learns that it was not actually Cthulhu's followers who woke Cthulhu from his rest; it was a group of sailors who stumbled on the city of R'lyeh after it rose from the bottom of the ocean. One of them pushes on the door to Cthulhu's tomb, and the tentacle-faced god crawls out in pursuit of the sailors and their ship. Just as R'lyeh is initially buried underwater, so the children in *The Magician's Nephew* can only reach Charn after entering the Wood Between the Worlds and jumping into a lake. While it is certainly suggested that Jadis and Cthulhu have plenty of willing followers, in the end it is curious children and unwitting sailors who accidentally wind up unleashing the elder gods.

The significant difference, of course, is what happens after these evil forces come into play. Although Lewis and Lovecraft provide similar origin and awakening stories for Jadis and Cthulhu, what happens afterwards is radically different (and profoundly relevant to the worldviews of the respective authors). In *The Lion, the Witch, and the Wardrobe*, Jadis is allowed a temporary victory over Narnia and the forces of Aslan when she puts the land under her seemingly eternal winter and kills Aslan with her knife on the Stone Table. But the narrator's description of the aftermath of the battle with Jadis's army says it all: "The battle was all over a few minutes after their arrival. Most of the enemy had been killed in the first charge of Aslan and his companions; and when those who were still living saw that the Witch was dead, they either gave themselves up or took to flight" (175). Aslan rises to life, Jadis is killed, and her army is routed.

In "The Call of Cthulhu," most of the sailors who accidentally wake Cthulhu from his sleep are immediately killed. Two manage to escape to their ship, but one of those two dies of madness some days later, leaving just one sailor alive to retell the encounter. Although the

lone survivor succeeds in injuring Cthulhu by ramming him with the ship, Cthulhu instantly recovers from the injury and – unlike Jadis – presumably lives to conquer the human race another day. In the story's final paragraph, the narrator concludes with a series of ominous musings: "Cthulhu still lives, too, I suppose. . . . Who knows the end? What has risen may sink, and what has sunk may rise. Loathsomeness waits and dreams in the deep, and decay spreads over the tottering cities of men. A time will come – but I must not and cannot think" (157)!

Is there any evidence that Lewis knew of Lovecraft's work or vice versa? So far, nothing has been discovered to prove that either was aware of the other, but Nelson speculates that Lewis came across Lovecraft in some of the American science fiction magazines which published Lovecraft's work. While this is a reasonable assumption, it is not proof.

Fortunately, there is at least one small thread that connects Lovecraft with the Inklings: a letter Lovecraft wrote to August Derleth in the mid-1930s concerning Lovecraft's opinion of the novels of Lewis's friend and fellow Inkling, Charles Williams:

> He [Williams] is trying to illustrate human nature through symbols & turns of idea which possess significance for those taking a traditional or orthodox view of man's cosmic bearings. There is no true attempt to express the indefinable feelings experienced by man in confronting the unknown. . . . To get a full-sized kick from this stuff one must take seriously the orthodox view of cosmic organisation – which is rather impossible today. (qtd. in Joshi, *I Am Providence* 878)

Such remarks demonstrate the gulf between Lovecraft's materialism and the supernaturalism shared by most of the Inklings. It is curious that Lovecraft says the orthodox view of "cosmic organisation" is impossible to take seriously, given that Williams himself obviously took it very seriously, as did his fellow Inklings who gathered twice a week in Oxford during the very decade Lovecraft penned his remarks.

From "Dagon" to "The Call of Cthulhu" and from *The Magician's Nephew* to *The Last Battle*, both authors demonstrate a consistency of outlook that matches the worldview that each author affirmed. Though the great evils Lovecraft and Lewis invented for their literary creations had similar origin and awakening stories, Lovecraft refused to give his readers a hope that he did not believe in. Lewis depicted a force of good based on his "mere Christianity," a force strong enough

to overcome the evil and redeem whatever horrors inhabit the cosmos. Lovecraft and Lewis alike continue to speak to the hearts, dreams, and nightmares of their readers, giving powerful voice through fiction to the beliefs of the materialist and the Christian, respectively. In the end, it is up to readers to decide which vision adheres more closely to the fabric of reality. Yet our personal viewpoints need not prevent us from admiring what both writers achieved rendering their private beliefs in powerful public fantasies.

WORKS CITED

Carpenter, Humphrey. *The Inklings: C.S. Lewis, J.R.R. Tolkien, Charles Williams, and Their Friends*. Houghton Mifflin, 1979.

Joshi, S.T., editor. *Against Religion: The Atheist Writings of H.P. Lovecraft*. Sporting Gentlemen, 2010.

---. *H.P. Lovecraft: A Life*. Necronomicon, 1996.

---. *I Am Providence*. Hippocampus P, 2010. 2 vols.

Klinger, Leslie, editor. *The New Annotated H.P. Lovecraft*. Liveright, 2014.

Lewis, C.S. *The Collected Letters of C. S. Lewis*. Vol. 1, edited by Walter Hooper, HarperCollins, 2004. 3 vols.

---. *The Last Battle*. 1956. New York, Collier, 1970.

---. *The Lion, the Witch, and the Wardrobe*. 1950. New York, Collier, 1970.

---. *The Magician's Nephew*. 1955. New York, Collier, 1970.

---. "Myth Became Fact." *God in the Dock*, edited by Walter Hooper, Eerdmans, 1970, pp. 63-67.

---. *Surprised by Joy: The Shape of My Early Life*. 1955. HarperOne, 2017.

Lovecraft, H.P. "The Call of Cthulhu." 1928. *The New Annotated H.P. Lovecraft*, edited by Leslie Klinger, Liveright, 2014, pp. 123-57.

---. "A Confession of Unfaith." 1922. *Against Religion: The Atheist Writings of H.P. Lovecraft*, edited by S.T. Joshi, Sporting Gentlemen, 2010, pp. 1-7.

---. "Dagon." 1919. *The New Annotated H.P. Lovecraft*, edited by Leslie Klinger, Liveright, 2014, pp. 3-10.

---. Letter to Robert Howard. 16 Aug. 1932. *Against Religion: The Atheist Writings of H.P. Lovecraft*, edited by S.T. Joshi, Sporting Gentlemen, 2010, pp. 36-38.

Nelson, Dale. "Jack and the Bookshelf #32." *CSL: The Bulletin of the New York C.S. Lewis Society*, July-Aug. 2017, pp. 9+.

Poole, W. Scott. "Historicizing Lovecraft: The Great

War and America's Cosmic Dread." *Interdisciplinary Humanities*, vol. 33, no. 3, Fall 2016, pp. 36-52.

---. *In the Mountains of Madness: The Life and Extraordinary Afterlife of H.P. Lovecraft*. Soft Skull, 2016.

Sayer, George. *Jack: A Life of C. S. Lewis*. Crossway, 1988.

A Passive Darkness: The Veil in Henry Vaughan's "Cock-Crowing" and C.S. Lewis's *Till We Have Faces*

by Grace Seeman

Grace Seeman is a senior English Literature major at Taylor University. She has studied abroad in the Republic of Ireland, Spain, and England, and plans to attend graduate school overseas in pursuit of a teaching career in the field of literature. She was one of the honorees in the student critical writing competition.

That moment in a traditional wedding ceremony when the bride's veil is lifted is rich with symbolic meaning; among other things, it signifies a simultaneous hope for and actualization of the great human desire to know and to be known in return. Both Henry Vaughan and C. S. Lewis utilize this same image and its connotations, veiling their characters both metaphorically, as in the narrator in Vaughan's poem "Cock-Crowing,"[1] and literally, as in Orual, Lewis's mythic queen in *Till We Have Faces*. In both works, however, the veil is leaden, so much so that both characters come face-to-face with their inability to lift their respective veils. Both Lewis and Vaughan use the imagery of darkness and light to embue this image with theological nuance. In so doing, they situate themselves in the doubt-ridden theology of the early modern period, while at the same time refusing to let such doubt impinge upon their ultimate faith in a good and saving God.

Vaughan's poem "Cock-Crowing" has two major characters: a rooster and the narrator. In the course of its forty-eight lines, it uses the Hermetic image of the magnetism between earth and heaven to symbolize the common bond between humanity and God. For as the rooster is compelled to crow by the appearance of its native sun, so also is man compelled to seek his creator God.

This analogy breaks down when the efficacy of such a compulsion is called into question, for while there is no evidence in the poem of the rooster falling short of perfection in its response to the sun, Vaughan's narrator does precisely that in his pursuit of God. The ideal unity is defined within the poem as full mutual knowledge, as when the narrator prays to God: "Seeing thy seed abides in me, / Dwell thou

1 Henry Vaughan, "Cock-Crowing," in *The Norton Anthology of English Literature*, ed. Stephen Greenblatt (New York: W. W. Norton & Company, 2012), 23-24. Further line references given in text.

in it, and I in thee." However, the realization of this state is impaired by the presence of a veil which "is all the cloak / And cloud which shadows thee from me" (39-40), a veil that, in short, lies between the narrator and his achievement of the state of full knowing and being-known.

Moreover, the narrator has no power over the veil, for he cannot in his own power remove this obstacle to his union with God. Such a reality is made especially evident through the passivity of his language concerning the veil, as when he states, "[this veil] must be broken yet in me" (38). By choosing not to use the active voice, Vaughan suggests that the narrator is spiritually impotent. This inability to do anything about the problem is also suggested when he describes the being veiled as standing under a "cloud which shadows thee from me" (40), emphasizing the apparent inevitability of man's being acted upon and thwarted, rather than actively bringing about the actualization of the longed-for ideal unity.

Suggesting his frustration, the narrator cries out, "O take [the veil] off! Make no delay" (43) in both the first and the second-to-last lines of the last stanza in the poem, indicating that God, the "immortal light and heat" (19) whom he has been addressing since the fourth stanza, holds the power over the veil. Indeed, he explicitly hopes that the rending of the "veil which [God] hast broke" (37) will be replicated in his own personal veil, leaving no doubt that it must be God and not himself who overcomes the barrier keeping them apart.

Orual of Glome, the dominant figure in Lewis's *Till We Have Faces*, differs from Vaughan's narrator not only in that her veil is physical, but also in that she has the power to lift it. The veil features centrally throughout the entire novel, but its presence in the book's second part furnishes ample reason to see this difference as more superficial than anything else. Orual unveils herself twice in this section: first, when she converses with Ansit upon Bardia's death, and second, when she walks out of the city to the river to commit suicide. Sharon Jebb describes the shallow ways that Orual uses her veil. "To the best of her ability, she grasps her new role [as Queen], warring and ruling and *making use* (emphasis mine) of the fear which the veil instills in ambassadors and subjects alike."[2] True, Orual is capable of removing her physical veil, but there is a disconnect here between the veil as an object and the veil as a symbol that is rooted in her pragmatism. What she (and the reader) come to understand is that,

2 Sharon Jebb, "'I Lived and Knew Myself': Self-Knowledge in *Till We Have Faces*," *Renascence* 63, no. 2 (2011): 115.

like Vaughan's narrator, she is powerless in regard to the metaphorical/ spiritual/moral veil, the one that really matters.

In the first scene, Orual goes to pay her respects to Ansit, Bardia's widow. What begins as a paying of respects escalates into verbal sparring as the two women debate each other's claims to Bardia and their own resultant loss. As this initial conflict reaches its climax, Orual realizes that Ansit is jealous of her and, more to the point, is jealous of the way she controlled Bardia's time. She cries incredulously, "Is it possible you're jealous?"[3] and when she is not dignified with any response, she writes, "I sprang to my feet and pulled aside my veil. 'Look, look, you fool!' I cried. 'Are you jealous of this?'"[4] This action is more a self-protecting deception than an unveiling. In the face of Ansit's justified accusation of Orual regarding Orual's monopolization of her husband, Orual has no logical rebuttal and, rather than admitting her own fault and the corruption of her own heart, she appeals to her own ugliness by unveiling herself.

The second scene contains similar imagery. Orual has a need of getting out of the city unseen in order to kill herself and to escape Ungit, the terrible goddess that she has become. In service of this end, she thinks to herself, "My veil was no longer a means to be unknown. It revealed me; all men knew the veiled Queen. My disguise now would be to go bareface; there was hardly anyone who had seen me unveiled."[5] As before, her veil is something that she uses for her own benefit; its physical removal here explicitly and intentionally becomes yet another added layer of her metaphorical veil, yet another means by which she may be unseen.

Through studying these instances, then, the difference between Orual's veil as an article of clothing and Orual's veil as a symbol becomes apparent. This, in turn, undermines the easy assumption that her ability to remove the former suggests a corresponding ability to remove the latter. Sally A. Bartlett addresses this distinction succinctly, asserting that "The veil [Orual] wears over her face to mask her ugliness before the world, she has already had intact internally for years, acting as a protective barrier between her and her despised self."[6] Since the internal veil preceded the physical one, both chronologically and psychologically, the emphatic difference between a superficial unveiling and a profound one becomes a central aspect of

3 C. S. Lewis, *Till We Have Faces* (Orlando: Harcourt Inc., 1984), 262.
4 Lewis, *Till We Have Faces*, 262.
5 Lewis, 278.
6 Sally A. Bartlett, "Humanistic Psychology in C. S. Lewis's *Till We Have Faces*: A Feminist Critique," *Studies in the Literary Imagination* 22, no. 2 (1989): 193.

the characterization of Orual.

Thus, the spiritual or metaphorical veil is foregrounded in the story. The physical veil is primarily a tool; it is necessarily periphery, necessarily being used by someone – by Orual herself. Her true self (her "face") is hidden by the veil she cannot lift. By the conclusion of *Till We Have Faces*, as critic Curtis Gruenler summarizes, "Orual comes to acknowledge that the reason the gods don't speak clearly has to do with the veil that has covered her own face from herself and prevented her from seeing."[7] This is of special interest because, as one might expect, Orual does not wear her physical veil when she is alone, yet Gruenler's analysis discusses her as if she is continually veiled.[8] It becomes evident (and obviously significant) not only that the removal of the physical veil does not mirror a similar removal of the internal veil, but also that, throughout Orual's entire story, she cannot find a way to remove that second, more significant veil. In other words, she suffers from the same condition as Vaughan's narrator in "Cock-Crowing"; they both are shown to be necessarily passive with regards to the lifting of their true veils, incapable of removing that which keeps them from being known.

Such similarity, though, is not found simply in the entrapment of these characters; it also continues into their liberation, as they both require divine action to be unveiled. Indeed, as Vaughan's narrator is pleading with God to unveil him implies that God alone is able to do so, Orual finds herself truly unveiled only when she stands before the council of the gods: "Hands came from behind me and tore off my veil – after it, every rag I had on,"[9] she writes, noting that they do so at the command of the divine judge who is hearing her complaint. Only in this state is she capable of being answered; only in this state, with her veil ripped from her, is she unable to use it to her advantage by hiding behind it. Its removal – regardless of the dictates of her impotent will – requires her to be known and forces her to stand before the divine as bare as Vaughan's narrator yearns to be.

Their respective unveilings are not the final acts for either character, however; neither Vaughan nor Lewis is willing to be so simplistic. They invite continued thought as they depict the results of the completed unveiling, and nuance these theologically-laden moments with language of darkness and light. Vaughan is notorious

<hr/>

7 Curtis Gruenler, "C. S. Lewis and René Girard on Desire, Conversion, and Myth: The Case of *Till We Have Faces*," *Christianity & Literature* 60, no. 2 (2011): 260.
8 Lewis, 154.
9 Lewis, 289.

for this sort of imagery. This reputation makes sense upon reading "Cock-Crowing," for in it, not only is the sun itself the planter of the "sunny seed" (1) in the rooster, but God is described as "immortal light and heat" (19), as noted earlier, as well as the creator of "a perfect day" (45) and as having the ability to "warm me at thy glorious eye" (46). Being a part of this day, being thus warmed and "brush[ed] with thy light" (44); these are the images of the poem's last stanza and describe the ideal of Vaughan's unveiled narrator, standing in the bright sunlight of God's grace.

However, while this sampling of language is quite representative, "Vaughan's popular epithet of 'poet of light' needs some qualification. He is by no means a Boehme or a Blake, but the consciousness of darkness, indeed, the conviction that light cannot do without darkness, is, according to Sandbank, essential to the understanding of what he says and of how he says it."[10] In "Cock-Crowing," the language of darkness, while less obvious than that of light, is indispensable to our experience of the shining conclusion. In the midst of the dominant sun metaphors, God's absence is posited, and "In such a dark, Egyptian border, / The shades of death dwell and disorder" (29-30). Should God abandon the narrator by refraining from enacting the unveiling Himself, He would by default yield precedence to the veil's "cloud which shadows [him] from [the narrator]" (40). This imagery is not used as a simple contrast, though, for in begging to be unveiled and let into the light, the narrator is asking for action, not asserting reality. In short, while the narrator's divine unveiling leads inevitably to light, the unveiling itself is not shown to be inevitable. In other words, the language of darkness implies a sense of doubt or even despair which contrasts with the longed-for enlightenment of the narrator.

Till We Have Faces also uses the juxtaposition of darkness and light in a similarly stark, dramatic fashion. Gruenler notes this, asserting that "Lewis's novel can be seen to encompass both dark and light for a full-orbed representation of the sacred as both lie and truth."[11] To be sure, darkness and light are the subjects of intense contrast throughout the work, most obviously in Orual's final judgment episode. In this scene, however, instead of moving from darkness to light, as in Vaughan's poem, Lewis initially sends Orual from light into darkness. At the beginning of her vision, she writes, "I walked in the dry sand up to my ankles, white with sand to my middle, my throat rough with

10 S. Sandbank, "Henry Vaughan's Apology for Darkness," *Studies in English Literature, 1500-1900* 7, no. 1 (1967): 142.

11 Gruenler, "C. S. Lewis and René Girard," 249.

sand – unmitigated noon above me, and the sun so high that I had no shadow."[12] She continues in this uncompromising light for one hundred years, until she abruptly "was hurried in out of the burning sunlight into the dark inwards of the mountain,"[13] remaining in that mountain's shadowy heart in front of "the dark assembly."[14] Here she stays until the gods accuse her in return and the darkness proves to be only penultimate; she moves to a higher court, an ascent marked by "the air . . . growing brighter and brighter . . . as if something had set it on fire."[15] It is in this light that, rather than Ungit, Orual is proclaimed by the truest god to be Psyche.

This three-part process is not without effect in Lewis's treatment of the sacred, as Gruenler asserted. It especially gives great weight to the intermediary stage of darkness, leaving Orual in it at the end of the third chapter, and thus complementing "Cock-Crowing" by fleshing out what Vaughan merely suggests. This stage, situated between the punishing and the sublime light, does the vital work of unveiling Orual; however, the veil is re-inserted into the scene in a surprising way. Her judge is described thus: "Male or female, who could say? Its face was veiled. It was covered from crown to toe in sweepy black."[16] She has been known, symbolically speaking, but does not know in return and, although this is halfway to the end goal of full, mutual knowledge, it is accompanied by profound shame as Orual comes to a brutal understanding that her complaint is no more than "speech which has lain at the center of [her] soul for years, which [she has], all that time, idiot-like, been saying over and over."[17] The nuance of Lewis's two veils – one removed, yet one still in place – aligns with and fills out Vaughan's notion of a characteristically veiled darkness.

Debora Shuger, a scholar of Renaissance religious thought, examines two of the sixteenth century's most influential theologians – Richard Hooker and Lancelot Andrewes – and characterizes their theological perspective thus:

> While both [Hooker and Andrewes] analyze spiritual experience in the language of participation and thus seem to affirm the presence of God to the soul, in fact, that analysis and that affirmation take place only within a larger context that represents religious experience as suffused with doubt,

12 Lewis, 286.
13 Lewis, 288.
14 Lewis, 293.
15 Lewis, 307.
16 Lewis, 289.
17 Lewis, 294.

fear of rejection, a sense of the absence of God that verges on
despair.[18]

It seems likely that both Vaughan (a Renaissance religious poet)
and Lewis (a Renaissance scholar) are dialoguing with this very idea,
especially when the thematic darkness is given its full weight and not
simply ignored in favor of the abundant, traditionally Christian image
of light. Its encroaching presence in "Cock-Crowing" and part two
of *Till We Have Faces* visualizes the Renaissance/modern doubt that
resists any assurance of divine concern in humanity, a doubt that may
be intensified by man's spiritual and psychological impotence – and
thus his necessary passivity – concerning the removal of his darkening
veil. In a theology where God may or may not be involved in the
lives of his creatures, the fact that He alone may provide them access
to Himself becomes deeply troubling. Yet in the face of this, light
persists, and is given the dignity of being the parting image in both
pieces – an ultimacy that makes it an assertion of faith despite the
reality of doubt.

Light and darkness intertwine with activity and passivity in
Vaughan's "Cock-Crowing" and Lewis's *Till We Have Faces*. The two
sets of opposites inform one another, both in relationship to the central
image of the veil and, in that interplay, suggesting the Renaissance
theological crisis surrounding the possibility of divine disinterest.
Still, while Vaughan and Lewis both outline the contours of this
fear in terms of a passive darkness, they, in two different historical
moments, choose to leave their readers with the hope of an active light
and of a God who, despite themselves and the nighted world in which
they live, enables the great human desire for full, mutual knowing and
refuses to let himself remain unknown.

18 Debora Kuller Shuger, *Habits of Thought in the English Renaissance* (Toronto:
University of Toronto Press, 1997), 70.

WORKS CITED

Bartlett, Sally A. "Humanistic Psychology in C.S. Lewis's *Till We Have Faces*: A Feminist Critique," *Studies in the Literary Imagination* 22, no. 2 (1989): 185-98.

Gruenler, Curtis. "C. S. Lewis and René Girard on Desire, Conversion, and Myth: The Case of *Till We Have Faces*," *Christianity & Literature* 60, no. 2 (2011): 247-65.

Jebb, Sharon. "'I Lived and Knew Myself': Self-Knowledge in *Till We Have Faces*," *Renascence* 63, no. 2 (2011): 111-29

Lewis, C. S. *Till We Have Faces*. Orlando: Harcourt Inc., 1984.

Sandbank, S. "Henry Vaughan's Apology for Darkness," *Studies in English Literature, 1500-1900* 7, no. 1 (1967): 141-52.

Shuger, Debora Kuller. *Habits of Thought in the English Renaissance*. Toronto: University of Toronto Press, 1997.

Vaughan, Henry. "Cock-Crowing." In *The Norton Anthology of English Literature*, edited by Stephen Greenblatt, 1736-37. New York: W. W. Norton & Company, 2012.

"All This and Heaven Too": The Friendship of David Bleakley and C. S. Lewis

by Richard James

Richard James is a retired pastor who has attended every C.S. Lewis & Friends Colloquium since the first one in 1997. He has published articles in *Inklings Forever, CSL,* and *The Lamp-Post* and has published two essays in volume one of *C. S. Lewis: Life, Works and Legacy.*

In June 2017, David Bleakley – a leading Anglican churchman, educator, and politician – died in County Down, Northern Ireland at the age of ninety-two. Both a pacifist and a Christian Socialist, Bleakley played a significant role in bringing reconciliation between the sectarian Protestant Unionists and the sectarian Catholic Nationalists in the last half of the twentieth century. Since Bleakley is less well-known in the United States than his spiritual mentor and friend, C.S. Lewis, this essay provides a brief overview of Bleakley's life, then considers his relationship with Lewis, his mentor and friend, and Bleakley's significant role in promoting the "Lewis in Ireland" theme during and shortly after the centenary of Lewis's birth.

In the fall of 1946, at the age of twenty-one, David Bleakley, a former Harland and Wolff shipyard electrician from East Belfast, County Down, became the first Northern Ireland student to enter Ruskin College in Oxford on a Trades Union Congress scholarship. Even with this scholarship, Bleakley faced tremendous obstacles as a young man from a working-class home and only a primary school education. Bleakley had read of others doing so, however, and believed that if he put his mind and will to it, he could do it too.

Upon taking his diploma in Economics and Political Science with distinction in 1948, he returned to Belfast to continue his education at Queen's University, Belfast (QUB), earning his BA in 1951 and his MA in 1955. In 1949, he married his childhood friend, Winnie Wason, and, with her, became active in the Northern Ireland Labour Party (NILP). Bleakley ran for the East Belfast parliament seat in 1949 and 1953 before winning it in 1958 and serving there until 1965.

After leaving Parliament, Bleakley returned to the classroom as a teacher in Tanzania (1967-69) and was a Visiting Senior Lecturer in Peace Studies at the University of Bradford in Yorkshire. He also served as the head of the Department of Economics and Political

Studies at Methodist College, Belfast (1969-1979). In 1971, while at Methodist, the current sectarian Unionist Prime Minister Brian Faulkner appointed the non-sectarian Bleakley to his cabinet as the Minister of Community Relations. This position made Bleakley a Privy Councillor with the lifetime title, "The Right Honourable," and made him the first non-Unionist to hold a cabinet post in the fifty-year history of the NI Parliament.

Bleakley, though, was more than an educator and a politician. His dedicated service was built upon his deep Christian faith and sense of vocation. His life-long service as an Anglican lay leader, first in his local community and the Church of Ireland, ultimately led him to such places as Kenya, the United States, the Soviet Union and Israel. Who of his family, friends, neighbors and fellow shipyard workers in East Belfast could have imagined him becoming, in the years 1971-1979, a founding member of the policy-making council for the eighty-five million members of the Anglican Communion? In 1983, his church called him to be the president of its international Church Mission Society, in which position he served for fourteen years. In 1980, Bleakley was the first lay person elected as the General Secretary of the ecumenical Irish Council of Churches, serving in that post until 1992.

While leading and serving denominational, ecumenical and international manifestations of the church from 1971 to 1997, he remained concerned about the religious and political discrimination that many of his fellow working-class Irish neighbors experienced in their daily lives. Primarily in recognition of his service as the chairman of the Northern Island Standing Commission on Human Rights, Bleakley was given the title, CBE (Commander of the Order of the Empire) by Queen Elizabeth II in 1984.[1]

Intertwined with his various leadership roles, Bleakley authored sixteen books and dozens of articles in various newspapers and

1 "Bleakley, David" in *International Who's Who of Authors and Writers 2004*. 19th Edition. ed. Alison Neale (London: Europa Publications, 2003), 59; "Bleakley, David" in *Historical Dictionary of the Northern Ireland Conflict*. 2nd Edition. by Gordon Gillespie (Lanham, MD: Rowman & Littlefield, 2017): 39; "Veteran NI Labour politician and author dies," *News Letter* (Belfast) 27 June 2017. https://www.newsletter.co.uk/news/veteran-ni-labour-politician-and-author-dies-1-8028784; "Major figure in Northern Ireland's Labour politics of the 1960s," *The Irish Times* (Dublin) July 22, 2017. https://www.irishtimes.com/life-and-style/people/major-figure-in-northern-ireland-s-labour-politics-of-the-1960s-1.3161466 and "David Bleakley, Northern Ireland Labour Party MP," *The Telegraph* (London), 06 July 2017. https://www.pressreader.com/uk/the-daily-telegraph/20170706/282316795065308.

periodicals, published from 1954 through 1998. Each book, whether a study of Irish history, a sermon, a biography, or a three-volume survey on the relationship of work and technology, demonstrated his non-sectarian Christian commitment to reconciliation based on "parity of esteem" for every Northern Irishman. Sadly, all his books are now out of print, but many can still be found in libraries that specialize in the history and literature of Northern Ireland.[2]

Bleakley's final book, *C. S. Lewis – at Home in Ireland: A Centenary Biography*, provides highlights of his important relationship with Lewis. The book was Bleakley's contribution to the promotion of the 1998 C.S. Lewis Centenary celebration in Northern Ireland as well as the first full-length book to examine the life of Lewis in his Irish setting.

Separated by twenty-seven years, both Lewis and Bleakley were natives of the same East Belfast suburb of Strandtown, raised just a few blocks from the commercial area known then and still today as the "Holywood Arches." Both men grew up in the same physical environment, sharing the same churches and business establishments, the same views of Belfast Lough, the County Antrim hills and coastline across the lough, the Holywood and Castlereagh Hills of County Down and the Mourne Mountains, and the same noises of the local shipyard. Possibly as early as 1934, Bleakley had another important, if indirect, connection to the Lewis family. He was a member of the Belfast 10th Cub Scout Pack and Boy Scout Troop whose early meeting place had been in the coach house of Dundela Villas, the very place of C. S. Lewis's birth and his home for the first seven years of his life. Bleakley's scoutmaster was Lewis's first cousin, Harry Keown, who then owned the Dundela Villas property. Photographs from about 1901 and from 1921 show the Lewis family and the scout troop in front of the same Dundela Villas porch.[3] Before 1946 they were simply two Strandtown natives, separated by twenty-seven years and different economic and educational backgrounds, yet linked by an affection for their home in East Belfast. This separation would change through a "providential" encounter in Oxford.

One morning in Oxford, Bleakley was ordering a coffee in a popular student café in Cornmarket Street. Hearing him order, a stranger came over to him, put his hand on his shoulder and said, "What part of Belfast gave you that accent?" Looking up, Bleakley

2 A list of Bleakley's books is provided following this essay.
3 "C.S. Lewis and the Tenth," Tenth Belfast Scout Group, Accessed June 19, 2018. http://tenth-scouts.co.uk/history/cs-lewis

saw a farmer-like man in a sports-coat and cords, who had asked the question in what was clearly an Ulster accent. Bleakley told him his address in Strandtown on Nevis Avenue and immediately the man said, "That's not far from where I live."

C. S. Lewis introduced himself and was very interested in Bleakley's shipyard-to-university translation. Before they separated, he suggested that Bleakley might drop in to see him some time in the College where he worked. "Mag-da-len" he said, "Though these odd English pronounce it "Maudlin." He instructed Bleakley just to "call in at the gate-lodge and ask for C. S. Lewis." Later that night at dinner, his Ruskin advisor and college principal, Lionel Elvin, said to him, "David, my dear fellow, that's one of Oxford's most interesting men; do go and see him."[4] He did, and thus began a close friendship.

Afterwards, Bleakley met Lewis occasionally at Magdalen College, sometimes with one of his students like Kenneth Tynan. He remembers that Lewis "was easy to talk to" and that he "was privileged to experience the skill of a great communicator, who got at the spiritual heart of things in language simple but memorable."[5] Readers of the Lewis letters and biographies know how much he enjoyed taking long walks with his brother Warnie and other friends like J.R.R. Tolkien, Cecil Harwood, and Owen Barfield.[6] Bleakley soon discovered that Lewis loved to walk – not only around Oxford, but sometimes between his rooms in Oxford and his home at the Kilns near Headington. Lewis invited Bleakley to walk with him, going most of the distance together, but then separating to go to his college residence in Old Headington and Lewis on to the Kilns. Sometimes the walks would include conversation about the "goings on" back home in Strandtown and Ulster in general. Even though Lewis was not known for reading the newspapers, both he and Warnie always seemed to be interested in the weekly clippings sent to Bleakley by his Godmother from the *Belfast Telegraph* and other regional papers. As they walked, they also discussed suggested readings; family matters, especially parental relationships; current political issues;[7] and, very important to both

4 David Bleakley, *C. S. Lewis at Home in Ireland: A Centenary Biography*. (Bangor, Co. Down: Strandtown Press, 1998).
5 Bleakley, 52.
6 Roger L. Green & Walter H. Hooper, *C. S. Lewis: The Authorised and Revised Biography*. (London: HarperCollins Publisher, 2003), 87-88, 91, 135. Also see Kyoko Yuasa's essay in this same volume.
7 Often discussed was the Atlee Labour Government (1945-1951) which Bleakley supported and Lewis did not. But Lewis was "very tolerant to those who felt otherwise." Bleakley, 57, 59.

men, spiritual matters.[8] These walks with Lewis featured thoughtful conversation, "full of phrases, questions, and insights sufficient for a lifetime's reflection." But they sometimes included "seemingly 'out of the blue' remarks" both "startling and revealing."[9]

For example, on one of these walks up the Headington Hill, Lewis put a question to him that caught him off-guard. Bleakley calls this an example of Lewis "being Puckish." But the confusion for Bleakley, then only twenty-two, was that this "lay theologian" Lewis, who had already written several books on Christianity, feigned to need advice on how to define "Heaven." Bleakley says that he "tried" to answer, but his "theological meanderings" were soon interrupted by Lewis, who said, "My friend, you're far too complicated; an honest Ulsterman should know better. Heaven is Oxford lifted and placed in the middle of the County Down."[10]

Two further Bleakley-Lewis connections stand out. On one of their walks, Bleakley had mentioned to Lewis that he was looking for a closer link between faith and current social concerns and had not yet found it in Oxford. Lewis told him about the Cowley Fathers and their monastic Society of Saint John the Evangelist (SSJE), whose Anglo-Catholic mission house was just a few blocks from Magdalen College (on the Cowley Road). The SSJE, according to Lewis, had a strong sense of social purpose and was very much involved with the needs of the world both in Britain and further afield. Lewis encouraged Bleakley to pay them a visit, which he promptly did.[11] On his visit, Bleakley met Lewis's spiritual director and confessor, Father Walter Adams. He also eventually developed a close relationship with Father Christopher Bryant and the SSJE. That relationship led to "a lifelong association and an opening of fellowship with the wider national and international Church." Bleakley credits Lewis, his "fellow pilgrim" and "spiritual Navigator," for pointing him towards the society which prepared him to serve in Christian leadership within the greater Anglican Communion.[12]

Another important Bleakley-Lewis encounter came in 1958, the year Bleakley won his first East Belfast election to become a Labour Party MP. That was also the year Lewis and his wife, Joy Davidman, flew on a plane for the first time, flying to Belfast for a two-week belated honeymoon. They arrived in Belfast on July 4, 1958, spending

8 Bleakley, 53-59.
9 Bleakley, 52-53.
10 Bleakley, 53.
11 Bleakley, 61-62.
12 Bleakley, 62.

the first week there in Crawfordsburn and staying in the "Honeymoon Cottage" at the Old Inn near the home of his longtime friend, Arthur Greeves.

On one of their days in Crawfordsburn, Bleakley arranged for them to visit with him at the Stormont Parliament Buildings which Lewis had not yet seen. He took Davidman and Lewis on a quick tour of the building and then walked out with them onto the steps of the Parliament that overlooks a magnificent view of the distant Castlereagh Hills. Bleakley writes that he and Lewis shared some reflections on the "then" of 1940s Oxford and the "now" of their native Ulster and the County Down in 1958. For Bleakley it was a "magic moment," in which Lewis revealed an acceptance and enthusiasm for Bleakley's political commitment and career when with a "jovial wave of his hands," in a kind of double benediction to both the buildings which were behind them and the County Down vista before them, he said: "David, my friend, you've really made it. Look behind and before you; all this and Heaven, too."[13]

An important part of Bleakley's later years was the promotion of C.S. Lewis in his native Northern Ireland, especially in Belfast and nearby County Down. From 1996 through January of 1999, he was actively involved in the C.S. Lewis Centenary Group.[14] This included attending the unveiling of the birthplace memorial Blue Plaque at 47 Dundela Avenue, "The Searcher" sculpture by Ross Wilson in front of the Holywood Arches Library, and the service celebrating the centenary of Lewis's baptism at St. Mark's Church. He also led tours of such places as "Little Lea" and St. Mark's Church and gave talks at local clubs, churches, conferences, libraries and universities on "the Irish C. S. Lewis." He was also busy writing letters to the editors in regional newspapers, being interviewed for newspaper articles and radio programs, and writing and promoting his book, *C.S. Lewis – at Home in Ireland*.[15]

Finally, Bleakley initiated and completed a special Lewis memorial project in his (then) hometown of Bangor through the North Down Borough Council. One of Lewis's favorite walks with his lifelong friend Arthur Greeves was the two and one-half miles to

13 Bleakley, 59-60.
14 *C.S. Lewis News, the Newsletter of the C.S. Lewis Centenary Group*, Nos. 1-19, (May 1997-Dec 1998). https://web.archive.org/web/19991022023057/http://dnausers.d-n-a.net:80/cslewis/news.html.
15 David Bleakley, C.S. Lewis – at Home in Ireland website (1998), https://web.archive.org/web/20021012132231/http://www.cix.co.uk:80/~cosine/cslewis/index.htm

Bangor from Crawfordsburn, stopping at the building then known as "Bangor Castle" to enjoy a "favourite" view of the countryside and Belfast Lough. The resulting memorial to Lewis was a bench with a message about Lewis engraved on a metal plaque. The engraving on the plaque reads:

C.S. Lewis (1898-1963)

> From his favourite vantage point C. S. Lewis, saint and scholar from the County Down enjoyed a view of the countryside and Belfast Lough after walking tours locally with his lifelong friend Arthur Greeves.
>
> Devoted to his native County and Oxford University, C. S. Lewis loved both places. His description of perfection recorded in "C. S. Lewis – at home in Ireland" says it all:
>
> *"Heaven is Oxford lifted and placed in the middle of County Down"*
>
> During 1998 North Down Heritage Centre made an important contribution to the C.S. Lewis Centenary Celebration. [16]

Having fulfilled its purpose by the beginning of 1999, the "C.S. Lewis Centenary Group" dissolved and a second group for promoting the "Irish Lewis" was formed – the "C.S. Lewis Association of Ireland," of which Bleakley was an active member.[17] Also, near that same time he did an interview for the *Bulletin of the Greater East Belfast Partnership* about his life that was published in June 2000.[18] Another interview was done with a reporter from the *Belfast Telegraph* in 2002 specifically about the listing of "Little Lea" and then again in 2004 with that same journalist about the sale of the same.[19] Also, in November 2002 Bleakley led the unveiling of a Narnia mural honoring C.S. Lewis in the Wandsworth community as reported in *The News Letter* (Belfast).[20]

With the release of the highly successful Disney-Walden Media

16 © Rossographer (cc-by-sa/2.0), "J5081 : C.S. Lewis plaque, Bangor," Accessed June 19, 2018. https://www.geograph.org.uk/photo/3931872
17 "C.S. Lewis Association of Ireland" website, Chairman, Michael Wardlow as of Oct 30, 2003. Accessed June 19, 2018. https://web.archive.org/web/20030814063648/http://www.cslewisireland.org:80/
18 "Bulletin Interviews David Bleakley: 'Chance favours the mind that is prepared.'" *Bulletin* (Greater East Belfast Partnership), Issue 20 (June 2000), 8.
19 Ben Lowry, "David Bleakley wants home to be listed; Call for listing of C.S. Lewis home," *Belfast Telegraph*, (05 March 2002), 1 and Ben Lowry, "Sale of 'Narnia' house moves a step closer; Buyer found for boyhood home of author Lewis," *Belfast Telegraph*, (06 Jan 2004), 1.
20 "Narnia mural takes a lion's share of C. S. Lewis memory," *The News Letter* (Belfast) [Ulster Edition], (11 Nov 2002), 11.

movie version of *The Lion, the Witch, and the Wardrobe*, Bleakley was sought out by the media to provide insight into the life of Lewis. His interview on the DVD, *Chronicling Narnia*, was released in November 2005 just before the movie came to theatres.[21] Included in the four-disc edition of the film was a seventy-five-minute biographical video with the title, *C. S. Lewis – Dreamer of Narnia*, in which Bleakley and other Lewis scholars were interviewed about Lewis and his life both in Belfast and Oxford.[22]

It is never easy to assess someone's life and the role they played in influencing their world. Few of us have the diversity of experience, the depth of purpose, the opportunity of years, the support of friends and the variety of gifts to do anywhere near what the Rt Hon David Bleakley MP, CBE (1925-2017) accomplished over the ninety-two years that were mostly lived in Belfast and County Down. This essay echoes Bleakley's self-description in which he identified himself in three ways: as an *educator* – an effective and practical teacher of economic and political change in both Northern Ireland and Tanzania; as a *public servant* – both as a non-sectarian Labour politician and as an ecumenical Irish Christian faithfully seeking to bring reconciliation in difficult places and troubled times; and as an *author* – writing sixteen books and dozens of periodical and newspaper articles for both the secular and religious press.[23] In addition, I hope this essay reveals David Bleakley to be a faithful friend of C.S. Lewis – acknowledging both his spiritual debt to him and promoting Lewis's Irish background, especially highlighting its significant role in Lewis's life and writings.

21 "David Bleakley Interview and Biography," *Chronicling Narnia*. London: ArtsMagicDVD. Released November 15, 2005.

22 "David Bleakley Interview," *C. S. Lewis – Dreamer of Narnia*, Disc 3 of *The Chronicles of Narnia: The Lion, The Witch, and The Wardrobe* – Four-Disc Extended Edition, Walt Disney Studios Home Entertainment//PG//December 12, 2006.

23 Bleakley, David" in *International Who's Who of Authors and Writers* 2004, 59.

A CHRONOLOGICAL BIBLIOGRAPHY OF THE BOOKS OF DAVID BLEAKLEY:

Young Ulster and Religion in the Sixties: An Inquiry into the Attitudes to Religion of Young Ulster People in the 15-20 Age Group. Belfast: Published by a Group of Church of Ireland members, 1964.

1966 and All That: A Discussion about the Church in Contemporary Society. 1966.

Peace in Ulster. London: Mowbray, 1971.

Despair and Hope in Northern Ireland. Cambridge: University Church, 1973. Great St. Mary's Sermons.

Faulkner: Conflict and Consent in Irish politics. London: Mowbray, 1974.

Crisis in Ireland: inter Irish and Anglo-Irish Relations. London: Fabian Society, 1974. Series: Fabian research series, 318.

Saidie Patterson, Irish peacemaker. Belfast: Blackstaff Press, 1980.

In Place of Work . . . the Sufficient Society: A Study of Technology from the Point of View of People. London: SCM Press, 1981.

Ireland and Britain 1690-1990: A Search for Peace. New Malden, Surrey: Fellowship of Reconciliation, 1982. Alex Wood memorial lecture, 1982.

Work: The Shadow and the Substance: A Reappraisal of Life and Labour. London: SCM, 1983.

Beyond Work: Free to Be. London: SCM, 1985.

Christian Witness in a Post-Industrial Society. London: Church Missionary Society, 1985. Series: Bishop J.C. Jones CMS Memorial Lecture, no. 28.

A Tale of Three Cities: Beirut, Belfast, Birmingham: a sharing in suffering. London: Church Missionary Society, 1985.

Northern Ireland – More than a Holy War: Towards a New Beginning. Belfast: Irish Council of Churches, 1989.

Peace in Ireland: Two States, One People. London: Mowbray, 1995.

C.S. Lewis at Home in Ireland: A Centenary Biography. Bangor: Strandtown Press, 1998.

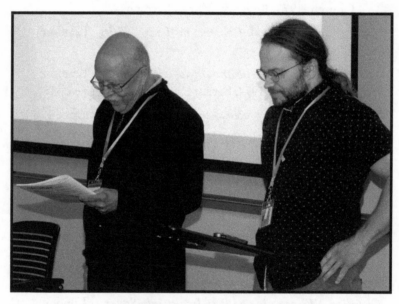

Paul Michelson and Brandon Harnish
respond to questions from the audience.

Michelson presented
"W.H. Lewis, Historian: A Prolegomena."

Harnish presented
"Scientism and Its Consequences
in the Thought of C.S. Lewis and F.A. Hayek."

III. Essays on Inklings and Others

Shakespeare's and Tolkien's People-Trees

by Grace Tiffany

Grace Tiffany is a professor of English, specializing in Shakespeare, at Western Michigan University, where she has also taught a course on C. S. Lewis and J. R. R. Tolkien. She has published two monographs and numerous articles on Shakespeare and Renaissance literature, as well as an article on C. S. Lewis and Plato in *Christianity and Literature*. Her newest book is *Borges on Shakespeare*, issued by the Arizona Center for Medieval and Renaissance Studies (2018).

Tolkien couldn't really have disliked Shakespeare. As an Englishman educated in the early twentieth century, he began to read Shakespeare in primary school, and could no more have uprooted Shakespeare's words and plots from his mind than he could have discarded the alphabet. Disdaining Shakespeare would have been like disdaining English itself.

Yet Tolkien did feel wounded by Shakespeare. First, he was angry at the damage done by Shakespeare to the *idea* of elves. *Elves,* Tolkien wrote to a friend, was "a word in ancestry and original meaning suitable enough" to the doughty beings of that name in his *Silmarillion* and *The Lord of the Rings.* "But the disastrous debasement of this word, in which Shakespeare played an unforgiveable part, has really overloaded it with regrettable tones, which are too much to overcome."[1] The culprits were Shakespeare's comic elves, the cute fairies of *A Midsummer Night's Dream*, who have names like Cobweb and Peaseblossom, stand about an inch tall, travel on the backs of beetles, and do nothing more heroic than push housewives off stools. These are not the kind of elves Tolkien wanted Elrond and Glorfindel to socialize with or, for that matter, to be confused with by readers. Tolkien felt himself (and literature) further injured by Shakespeare's treatment of trees in *Macbeth*. As most Tolkien scholars know, *The Two Towers'* militant tree-folk, the Ents and Huorns, were born from Tolkien's disgust with *Macbeth*'s Birnam Wood. In Shakespeare's tragedy, the Witches predict that Macbeth won't be dislodged from his throne until the forest of Birnam comes to his castle, "high Dunsinane Hill" (4.1.93).[2] This prophecy cheers Macbeth, since he knows a tree

1 Tolkien, letter to Hugh Brogan, 18 September 1954, in *The Letters of J. R. R. Tolkien*, ed. Humphrey Carpenter (Boston: Houghton Mifflin, 2000), 185.
2 Unless otherwise indicated, all references to Shakespeare's play are to *The Riverside Shakespeare*, ed. G. Blakemore Evans (Boston: Houghton Mifflin, 1974).

can't "[u]nfix his earthbound root" (4.1.96). (The masculine possessive pronoun – "his . . . root" – was used conventionally for objects in early modern English and shouldn't fool us into thinking Macbeth believes trees are sentient.)[3] Of course, Macbeth is foiled in the end because the soldiers advancing on his castle camouflage themselves with branches, and thus bring the woods to Dunsinane in a way unforeseen. Tolkien hated this. In a 1955 letter to W. H. Auden, he wrote, "[The Ents]' part in [*The Lord of the Rings*] is due . . . to my bitter disappointment and disgust from schooldays with the shabby use made in Shakespeare of the coming of 'Great Birnam wood to high Dunsinane hill'; I longed to devise a setting in which the trees might really march to war."[4]

Tolkien's love of "faërie" lay at the root of his disappointment in *Macbeth*. He could not fully value a *play* when it featured characters who derived in part from fantasy, such as witches. In fact, the presence of witches in *Macbeth* confused Tolkien as to its category. Because he associated witches with medieval romance, Tolkien wrongly assumed a play containing them must be, or have been intended as, a faërie play. After all, shabby Shakespeare had written one before, in *A Midsummer Night's Dream* (though he totally botched the elves). And since *Macbeth* was, in Tolkien's opinion, an attempt at faërie, it sinned against itself when it passed up its chance to make trees magically walk. Yet its failure was finally a failure of its medium. In "On Fairy-stories," Tolkien rejected *Macbeth* in these terms: "To be dissolved, or to be degraded, is the likely fate of Fantasy when a dramatist tries to use it, even such a dramatist as Shakespeare. *Macbeth* is indeed a work by a playwright who ought, at least on this occasion, to have written a story, if he had the skill or patience for that art."[5] Tolkien thought Shakespeare knew walking trees would trigger imaginative overload in an audience already being asked to swallow the "bogus" magic of the playhouse, with its "*visible and audible presentation of imaginary men.*" Dependent on flesh-and-blood actors, plays stay too rooted in our own world truly to deliver another. "To introduce, even with mechanical success, into [theater's] quasi-magical secondary world a further fantasy" – that of sentient, walking trees – "is a world too much," Tolkien wrote. Thus "[v]ery little about trees as trees can be got into a play."[6] In other words, had Shakespeare been a writer of tales, he

3 E.g., "How far that little candle throws his beams" (Portia, Shakespeare's *The Merchant of Venice* 5.1.90).

4 *Letters*, 212.

5 Tolkien, "On Fairy Stories," 33-99, in Tolkien, *The Tolkien Reader* (New York: Ballantine Books, 1966), 71.

6 Tolkien, "On Fairy Stories," 71-72.

might have made a success of *Macbeth*. But he was a sloppy, impatient playwright, so he threw the hastily composed work onto the scaffold, disastrously peopled with actors. There, the players and props caused a plot crisis. Birnam Wood could not be a forest of walking trees, since it was played by men who looked just like what they were – people holding branches. Defeated, Shakespeare wrote these compensatory lines for Prince Malcolm: "Let every soldier hew him down a bough, / And bear't before him" (5.4.4-5).

Tolkien's argument – that a kind of "double fantasy" overload is risked by any dramatist dabbling in faërie – is ingenious, well considered, and possibly correct. Even so, I must call attention to some facts about *Macbeth* that Tolkien ignored. First, the play was not conceived as fantasy but as historical tragedy. Its dramatization of men's use of foliage as camouflage – a common military tactic – derives directly from the chronicle accounts of the final battle of the medieval king "Makbeth" on which Shakespeare relied for his play.[7] As in *Holinshed's Chronicles*, the play's main subject is political morality and historically significant choices. The Witches, whom Tolkien calls "almost intolerable," are a puzzle, but Banquo and Macbeth do not themselves speak from a world of fantasy when Banquo asks them if they are "fantastical" (1.3.53). Posed within a faërie world, the question would be inappropriate. (Captain Kirk, for example, wouldn't ask a Klingon visitor whether he is a science fiction character.) As for the audience, the early-modern English considered witches part of their own, non-romance world. The spell-casting hags on the Globe or Blackfriars stage more resembled eccentric neighbors they suspected of sorcery than the wicked sprites met by the literate in Arthurian tales. Likewise, Banquo and Macbeth aren't Round Table knights but contemporaries of Edward the Confessor, operating politically in a world which looks forward to the reign of the original audience's own ruling monarch, James I.

The supernatural evil that permeates *Macbeth*'s world does, of course, have its reflection in the Witches. But no one who paid very close attention to the play could doubt that the real source of evil in the story lies in the hearts of Macbeth and his wife. Indeed, a central, tantalizing question of the play is whether the visions with which the Witches plague Macbeth (and which no one else sees) are magic, or simply illusions projected by Macbeth's power-hungry

7 "Malcolme . . . commanded every man to get a bough of some tree or other . . . and to march forth therewith." From Raphael Holinshed, *Selections from Chronicles of England, Scotland, and Ireland*, excerpted in *William Shakespeare, Macbeth*, ed. Sylvan Barnet (New York: Signet, 1998), 118.

mind, responding to the weird sisters' suggestions. It is ambition, not enchantment, that most interests Shakespeare here. From his drama of human politics, equivocal statements, moral mistakes, and the claustrophobic effects of all these on the soul of a soldier, the fifth-act spectacle of walking trees could only have been a distraction, not because it would have made fairies look human, but because it would have made humans look "faery." To this observation we should add that Shakespeare's play-long comparison of human beings to vascular plants – begun when King Duncan tells Macbeth "I have begun to plant thee, and will labor / To make thee full of growing" (1.4.28-29) – has its culmination in the visual spectacle of leafy Englishmen, advancing to restore Scotland to verdant political health.

Tolkien didn't care about any of this. His fictive aims, after all, were different from Shakespeare's dramatic ones. Tolkien thought trees and elves were properly part of mythology, a genre which by its nature demanded otherworldly heroes and even a sentient physical landscape. In his writings Tolkien made plain that the components of his Middle-earth – its wizards, its elves, its animated trees – were "neither allegorical nor topical."[8] His characters did not acquire their meaning through direct symbolic connection to the reader's world. They were free-standing (or free-walking), complex inhabitants of a separate world with its own textured history. Tolkien's commitment to unique sub-creation was such that he eschewed the ready-made versions of animated trees, the dryads of classical myth, and disliked C. S. Lewis's use of them in his Narnia tales.[9] Perhaps he also resented Lewis's copying his Huorns in making Narnia's dryads walk, and going him one better in *Prince Caspian* by explaining how they did it: "when trees move they don't walk on the surface of the earth; they wade in it as we do in water."[10] Although Tolkien did use the word "dryad" in an early essay about tree-spirits, he fashioned new terms in *The Lord of the Rings* to convey that his tree-fairies, as he'd earlier

8 Tolkien, Foreword, *The Fellowship of the Ring* (Boston: Houghton Mifflin, 2000), xiv.

9 Humphrey Carpenter notes Tolkien's dislike for Lewis's indiscriminate "borrow[ings] . . . from other mythologies and narratives," which made for an unconvincing "secondary world." See Carpenter, *The Inklings* (Boston: Houghton Mifflin, 1979), 223-24.

10 C. S. Lewis, *Prince Caspian* (New York: Harper Collins, 1979), 145. Cynthia Cohen has carefully distinguished among the levels of mobility enjoyed by different categories of trees in Middle-earth, from "trees that do nothing unusual" to trees that stay rooted but wave their branches to trees that are "consistently ambulatory" (Cohen, "The Unique Representation of Trees in *The Lord of the Rings*," *Tolkien Studies* 6 (2009): 91-125). But she cannot say how walking trees walk, because Tolkien doesn't.

written, were "quite separate creation[s] living in another mode," and also were spirits "in the process of creation."[11] Verlyn Flieger writes that an early draft of *The Lord of the Rings* expresses this idea of trees having human-like souls. In the draft, Tom Bombadil describes Old Man Willow and the spirit that inhabits him as originally two separate entities. An old man's "grey thirsty earthbound spirit" became "imprisoned in the greatest Willow of the Forest," and then "spread his own malice to surrounding trees through their roots."[12] Like other sentient trees of Middle-earth – the menacing trees of the Old Forest, the suffocating woods of Mirkwood, the Huorns and their treelike shepherds, the Ents – Old Man Willow is no mere occasion for the choices of Middle-earth's persons, but a person himself, a being once or still capable of choosing good or evil. First awoken by the elves, Tolkien's trees are kin to the elves. Both kinds are rounded characters, moral agents.

In contrast, Shakespeare's fairies, be they elves or classical sprites, exist to supply atmosphere and symbolism. They are generally flat figures, unlike *The Lord of the Rings*'s profoundly deliberative Elrond, painfully surrendering his daughter to a mortal's fate; or Galadriel, tempted by but finally victorious over the lure of the Ring; or Treebeard, slowly deciding to march to war against Saruman. No similar choice-making episodes or moments appear in the speeches of *Macbeth*'s Witches, or *The Tempest*'s Ariel, or the gods Jupiter, Diana, or Hymen from the late comedies and *As You Like It*. In Shakespeare, soliloquies are for humans. Even Oberon, *A Midsummer Night's Dream*'s fairy king, ponders no subject more fraught than the most timely moment to end a joke he's playing on Titania.[13] Shakespeare's supernatural beings are simple because they interest him less than his mortal ones. They are dramatic devices which occasion and clarify the choices of human characters.

Thus Shakespeare often associates his supernatural characters – Ariel, for example, and Titania and Oberon, and Hymen – with

11 Tolkien, quoted in Verlyn Flieger, "How Trees Behave – Or Do They?" *Mythlore* 32 no. 1 (Fall-Winter 2013): 1.
12 Flieger, 1.
13 Superficially, *The Tempest*'s Caliban, who is given a speech of pathos, a role as political plotter, and a moment of repentance for his folly, seems an exception to the rule of flat Shakespearean fairy characters. He is not, however, a real fairy, though the European visitor Trinculo calls him one (4.1.196-97). He has human features and, though he's smarter than Trinculo, no non-human powers. As Trinculo also links him to a New World "Indian," it may simply be, as many directors have concluded, that Caliban is a New World native with an appearance unfamiliar to the Europeans.

symbolic aspects of the dramatic landscape, including trees. For trees in Shakespeare go against the trees of Tolkien and even of Lewis in refusing to be people. They exist, instead, as things which stand for and reveal things about people. Indeed, Shakespeare is a perpetrator of what C. S. Lewis called the demystification of the dryad: the reduction of the tree from "a mysterious entity" to "a symbol."[14] Whether we find our imaginations shrunk or enlarged by Shakespeare's trees depends on whether we, like Tolkien, find faërie the richest possible genre or are at least equally transported by the theater of the human. But to assess what human qualities and experiences Shakespeare's trees symbolize, we must first divide them into two categories: individual trees and forests.

What we find is that Shakespeare's particular trees are laden with biblical values. We generally find behind each either the fatal, snake-haunted Tree of the Knowledge of Good and Evil, or the Cross. In *As You Like It*, Orlando sees his treacherous brother sleeping under an "old oak" around which is entwined a "green and gilded snake," ready to bite (4.3.104, 108). Unlike Old Man Willow, who knows evil, this tree only bears evil. *As You Like It* is a comedy, so evil doesn't win. The snake slithers away at the sight of the virtuous Orlando, and the brother lives, repents, and is forgiven. In the also-comic *Merry Wives of Windsor* – in a scene which Tolkien must have doubly despised, since it featured both fake fairies *and* an inanimate tree – Falstaff ("a man of middle earth"! [5.5.80]) goes to "Herne's Oak" to commit adultery (he hopes) with the merry wives. The bitter tragic hero of *Timon of Athens* finds at a tree-root a cache of gold, a "yellow slave" (4.3.34), and gives it to the warrior Alcibiades to fund the destruction of Athens. Like Chaucer's "Pardoner's Tale," the Timon episode reminds us of Paul's warning against the love of money, "the root of all evil" (1 Tim. 6:10),

14 C. S. Lewis, "The Empty Universe," in *Present Concerns*, ed. Walter Hooper (New York: HarperCollins, 1986), 104. Lewis's position only superficially resembles that of the speaker of Swinburne's "Hymn to Proserpine," Julian the Apostate, in the most famous poetic lament for the death of paganism. Julian laments, "Thou hast conquered, o pale Galilean, / The world has grown gray from thy breath" (ll. 35-36). Lewis thinks that "Animism," the belief in sentient nature whose loss Julian laments, is a lie (though fun for children's fiction), but he finds in Christianity's supernatural intervention in Nature an occasion of real color, joy, and purpose. What he laments is the destruction of the spirit-inhabited universe by a scientism which leaves everything strictly material, and thus dead. "In emptying out the dryads and the gods (which, admittedly, 'would not do' just as they stood) we appear to have thrown out the whole universe, ourselves included" (*Present Concerns*, 129). For Swinburne's poem, see Algernon Charles Swinburne, "Hymn to Proserpine," in *The Norton Anthology of English Literature, vol. 2*, ed. M. H. Abrams (New York: Norton, 2000), 1625-28.

and also of the tree in Genesis from which Eve ate and brought death to mankind. The death-tree is found also in *Titus Andronicus,* when Aaron buries gold beneath an elder, a Judas tree. Later the play brings the spectacle of Aaron, like Judas, with a noose around his neck, about to be hanged from this same tree.

As for the tree that is the Cross, it is most often present as human spectacle given weight and meaning through accompanying language. These crosses partake of what Tolkien called "the visible and audible presentation of imaginary men": the actor playing Richard II spreading his arms as he laments that the "Pilates" of Parliament have led him to his "sour cross" (*Richard II* 4.1.240-41); the "side-piercing sight" of King Lear *"crowned with weeds and flowers"* (stage direction, *King Lear* 4.6.85); the suffering postures assumed by generations of stage Ariels as Prospero describes Ariel's prior confinement within a cloven pine (*Tempest* 1.2.277). Harry Berger reads Christian symbolism into that scene: "let Ariel, trapped in the tree of fallen human nature . . . be an emblem of Prospero's . . . experience."[15] Prospero himself, a wizard marooned on an enchanted isle, inescapably reminds us of Shakespeare, mage of the round theater, whose "rough magic" animates "the great globe itself" (5.1.30, 4.1.53). This – the living image lent meaning by poetry – is Shakespeare's "bogus" magic. The adjective "bogus" comes from Tolkien, for whom trees, again, were beings, not symbols (with the grand exception of the tree in "Leaf by Niggle," an acknowledged allegory). Tolkien's imagination must have been stirred by the Anglo-Saxon poem, "The Dream of the Rood," wherein a sentient Cross recalls being "hewed" and "wrought . . . for a spectacle," then mounted heroically by Christ (ll. 31-44).[16] Still, Middle-earth never once yields a tree that tempts us to look beyond itself to the Cross, or to the Tree of Knowledge. Shakespeare's plays, on the other hand, offer few standing trees that do not.

In Shakespeare's theater, single trees could be represented by wooden stage posts decked with branches.[17] When no climbing or hanging was required, the players used portable box trees, which were useful for comic pranks. "Get ye all three into the box-tree,"

15 Harry Berger, *Second World and Green World: Studies in Renaissance Fiction-Making* (Berkeley: University of California Press, 1990), 154.
16 Anonymous, "The Dream of the Rood," in *The Literature of Medieval England*, 156-57, ed. D. W. Robertson, Jr. (New York: McGraw-Hill, 1970), 156.
17 Andrew Gurr writes that the discovery-space entrance in the public theaters were made large enough so that stage hands could carry in boxed trees. See Gurr, "The Bare Island," in *Shakespeare Survey 47* (1994): 29-43, 32; and also Gurr; *The Shakespearean Stage 1574-1642* (Cambridge, U.K.: Cambridge University Press, 1992), 191.

Maria whispers in *Twelfth Night*, as she and her pals prepare to spy on the despised Malvolio (2.5.15). Lone trees thus formed part of the spectacle. Forests, on the other hand, were largely invisible, almost completely made of words.[18] Shakespeare's depictions of woodlands conjure up what Jeanne Addison Roberts calls a "Shakespearean wild," a perilous realm which yields no "utopian vision of ecological interdependence," as some ecocritics would have it, but instead menaces women and men.[19] We've seen that this woods holds snakes, but in fact, its most savage element is the human heart freed from civil rule. In the woods women risk rape, and men risk the impulse to rape. There human males may be metaphorically transformed into the wolves of fairytale, or, debased, become the aggressors of romances such as Chaucer's "Wife of Bath's Tale," with its knight turned virgin-violator in the forest. In Shakespeare the wild which summons forth male savagery is linked to the masterless, unprotected female, she who "makes men mad," to quote Othello (5.2.111). As the speaker complains in Shakespeare's Sonnet 129, "Savage" lust is a force visited on a man, a "bait / On purpose laid to make the taker mad." This may be why, in *The Two Gentlemen of Verona*, the woman whom Proteus follows into the woods and there threatens to "force" (5.4.58) is named "Silvia," which means not only "woods" but, to the Greeks, *silva*, or chaos (a striking parallel to the English word "wood," which in Shakespeare's time meant "mad"). Silvia is of course innocent, a ghost trapped in her organism, like Ariel in the cloven pine. She is doomed by her body, which, in the wild, prompts men to abandon their higher reason and restraint. Similarly, in *A Midsummer Night's Dream* Demetrius becomes "wode" (mad) "within this wood" because of the beauty of Hermia, whom he pursues. And though Demetrius now loathes Helena, who chases him, Helena's very presence also tempts him to thoughts of rape. He warns Helena of the risk she runs as a virgin in a "desert place," and adds, "If thou follow me, do not believe / But I shall do thee mischief in the wood" (1.2.219, 236-37). In *Titus Andronicus*, "forlorn and lean trees" witness the rape of Lavinia by Queen Tamora's sons (2.3.94). The ravaged and mutilated victim, whose hands the men cut off, is later compared by her uncle

18 "There is no hint that [Shakespeare] bothered at all about undifferentiated trees for forest scenes," says Gurr (*Shakespearean Stage*, 189).

19 Jeanne Addison Roberts, *The Shakespearean Wild: Geography, Genus, Gender* (Lincoln: University of Nebraska Press, 1994). Rebecca Bushnell calls the Shakespearean forest "terrifying to humans." See her "Shakespeare and Nature," in *Shakespeare and Our Time*, ed. Dympna Callaghan and Suzanne Gossett (New York: Bloomsbury, 2016): 327-34, 330.

to a tree "lopp'd and hew'd," her body "bare / Of her two branches" (2.4.17-18, 45). Lavinia is both victim and emblem of the wild woods that tempted the violence. More importantly, the tree which she physically figures, through Marcus's poetry, becomes a symbol of her.

Between Tolkien's Huorns and Shakespeare's Lavinia stretches a gap wider than that between story and theater. The theme of sexual violence in the woods is foreign to *The Lord of the Rings*. While Shakespeare's hewn tree is a brutalized woman, Tolkien's hewn tree is a brutalized tree, which for Tolkien is sufficiently outrageous. With more success than Lavinia, Tolkien's trees fight back. The Orcs' assault on Fangorn Forest provokes the Ents' destruction of Isengard, the epicenter of Saruman's devilish machinery. Thus Tolkien imagines a spirited nature vanquishing the soulless technology that would murder it.[20] One of his letters decries the "spirit of 'Isengard'" that is "always cropping up," as in the "design of destroying Oxford . . . to accommodate motor cars."[21] Shakespeare, not a modern but a Renaissance Englishman, was a friend of Early Modern technology, because, why should he not be? He would have loved a car. For him, the road through Oxford let him travel from Stratford to London, and the transformation of wild woods to wooden playhouses turned him into Shakespeare.[22] In 1600, farmland was better than wilderness, gardens better than wildflowers, marriage better than sexual license, and stage-boards better than forest floors. Nature cultivated was nature improved, as Polixenes argues in *The Winter's Tale*, when he likens the hybridization of flowers to the marital subjugation of a wild woman to a gentleman. When "we marry / A gentler scion to the wildest stock," we practice "an art which . . . shares / With great creating Nature," he says (4.4.92-93, 87-88). Properly, feminine woodland submits to reasoning masculine guidance, and its threat is dispelled thereby. The perfect emblem of this comity is *As You Like It*'s Orlando pinning his artful, wife-winning love poems on trees as he wanders the Forest of Arden. The poem-bedecked stage posts couldn't less resemble Tolkien's

20 Ina Haberman and Nikolaus Kuhn's comments on Tolkien's "evocations of benign natural forces and the contrasting industrialized forces of evil," in "Sustainable Fictions: Geographical, Literary, and Cultural Intersections in J. R. R. Tolkien's *The Lord of the Rings*," *The Cartographic Journal* 48, no. 4 (2011): 263-73. See also Brian McFadden's discussion of the Ents in "Ents, Elves, and Eriador: The Environmental Vision of J. R. R. Tolkien," *Intertexts* 11 no.1 (Spring, 2007): 89+.

21 Tolkien, Letter to Michael Straight, Jan. or Feb. 1956, in *Letters*, 235.

22 For Shakespeare's views on the healthful taming of the wild, see Mustapha Fahmi's "Shakespearean Georgic: An Ecological Reading of Shakespeare's *As You Like It*," a paper presented at the British Shakespeare Association annual meeting, Newcastle, U.K., September, 2005.

wild Ents and treeish Huorns, whose masculinity is registered neither in violation nor in cultivation, but in free growth and wandering, and who leave civil gardens to their missing Entwives – or rather, who are themselves left by Entwives gone agricultural.

Shakespeare stands with the Entwives, who celebrate "corn in the blade" and "harvest com[e] to town." For him, that "land is best."[23] *Macbeth*'s branch-wielding men are his tragedy's version of Orlando's poems tacked on trees: a healthful hybridity, a rational tree-mastery. Birnam Wood signifies the defeat of the ambitious madness into which Macbeth has been tempted by scary females: the Witches and a bossy wife he failed to subdue.

Of course, that Tolkien didn't like Birnam Wood doesn't mean he cared nothing for stories of politics and moral choice. Consider, for example, the painstakingly rendered strategies and ultimate fall of Denethor as portrayed in *The Return of the King*. It's just that Tolkien considered *story* a freer domain than *drama* for any plot, and found all tales most enthralling when they unfolded in some Other-world, where stones had virtue, ropes and rings sought their masters, and trees were spirits who walked.

23 J. R. R. Tolkien, *The Two Towers* (Boston: Houghton Mifflin, 1996), 466.

Tom Bombadil: Lessons from the True Ring Lord

by Allison DeBoer

Allison DeBoer is a student at Seattle Pacific University (SPU). She is majoring in English Creative Writing with an emphasis in fiction. Allison is a tutor in the SPU Writing Center and plans to pursue a career in editing and publishing, focusing specifically on Christian-based work. She was one of the honorees in the student critical writing competition.

In J.R.R. Tolkien's *The Lord of the Rings*, Tom Bombadil is a largely elusive "enigma."[1] Over the years, critics and readers of the novel alike have offered numerous hypothesis as to *who* Tom Bombadil is. Klaus Jensen and Ruairidh MacDonald begin their essay "On Tom Bombadil" with the image of Frodo in the Old Forest staring in awe at Tom Bombadil asking, "Who are you?" Arguably, this is a question asked by nearly all who read *The Lord of the Rings* when Bombadil's character first steps out onto the page.

Many critics have written Tom off as an anomaly – a nobody character – who holds little to no importance outside of his brief appearance in *The Fellowship of the Ring*. Other critics have figured Bombadil to be some sort of nature spirit or child-like jester. Even Tolkien himself appears conflicted over Tom's true role, writing that: "Tom Bombadil is not an important person to the narrative" while later noting, "Bombadil represents something that otherwise would have been left out."[2] And while some critics have gone as far as to give Bombadil mystical or divine qualities, readers (or at least movie viewers) might find themselves asking, "How important can Tom Bombadil really be?" Nonetheless, writers can create characters that go beyond anything they themselves may have anticipated. I believe that Tom Bombadil is one such character. In fact, despite Tom Bombadil's limited appearances in the narrative, he plays a profoundly significant role.

This essay will show that Tom Bombadil – through his unique relationship to the ring, his persistent childlike nature despite the extensive knowledge and power he possesses, and his influence within

1 Anne Marie Gazzolo, "The Enigmatic Presence of Tom Bombadil and Goldberry," Amon Hen: *The Bulletin of the Tolkien Society* 244 (2013): 25-26.

2 Letter to Naomi Mitchison, 25 April 1954, in *The Letters of J.R.R. Tolkien*, ed. Humphrey Carpenter (Boston: Houghton Mifflin, 2000), 178.

and outside his borders (especially with regard to light and redemption) – encourages readers to become more attuned to the world around them while letting go of the need for control. Tom Bombadil reflects the significance of being in harmony with all things and provides the clearest example in *The Lord of the Rings* of how to transcend the temptation to grasp power.

Regardless of what critics have to say about the relevance of Tom Bombadil, he is the only one throughout the narrative over whom the ring has no power. This is a crucial ability, as, arguably, the entire purpose of the war of the ring is to overcome the power of the ring by ridding Middle-earth of its presence. To understand Tom's uncanny ability, it is necessary to note the qualities of the ring and the scope of the ring's power. In Gandalf's earliest conversations with Frodo about the ring, he tells the young hobbit that, "In the end it would utterly overcome anyone of mortal race who possessed it."[3] Gandalf talks about the physical *fading* one begins to experience after being under the ring's influence for too long, and the immediate power of invisibility one receives from wearing the ring.[4]

Gandalf tells Frodo that "[Bilbo] gave it up in the end on his own accord: an important point."[5] However, this is neither true of Bilbo nor of any of the long-time ring bearers: Gollum, Bilbo, or Frodo. In each specific case, some sort of outside source had to intervene in order to pry the ring from of its beholders: Bilbo had to drop the ring on the floor for Gandalf to pick up, Gollum had to fall into an abyss, and Frodo had to lose his ring finger in order to be released from its hold. Perhaps the inability to rid oneself of the ring connects to the inscription on the ring itself: "one ring to rule them all . . . and in the darkness bind them."[6] This points not just to the dark (evil) nature of the ring but to its purpose in "ruling" over all who encounter it.

Even the strongest, most powerful characters in the novel like Gandalf feel overmatched against the ring's power. After being warned of the ring's dark power, Frodo asks Gandalf to take the ring to which Gandalf responds, "No! With that power I should have power too great and terrible. And over me the Ring would gain a power still greater and more deadly. . . . [T]he wish to wield it would be too great for my strength."[7] Not even the wizard Gandalf has strength enough

3 J.R.R. Tolkien. *The Lord of the Rings: 50th Anniversary One-Volume Edition.* (Houghton Mifflin Harcourt, 2004), 44.
4 Tolkien, 47.
5 Tolkien, 49.
6 Tolkien, 50.
7 Tolkien, 61.

to resist the ring's temptation, and yet an odd, "insignificant" forest-dwelling creature named Tom Bombadil does. While it seems that Gandalf is right when he says, "This is the Master Ring, the One Ring to rule them all" (50), we must not forget that Tom is also described as "master."[8] Indeed, I would argue that, over the ring, he is master.

It is in the Old Forest, standing beside Frodo and his friends, that Tom *asks* for the ring. Frodo gives it to him and Tom is the only one who demonstrates total resistance to the ring's power.

> [Tom] put it to his eye and laughed. . . . [H]is bright blue eye gleam[ed] through a circle of gold. Then Tom put the Ring round the end of his little finger and held it up to the candlelight. For a moment the hobbits noticed nothing strange about this. Then they gasped. There was no sign of Tom disappearing. Tom laughed again, and then he spun the Ring in the air – and it vanished with a flash. Frodo gave a cry – and Tom leaned forward and handed it back to him with a smile.[9]

Significantly, Tom *sees through* the ring. This image connects with the description of the "eye" in the dead marshes episode. There, Frodo feels the weight of the ring on the chain around his neck as he always does, yet it is explained that: "It was more than the drag of the Ring that made him cower and stop as he walked. [It was] The Eye: that . . . hostile will that strove with great power . . . to pin you under its deadly gaze, naked, immovable."[10]

Yet in this singular moment in the Old Forest, Bombadil's blue eye looks through the hole in the ring, peering out to the other side when all others find themselves entrenched within. In other words, it is not the eye of the Dark Lord that holds power in this moment but the eye of Tom Bombadil. Throughout the book, the ring is a force working within each of its beholders as one of "the two powers [that] strove in him."[11] Yet in an instant, the piercing eyes and joyous laugh of Tom Bombadil become the only power evident. The ring lies silent in his palm.

Critics have more easily dismissed Tom's relationship to the ring, however, given that outside of his borders, he has no role in bringing about its destruction. In fact, at the Council of Elrond, sending the ring to Bombadil is discussed yet ultimately turned down as Gandalf notes that: "[Tom] would be an unsafe guardian, perhaps forgetting the

8 Tolkien, 124.
9 Tolkien, 133.
10 Tolkien, 630.
11 Tolkien, 401.

ring, or tossing it aside."[12] Gandalf continues further that Bombadil can be of little help to the end goal as "he cannot alter [the ring's] power over others."[13] Glorfindel concludes that "power to defy our enemy is not in him."[14]

While conceding that Tom does not in any physical way (given his power over the ring) help to bring about its demise, and while Tom may not possess the interest (desire?) to hold onto the ring, I would assert that the significance of Tom's relationship to the ring is not that he does something (or nothing) about it but that he is immune to its corruption. One need not agree with Glorfindel's statement that "power to defy our enemy is not in him." Tom has already defied the enemy's power by defying the ring. Tom may not participate in the destruction of the ring, but his immunity to it shows that there is some power (goodness? holiness?) greater than evil at work in the world.

In addition to his resistance to the ring's power, Tom also possesses tremendous power of his own. In other words, he is not just a laughable being who happens to be in the right place at the right time. Anne Marie Gazzolo notes that "[Tom] could have with the power that is in him done far more than to command that the spirited tree release the hobbits, but he does not." She also notes that for a creature "who loves to sing in nonsensical rhymes, who holds and wields wondrous power over others, [he] remains unaffected by how that [power] could corrupt."[15]

This is the opposite of Gandalf's problem with the ring. He claims that because of the power he himself possesses, the ring would be able to use that power to corrupt him. Tom, while possessing unique power of his own, is unphased by any sort of power the ring has to offer. Even outside of Tom's borders, his power over the ring is known. At the council of Elrond, Erestor asks, "It seems that [Bombadil] has a power even over the Ring,"[16] to which Gandalf replies, "No, I should not put it so. Say rather that the Ring has no power over him. He is his own master." Tom is not moved by the temptation of the ring precisely because he allows himself to live in harmony with the world instead of needing to have control over it.

Tom is able to relinquish the need for control because he maintains a childlike nature despite his power and timeless understanding of the knowledge and history of Middle-earth. Walking beside Tom through

12 Tolkien, 265.
13 Tolkien, 266.
14 Tolkien, 267.
15 Gazzolo, 25-26.
16 Tolkien, 265.

the forest, the hobbits listen intently as Tom speaks of ancient things and "they [begin] to understand the lives of the Forest apart from themselves, indeed to feel themselves as the strangers where all other things [are] at home."[17] Through the words and presence of Tom, the young hobbits begin to see just how great and vast and interconnected the realm of Middle-earth is and thus, "Tom's words laid bare the hearts of the trees and their thoughts." The hobbits, in wonder, begin to understand that there is so much more beyond the Shire and, indeed, beyond their imaginations. Thus, readers can infer that regardless of his jovial and carefree mannerisms, Tom has a thorough and expansive knowledge of the natural world.

Despite his incredible age and knowledge, Tom remains the most childlike character in the novel. However, this very persona has brought forth concern from some critics. Specifically, Jensen and MacDonald state that the introduction of Bombadil's singsong and jovial character represents a "sudden regression to a more traditional fairy-tale form [that] is not an easy pill to swallow for the adult reader."[18] In other words, Tolkien has been accused of inserting Tom as a child's amusement in an adult's novel. Critics have especially attacked the childlike way in which Bombadil appears to speak and sing. Lynn Forest-Hill responds to such critics claiming that Tom's "nonsense rhymes" are "nevertheless song[s] of power in [their] own right . . . going beyond our expectation and comprehension."[19] She notes that Tom's musical style "reliant on rhythm rather than meaning, defines his control over the natural threats of the forest."[20] In other words, Tom's childlike music is not just for show but demonstrates and even enacts much of his power and influence. Forest-Hill argues that Tom's character contains a complex, unique, and systematic approach to language that is much more than "childlike."

In response to the critics of Tom's childlike nature, I'd argue that this is precisely the point. His "childlike" quality, despite his profound knowledge and wisdom, is what makes him unique and even transcendent. While he reminds readers of childlike ideals, he, at the same time, has existed from "before the river and the trees."[21]

17 Tolkien, 129-30.
18 Klaus Jensen & Ruairidh MacDonald, "On Tom Bombadil: The Function of Tom Bombadil," *Mallorn: The Journal of the Tolkien Society* 44 (2006): 37-42.
19 Lynn Forest-Hill, 'Hey dol, merry dol': Tom Bombadil's Nonsense, or Tolkien's Creative Uncertainty? A Response to Thomas Kullmann," *Connotations* 25 no. 1, (2015/2016).
20 Forest-Hill, 102.
21 Tolkien, 173.

Other characters in *The Lord of the Rings* also recognize Tom's ancient existence. At the Council of Elrond, Elrond remarks, "But I had forgotten Bombadil, if indeed this is still the same that walked the woods and hills long ago, and even then was older than the old."[22] While he is experienced beyond most adults and possesses an almost supernatural power, Tom has maintained his childlike joy and peace. A recurring theme throughout *The Lord of the Rings* is that wherever there is both power and knowledge comes the fear of corruption, yet this is not so for Bombadil. Thus, by possessing the best of both knowledge and innocence, Tom calls readers to embrace the truth that we don't have to be one or the other in order to live in harmony with the world around us. Accordingly, Jensen and MacDonald note that: "It is with Bombadil that the mythical image of childhood is evoked in its purest form."[23]

Another criticism of Tom's character is that his unwillingness or inability to leave the borders of his home territory shows his limited influence in Middle-earth and relevance to the novel as a whole. Forest-Hill concedes this point, stating that "the power and effect of Tom's language appear to be geographically limited when he refuses to cross the border of the lands he controls."[24] At the Council of Elrond, Gandalf shares a similar sentiment saying, "[Tom] is withdrawn into a little land, within bounds that he has set . . . and he will not step beyond them."[25] On the other hand, Tom Bombadil's influence spreads far and wide, even if his physical presence does not. Creatures and beings from all over Middle-earth know of his presence and they all have their own name for him. Elrond brings this up also at the council saying, "[Bombadil] was not then his name. Iarwain Ben-adar we called him, oldest and fatherless. But many other names he has since been given by other folk: Forn by the Dwarves, Orald by Northern Men, and other names beside."[26]

Further, Tom has a direct impact on many events throughout the story. In each of these occurrences, a temporary moment of darkness turns light at the recollection of Tom's name. The first example appears when Frodo and Sam are taken by a barrow-wright into a hole under the ground. In their distress, they call out to Tom and "there was a loud rumbling sound as of stones rolling and falling, and suddenly *light* streamed in, real light of day. A low, door-like opening appeared

22 Tolkien, 265.
23 Jensen & MacDonald, 37-42.
24 Forest-Hill, 103.
25 Tolkien, 265.
26 Tolkien, 265.

at the end of the chamber beyond Frodo's feet; and there was Tom's head (hat, feather, and all) framed against the light of the sun rising red behind him."[27] Later, in Shelob's lair as Sam is preparing to fight the spider, we are told:

> And he laid his hand upon the hilt of his sword; and as he did so, he thought of the *darkness* of the barrow whence it came: I wish old Tom was near us now! he thought. Then, as he stood, darkness about him and a blackness of despair and anger in his heart, it seemed to him that *he saw a light:* a light in his mind, almost unbearably bright at first, as a sun-ray to the eyes of one long hidden in a windowless pit.[28]

At the end of the story when Frodo is sailing away on the sea, [he] "smelled a sweet fragrance on the air and heard the sound of song that came over the water. . . . [I]t seemed to him that as in his dream in the house of Bombadil, the grey rain-curtain turned all to silver glass and was rolled back, and he beheld white shores and beyond them a far green country under a swift sunrise."[29] For such an "insignificant character," Tom Bombadil's image is recalled often and significantly, providing strength and light and resilience in the face of great adversity for those who invoke his presence.

Ultimately, Tom Bombadil transcends not only the temptation of the ring but the limitations of all the other characters. He overcomes the ring while remaining both innocent and experienced. In addition, the utterance of his name brings light into dark places, serving as a reminder of redemption even though he is supposedly "limited" by his territorial bounds. Finally, he represents a life lived free from the desire for power. Instead he lives in harmony with all creatures.

Upon entering Tom Bombadil's dominion, Frodo is lost in more ways than one. All odds are against him, yet in Tom's home, Frodo is rejuvenated and redirected for the journey ahead. Tolkien's "insignificant" character provides readers that same consolation. Jensen and MacDonald state: "The ring journey confronts Frodo with the question of how to transcend himself and partake of the divine while remaining a mere mortal."[30] Perhaps this is so for Frodo. But clearly Tolkien presents Tom Bombadil as already transcendent. By his example, he inspires readers to do the same.

27 Tolkien, 187-88.
28 Tolkien, 719.
29 Tolkien, 1030.
30 Jensen & MacDonald, 37-42.

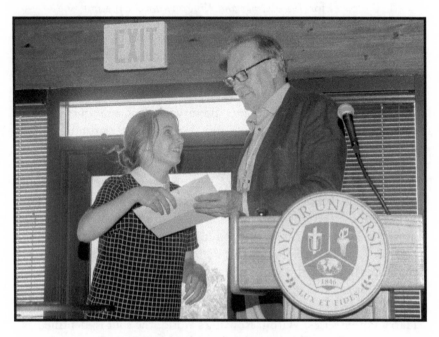

Grace Seeman receives a student writing award
for her essay, "A Passive Darkness."

Rings, Charms, and Horcruxes:
Souls and Sacrificial Love in
Harry Potter and *The Lord of the Rings*

by Emily Austin

Emily Austin is an artist and photographer, studying fantasy literature at Signum University. Emily integrates her many interests by visually exploring the imagined worlds of Tolkien, Lewis, and others. She recently designed the cover for *The Inklings and King Arthur*. At present, she is creating a series of illustrations for *Perelandra*, including several pieces shown at the 2018 Colloquium. Emily displays her work at emilyaustindesign.com and on Twitter and Instagram @emmekamalei.

Two of the most famous literary phenomena of the past century, *The Lord of the Rings* and *Harry Potter*, naturally invite many comparisons. J.R.R. Tolkien and J.K. Rowling use their stories to address shared themes: power, fate, love, friendship, death, and sacrifice. It has been argued that the *Harry Potter* series also conforms to Tolkien's definition of Fantasy as presented in "On Fairy-stories" (Sturgis). Both authors also use vivid dichotomies to illustrate ideas about morality and human nature. Such contrasting pairs in *Harry Potter* and *The Lord of the Rings* especially emphasize the importance of the soul and its relationship to love, particularly love that is sacrificial.

The concept of the soul figures prominently in the plot of the Harry Potter series. Within Rowling's world, the soul is identified as the center of personhood, and it flourishes through loving, symbiotic relationships with others. An unhealthy soul, by contrast, rejects all but the self. Rowling's primary image for this idea is Voldemort and his infamous Horcruxes, the dark objects made by splitting his own soul through acts of violence. Voldemort seeks power and self-actualization to a truly inhuman degree, a choice that leads to disastrous consequences for the wizard community and for Voldemort himself. The series explicitly ties one other spell to souls: the Fidelius Charm, which involves "the magical concealment of a secret inside *a single, living soul*". The information is hidden inside the chosen person, or Secret-Keeper" (*Prisoner* 216, emphasis mine). Knowledge

held by a Secret-Keeper is "impossible to find" unless revealed by that individual alone. The Horcrux and the Fidelius Charm are linked by their association with souls. In fact, the Fidelius Charm functions as the inverse of a Horcrux: instead of encasing a soul fragment in a physical object, this spell places immaterial information within a soul.

A parallel dichotomy exists within *The Lord of the Rings*, in which Tolkien sets the Three Rings of the Elves against the One Ring. Like Horcruxes, which contain a portion of their creator, the Ring might be said to contain a bit of Sauron, for he "let a great part of his own former power pass into it, so that he could rule all the others" (Tolkien 51). In contrast, Galadriel, Elrond, and Gandalf wield the Three Elven Rings to protect and preserve Middle-earth, in an act that mirrors the Fidelius Charm's purpose. They seek to destroy the One Ring despite the possibility that their own power will fade. Tolkien and Rowling each strongly contrast dominance and power with a willingness to give up power and even life itself for the sake of others. They also both insist through their works that evil is inherently self-destructive, and that love triumphs through the relationship of the self with the other.

THE SOUL AND HUMANITY

Both *The Lord of the Rings* and *Harry Potter* probe the nature of humanity – or more precisely in these fantasy universes, rational/relational creatures of all sorts. In Rowling's series, a person is human to the degree that her soul is healthy. In a philosophical look at souls in the Potterverse, Scott Sehon concludes that the overall depiction does not consistently uphold a particular philosophical standpoint, but rather a "sentimental" conception, where "the soul is associated with that which makes us most human, with our capacity to love and our moral conscience" (17). The loose parameters of this presentation mean that Rowling's souls may be interpreted spiritually, psychologically, and/or metaphorically. Certainly, they are associated with an afterlife throughout the series, notably so in the mechanics of Horcruxes. Thus Hermione describes a Horcrux as "the complete opposite of a human being" (*Hallows* 43) precisely because a soul can survive beyond the body housing it, whereas the soul fragment placed in a Horcrux will no longer be able to exist without its container.

In *Harry Potter and the Half-Blood Prince*, Professor Slughorn claims that a Horcrux is "an object in which a person has concealed part of their soul" so that "even if one's body is attacked or destroyed, one cannot die, for part of the soul remains earthbound and

undamaged" (*Prince* 413). A dark witch or wizard achieves this split through murder, "the supreme act of evil" (414). Slughorn is quick to assert the unnaturalness of such an act: "you must understand that the soul is supposed to remain intact and whole. Splitting it is an act of violation, it is against nature" (413). By definition, then, a Horcrux requires harming both the self and another. By creating multiple Horcruxes, Voldemort "[grows] less human with the passing years" (*Prince* 417). Rowling represents this inner state through Voldemort's physical attributes, particularly his face: "hairless, snakelike, with slits for nostrils and gleaming red eyes whose pupils were vertical" (*Hallows* 1). The cavalier, cruel way Voldemort treats souls constitutes the most terrifying aspect of his character.

Of course, Sauron is also famously associated with a Red Eye. Characters in *The Lord of the Rings* frequently use epithets such as "The Eye" or "The Enemy" rather than name him outright. Such language suggests that Sauron as an individual being has faded or diminished; thus readers are encouraged to view him more as an impersonal, malicious power than as a person. Furthermore, as Anna Smol notes, despite some type of physical form, "Sauron's presence is generally felt more as a disembodied enemy than someone with actual limbs" ("Frodo's Body"). Like Voldemort, the other Dark Lord, Sauron is associated with a sense of decline. Elrond confirms that, before creating the One Ring, Sauron "was not yet evil to behold," and thus was able to deceive the Elven-smiths who created the lesser rings (Tolkien 242). It was only later that Sauron's true nature was fully revealed. For both Dark Lords, external appearance eventually comes to reflect an internal state.

As an extension of its master's will, the One Ring dehumanizes its victims. For example, the Ringwraiths are subject to its control via their own nine rings and have gradually suffered "loss of life and soul" to become "deathless and bodiless servants of Sauron (Flieger, "The Body in Question"). Gollum becomes perhaps the most obvious example of the Ring's effects. His long possession of it (or perhaps more accurately, the Ring's long possession of him) caused Sméagol's psychological split into two identities: one conniving and evil, the other broken and conflicted, yet retaining a glimmer of personhood. In Gandalf's description, Gollum had just "a little corner of his mind that was still his own, and light came through it. . . . But that, of course, would only make the evil part of him angrier in the end. . . . Unless it could be cured" (Tolkien 55). Although Tolkien does not use the word soul the way Rowling does, this seems primarily to

stem from his use of Anglo-Saxon concepts of spirit and body instead (Devaux 154). Indeed, if Gollum were transferred, hypothetically, into the Potterverse, it would seem natural to say that his soul was under attack by the Ring. The idea of his split personality certainly finds a parallel in Voldemort's divisive magic.

The Ring also powerfully diminishes Frodo, who develops a unique understanding for Gollum's condition through his own experience. Indeed, their situations are closely tied. According to John Garth, Gollum functions as "the yardstick of [Frodo's] degradation towards the sub-human" (49). Once again, there are outer physical effects revealing internal conditions. Verlyn Flieger suggests that "what happens to Frodo's body over the course of his journey is the outward manifestation of his changing inner condition" ("Body"). For example, the Ring's imposition of invisibility can be interpreted as symbolizing "a progressive fading and loss of self" in Frodo. Elsewhere, Flieger maintains that both Frodo and Gollum become internally split, their respective situations mirroring each other (*Splintered* 149-50). John Garth echoes this, claiming that, like Gollum, Frodo "starts to show signs of a split personality" as the Ring slowly overwhelms him (50). Anna Smol expresses it slightly differently, noting that as Frodo's journey progresses, "the boundaries of his self are disintegrating" ("Frodo's Body"). For Tolkien, as for Rowling, physical change and degradation becomes a powerful tool for depicting a character's inner state.

If Tolkien and Rowling both provide readers with memorable (and sometimes horrifying) images of the havoc evil wreaks upon individuals, they also balance these pictures of degradation with equally powerful images of goodness and healing. The Three Rings of the Elves and the Fidelius Charm lie on this side of the spectrum, representing a virtuous desire to preserve and protect things outside oneself. Rowling's Fidelius Charm is protective by nature. The magic utilizes an individual's soul to house information in order to shield lives, usually by preserving a place of refuge from identification and infiltration (*Prisoner* 216, *Phoenix* 105). As far as can be deduced from the text, the soul in question is not harmed because the spell simply enhances a common human activity – the acquisition and protection of knowledge – rather than attempting something unnatural like the Horcrux. It is an inverse of the Horcrux not only in function, but also in purpose – protecting others over the self; preserving life, but not seeking immortality.

Tolkien's Elven Rings are also essentially protective rather than

offensive, "not made as weapons of war or conquest" (Tolkien 268). As the One Ring always carries out its maker's intentions, the Three Rings also consistently reveal the purposes of their creators. Readers learn specifically that "those who made them did not desire strength or domination or hoarded wealth, but understanding, making, and healing, to preserve all things unstained" (268). Gandalf's status as a Ring-bearer aligns with his desire to see Gollum healed and reveals his understanding and compassion for the souls of others. His Ring also connects with his overarching mission to "contest the power of Sauron" by unifying others, while "forbidden to match his [Sauron's] power with power, or to seek to dominate Elves or Men by force and fear" (1084). Unlike Sauron (or Voldemort), Gandalf seeks to unite free creatures rather than dominate, in keeping with his given task of opposing not only Sauron's intentions but also his methods.

The other two bearers similarly use their Rings to resist the Dark Lord. Elrond illustrates the healing virtues attributed to the Elven Rings. His status as a "master of healing" comes to the forefront when he tends Frodo's Nazgul-wound, saving the hobbit from a terrible fate as "a wraith under the dominion of the Dark Lord" (Tolkien 221, 222). As for Galadriel, she uses her Ring to create Lothlórien, a land known for its unchanging and restorative qualities (349, 351, 358). Secondly, she contributes gifts to the Fellowship that aid them throughout the rest of the story. Significantly, Verlyn Flieger identifies Galdariel's Phial, her gift to Frodo, as an object "opposite" to the Ring itself (*Splintered* 159). The Phial is closely related to Galadriel's mirror, in whose waters it preserves the light of Eärendil (Tolkien 376). When Frodo and Sam meet with Galadriel and look into her mirror, she emphatically states that the door of her mind "is closed" to Sauron, while "[lifting] up her white arms, and [spreading] out her hands towards the East in a gesture of rejection and denial" (365). Immediately following, the text draws attention to "a ring about her finger . . . like polished gold overlaid with silver light." This passage vividly illustrates the opposition of Galadriel's Ring to Sauron's. As the story continues, her gift of the Phial serves as a recurring reminder of her active resistance to the Dark Lord's will.

Relational Goodness, Self-Destructive Evil

In keeping with themes of domination and community, each story's heroes and villains demonstrate very different attitudes towards relationships and trust. In *Harry Potter*, characters identified

as admirable generally value relationship, friendship, and community. Healthy friendships grow from an awareness of and value for the needs of others, not just the self (Thorsrud 40). Paris and Johnston see this as a core tenet of the books, maintaining that the series consistently affirms "the duty of care toward others" as what "enables human freedom and flourishing." This attitude of caring can only develop when Harry and other characters "see those they love as ends-in-themselves, ends for whom they would lay down their lives" ("Hallowing"). By contrast, when people view others as objects, freedom and flourishing are not possible. Even well-intentioned Potter characters demonstrate this truth. Sirius Black treats the house-elf Kreacher with disdain and indifference, failing to see him "as a being with feelings as acute as a human's," and this choice leads directly to Kreacher's betrayal and Sirius's own death (*Phoenix* 766).

Fidelius Charms uphold the series-long emphasis on relationship, requiring trust and interdependence to succeed. A Secret-Keeper takes on personal risk as a potential target of attack in order to protect others. The charm's subjects bear risk too: if the relationships involved degrade, its protection over them will be useless. We see such a breakdown in Peter Pettigrew's betrayal of Lily and James Potter, which enabled Voldemort to find and kill them. When Dumbledore says that "[Lily] and James put their faith in the wrong person" (*Hallows* 280), he is not blaming the Potters for their own deaths, but he is acknowledging an inherent risk in trusting others. It requires vulnerability; nothing completely safeguards against the chance that someone might let us down. Nevertheless, as the Potter series upholds, trust is worth the risk.

Tolkien's protagonists similarly see the importance of faithful, trusting relationships. John Garth points out that, like Tolkien's own wartime experiences, "it is in camaraderie that Frodo finds the key to endurance" (43). The Three Rings themselves were created in trust, which admittedly left them open to Sauron's deceptions. In their "eagerness for knowledge," Celebrimbor and the other Elven-smiths accepted Sauron, "received his aid and grew mighty in craft, whereas he learned all their secrets, and betrayed them, and forged secretly in the Mountain of Fire the One Ring to be their master" (Tolkien 242). We might say about these Elven-smiths what Dumbledore said about James and Lily – they trusted the wrong person. Galadriel explains to Frodo the consequence of this mistake: "if you fail, then we are laid bare to the Enemy. Yet if you succeed, then our power is diminished, and Lothlórien will fade" (365). Nevertheless, in a choice requiring

both trust and self-sacrifice, Galadriel rejects the One Ring and accepts the tragic fate awaiting her and her people, saying, "The love of the Elves for their land and their works is deeper than the deeps of the Sea, and their regret is undying. . . . Yet they will cast all away rather than submit to Sauron: for they know him now" (365). Rather than take the Ring and attempt to save Lothlórien with it, Galadriel chooses to trust Frodo. Elrond and Gandalf make the same choice, understanding it as the only way to overcome a great evil.

Far from displaying this sort of trust, Sauron consistently destroys relationships along the path to power. Sauron uses the Ring to dominate and dehumanize those under his control. Sam also ponders the "lies or threats" that the Dark Lord must have used to coerce men from distant lands to fight for him (661), and this seems to be the modus operandi of all Sauron's forces. Sauron sows division among his foes: as Haldir acknowledges, "in nothing is the power of the Dark Lord more clearly shown than in the estrangement that divides all those who still oppose him" (348). Sauron created the Ring for domination, so it also fosters the same desire in anyone who encounters it, twisting even the best of intentions into destructive ones. This temptation is a bait and switch, however, since any power wielded with the Ring will ultimately serve Sauron instead of its current bearer. Indeed, with time, the Ring removes individual will completely, bringing its bearer under Sauron's control. Drawing a comparison to modern warfare, Anna Smol describes the Ring as "a machine that drains individuals of their ability to act on their own." Just as the soldiers of the twentieth century encountered new methods of war that left them feeling "dehumanized" and powerless, so the Ring removes self-determination and "consumes . . . autonomy in order to fulfill its own desire (which is one and the same with Sauron's): to dominate all life" ("Frodo's Body"). This is why it is impossible to use the Ring in equitable collaboration with others – as Gandalf reminds Saruman, "only one hand at a time can wield the One" (Tolkien 260).

The philosophy of Voldemort sounds strikingly similar in its pursuit of solitary power and rejection of relationship. In the very first Harry Potter book, Voldemort's servant Quirrell claims, "There is no good and evil, there is only power, and those too weak to seek it" (*Stone* 291). Paris and Johnston identify Voldemort's position as "neo-Nietzschean," a worldview in which "neighbor-love is a vice rather than a virtue" ("Hallowing"). If power is all that matters, then others are mere tools for obtaining it. Throughout the saga, Voldemort does consistently display this attitude, "[insisting] on the sacrifice of others

to the god of his own self." Dumbledore asserts that even as a child, Tom Riddle was "highly self-sufficient, secretive, and, apparently, friendless. . . . He preferred to operate alone" (*Prince* 230). Adult Voldemort chooses even more extreme self-reliance, and quite literally rejects the rest of humanity by killing others to prolong his own life. He may call Death Eaters his "friends" (*Goblet* 217), but in reality they are "merely instruments to be manipulated, punished, and rewarded insofar as they fulfill his needs" (Thorsrud 43).

Like the Ring, Voldemort's Horcruxes also reproduce seeds of division. In *Harry Potter and the Deathly Hallows*, Harry, Ron, and Hermione must battle the negative influence of the locket Horcrux while waiting to destroy it. Later, Ron describes how the object exacerbated his negative thoughts: "it made me think stuff – stuff I was thinking anyway, but it made everything worse" (*Hallows* 155). The Horcrux played upon each person's mental and emotional weak spots. Voldemort's soul-shard within sought to turn the three friends against each other for its own purposes, much like the Ring's influence on anyone too close to it. Both objects foster domination and extreme self-sufficiency, both in service of their creators' goals and as a reflection of their values.

Such pursuit of domination and self-sufficiency comes with its own vulnerabilities, however. While Voldemort imagines himself invincible, his multiple-Horcrux safety net, so carefully crafted to avoid direct dependence on others, still fails in the end. Jennifer Hart Weed links this idea to the claim of medieval philosopher Boethius, that "evil dehumanizes the evildoer" (151). As discussed above, dehumanization certainly seems to be a direct result of soul-splitting. Dumbledore says of Voldemort that "crucial parts of himself have been detached for so long, he does not feel as we do," and thus he fails to perceive that outside forces are destroying his Horcruxes (*Prince* 422). As Nikolaus Wandinger asserts, "this kind of immortality . . . comes at a great cost," not only to the victims, but also to the maker himself (32). In the final installment of the series, Voldemort cannot even perceive Harry's frequent telepathic intrusions into his mind. Again, Dumbledore has some applicable (and prophetic) commentary, when in the previous book he assures Harry:

> "You are protected . . . by your ability to love! . . . The only protection that can possibly work against the lure of power like Voldemort's You have flitted into Lord Voldemort's mind without damage to yourself, but he cannot possess you without enduring mortal agony. . . . He was in such a hurry to mutilate

his own soul, he never paused to understand the incomparable power of a soul that is untarnished and whole." (424-25)

Rowling pits Harry's capacity for love directly against Voldemort's all-consuming pursuit of power. Voldemort's downfall results directly from hubristic trust in himself, coupled with his disdain for relationships and his rejection of soul care. Indeed, even during their final confrontation, Voldemort refuses Harry's warnings about the Elder Wand and "succumbs to his own self-deception; his downfall is a self-judgment" (Wandinger 45). Harry, with a healthy soul rooted in care for friends and intense desire for family, ultimately possesses power of a sort that Voldemort fails to comprehend – a power rooted in love (*Phoenix* 776).

Sauron similarly undermines himself by failing to understand his enemies. This again relates to the Boethian view that evil is "more harmful to the malefactor than to the victim" (T. A. Shippey 133). Of course, this perspective becomes deeply troubling if taken too far, and Shippey notes that Tolkien's world balances this idea with other, more "Manichean" assertions that "evil does exist, and is not merely an absence . . . it has to be resisted and fought, not by all means available, but by all means virtuous" (134). Gandalf, Elrond, and Galadriel understand this, which is why they reject Sauron's methods as much as his ideals. Elrond explains that the Council's plan to destroy the One Ring is completely foreign to the Dark Lord's thought: "the only measure that he knows is desire, desire for power; and so he judges all hearts. Into his heart the thought will not enter . . . that having the Ring we may seek to destroy it. If we seek this, we shall put him out of reckoning" (Tolkien 269). This is indeed what happens – Sauron only learns of his greatest danger at the last hour, when Frodo succumbs to the Ring on Mount Doom:

> The Dark Lord was suddenly aware of him . . . and the magnitude of his own folly was revealed to him in a blinding flash, and all the devices of his enemies were at last laid bare. Then his wrath blazed in consuming flame, but his fear rose like a vast black smoke to choke him. For he knew his deadly peril and the thread upon which his doom now hung. (946)

In *Splintered Light*, Verlyn Flieger says of Sauron's fall that "darkness causes itself to be un-made" (160). Evil does not trouble itself to understand goodness or virtue, love or friendship – and that, of course, is precisely what becomes its undoing. Through the characters of Sauron and Voldemort, Tolkien and Rowling offer

pictures of evil as inherently self-destructive (and, in reverse, pictures of good as healing and salvific).

CONCLUSION: LOVE AND SACRIFICE

This, then, is one of many important parallels between the Tolkien Legendarium and the Potter universe. Both works insist on a version of personhood that is rooted in love, trust, and self-sacrifice. Healthy souls are outward focused and concerned primarily for the other and the building of significant relationships. Sacrifice occupies a key position in both Tolkien's and Rowling's creations. It characterizes the bearers of the Elven-Rings, who all reject the temptation of the One Ring – despite great personal cost – because they understand its destructive nature. Frodo too represents the great value (and great cost) of sacrifice, speaking to it when he says, "I tried to save the Shire, and it has been saved, but not for me. It must often be so . . . when things are in danger: someone has to give them up, lose them, so that others may keep them" (Tolkien 1029). Frodo does finally succumb to the Ring's control on the Cracks of Doom. Nevertheless, his original choice to bear it for others and his sacrificial ring-bearing (cross-bearing) allows for a measure of redemption to enter the story.

In Harry's saga, the word sacrifice appears "only in reference to clear acts of self-giving out of love" (Wandinger 47). James and Lily Potter choose self-sacrifice over their own lives, dying to protect their son. With Lily in particular, that act becomes the axis around which the entire seven-book series turns. Gallardo and Smith maintain that "it is Lily Potter's eternal power of love that thwarts Voldemort throughout the series" (98). Significantly, at the very moment when the Potters realize their Fidelius Charm has been broken, Lily's response deals the first death-blow against Voldemort's Horcruxes. Thus, at the moment when Fidelius Charm and Horcruxes meet, the spell which appears weaker and more vulnerable proves to be eventually victorious.

Lily's sacrifice gives Harry immediate magical protection, but it also yields even greater fruit at the climax of the story, when Harry follows her example by offering up his own life for others. Wandinger emphasizes that "It is the thoughts of his friends, the people he loved, who risked and lost their lives for him . . . that drive him. In short, it is love and care for the life of others that motivates Harry to go along the path to his death" (39). Clearly, both *Harry Potter* and *The Lord of the Rings* insist that loving, trusting, and sacrificing for others is essential for the health of individual souls – and for the health of

larger communities. Tolkien and Rowling develop this concept in different ways, but their narratives espouse similar messages: evil rejects community, damages itself in pursuit of power, and enables its own destruction by failing to understand goodness. Goodness upholds mutual love and trust to foster community. Those pursuing goodness will undergo moral struggles, but learn to trust one another, reject the methods of evil, and make sacrificial, loving choices even when hope seems lost. Horcruxes and the One Ring on one side and the Fidelius Charm and Elven Rings on the other provide a clear delineation of these underlying messages.

WORKS CITED

Devaux, Michaël, translated by David Ledanois. "Elves: Reincarnation." *J.R.R. Tolkien Encyclopedia: Scholarship and Critical Assessment*, edited by Michael D. C. Drout, Routledge, 2007, pp. 154-55.

Flieger, Verlyn. "The Body in Question: The Unhealed Wounds of Frodo Baggins." *The Body in Tolkien's Legendarium: Essays on Middle-Earth Corporeality*, edited by Christopher Vaccaro, Kindle ed., McFarland & Company, Inc., 2013.

---. *Splintered Light: Logos and Language in Tolkien's World.* 2nd ed., The Kent State University Press, 2002.

Garth, John. "Frodo and the Great War." *The Lord of the Rings, 1954-2004: Scholarship in Honor of Richard E. Blackwelder*, edited by Wayne G. Hammond and Christina Scull, Marquette University Press, 2006, pp. 41-56, http://public.eblib.com/choice/publicfullrecord. aspx?p=476963. WorldCat.org.

Gallardo C., Ximenia, and C. Jason Smith. "Happily Ever After: Harry Potter and the Quest for the Domestic." *Reading Harry Potter Again: New Critical Essays*, edited by Giselle Liza Anatol, Praeger, 2009, pp. 91-108.

Hart Weed, Jennifer. "Voldemort, Boethius, and the Destructive Effects of Evil," *Harry Potter and Philosophy: if Aristotle Ran Hogwarts*, edited by David Baggett and Shawn E. Klein, Open Court, 2004, pp. 148-57.

Paris, Jamie, and Susan Johnston. "The Hallowing of Death: Sacrifice, Salvation, and the Death of the Superman in Harry Potter." *Harrypotterforseekers. com*, http://www.harrypotterforseekers.com/articles/ thehallowingofdeath.php.

Rowling, J. K. *Harry Potter and the Deathly Hallows (Hallows).* Kindle ed., Pottermore, 2015.

---. *Harry Potter and the Goblet of Fire (Goblet).* Kindle ed., Pottermore, 2015.

---. *Harry Potter and the Half-Blood Prince (Prince).* Kindle ed., Pottermore, 2015.

---. *Harry Potter and the Order of the Phoenix (Phoenix)*. Kindle ed., Pottermore, 2015.

---. *Harry Potter and the Prisoner of Azkaban (Prisoner)*. Kindle ed., Pottermore, 2015.

---. *Harry Potter and the Sorcerer's Stone (Stone)*. Kindle ed., Pottermore, 2015.

Sehon, Scott. "The Soul in Harry Potter." *The Ultimate Harry Potter and Philosophy: Hogwarts for Muggles*, edited by Gregory Bassham, Wiley, 2010, pp. 7-21.

Smol, Anna. "Frodo's Body: Liminality and the Experience of War." *The Body in Tolkien's Legendarium: Essays on Middle-earth Corporeality*, edited by Christopher Vaccaro, Kindle ed., McFarland & Company, Inc., 2013.

Sturgis, Amy H. "Harry Potter is a Hobbit: Rowling, Tolkien, and The Question of Readership," *CSL: The Bulletin of the New York C. S. Lewis Society*, vol. 35, no. 3, 2004, pp. 1-15.

Thorsrud, Harald. "Voldemort's Agents, Malfoy's Cronies, And Hagrid's Chums: Friendship in Harry Potter," *Harry Potter and Philosophy: If Aristotle Ran Hogwarts*, edited by David Baggett and Shawn E. Klein, Open Court, 2004, pp. 38-48.

Tolkien, J. R. R. *The Lord of the Rings*. One volume ed., Kindle, Houghton Mifflin, 2005.

Shippey, T. A. *J.R.R. Tolkien: Author of the Century*. Houghton Mifflin, 2001.

Wandinger, Nikolaus. "'Sacrifice' in the Harry Potter Series from a Girardian Perspective." *Contagion: Journal of Violence, Mimesis, and Culture*, vol. 17, 2010, pp. 27-51.

Baptising the Reader:
The Faithful Imagination in George MacDonald

by Lesley Willis Smith

Lesley Willis Smith is a graduate of the Universities of Sheffield (UK) and Alberta (Canada), where she wrote her PhD dissertation on Jane Austen. For several years she was a member of the Department of English of the University of Guelph, Ontario, specializing in the nineteenth-century British novel and children's literature. Her publications include articles on Jane Austen and George MacDonald, and the recent book *The Downstretched Hand: Individual Development in George MacDonald's Major Fantasies for Children*. Lesley and her husband Christopher live in Canterbury, England.

C.S. Lewis famously affirmed that his imagination was "baptized" by reading George MacDonald's *Phantastes* (Lewis xxxiii); and G.K. Chesterton described MacDonald's *The Princess and the Goblin* as a book which "has made a difference to my whole existence" (9). This comment is particularly striking since *The Princess and the Goblin* is technically a children's book. But MacDonald says, "I do not write for children, but for the childlike, whether of five, or fifty, or seventy-five" ("The Fantastic Imagination" 9); probably because he believes that "We *are* not yet – we are only *becoming*" ("Sorrow" 97). This *becoming* is at the heart of George MacDonald's vision of the mystery of life.

My purpose is to examine that vision in *At the Back of the North Wind, The Princess and the Goblin*, and *The Princess and Curdie*. At the heart of the mystery is the need to develop a relationship between the self and God – the child and the Father, or, as MacDonald says, between the "upstretched" and the "downstretched hand" ("Sketch" 72) – for MacDonald sees the ultimate fulfilment of the individual in oneness with God. "I baptise thee in the name of the Father, and of the Son, and of the Holy Spirit," says the Christian formula – and at a profound level the three books are about the relationship of the soul with God in the persons of the Trinity: the Father in *At the Back of the North Wind*, the Son in *The Princess and the Goblin*, and the Holy Spirit in *The Princess and Curdie*.

It is a mistake, however, to think of these three books as a trilogy; even the titles of the two *Princess* books refer to different people –

the first to Princess Irene and the second to Queen Irene in her re-incarnation as "the old princess." But the books are organically linked. Diamond, in *At the Back of the North Wind*, reads "the story of the Little Lady and the Goblin Prince," and *The Princess and the Goblin* ends: "[T]he rest of the history of *The Princess and Curdie* must be kept for another volume" (308).

Diamond, in *At the Back of the North Wind*, has human father figures – Mr. Raymond, who becomes virtually a father figure to the whole family, the policeman who follows Diamond to Old Sal's cellar, and his own father, Joseph the coachman. But God the Father works here through an intermediary presence, and a feminine one at that. North Wind, in some respects a mother figure – "The yacht shall be my cradle, and you shall be my baby," she says before blowing Diamond towards the North Pole (105) – is not only a force of nature but the doorway to eternity. Diamond walks through her to reach the imaginary land at her back when he is seriously ill. While enlarging his experience of life, she prepares him to die. On their very first meeting, when she persuades him to go out at night, "sharp as a knife came the wind against his little chest and his bare legs" (18). But Diamond never recognises her as death, and she does not insist on it: "'Sometimes [people] call me Bad Fortune, sometimes Evil Chance, sometimes Ruin; and they have another name for me which they think the most dreadful of all.' 'What is that?' asked Diamond, smiling up in her face. 'I won't tell you that name,'" she replies (363-64).

Diamond, however, is not passive. He gets down from North Wind's back to help Nanny; he has her taken to hospital when she falls ill, visits her there, and later has her admitted into his family as a nursemaid. He becomes a father figure himself, driving the cab with the help of Old Diamond, the horse for whom he has been named, after his father falls ill. North Wind also teaches Diamond courage. When she takes him up to the clerestory of a cathedral and he is afraid, she lets go of his hand and vanishes – leaving him to walk along feeling little puffs of wind. "You had to be taught what courage was," she says when she returns (83), and he never trembles again.

In London, North Wind never appears in person. But here Diamond, in a very practical way, becomes involved in the everyday world about him, something necessary to full individuation – and his father, Joseph, "seemed ever so much better from finding that his boy was already not only useful to his family but useful to other people, and quite taking his place as a man who judged what was wise, and did work worth doing" (251).

Eventually Diamond and his family move to the country estate of the newly married Raymonds, and Diamond is clearly approaching the eternity which North Wind can only imagine. But she must stop, and Diamond must go on: "I should like to get up into the sky," he tells his friend the tutor (344). And one night North Wind takes him out through his tower window, coming close to fulfilling one of the prophecies of Jeremiah: "Death is come up into our windows, and is entered into our palaces, to cut off the children from without" (Jeremiah 9:21).

When they first meet, Diamond is afraid that going out with North Wind may give him a toothache: "You shall not be the worse for it – I promise you that," she says. "You will be much the better for it" (8). MacDonald has turned a negative into a positive. Death is solemn and awe-inspiring, but not terrifying; the unknown is full of promise, as the tutor says at the end: "A lovely figure, as white and almost as clear as alabaster, was lying on the bed. I saw at once how it was. [Everyone] thought he was dead. I knew that he had gone to the back of the north wind" (378). Diamond has been taught how to live, how to die – and how to let go: "There is one thing you may be sure of," the tutor has told him, "that there is a still better love than that of the wonderful being you call North Wind" (376) – and that, though never specifically referred to, is the love of God the Father.

In *The Princess and the Goblin*, the case is very different. This book is a fairy tale, with the customary element of threat. Irene's mother is dead, her father, the king, lives far away, and the princess is not allowed out after dark for fear of malevolent goblins. But Irene's many protectors – the servants, the guards, Curdie the miner boy – all prove totally ineffectual because they are protecting her from the wrong danger. Spiritual danger is now the menace to be feared, and the sense of divine assistance comes to the princess through her mysterious great-great-grandmother, Queen Irene, whom she discovers living, unknown to anyone else, at the top of the castle tower.

Queen Irene is associated, but not clearly identified with, Jesus, the perfect self in whom all possibility of fulfilment is to be found. Almost omniscient but not quite, she knows everything that happens to Curdie when he is captured by the goblins, but not what happens to Irene. When she sends her under the mountain to rescue him, she is worried about her granddaughter: "I've been waiting for you . . . and beginning to think whether I had not better go and fetch you myself," she tells Irene on her return (222-23). And while the Queen implies that she is nearly two thousand years old (the length of the

Christian era), Jesus himself says simply: "Before Abraham was, I am" (John 8:58). But Queen Irene's name means "peace," and "the Prince of Peace," in Isaiah, is one of Jesus's titles (Isaiah 9:6). And she does what Jesus does, not only washing the princess's feet but healing her wounded thumb and forgiving her on the night when Irene, in a panic, disobeys her grandmother's instructions to come to her and rushes out into the dark. This forgiveness is particularly important, for Irene finds it hard to forgive herself. And not only does the Queen excuse her – "You were taken by surprise, my child, and are not so likely to do it again" (147) – but she gives her a ring attached to a marvelous thread she has been spinning for her.

Irene's relationship with her grandmother turns on the development of the princess's faith. She has a good start, for when she is out in the dark, she sees Queen Irene's lamp shining straight through the stone wall of the tower – "It is a gift born with you," says the Queen (150). For some time, however, Irene wonders if her grandmother could have been a dream; but the moment she temporarily surrenders to doubt, a dove flies in through the window and perches on her head – something which recalls the baptism of Jesus (Matthew 3:16, Mark 1:10, Luke 3:22).

Queen Irene's influence is significant from the outset. Irene is much struck by their having the same name, and much more by her grandmother's saying: "I came here to take care of you" (26). But the first sign of growing maturity in the princess is that next day, faced with her nurse's inability to believe what she says about her grandmother, she finally asks the nurse *why* she won't believe her: "'Because I can't believe you,' said Lootie. . . . 'Ah! Then, you can't help it,' said Irene, 'and I will not be vexed with you any more'" (35). This growth in understanding prepares her for what happens much later when she takes Curdie to meet her grandmother; for when he can't see the marvelous things around him – including the Queen herself – Irene asks him what he does see. And she concludes: "I must be fair – for if I'm not fair to other people, I'm not worth being understood myself" (228).

Not until almost the end does Irene hear that the goblins had planned to marry her to their prince, and the greatest risk she runs when she follows the Queen's thread under the mountain is the risk of losing her faith in her grandmother. But after a moment of desolation when the thread disappears into a pile of stones – "She was forsaken indeed!" (201) – she starts to move them. "[W]ith aching back, and bleeding fingers and hands, she worked on" (205). And when Curdie

proves to be imprisoned there and helps her from the other side, she goes straight into the cave and leads him out through it.

Later the Queen 'baptises' Irene in her silver bath: "[S]he sank in the clear cool water. . . . When she opened her eyes, she saw nothing but a strange lovely blue *over* and beneath and all about her" (230; italics mine). Afterwards "she felt as if she had been made over again" (231-32) – "I make all things new," says Jesus in Revelation (21:5). The princess has symbolically undergone the death and resurrection of Jesus – something the Queen has no need to do because she has already died and is a living resurrection. When the castle is flooded, Irene says: "My grandmother is in no danger. . . . I believe she could walk through that water and it wouldn't wet her a bit" (303).

Eventually Curdie comes to believe in the Queen, who comes to him in a dream and heals his wounded leg. After helping to repel the goblin invasion, he looks for Irene – and, following Queen Irene's thread for the first time, he discovers the princess in his parents' cottage. "I wasn't good enough to be allowed to help you; I didn't believe you," he exclaims. And it is belief, or rather the verb "to believe," with its connotations of active will, that matters in *The Princess and the Goblin*, not the noun "faith" – just as it does in St. John's Gospel, a major influence on this book, in which the word "faith" does not occur at all and the word "believe" occurs over and over again. Believing is not a given but a struggle – beginning with inspiration but calling for an active and persevering response. What really matters in *The Princess and the Goblin* is that Irene believes in her grandmother and therefore begins to grow into her own identity as a queen, that is, a whole, individuated person.

The Princess and Curdie, published a decade after *The Princess and the Goblin*, is very different in mood and focus. Irene's role is much diminished; Curdie is now the central character. Queen Irene's primary association in this book is with the third person of the Trinity, the Holy Spirit, of whom St. Thomas Aquinas says "Non habet nomen proprium" ("he has no name;" Aquinas qtd. in Jung). She is now "the old princess." The person is one – but another side of her being comes to the fore.

In this book, Curdie is now nearly fourteen, and he has "gradually [been] changing into a commonplace man" (22). Forgetting his faith in the reality of Queen Irene, "he rather shrunk from thinking about it, and the less he thought about it, the less he was inclined to believe it when he did think about it" (20). The narrator suggests that "there is this difference between the growth of some beings and that of others:

in the one case it is a continuous dying, in the other a continuous resurrection" (22). Curdie has begun "dying." Paradoxically, what kick-starts his "resurrection" is the casual cruelty of shooting a pigeon. It is a crime against nature, as Curdie realises: "He had done the thing that was contrary to gladness; he was a destroyer! He was not the Curdie he had been meant to be!" (26) The shock makes him remember Irene's grandmother, and he speeds to the tower to ask her to heal the bird.

Saving the pigeon involves a confessional experience: "All at once a light seemed to break in upon [Curdie's] mind. . . .'I know now, ma'am; I understand now. . . . I see now,'" he exclaims (39-40), and the old princess relieves him of guilt by saying, "I am so glad you shot my bird!" (41) Soon afterwards Curdie is given a mission to reform a nation in moral decline. He knows only that he must go to court; but in fact, he will be the instrument of the old princess, an immanent force throughout, and she tells him he "must be ready to let my idea, which sets you working, set your idea right" (105). Here, MacDonald seems to suggest that she reflects the inspiration of the Holy Spirit.

She sensitises Curdie's hands in her fire of roses so that he can discern character, and summons an animal companion, Lina, whose paw discloses the hand of a child – but who fights for Curdie during his journey to the capital, Gwyntystorm, driving off attacking birds and subduing strange beasts, the Uglies, who become allies. The old princess only reappears when Curdie reaches the palace, and he does not recognise her in the guise of a housemaid. The king is ill, despairing over his people and kept sleepless and confused by conspirators. Irene, minus her ring and thread, has talked about the Queen, but with little effect until Curdie and Lina arrive. Together they get rid of the corrupt doctor and provide the king with wholesome wine and bread (an obvious image of Holy Communion).

After Lina's beasts have expelled the unworthy servants and captured the conspirators, the old princess purifies the king in her fire of roses; when it dies down "the face of the king . . . shone from under the burnt roses like a diamond in the ashes of a furnace" (295). Curdie falls into a sleep from which "He woke like a giant refreshed with wine" (297). The phrase is a verbatim quotation from Psalm 78.66, as found in the Anglican *Book of Common Prayer*, and it complements the description of the old princess: "She was large and strong as a Titaness" (*Curdie* 295). Soon, the king, Curdie, Lina, the Uglies and their few allies march against an invading army. Their victory is sealed by the old princess's pigeons, "the white-winged army of heaven" (311)

– counterparts of the vicious birds who attacked Curdie on the heath.

The ending of the novel is not "fairy tale happy": "The nation was victorious, but the people were conquered" (313), and they are now afraid of their king. But when the victors sit down to supper, the second and third persons of the Trinity metaphorically coalesce. The housemaid looks into Curdie's eyes as she pours the wine, and "Curdie started, and sprang from his seat, and dropped on his knees, and burst into tears." Then the old princess resumes the name of Queen Irene, and "in ruby crown and royal purple she served them all" (316). This passage echoes the miraculous moment in St. Luke's Gospel when the risen Jesus was recognised by his disciples in the breaking of bread (24:30-31).

Even though the Queen's face is "radiant with joy, the joy [is] overshadowed by a faint mist as of unfulfilment" (316). Curdie and Irene are married, but they die childless; the nation eventually relapses into wickedness and the city collapses in ruins, its very name forgotten – the ultimate symbol of loss of identity. Yet the Queen's "unfulfilment" promises that there is more to come. Gwyntystorm is destroyed, but Queen Irene is not destroyed; nor are Irene and Curdie, the king, the Uglies, or anyone with honest human hands – not even the conspirators, who, like the Uglies, are visited by the Queen after the king's victory.

In all three fantasies, reflecting the fatherhood of God in *At the Back of the North Wind*, the sonship of Jesus in *The Princess and the Goblin*, and the influence of the Holy Spirit in *The Princess and Curdie*, the central characters are going on to eternity; and MacDonald invites the reader to share the infinite possibility and infinite life awaiting them.

WORKS CITED

Aquinas, Thomas. *Summa Theologica*, 1, 36, article 1. Cited in Carl Jung, "A Psychological Approach to the Trinity," *Psychology and Religion: West and East*, vol. 11, 2nd ed., of the *Collected Works of C. G. Jung.* Routledge and Kegan Paul, 1969, par. 276, n.8.

Chesterton, G.K. Introduction. *George MacDonald and His Wife*, by Greville MacDonald. Johannesen, 2005.

Lewis, C.S. Preface. *George MacDonald: An Anthology*, edited by C.S. Lewis. Fount Paperbacks, 1988.

MacDonald, George. *At the Back of the North Wind*. Johannesen, 1992.

---. "The Fantastic Imagination." *A Dish of Orts*. Johannesen, 1996.

---. *The Princess and Curdie*. Johannesen, 2000.

---. *The Princess and the Goblin*. Johannesen, 1994.

---. "A Sketch of Individual Development." *A Dish of Orts*. Johannesen, 1996.

---. "Sorrow the Pledge of Joy." *The Hope of the Gospel*. Johannesen, 1995.

Joy Davidman's *Weeping Bay*:
An Anti-Catholic Diatribe?

by Marie K. Hammond

Author of two novels and many articles, Marie K. Hammond
has also taught mathematics at the high school and college
levels. She continues to work as a math tutor and teaches a
weekly Bible study class. Marie and her husband Sam led
a C.S. Lewis & Friends reading group for twelve years.

Joy Davidman believed, and evidence indicates, that distribution
of her novel *Weeping Bay* was sabotaged by an employee of its
publisher. In 1951, the year after the publication, Davidman wrote to
poet Kenneth Porter:

> I hope you like *Weeping Bay* – if you can find a copy. The
> book was quietly suppressed at Macmillan's home office by an
> ardently Catholic sales manager, for reasons you'll understand
> when you read it. They've since fired the guy and sent me an
> implied apology, but too late to do me any good.[1]

Apparently, the sales manager believed the novel was inimical to
Roman Catholicism. Was he correct? Did contemporary reviews of
the work and later analysis support this opinion? Does the novel itself
express hostility to the Catholic Church? Are Joy Davidman's other
writings from this period anti-Catholic? These questions have some
bearing on whether *Weeping Bay* is a novel of enduring value, worthy
of our attention today, or whether it should be interpreted as a simple
diatribe, best left forgotten.

The story takes place in a small, impoverished fishing and factory
town called Weeping Bay on the Gaspé Peninsula of eastern Quebec.
An idealistic young priest named Desrosiers comes to town, hoping
to organize a Catholic workers' union in order to improve conditions
at the local stove factory. Meeting stiff opposition from the factory
owner, as well as the local Church and civil authorities, he fails in his
mission and ultimately leaves the town perhaps worse off than when
he came. The large cast of characters includes a few defiant voices

1 Joy Davidman, *Out of My Bone: The Letters of Joy Davidman*, ed. Don
W. King (Grand Rapids: William B. Eerdmans Publishing Company, 2009), 119.
Davidman, of course, could not have anticipated the widespread availability of
books from online sources. Anyone who wishes to read *Weeping Bay* can gain access
through the Hathi Trust Digital Library.

speaking in the interests of the poor, but most of the townfolk are quietly complacent.

The reviews that appeared shortly after the publication of *Weeping Bay* were astoundingly divergent, from exceedingly negative to exceptionally positive. By far the harshest review, written for *The Catholic World*, describes Miss Davidson [sic] as "a fiercely partisan pamphleteer who . . . seems to believe that Catholic priests are either effete weaklings or slick money gatherers" and "that the teachings of the Church are rank superstitions used to bemuse simple people." The reviewer goes on to provide a rather stinging criticism of certain literary elements of the novel.[2]

Other reviews take issue with specific problems such as melodramatic twists in the plot, characters who are not entirely credible, "bursts of blasphemy," and a theme that is not expressed clearly. Yet these same critics also say that the story "makes an enduring impression," "bears marks of authenticity," has "excellent descriptive passages," and is told "with a sharp eye for detail."[3]

Yet other reviews express glowing praise for both the novel and its author. The same literary elements found deficient by some critics are strongly admired by others. One writes:

> *Weeping Bay* is ably integrated; its characters are well rounded and credible; its story moves without delay and without sacrificing style to story. The tourist town of Weeping Bay comes fully alive on all its levels in Miss Davidman's novel.[4]

Another is even more laudatory:

> It is, in short, a fine novel by a first-rate writer, who has both courage and insight, and supplements these with great natural ability. Best of all, perhaps, it is clearly and in every line a novel by a writer who has unquenchable faith in people, no matter what.[5]

A careful reading of eleven reviews from Davidman's contemporaries (and perhaps a bit of reading between the lines),

2 Mary Sandrock, review of Joy Davidman's *Weeping Bay, Catholic World* (June 1950), 233.

3 Granville Hicks, "Stove Lids in Arcady," *New York Times Book Review* (March 5, 1950), 5; and Richard P. Breaden, review of Joy Davidman's *Weeping Bay, Library Journal* (Feb 1, 1950), 171; and Ann F. Wolfe, "Labor Problems on the Gaspé," *The Saturday Review* (March 18, 1950), 16.

4 August Derleth, "Tourist Town Comes to Life Along Gaspé," *Sunday Chicago Tribune* (March 12, 1950), 4.

5 Joseph Henry Jackson, "A Novel of the Gaspé," *San Francisco Chronicle* (March 7, 1950), 18.

suggests that these evaluations are colored by the writers' own perceptions of Roman Catholicism. Those who found her implied criticisms of the Church unwarranted and unfriendly were more likely to make negative comments about all aspects of the book, while those who saw the depictions of Catholicism as believable and accurate gave positive overall reviews. The latter group saw the book more as a successor to the proletarian novels of the Depression era, stressing themes such as the right of a working man to fair wages and the new types of economic exploitation emerging in the machine age, rather than as a commentary on the Catholic Church. The writers of favorable reviews did mention the Church, but only in terms of specific issues, primarily the prohibition against birth control. One reviewer observes the connection between personal tragedies in the story and the Church's "iron-clad prohibition" against pregnancy prevention. Another sees the book as a "plea for a more flexible Catholicism."[6] Thus it seems that the wide divergence of opinion about *Weeping Bay* expressed by magazine and newspaper critics derives, at least in part, from the reviewers' attitudes toward specific Roman Catholic teachings and how they affect society.

The two scholars who have done the most extensive research on Davidman also have divergent views on the quality of *Weeping Bay*. Lyle Dorsett based his biography of Davidman (1983) on interviews with her closest friends as well as her brother, cousin, and two sons. Don King's work is more recent: a scholarly edition of her letters (2009), a critical study of her writings (2015), and an edition of her poems (2015). In his biography, Dorsett repeatedly mentions Davidman's concern for economic justice which began early in her life. Reacting to the abject poverty she witnessed during the Depression years,

> Joy's growing disdain for the values, institutions, and political philosophy that led to economic collapse and then excused the turning of deaf ears to the cries of the impoverished, eventually transformed her into a radical with missionary like zeal.[7]

At twenty-three she joined the Communist Party of the United States of America, reveled in political debate, and "with evangelistic fervor"[8] used her writing skills to promote the cause. About ten years later, after marrying and giving birth to two sons, Davidman rejected

6 Chad Walsh, "First Things First: How Does One Come to Know God?" *Presbyterian Life* (May 27, 1950), 37; and unsigned review of Joy Davidman's *Weeping Bay*, *Kirkus* (Jan 1, 1950), 8.

7 Lyle W. Dorsett, *And God Came In* (New York: Macmillan Publishing Company, 1983), 33.

8 Dorsett, 40.

Communism and embraced Christianity. She wrote an essay about her change of heart, saying she now wanted "to serve God in books and letters as best I can."[9] Soon thereafter she wrote *Weeping Bay*.

Dorsett's comments about the novel are generally positive. In summarizing the plot, he speaks of the corrupting influence of money on the local clergymen, who depend on the factory owner to maintain their opulent way of life. When the young priest Desrosiers tries to organize a union, Dorsett sees the ensuing conflict, not as a religious argument, but as a clash between capital and labor. He observes that Davidman uses the book "as a pulpit to preach several sermons of her own," often relating to the conflict between the idealistic Desrosiers and the older parish priest. She is severely critical of priests who live in luxury while their parishioners cannot feed their families, as well as of the conservative faction of the Catholic Church for its resistance to birth control and of churchgoers who think they can buy forgiveness. Dorsett observes that the biblical text for her "sermons" (quoted as an epigraph) is a passage from John 21, in which Jesus tells Peter, "Feed my sheep."[10] His final analysis of the novel is laudatory: "Her second novel, *Weeping Bay*, carries a powerful spiritual message, and it will continue to inspire people who are fortunate enough to find a rare copy."[11]

Don King's evaluation of the book is considerably less positive. He finds fault with the large cast of characters and with the absence of a central voice to express a developed and convincing point of view. One response to these criticisms might be that the town itself could be regarded as the main character, one of many such towns, almost indistinguishable from one another. King mistakenly asserts that Desrosiers has returned to his hometown.[12] However, when the young priest says, "I know these streets," he is recognizing *any* typical Gaspé village with its poverty and pain and the tourists "who admire the scenery but do not notice the people."[13] Another possible reading makes Desrosiers the principal character. The uncertain point of view

9 Joy Davidman, "The Longest Way Round," in *These Found the Way: Thirteen Converts to Protestant Christianity*, ed. David Wesley Soper (Philadelphia: Westminster Press, 1951), 26. Soper's work came out the year after *Weeping Bay* was published, but Davidman had written her essay in 1949, a year before the novel's publication.

10 Dorsett, *And God Came In*, 82-83.

11 Dorsett, 147.

12 Don K. King, *Yet One More Spring: A Critical Study of Joy Davidman* (Grand Rapids MI: William B. Eerdmans Publishing Company, 2015), 145.

13 Joy Davidman, *Weeping Bay* (New York: The Macmillan Company, 1950), 22, 23.

may be intended as an expression of the young priest's insecurity in his role as union organizer, not knowing quite how to proceed and reassessing his efforts time after time.

King does, in fact, perceive Davidman's perspective as anti-Catholic, claiming that she "portrays the Catholic clergy at best as misguided . . . or at worst as perfidious." King goes on to speculate that Davidman's "antipathy for Catholicism" may be tied to "the belief that the Catholic Church was at least partially complicit in the persecution of the Jews before and during World War II."[14] It should be noted, however, that Davidman rarely mentions ill-treatment of the Jews in her writing, much less blames any religious group for it. King's further criticism takes aim at the effectiveness of the novel, because, as he sees it, the reader is unable to empathize with the anguished characters. In his evaluation, the plot and personalities are overshadowed by Davidman's polemic against Catholicism.

It should be noted that another book-length study of Joy Davidman appeared in 2015. In it, author Abigail Santamaria mentions *Weeping Bay* only briefly. She states (mistakenly) that the book received mostly bad reviews and notes that the Canadian arm of Macmillan refused to publish it.[15]

It is true that Davidman uses *Weeping Bay* as a platform to express her ideas, and parts of the book (especially the last chapter) do sound rather preachy and polemical. Yet other reviewers (including this reader) do feel empathy with the characters and come to much different conclusions about the artistic value of the book. In addition, there is no indication that Davidman extends her polemic from the specific situation of the Catholics in poverty-stricken towns on the Gaspé peninsula depicted in the novel to the entire Catholic Church.

In determining whether the novel itself reveals a specific "prejudice" on the part of Davidman, setting, plot, and characters must be analyzed, not just some passages taken out of context. The setting of *Weeping Bay* plays a significant part in developing its themes. The natural beauty, from its lush forests to the steep cliffs towering over the St. Lawrence River, draws wealthy tourists. At the same time the

14 King, *Yet One More Spring*, 148.
15 Abigail Santamaria, *Joy: Poet, Seeker, and the Woman Who Captivated C. S. Lewis* (Boston: Houghton Mifflin Harcourt, 2015), 200. Of the eleven contemporary reviews, three could be categorized as mostly negative (Sandrock, Breaden, and Wolfe), two as mixed (Hicks and Walsh), and six as predominantly positive (Derleth and Jackson, as well as James Hilton, "When the Abbé Organized a Labor Union," *New York Herald Tribune Book Review* (March 12, 1950), 6, and three unsigned reviews, from *The United States Quarterly Review* (June 1950), 156; *The New Yorker* (March 11, 1950), 103; and *Kirkus* (Jan 1, 1950), 8.

small villages are hemmed in by the mountains and the great river, with poor soil and limited space to build and farm. Their isolation prevents inhabitants from seeking better opportunities in education or employment, and from learning about family planning. Thus, the people remain poor with little hope for better circumstances in this life.

The book's plot is dominated by the unrelenting poverty of the townsfolk, whose difficulties are exacerbated by high birth rates. Here the Church plays a role, banning contraception and calling it a mortal sin with eternal consequences. The women are left with the choice of bearing child after child in quick succession or performing self-induced abortions. When people die, the Church in Weeping Bay accepts money from family members to pay for masses intended to shorten the deceased person's time in Purgatory, contributing further to the pervasive poverty. These two factors, the ban on birth control and the receiving of money for spiritual favors, constitute the formal involvement of the Catholic Church in prolonging the town's problems. In considering other agents that move the plot forward, the greater cause would seem to be the local capitalists. The owners of the factory and supply store, as well as the companies that control the fishing waters and forest lands, pursue their profits ruthlessly. They keep the workers weak and compliant through continual debt, fear of foreclosure, and suppression of collective bargaining. The local police support them, as does the Church, in the interest of keeping peace and encouraging the right priorities. Obviously, Davidman's plot does not assign exclusive blame to the Catholic Church for the misery of the townspeople, but assigns it rather to economic, civic, and religious institutions working in concert to preserve the status quo.

In examining the characters of the story, an equally complex and perhaps even contradictory picture emerges regarding the role of the Church. Four major characters in the novel are Catholic priests or members of a religious order. Two are, without question, negatively portrayed. The parish priest, Curé Chouinard, lives in a fine house, eats fancy delicacies, listens to opera recordings, and prefers to keep the simple, pious townsfolk "happily innocent of corrupting luxuries."[16] His highest priority seems to be maintaining his influence and way of life, which leads him to promote wealthy business interests over the needs of the poor and to take an active though concealed role in suppressing the workers' union. Chouinard's assistant, the Abbé Bellavance, is an austere and thoroughly vain young man enlisted

16 Davidman, *Weeping Bay*, 30.

by his superior to do unpleasant tasks. These are two of the most detestable characters in the novel.

The other two clergymen are among the most favorably depicted individuals in the story. One of them, the Abbé Desrosiers, is the closest thing the novel has to a protagonist, with whom readers identify and sympathize. Commissioned by the Syndicate of Catholic Workers, a Church-sanctioned body, Desrosiers comes to town specifically to organize a union at the local factory, an undertaking Davidman would have approved enthusiastically. Unquestionably idealistic though somewhat weak and wavering, he prays earnestly for strength: "Make me a man, Christ Jesus. Make me a leader of men to lead Your people out of the house of bondage."[17] The young priest gives up his comfortable life at the hotel and boards with the poorest family in town, eventually gaining enough courage and resolve to stand up to the authorities.

Don King claims that Desrosiers sells out in the end and gives up his cause.[18] This is far from clear, however. In his final confrontation with the Curé Chouinard, Desrosiers speaks his mind, knowing he has opened a door for continued debate on the issue of workers' rights. He asks the Curé why he tries to prevent the men at the factory from earning a decent living. To make his point, Desrosiers quotes Scripture and cites the teachings of Thomas Aquinas. Responding to Chouinard's arguments in favor of pious poverty, the younger man explodes in a rage:

> "Father Chouinard! . . . Are the half-starved children stupefied with alcohol serving God? Are the fishermen serving God when they beget ten children on their wives, and then, when the wives die of it, another ten on their oldest daughters?"

Ultimately, Desrosiers agrees that he has failed in his mission and must leave town, but even then he negotiates the release from prison of the local man who helped him recruit workers for the union. Despite his defeat, Desrosiers has the last word: "All the same," he said, "the sheep should be fed."[19]

The fourth clergyman, the schoolteacher Brother Lactance, is the kindest, gentlest character in the book. Thinking himself simple-minded, he spends his spare time tending a flower garden. Yet Brother Lactance takes an active interest in a deaf-mute child from a poor family, loves and protects him, and tries to encourage his artistic talent.

17 Davidman, 38.
18 King, *Yet One More Spring*, 148.
19 Davidman, *Weeping Bay*, 237, 238.

Perhaps more important than these traditional "characters" is the depiction of the town itself as a character. The opening scene depicts the residents as they are perceived through the eyes of wealthy tourists. These outsiders witness cruel poverty but have no desire to understand it. They are demeaning and judgmental, comparing the local children to animals, too idle and boorish to learn English. Davidman emphasizes that the privileged classes (American tourists) are ignorant and uncaring about the wretchedness of their fellow humans living in dire poverty. From this insensitive viewpoint, the town is perceived to be full of subhuman creatures without recognizable individuality. Davidman seems to be indicting all adherents of an economic system that refuses to see the needs of the neediest among us. She casts her net far wider than just the Catholic Church.

One last character who should be mentioned is a scarcely believable traveling evangelist who appears most prominently in the final chapter.[20] This is the weakest part of the novel, where Davidman comes closest to delivering a simplistic diatribe, nearly spoiling the mood and drama of the novel. This unconvincing character, a carnival electrician from New Orleans, preaches an alternate interpretation of Christianity to two men who have rejected Catholicism. The visiting evangelist extolls the value of reading the Bible, singing gospel hymns, and trusting Jesus, ideas not emphasized among Catholic laypersons of the 1940s. Davidman wrote this book very early in her experience of Christianity, and she allows her own religious preferences to seep into the work. This last chapter might be regarded as pro-Protestant propaganda. But *Weeping Bay* is much more than its last chapter. It deals with larger issues than doctrinal differences. The book is best characterized as a pro-labor work of fiction, a call for fair wages, and a plea to care for the poor and weak, set in an overwhelmingly French Catholic community, where those with privilege and power (religious and otherwise) oppose change.

What of Davidman's other writings? Do they show the kind of bias against Roman Catholicism some critics see in *Weeping Bay*? Especially striking are parallels between Davidman's first major literary success, a long poem called "Letter to a Comrade," and *Weeping Bay*. Published twelve years before the novel, in the same year she joined the Communist Party, the poem traces a comrade's travel

20 Davidman may have modeled this character after the preacher in the 1943 movie *The Ox-Bow Incident* who, like the carnival preacher, sings his gospel message of love and kindness. Davidman wrote a favorable review of the movie for the American Communist Party publication *New Masses* (March 18, 1943), 30-31.

through different regions, including Canada.[21] Her descriptions of small towns in Quebec employ identical words for images, colors, and signs of hopelessness in the poem and the novel. In these two works, written so many years apart, Davidman seems to be remembering the same impressions of poverty in Canada, which must have affected her deeply when she witnessed it.

Other poems Davidman wrote while in her twenties show her fervor for political activism on behalf of workers and her disdain for those who pass their time in frivolous activities.[22] Her earliest writings reveal that she hungers for justice, and in fact this theme permeates all her work. It shows up again in her last book, *Smoke on the Mountain: An Interpretation of the Ten Commandments*. Discussing theft, she broadens the definition to include those who do not pay a fair wage: "[T]he thief is not only he who steals my purse, but also he who steals my trade; and he who underpays me, and he who overcharges me. . . ."[23] In the same book, Davidman shows sympathy for persecuted Catholics when she tells the story of Titus Oates, whose false witness resulted in great animosity toward English Catholics.[24] Don King, in his analysis of *Smoke on the Mountain*, observes that Davidman is "cognizant of Protestant and Catholic thought and remains balanced in her comments upon both."[25]

Davidman's letters also give clues about her attitude toward Roman Catholicism and religious institutions in general. Her first extended discussions about Christian topics appear in 1948, just after her conversion. Not surprisingly, she allows her ideas on Marxism, rationalism, and progressivism to intrude in these discussions. In one letter she criticizes the Catholic Church for substituting "idolatrous worship of Christ" in place of his revolutionary political and economic ideas. She goes on to applaud "the *rediscovery* of the principles of Christ, the reemergence of *revolutionary* religion. For indeed *we*, for the first time in history, have given Christ's ideas the scientific and practical extension which alone can translate them into action."[26]

Davidman's enthusiasm for her newfound beliefs leads her to

21 Joy Davidman, *Letter to a Comrade* (New Haven: Yale University Press, 1938), 17-18. This collection of poems, named for its longest piece, was published as part of the *Yale Series of Younger Poets*, edited by Stephen Vincent Benét.

22 See, for example, other poems in *Letter to a Comrade*: "Twentieth-Century Americanism," 25-28; "Survey Mankind," 44-47; and "For the Revolution," 55-56.

23 Joy Davidman, *Smoke on the Mountain: An Interpretation of the Ten Commandments* (Philadelphia: The Westminster Press, 1953), 100.

24 Davidman, *Smoke*, 106

25 King, *Yet One More Spring*, 156-57.

26 Davidman, *Out of My Bone*, 50-52.

arrogantly assume that no one before her generation had considered Christian social activism. In the same letter, she comments on the atheism of Lenin, who "grew up in a Greek Catholic world." She says that rebellious Catholics "almost always become atheists" because "the Catholic Church speaks for God; therefore if the Church is corrupt there is no God."[27] Again, her Marxist beliefs lead to several unfounded generalizations. On the other hand, Davidman's harsh criticism is not restricted to the Catholic Church. Her letters contain references to other religious groups: "dour Scottish Calvinists,"[28] rabbis who turned in fellow Jews to the Tsar's secret police, "the Presbyterian worship of respectability and riches,"[29] and the Anglican Church, "full of perverts, eunuchs, and Manichees."[30] She spares no one. Showing her general disdain, she says,

> As far as I can see, every organized church in the world ends either by missing the point and tangling itself in trivialities or by contradicting the point altogether. And certain of my past experiences have left me suspicious of *all* organization.[31]

Considering the negativity of these comments, it is a bit surprising to find in Davidman's letters some praise of Catholicism and other religions. Nevertheless, she claims that "in our time there is a growing underground movement in many churches, even in the Catholic church, with the object of driving the money-changers out of the temple,"[32] and "the Catholics are strong because, in spite of everything, they really *do* believe in Christ. . . ."[33]

Joy Davidman called herself a "traditional sort of Christian" who became a Presbyterian because that was the denomination of her local church, but who claimed she "really belongs with the Anglicans, and not Broad Church either." (She was eventually confirmed in the Episcopal Church.) Her tendency to make sweeping absolute judgments subsides to a degree as she matures in her faith. The year after *Weeping Bay* was published, she writes, "Right now I'm teaching myself *not* to have views – to recognize that I'm not entitled to an opinion where I don't know the facts."[34] Her brother-in-law Warren Lewis, who knew her toward the end of her life, describes her as "a

27 Davidman, 52.
28 Davidman, 66.
29 Davidman, 76.
30 Davidman, 121.
31 Davidman, 278.
32 Davidman, 73.
33 Davidman, 124.
34 Davidman, 118.

witty, broad-minded, well-read, and tolerant Christian."[35]

In conclusion, *Weeping Bay* does indeed portray the Roman Catholic Church in a bad light. It is clear from the letter quoted at the beginning of this essay that Joy Davidman understood the book might be perceived in this way. But her goal in writing the novel was to depict the misery and hopelessness of people trapped in poverty, not to vilify the Catholic Church as such. Insofar as the Church (any Church) conspires with other institutions to protect the powerful and persecute the weak, it is guilty. The central issues here are social and economic, and religion is simply one tool of oppression among many.

Davidman's sharp criticism of the Church, therefore, does not prove that the book is entirely "anti-Catholic." Her censure is largely restricted to two or three issues which are not central to the Church's teaching and practice, but to its practice in a specific place and time. The negative portrayals of certain of the Catholic clergymen show the corrupting influence of money and power, failings common to people of all professions, and are balanced by another clergyman who cares for the poor and stands up for justice. Reviewers who saw the book as primarily anti-Catholic may not have known of Davidman's long association with the American Communist Party, her strong sympathy with workers and labor unions, and her unhappy memories of pervasive poverty in the 1930s.[36]

If *Weeping Bay* preaches any message, it should be categorized as "pro-labor." Admittedly, the book is intense and disturbing to read, which is what makes it memorable and even offensive to some people. Today's readers may judge its merit for themselves, as the novel is now available through online sources. While copies of the actual printed book are scarce, the societal problems it describes are, unfortunately, not yet rare.

35 Warren Lewis, "Memoir," in *C.S. Lewis The Collected Letters, Volume III: Narnia, Cambridge, and Joy 1950-1963*, ed. Walter Hooper (San Francisco: HarperCollins, 2007), 1694.
36 Dorsett, *And God Came In*, 33.

Christ the Outlaw in Dorothy L. Sayers's
Catholic Tales and Christian Songs

by Barbara L. Prescott

Barbara L. Prescott is an independent scholar, literary anthropologist, educational researcher, and sometime poet. She is currently studying the early poetry of Dorothy L. Sayers, written while Sayers was at Oxford University. Her research will be published in an upcoming book, *Lyric Muse: The Oxford Poetry of Dorothy L. Sayers*.

Christ walks the world again, new-bound on high emprise,
With music in His golden mouth and laughter in His eyes;
The primrose springs before Him as He treads the dusty way,
His singer's crown of thorn has burst in blossom like the may,

He heedeth not the morrow and He never looks behind,
Singing: "Glory to the open skies and peace to all mankind."
<div align="center">("Desdichado," v.5)</div>

In her second collection of poetry, *Catholic Tales and Christian Songs* (1918), Dorothy L. Sayers focuses on Christ as Hero. Influenced deeply, as I will show, by the Romantic movement, this small book of poems was her first major statement as a Christian apologist. The poems in *Catholic Tales* present varied pictures of Christ in His many human and divine roles, some with fantasy and folktale elements, some retellings of the gospels, some even within children's rhyme. This essay looks especially at the first poem of *Catholic Tales*, "Desdichado," as it introduces Christ as the unconventional Hero, related to the Romanticism which Sayers studied at Oxford University from 1912 to 1915.

Catholic Tales is not an easy book to interpret. Its multiple perspectives and genres create an equivocal effect. Yet each of the poems plays a role in the larger exploration of the mortal, immortal, and legendary personae of Christ. By focusing upon the *Imago Dei* as simultaneously mortal and immortal, Sayers's faithful imagination coupled with her skills in languages, music, mythology, and literature, created a collection of poems that challenge readers to explore the unusual, and often neglected, aspects of Christ as the divine everyman hero.

Sayers's early interest in medieval legend, symbolism, and esoteric knowledge as it interplayed with Christian dogma is reflected in the language and images in several poems in *Catholic Tales*, such as "White Magic," "The Wizard's Pupil," and "Lignum Vitae." From her earliest years, Sayers also expressed a dramatic interest in the heroic: the adventures, the regalia, the legends, and the characteristics of the hero. In *Catholic Tales*, Sayers presents Christ as the quintessential Hero, portrayed through various mortal faces. In "Christ the Companion," we read about Christ as the Everyday Hero. In "Pantas Elkyso (παντας ελκυσω)," we find the Magnetic-Attracting Hero,[1] and in the "Triumph of Christ," we see the Conquering Hero. In "Byzantine," Sayers gives us the Iconic Hero as pictured on the cover of the book, and in "Rex Doloris," the Tragic Hero. The Wizard Hero in the enigmatic "White Magic" was inspired by the *Mabinogion*. Most interestingly, in "The Carpenter's Son," Sayers highlights the Craftsman Hero, the Maker Hero, the Creative Hero, who creates art with His own divine/human hands. This *Persona Dei* (Downing 117) of Christ is later explored more thoroughly by Sayers in *The Mind of the Maker*. Christ appears as the Savior Hero in "Justus Judex."

This paper focuses on the poem "Desdichado," the opening poem of *Catholic Tales*, through which Sayers develops the image of Christ as Outlaw Hero. Readers of religious poetry during the early twentieth century were not often confronted with the idea of Christ as a disenfranchised pied-piper outlaw in disguise. Sayers's literary imagination, integrating her faith with her prodigious knowledge and interests, presents her readers with several intriguingly unique poetic images of Christ in alternate legendary guise. *Desdichado* is a Spanish adjective meaning "unhappy," "unlucky," "disenfranchised," "disinherited." This title not only intrigues, it unsettles, especially since it is the first poem we encounter.

Before the body of the poem, the reader is met by two epigraphs placed between the title and the poem itself:

* *This is the Heir; come let us kill Him.*

* *Who is this that cometh up from the wilderness, leaning upon her Beloved?*

These two lines represent a characteristic feature of Sayers's poetry. She presents two statements, two epigraphs, two quotes at strategic points in her volumes of poetry, both in *Catholic Tales* and

1 Pantas Elkyso (παντας ελκυσω) translates from Classical Greek as, "I always attract" or "I attract all."

in her first book of poems, *OP. I.* By doing so, she deliberately sets up two different perspectives to alert the reader that there are different sides to the story, alternate ways to interpret the poem. Nothing is obvious, and things may not be what they appear to be on the surface. Sayers sets up this opposition of viewpoint several times in *OP. I.*, and she does so again at the very beginning of *Catholic Tales*.

The first statement is an excerpt taken from Matthew 21:38, the so-called "Parable of the Tenants," with its abrupt accusation and stark threat to destroy. Given that the obvious interpretation of the parable is that the "heir" is Christ, we expect to read: "This is the Heir; come let us welcome Him." Instead: "let us kill him." The speakers are Christ's accusers who have one purpose in mind. Christ will be destroyed not for a crime but because He is the Heir. Such a person is, indeed, a disinherited Hero.

The second line, a gentle question, presents an alternate perspective. Here is an opposite character, a woman, who is leaning upon her beloved. This reference is to Song of Solomon 8:5. Sayers capitalizes "Beloved," indicating the divine nature of the character. The first epigraph speaks of hatred, jealousy, and violence; the second speaks of love, approval, and tenderness. We have, then, an initial double viewpoint presented by these one-line epigraphs, rendered ironic perhaps since the loving one derives from the Old Testament and the violent one from the New. It is possible that Sayers borrows the literary device of an introductory epigraph from the French Romantic author, Victor Hugo, for whom it was a stylistic hallmark.[2]

"Desdichado" was written as a literary ballad of six verses, narrating the story of an outlaw folk hero. It is constructed of three stanzas and three varied refrains. The stanzas are composed of six lines each in iambic stress, lines ranging between twelve and fifteen syllables, with a rhyme pattern of *aabbcc*. A four-line singing refrain (rhyming *abcb*) follows each stanza. Each refrain opens with a repeated line ("Lady, lady, will you come away with me"), followed by three variations.

Sayers quickly introduces Jesus Christ by several vibrant and unexpected images in each stanza. In the first stanza, we receive snapshot images of Christ as a desperado, an outsider hero.

CHRIST walks the world again, His lute upon His back,

2 Victor Hugo's revolutionary use of the epigraph, ANÁΓKH, or ANANKE, a Greek word meaning, "Fate," at the beginning of the Preface in the novel, *Notre-Dame de Paris* (1832), set the tone of the entire book, became his literary hallmark, and set a precedent for future French Romanticist authors.

His red robe rent to tatters, His riches gone to rack,
The wind that wakes the morning blows His hair about His face,
His hands and feet are ragged with the ragged briar's embrace,
For the hunt is up behind Him and His sword is at His side, . . .
Christ the bonny outlaw walks the whole world wide.
("Desdichado," v.1)

Christ, it seems, is many men: an Orpheus-like troubadour (carrying a *lute*, an instrument symbolic of light and redemption), once a wealthy noble (*red robe*), now poor (*tatters*), unkempt (*ragged*), a knight (*sword*) without his horse (*walks*), now an outlaw and object of the hunt. Christ is indeed the "*desdichado*," disowned from His inheritance by human instigation, as He is outside social law, independent of accepted norms. This image of Christ is that of a classic folk hero desperado. Sayers's imagery of the lute is also intriguing. The lute, or lyre, is often symbolized in medieval literature as an instrument which brings light into the darkness. Sayers pointedly notes that the lute is slung across Christ's back, possibly an allusion to the cross. It is a colorful, compelling, moving (in both senses) image. Against a windy, disconsolate background, we get a clear sense of this mysterious folk hero/desperado/troubadour/knight being pursued by His enemies, yet confidently eluding them.

In the second stanza, Sayers repeats the first phrase, "*Christ walks the world again*," true to ballad format, stressing His continued involvement in the world. We are given yet another persona of Christ, that of "*a prince of fairy-tale*" and, like disguised, disenfranchised, princes in fairy-tales, He roams a bitter and grim world in the quest to seek His fortune and search for the water of eternal youth. Thus, Sayers presents Christ as the genesis of the Arthurian grail quest.

Christ walks the world again, a prince of fairy-tale,
He roams, a rascal fiddler, over mountain and down dale,
Cast forth to seek His fortune in a bitter world and grim,
For the stepsons of His Father's house would steal His Bride from Him;
They have weirded Him to wander till He bring within His hands
The water of eternal youth from black-enchanted lands.
("Desdichado," v.3)

Most intriguing is the fourth line, "*For the stepsons of His Father's house would steal His Bride from Him.*" Whatever Sayers means by this, it obviously relates to the unjust disenfranchisement of the rebel hero, who is actually a prince, whose loss is our loss (presumably, the church's loss, since the church is called the *Bride of Christ*), and whose heroic escape and exploits are for our good. In other words, He is *our*

hero, and though He appears ragged and forlorn, He is something more, although his true nature may be hidden during the days of his wandering.

The third stanza depicts Christ the hero walking in triumph.

> Christ walks the world again, new-bound on high emprise,
> With music in His golden mouth and laughter in His eyes;
> The primrose springs before Him as He treads the dusty way,
> His singer's crown of thorn has burst in blossom like the may,
> He heedeth not the morrow and He never looks behind,
> Singing: "Glory to the open skies and peace to all mankind."
>
> ("Desdichado," v.5)

The progression of these heroic images moves from ragged minstrel outlaw to disguised prince and finally to joyful conqueror, as Christ reveals His true identity and completes His heroic quest. Now *"newbound on high emprise,"* Christ's next task is to "return then to us, transfigured, and teach the lesson He has learned of life renewed."[3] In all three stanzas, Christ moves forward, supporting the sense of continual movement and action through this poem. Christ is the active Hero, intent upon the fulfillment of His mission. The many verbs of motion (*walks, wander, cast forth, come away, tread, ride, springs*) serve to carry the reader along with Him. We experience His movement. In this last stanza, Christ has finally become the triumphant catholic hero, independent of His trials, joyfully moving *"with laughter in his eyes."* The final verse ends on a victorious, jubilant note.

The three refrains, each following a stanza, adhere to classic ballad form. Each quatrain has the same opening line. The lines range from twelve to fifteen syllables, each with four stresses. The refrain begins with the cue *"Singing,"* directing our attention again to the ballad form, to our Hero, and to the volume's title, *Christian Songs*.

> Singing: "Lady, lady, will you come away with Me,
> Lie among the bracken and break the barley bread?
> We will see new suns arise in golden, far-off skies,
> For the Son of God and Woman hath not where to lay His head."
>
> ("Desdichado," v.2)

Sayers, true to form, jolts us into human incarnational reality, as uncharacteristic as it may be to juxtapose the human outlaw Hero and the immortal God. The "lady" addressed in the refrain may represent the church, "the Bride of Christ," to complement Christ as

3 Joseph Campbell, *The Hero with a Thousand Faces* (Princeton: Princeton University Press, 1972), 20.

human lover (and reminiscent of the epigraph). Here Sayers revises the traditional "Lady and the Outlaw" motif, a romantic theme found in numerous medieval and folk ballads. As we receive the invitation, directly from Christ as Outlaw Hero, we become participants in the action of the poem. We are that lady.

The refrain changes voice from third to first person. Christ addresses the lady directly. Sayers signals this change by her use of the word (like a stage direction), "*Singing*." We, as the lady, are given an invitation to leave our homely lives and to follow Christ. There are two obvious biblical references in the verse, "*break the barley bread*" and "*the Son of God . . . hath not where to lay His head*." It is a romantic, beguiling invitation with a promise attached of "*new suns*" and "*golden, far-off skies*," a seductive promise of eternal life. The refrain serves to invite us into the thrilling action of the poem and its Hero. We are given a chance to join in his heroic quest.

In the second version of the refrain, Christ offers us a choice between pursuing earthly pleasure or walking a difficult, uncomfortable path with Him. Along with this choice comes a promise. Should we choose the hard road together with Christ, we will end well by riding home beside Him. A sense of movement forward continues through the verse:

> Singing: "Lady, lady, will you come away with Me,
> Or sleep on silken cushions in the bower of wicked men?
> For if we walk together through the wet and windy weather,
> When I ride back home triumphant you will ride beside Me then."
>
> ("Desdichado," v.4)

In the third variant of the refrain, the verse which ends the poem, we receive the invitation for the final time. In this verse, Christ quotes a proverb, inviting us to experience a full but perilous life: "Here be dragons to be slain."[4] It is a final, romantic, appealing invitation to join the hero quest.

> Singing: "Lady, lady, will you come away with Me?
> Was never man lived longer for the hoarding of his breath;
> Here be dragons to be slain, here be rich rewards to gain . . .
> If we perish in the seeking,
> . . . why, how small a thing is death!"
>
> ("Desdichado," v.6)

4 *Hic sunt dracones* (Latin), a statement supposedly found on ancient maps denoting dangerous areas or habitats of unknown creatures.

Thus, Sayers presents the unique faces and personalities of Christ the god/man – a bonny outlaw, an Orpheus-like wandering troubadour, a knight in disguise, a fairy-tale prince, and a magnetic pied-piper, all within the context of "Desdichado."

The final verse points towards a final victory for Christ the Hero. However, Sayers hints that the story is still unfinished. We have received the invitation numerous times to join Christ in the adventure. As embodied people, earth-dwellers (just as Christ was once), we can respond to the rich life afforded by following the Hero. But we are here ultimately for greater reasons. Should we die in the pursuit of our quest, it is a rather small matter. The reward is in the journey, the acceptance of the Hero's quest, which will lead to eternal life. Death is inconsequential. There are greater things ahead for us, should we accept the invitation Christ offers. Like so many great romances (and the Song of Solomon), not even death can separate those bound by love.

Other than the obvious scriptural background, what formed the imagination of the author of "Desdichado" and the *Catholic Tales*? Indeed, there were specific literary roots in, and references to, the fiction and poetry of the Romantic movement. Sayers studied Romantic literature at Oxford primarily between 1913-1914 under the expert guidance of Mildred Pope, her tutor in French and English literature of the twelfth through nineteenth centuries. Three specific canonical literary influences from the Romantic movement, which Sayers applied to the figure of the Hero Christ, may be found in "Desdichado": Sir Walter Scott, Victor Hugo, and Gèrard de Nerval.

While a student at Oxford, Sayers took a series of literature courses, notably in Literary Form and French Drama, taught primarily by Pope.[5] In her class notes (held by the Marion E. Wade Center at Wheaton College), we find references to authors of the Romantic movement from Rousseau onward as well as evidence that she studied works by French, Spanish, and English poets and novelists of the period.[6] Through this training, Sayers began to associate and allegorize the character, El Desdichado, among many others, with that of Christ in His myriad heroic roles. Her translations of various heroic literary characters into aspects of the Hero Christ became for Sayers an adventurous poetic journey into her own Christian Romanticism.

5 *DLS Undergraduate Notes and Essays* 299, 1-1b. Here are extensive notes from *French Drama*, 1914, taught by Mildred Pope. Marion E. Wade Center, Wheaton, IL

6 Folder 1-14: *DLS Undergraduate Notes and Essays*, 1-14. Notes from class, *Literary Form III*. Marion E. Wade Center, Wheaton, IL

The title "Desdichado" clearly references Walter Scott's novel, *Ivanhoe* (1819) and the disguised, disinherited knight, El Desdichado, who is in reality Sir Wilfred of Ivanhoe. Sayers was familiar with *Ivanhoe* from an early age, but at Oxford she studied the work formally. Kindled by her Oxford literary training, the precocious young poet connected El Desdichado with Christ. In Scott's novel, disguises abound. Wilfred of Ivanhoe is disinherited by his father, Cedric, and assumes the disguise of El Desdichado, wandering the world as he follows his quest in the Crusades, only to return as an unacknowledged, disenfranchised hero. Yet Wilfred is not the only character Sayers borrows from *Ivanhoe*. There is a second heroic character in disguise, King Richard, disguised as the Black Knight, who also has been disenfranchised (disinherited from his kingdom by his brother John). Thirdly, Robin Hood, a Saxon dispossessed of his homeland, England, by the Normans, wanders through the novel as a pied piper outlaw with his band of Merry Men apostles. In Sayers's poem, Christ is a Robin Hood-like hero, particularly in the first and third stanzas, when "*the hunt is up behind him*" as he walks, a "*bonny outlaw.*" Scott's El Desdichado is victorious over his enemies, redeemed by winning a knightly tournament. Richard the Lion-Heart also discards his disguise, regaining the throne of England. Robin of Locksley continues his quest as Saxon outlaw defender of the poor. *Ivanhoe* ends on a satisfactory note all round, each hero in disguise revealing his true identity and assuming his rightful title.

Sayers's second source of inspiration for the title is the sonnet "El Desdichado" (1853) by French poet Gèrard de Nerval.[7] Sayers incorporates the imagery of de Nerval's enigmatic, wandering desperado into her heroic Christ figure. As in Sayers, de Nerval's wanderer is an outcast Orpheus-like figure complete with a magical lute. The mythical qualities of the lute are noted in the first and last verses, stressing the lute's spiritual power as a cohesive metaphor in the poem.

> Je suis le Ténébreux, – le Veuf, – l'Inconsolé,
> Le Prince d'Aquitaine à la Tour abolie :
> Ma seule Étoile est morte, – et mon luth constellé
> Porte le Soleil noir de la Mélancolie.
>
> I am the man of shadows, – the widower, – the unconsoled,
> The Prince of Aquitaine of the ruined Tower:

7 "El Desdichado," the best-known sonnet by de Nerval, was published for the first time on the cover of the Parisian newspaper, *Le Mousquetaire*, December 10, 1853.

My only Star is dead, – and my starry lute
Carries the black Sun of Melancholy.

The lute is emphasized again in the last verse:

Et j'ai deux fois vainqueur traversé l'Achéron :
Modulant tour à tour sur la lyre d'Orphée
Les soupirs de la Sainte et les cris de la Fée.

I have twice crossed the Acheron, victorious:
Modulating by turns on Orpheus' lyre
The sighs of the Saint and the cries of the Fairy.
("El Desdichado," vs.1,4)

The "man of shadows" in this poem represents Godfried d'Aquitaine, a medieval lord and troubadour famous for his misfortunes and wanderings. He carries a lute, a musical instrument equipped to bring light to the darkness, and, as made explicit by the end of the poem, is connected with the myth of Orpheus. In de Nerval's poem, the hero wanders on a romantic quest, looking for a lost love. The poem ends ambiguously. De Nerval's brooding poetic mysticism gained popularity in the French Romantic movement, which continued through the early twentieth century. Sayers seems especially to have been influenced by de Nerval as she wrote her own "Desdichado."

Sayers's studies with Mildred Pope also included study of Victor Hugo and his masterpieces *Les Misérables* (*The Outcasts or The Wretched*) and *Notre-Dame de Paris or Le Bossu de Notre-Dame* (*The Hunchback of Notre-Dame*) in which the hero, Quasimodo, is the social outcast.

In Hugo's powerful and unsettling *Les Misérables*, we follow the outcast hero, Jean Valjean, relentlessly hunted who finally offers himself as sacrifice for a greater cause. In *Notre-Dame de Paris*, we find the outcast and tortured bell-ringer, Quasimodo, whose final sacrifice for love lifts him to heroic status. At this point in her life, Sayers was, indeed, a Romantic, influenced by that literary movement to the extent that her poems reflected her involvement with the concept of the romantic hero. However, to Sayers, that quintessential romantic hero was best embodied in the figure of Jesus Christ. Sayers, like Hugo before her, might be said, at least in her early poetry to be a Christian Romantic.

By recognizing the analogy to the Romantic outlaw hero and Christ, Sayers responded imaginatively and faithfully to both her

literary context and her religious faith. Each hero, including the Romantic hero, contributes to the whole Hero. But only Christ can embody the complete universal Hero. By her varied and multiple images of Christ, Sayers stresses the fundamental point that only Christ is Everyman, Everyhero, what she might call The Catholic Hero. This anticipates the ideas of Joseph Campbell (1949) in his classic, *Hero with a Thousand Faces*.

Contemporary readers tend to view Dorothy Sayers almost exclusively through an English lens because of her background and later writings – fiction, essays, and drama. But, in fact, Sayers was a French scholar and a student of French literature, medieval through early twentieth century, especially well versed in Romantic French literature. Certainly, it is visible in her early poetry and particularly within *Catholic Tales* and "Desdichado."

W. H. Lewis, Writer and Historian: A Prolegomena[1]

by Paul E. Michelson

Paul E. Michelson is Distinguished Professor Emeritus of History at Huntington University, where he has taught a course on C.S. Lewis for many years, as well as occasional courses on Tolkien and the Inklings. He is the author, co-author, or editor of six books dealing with Romanian history and has published over 150 articles on topics ranging from the history of Romania to the Inklings.

INTRODUCTION

The writing of Warren ("Warnie") Hamilton Lewis (1895-1972), better known as the older brother of C. S. (hereafter "Jack") Lewis, has received surprisingly little attention. The purpose of this paper is to introduce his work as a popular historian and writer.

Benefitting from an early military retirement (at the age of thirty-seven), Warnie had both the means and the leisure to become what today would be called an "independent scholar." He did not pursue this out of necessity or professional obligation, but rather for the enjoyment of the enterprise. Settling into an Oxford area home that the brothers shared, he had full access, as well, to Jack's rooms and books at Magdalen College and to the extensive holdings of the Bodleian Library. At the same time, he was a regular participant in his brother's literary circle, the Inklings, went on frequent walking tours with him and his friends, and, in general, shared fully in Jack's life until Jack's death in 1963.

What kind of writing did Warnie Lewis do? In the first place, he became the family biographer. As the compiler and editor of the Lewis family papers between 1933-1935, he was the principal source of what scholars know about the Lewis family up to 1930. He was also the author of a memoir of the life of C. S. Lewis, in effect the first biographer of his famous brother. Finally, he was the first editor of his brother's correspondence, another key resource for the study of Jack's life and work.

1 I wish to express my gratitude to the Marion E. Wade Center at Wheaton College, particularly Associate Curator Marjorie Lamp Mead and Archivist Laura Schmidt, for their assistance, discussion of, and access to the Lewis archives. Quotes by Warren H. Lewis in this paper used by permission of The Marion E. Wade Center, Wheaton College, Wheaton, IL.

Secondly, Warnie was a participant in and sometime chronicler of the doings of the Inklings, the Oxford literary circle that included C. S. Lewis, J. R. R. Tolkien, Owen Barfield, Charles Williams, and others. Descriptions of the meetings of this community of writers, particularly during the peak years in the 1940s, found a place in his beautifully written diary of over a million and a quarter words. The 1982 publication of an edited version of the diary provided a good deal of inside information on the weekly gatherings of Lewis and friends.

Thirdly, W. H. Lewis, the professional writer, was a historian of the French *Grand Siècle*, the author of no fewer than six books on Louis XIV's seventeenth- and eighteenth- century France (two of which were popular enough to merit American paperback editions in the 1960s), and the editor of a seventh volume on the period, the *Memoirs of the Duc de Saint-Simon*. Many people are rather surprised to discover that the author of these works was the brother of C. S. Lewis.[2]

Lastly, following the acquisition in 1936 of a twenty-foot inland river and canal cruiser, he even found time to write pieces for a British motor boat enthusiast magazine. While not of historical interest as such, the articles show us another side of this surprising writer.

W. H. Lewis as Historian of the Lewis Family

Beginning shortly after the death in 1929 of his father, Albert James Lewis, Warnie compiled and edited eleven typed volumes of Lewis Family papers between 1930 and 1935.[3] Entitled *Memoirs of the Lewis Family, 1850-1930*, this is the principal source of what we know about the Lewis family through 1930.[4] It is composed of letters, photographs, diaries, and other written materials from the family archives along with commentary and a number of biographical

2 The dust jacket of the British edition of his first book, *The Splendid Century*, (1953) does not mention the connection, though the book is dedicated "To My Brother." The author blurb on the cover of the 1957 American paperback edition does mention that he "now lives with his younger brother, C. S. Lewis, in Oxford, England."

3 On the Lewis Papers, see Walter Hooper, "Lewis Papers," in Walter Hooper, *C. S. Lewis: A Companion and Guide* (San Francisco: HarperSanFrancisco, 1996), 770; Marjorie Lamp Mead, "The Lewis Family Papers," in Jeffrey D. Schultz and John G. West, Jr., eds., *The C. S. Lewis Readers' Encyclopedia* (Grand Rapids MI: Zondervan Publishing House, 1998), 251; and Colin Duriez, "Lewis Family Papers," in Colin Duriez, *The A-Z of C. S. Lewis. An Encyclopedia of His Life, Thought, and Writings*, third edition (Oxford: Lion Books, 2013), 166-67.

4 W. H. Lewis, ed., *Memoirs of the Lewis Family, 1850-1930* (Oxford: Leeborough Press, 1933-1935), 11 volumes. References to this material are by permission of the Marion E. Wade Center.

sketches supplied by Warnie. They demonstrate his skilled editorial hand and shows him to be a clear and colorful writer.

His entry for W. T. Kirkpatrick, known to history as "The Great Knock" from a memorable chapter in C. S. Lewis's *Surprised by Joy*,[5] the tutor of Albert Lewis and both of his sons, shows Warnie's skill at character sketching. Two decades before Jack's account, he writes:

> All my life I had been hearing stories of "Kirk" or "The Knock" as the boys of Lurgan College called him, and as the branch line train jolted me down from Waterloo to Bookham, I had pretty well made up my mind as to the man I was going to meet. . . .

> I anticipated considerable discomfort in his society. I got it, but not quite in the form in which I expected it. I arrived at Bookham shortly before the time of the evening meal on an autumn afternoon, and was met by . . . a tall, stringy old man with white side whiskers, untidy clothes, and an expressive and piercing grey eye, not over cleanly as to his person and radiating physical and mental energy. . . .

> But the mere book learning he imparted to me was the least of the services he did me. When I went to Bookham I had what would now be called "an inferiority complex," partly the result of Wynyard, partly of my own idleness, and partly of the laissez faire methods of Malvern. A few weeks of Kirk's generous but sparing praise of my efforts, and his pungent criticisms of the Malvern masters restored my long-lost self confidence: I saw that whilst I was not brilliant or even clever, I had in the past been unsuccessful because I was lazy, and not lazy because I was unsuccessful. . . .

> Most of my education he conducted outside of working hours: in his company one learnt that conversation was neither an aid to digestion, nor an obligation, nor yet an opportunity to show one's cleverness – it was an interchange of THOUGHT, a communal contribution to the elucidation of a problem, or an imparting of a piece of information: in the presence of that clear, cold intellect, ordinary "conversation" was seen for what it was, mere silliness.

Warnie concludes with these touching words: "I owe more to him than to any other person I have ever met; I was very fond of him."

For Warnie's role as historian of the Lewis family, mention should

5 C. S. Lewis, *Surprised by Joy. The Shape of My Early Life* (San Francisco: HarperOne, 2017), 161.

be made here of three other pieces: the 1906-1916 *Boxen* papers (the childhood stories written by the two Lewis brothers);[6] "The Pudaita Pie,"[7] a collection by the Lewis brothers of anecdotes or "wheezes" about their father compiled between 1922 and 1930; and Warnie's 1953 recollections of Malvern College.[8]

In the early 1960s, Warnie wrote "C. S. Lewis: A Biography," conceived of as a kind of "life and letters" volume in nineteenth-century sense, interspersing biography with correspondence and running to nearly 500 pages in manuscript.[9] Ironically, the publisher thought the sale of books by C. S. Lewis had reached their apogee. Much to the dismay of Warnie, the biographical parts of the manuscript were drastically cut.[10] It became instead *The Letters of C. S. Lewis* (1966), prefaced by Warnie's dramatically edited "Memoir of C. S. Lewis" – which became the first published biography of Lewis.[11]

About the volume, Warnie wrote that "I regret the omissions (and inclusions), but what has been retained seems readable."[12] The account is not only well-written, but it adds much to C. S. Lewis's account in *Surprised by Joy*. Warnie frankly discusses the Mrs. Moore situation, the tensions between the Lewis brothers and their father, the burdens on Lewis from his escalating volume of correspondence "much of it from total strangers," the Oxonian hostility toward Jack's

6 Initially published as *C. S. Lewis, Boxen: The Imaginary World of the Young C. S. Lewis*, edited by Walter Hooper (London: Collins, 1985). This appeared in a new edition, not identified as such, as C. S. Lewis and W. H. Lewis, *Boxen: Childhood Chronicles Before Narnia*, with an "Introduction" by Douglas Gresham and "The History of Boxen" by Walter Hooper (London: HarperCollins, 2008), with three additional items not found in the 1985 version.

7 Warren and C. S. Lewis, "The Pudaita Pie. An Anthology," *VII: Journal of the Marion E. Wade Center*, 32 (2015): 59-67, edited by Crystal Hurd. The same volume contains Hurd's somewhat revisionist piece dealing with Albert Lewis: "The Pudaita Pie. Reflections on Albert Lewis": 47-58. Readers will recognize here the unflattering depiction of the Albert Lewis of *Surprised by Joy*, particularly the baffling purveyor of non-sequiturs.

8 W. H. Lewis, "Malvern in My Time," *Malvern Beacon*, 1953: 14-17, a contribution written at the suggestion of George Sayer. Rprt. in *CSL: The Bulletin of the New York C. S. Lewis Society*, 12, no. 8 (1981): 1-3.

9 The manuscript is in the Wade Center collection. Lewis aficionados will be delighted to know that it will be available to the general public, edited by Myriam Frenkel as an *Inklings Studies Supplement*, No. 2, 2018.

10 The volume was published as *C. S. Lewis, The Letters of C. S. Lewis*, edited with a Memoir by W. H. Lewis (London: Bles, 1966). On the "editing," see W. H. Lewis, diary entry for April 16, 1966, in W. H. Lewis, *Brothers and Friends: The Diaries of Major Warren Hamilton Lewis*, edited by Clyde S. Kilby and Marjorie Lamp Mead (San Francisco: Harper and Row, 1982), 256-57: "Definitely is no longer my book at all."

11 W. H. Lewis, "Memoir of C. S. Lewis," in *The Letters of C. S. Lewis*, 1-26.

12 W. H. Lewis, diary entry for April 16, 1966, in *Brothers and Friends*, 257.

Christian writings and efforts, and the happy days that followed Jack's marriage to Joy Davidman. In general the work succeeds in its purpose: offering "my own memories of Jack . . . [including] the difficulties under which he worked, the patterns of stress and tension that determined many aspects of his life." At the same time, following his nineteenth-century models, he focused on "the general reader's convenience, not aiming at any scholarly punctiliousness."

Warnie relates that Jack had "remarkable talent for friendship, particularly for friendship of an uproarious kind, masculine and argumentative but never quarrelsome." This talent found its home in the group known as "the Inklings, a famous and heroic gathering" which "was neither a club nor a literary society, though it partook of the nature of both." Yet, Warnie cautions his readers, it was "no mutual admiration society: praise for good work was unstinted, but censure for bad work – or even not-so-good work – was often brutally frank. To read to the Inklings was a formidable ordeal, and I can still remember the fear with which I offered the first chapter of my first book – and my delight, too, at its reception."

Warnie's selection of materials from his brother's vast correspondence was also an eye-opening look behind the scenes of his life, just a fragment of the thousands of letters written by Jack.[13] Warnie knew the correspondence well, since he had served in effect as Jack's secretary from late 1942 until his death in 1963.[14] In a 1943 letter to Arthur Greeves, Jack writes that "Warnie . . . is a great help to me as a secretary – he types all my non-personal letters now."[15] In fact, Warnie typed somewhere in the neighborhood of 12,000 letters for his brother, and developed a reference system beginning in 1944.[16]

This was just in the nick of time, for as C. S. Lewis became

13 In the early 2000s, Walter Hooper completed the task begun by W. H. Lewis by publishing three massive, indispensable volumes of Lewis's correspondence, under the title *C. S. Lewis, The Collected Letters of C. S. Lewis*. For an analysis, see Brenton Dickieson, "A Statistical Look at C.S. Lewis' Letter Writing," at https://apilgriminnarnia.com/2013/05/23/statistical-letter-writing/, last accessed 31 vii 2018.

14 The first correspondence written by Warnie, according to Walter Hooper, was a letter from C. S. Lewis to Eric Fenn, November 30, 1942, published in C. S. Lewis, *Collected Letters of C. S. Lewis, Vol. 2: Books, Broadcasts, and the War, 1931-1949*, Walter Hooper (San Francisco: HarperSanFrancisco, 2004), 538. On Warnie as C. S. Lewis's secretary, see Walter Hooper, "Preface," Lewis, *Collected Letters*, 2: xiii-xv.

15 C. S. Lewis to Arthur Greeves, June 1, 1943, in Lewis, *Collected Letters*, 1:579.

16 See *Brothers and Friends*, 210-211, note 224. On the "system," see Walter Hooper, "Preface," xiv.

nationally and then internationally known as a result of his BBC lectures and the publication of *The Screwtape Letters*, his steady stream of correspondence became a deluge.[17] Warnie's assistance was, therefore, providential. Given the fact that C. S. Lewis's letters were an important aspect of his ministry as well as "a major part of Lewis's writings,"[18] Warnie played an invaluable role in typing them, organizing them, and first making them known and available to a wider audience.

W. H. LEWIS AS HISTORIAN OF THE INKLINGS

Warnie's writings regarding the Inklings was his second great literary contribution. He was also the unofficial historian of the group. His already-mentioned "Memoir of C. S. Lewis" sets forth the more or less "unvarying" format of the Thursday evening meetings in Jack Lewis's rooms at Magdalen College as well as describing "another ritual gathering, subsidiary to the Inklings proper" where "the same company used to meet for an hour or so before lunch every Tuesday at the Eagle and Child in St Giles', better known as the Bird and Baby."[19]

The tantalizing vignette of the "Memoir" was based on his beautifully written diary (published in an edited version in 1982), providing a good deal more inside information on the weekly gatherings of Lewis and friends.[20] Much of what we know of the inner life of this circle of literary friends, we owe to Warnie's colorful accounts, like the following.

> Thursday, 30th October, 1947. Dined with J[ack] in Magdalen. . . . A very small Inkling afterwards, only Tollers [Tolkien], Humphrey [Dr. Havard], and us two. A long argument about the ethics of cannibalism, how arising I forget: Tollers very firm, though in a minority of one, that no circumstances – death or consent of the victim included – can justify it. J instanced the Communion rite without shaking him. This

17 George Sayer wrote that "After the publication of *Screwtape*, Jack became almost dependent on Warren. . . . The two had a close understanding. Warren answered many of the letters without bothering Jack at all. His letters were, in fact, nearly as lively and far more businesslike than Jack's." Sayer, *Jack*, 274. It should also be noted that C. S. Lewis was unbelievably productive during the war in addition to his radio lectures and *Screwtape*, including the meetings of the newly-founded Oxford University Socratic Club (1941), completion of the science fiction trilogy, the publication of *The Abolition of Man* (1943), and various literary endeavors, such as *A Preface to Paradise Lost* (1942), all the while giving lectures and holding tutorials.

18 Green and Hooper, *C. S. Lewis: A Biography*, 2002, 294-95.

19 Lewis, "Memoir," 13-14.

20 Lewis, *Brothers and Friends*. The complete diaries are located in the Wade Center collection.

led to a discussion of the possible confusion which exists in our minds between aesthetic distaste and hatred of sin, e.g. in sodomy, do we really hate the *sin* as we should do, or have we a mere disgust at the thought of the act? Tollers then read us the last chapter of the [new] Hobbit, that is to say the last he has written: so I fear this toothsome standing dish will be off for some time to come.[21]

Thursday, 1st January, 1948. [Tonight] we had a drouthy though pleasant Inklings in Tollers' room: present both Tolkiens [Christopher Tolkien was also an Inklings], [C. E. 'Tom'] Stevens, Humphrey, J, and myself. An interesting talk on the various versions of the Bible, and the Collects: which drifted somehow to Houseman and the ferocity of his prefaces: and thence to the *Chanson de Roland*.[22]

Yes, it is a shame that Warnie Lewis didn't do even more of this kind of recording of his brother and the Inklings, but certainly the debt we owe to his diary entries about the Inklings is significant.

W. H. LEWIS AS HISTORIAN OF THE FRENCH GRAND SIÈCLE

Warren Hamilton Lewis was also the author of six books on Louis XIV's seventeenth- and eighteenth-century France and the editor of a seventh volume dealing with the period. Though they are written as popular histories, they have retained their value as works of reference today, especially the first volume, *The Splendid Century*. A full bibliography of these publications is given following this essay.

In many ways, Warnie's preparation for this historical work was ideal. From childhood, he had been a voracious reader. The Lewis family home in Belfast was a place "of endless books. . . . There were books in the study, books in the drawing-room, books in the cloakroom, books (two-deep) in the great bookcase on the landing, books in a bedroom, books piled high as my shoulder in the cistern attic, books of all kinds."[23] It would have been surprising for someone growing up in such an environment not to have developed a sense of bookishness.

After an inauspicious start at a pretty bad boarding school, W. H. Lewis had had a grueling private education with the formidable W. T. Kirkpatrick, which was then capped off at the British military academy, Sandhurst. Interestingly, his unofficial writing career might

21 Lewis, diary entry of October 30, 1947, in *Brothers*, 212.
22 Lewis, diary entry of January 1, 1948, in *Brothers*, 217.
23 C.S. Lewis, *Surprised by Joy*, 10.

just have been jumpstarted at Malvern College where he wrote papers for his classmates.[24]

Apart from the "excitement" of World War I, his subsequent military career with the Royal Army Service Corps until retirement in 1932 was a combination of exotic and not-so-exotic locales which provided for ample leisure time, at least until 1929, to read and pursue his historical hobby.[25] His service as an army supply officer in France, which involved extensive dealings with local authorities and people, provided him with an excellent practical education in French.[26] His early retirement to Oxford, then, provided him the perfect place to write with almost unlimited access to the Oxford libraries and book collections.

During this time, Warnie Lewis began his serious research on *Le Grand Siècle*. Writing to his father, he confessed that the "period as you know, is one of, or perhaps IS my favourite in History, so I anticipate a lot of enjoyment from the memoirs."[27] This blossomed after his retirement, resulting in the completion in 1942 of his eventual first book. The book was read aloud at meetings of the Inklings, leading Tolkien to write that at an April 1944 Inklings meeting "The best entertainment proved to be the chapter of Major Lewis's projected new book – on a subject that does not interest me: the court of Louis XIV; but it was most wittily written (as well as learned)."[28]

Warnie also turned out to have affinities with another of the Inklings, Charles Williams. According to Jack:

> My brother's lifelong interest in the reign of Louis XIV was a bond between Williams and him which no one had foreseen when they first met. Those two, and Mr. H. V. D. Dyson of Merton, could often be heard in a corner talking about Versailles, *intendants*, and the *maison du roy*, in a fashion

24 W.H. Lewis, "Malvern in My Time," 16.

25 This is amply documented by his diary, which details the often dreary routine of such military postings and which also contains frequent references to his reading. Cf. for example, W.H. Lewis, *Memoirs of the Lewis Family*, Vol VIII, 180, 189, 207, 218, 258-59, 262-67, for a listing of books he read in 1924. Used by permission of the Marion E. Wade Center.

26 Charles Wrong's suggestion that Warnie may not have known French very well because he misplaced circumflexes (in Charles J. Wrong, "W. H. Lewis: Popular Historian", *The Canadian C. S. Lewis Review* 86 (1994): 33) is unfounded: both Lewis brothers were notoriously poor spellers. There is no reason he would be any better in French.

27 W. H. Lewis to Albert Lewis, March 3, 1919, in W. H. Lewis, *Memoirs of the Lewis Family*, Vol VI, 94-95. Used by permission of the Marion E. Wade Center.

28 Letter to Christopher Tolkien, April 13, 1944, in *The Letters of J. R. R. Tolkien*, edited by Humphrey Carpenter (Boston: Houghton Mifflin, 2000), 71.

which the rest of us could not compete.[29]

How fitting, then, that Warnie's first actual publication on *Le Grand Siècle* appeared as a chapter, "The Galleys of France," in the 1947 *festschrift* for Charles Williams.[30] Its opening sentence bears out Tolkien's glowing praise: "Until the coming of the concentration camps, the galley held an undisputed pre-eminence as the darkest blot on Western Civilization; a galley, said a poetic observer shudderingly, would cast a shadow in the blackest midnight."[31]

The Splendid Century: Some Aspects of French Life in the Reign of Louis XIV was published six years later in 1953 and remains a standard work of reference and anthologization.[32] As recently as July 2018, *The Splendid Century* stood at number one on the Amazon.com bestseller list for historical French biographies.[33]

According to the author, the book was not intended "to offer a comprehensive survey of the *Grande Siècle* . . . for two reasons: firstly, had I written on every aspect of the period which interests me, I should have swollen the book to unmanageable proportions."[34] The second reason was simply that "many achievements of the age . . . I am not competent to deal [with]."[35]

The result was, in effect, a series of topical essays dealing with the King, the Court, the Church, the Army, the Country Gentleman, and so forth, drawing a colorful and memorable picture of life as it was lived in *Le Grand Siècle*.

Here are a few sample extracts of this informative and delightful book. First, a passage from the chapter on "The Town":

29 C. S. Lewis, "Preface," in C. S. Lewis, ed., *Essays Presented to Charles Williams* (London: Oxford University Press, 1947), v-vi.

30 W. H. Lewis, "The Galleys of France," in *C. S. Lewis, Essays Presented to Charles Williams*, 1947, 136-145. This later appeared as chapter ten of *The Splendid Century*, "The Galleys." The Williams volume, which unfortunately appeared posthumously, included contributions by Dorothy L. Sayers, J. R. R. Tolkien, Owen Barfield, and Gervase Mathew, as well as the Lewis brothers.

31 Lewis, "The Galleys of France," 136.

32 W. H. Lewis, *The Splendid Century: Some Aspects of French Life in the Reign of Louis XIV* (London: Eyre and Spottiswoode, 1953). W. H. Lewis's chapter on "The Town," appeared in Allan Mitchell and Istvan Deak, eds., *Everyman in Europe: Essays in Social History* (Englewood Cliffs, NJ: Prentice-Hall, 1974), Vol. I. See also John B. Wolf, "The Reign of Louis XIV: A Selected Bibliography of Writings since the War of 1914-1918," *The Journal of Modern History*, 36 (1964): 127-44, which praises Lewis's "ability to bring out the color and flair of his subject" and as "reasonably objective, but without new material or insights."

33 www.amazon.com/gp/bestsellers/digital-text/10332412011/ref=sr_ bs_0_10332412011_1, last accessed 24 vii 2018.

34 Lewis, *Splendid Century*, 9.

35 Lewis, 9.

Only those who have travelled on foot through a Chinese town [in Warnie's day] can form any accurate idea of a Paris street, and the resemblance between the two must have been remarkable. In Paris, the stroller would find the same narrow thoroughfare, carpeted in filth, with the central gutter, or rather succession of stagnant pools, choked with dung, entrails, litter of all kinds. . . . It was not until I first entered a Chinese city that I suddenly understood why Louis XIV's Parisians always wore scented gloves in the streets. . . . As late as 1697 all household filth was still being disposed of by being flung out of the windows.[36]

Next, a passage from the chapter on "The Art of Living":

The move to Versailles confronted the town lover with a choice: that of abandoning Paris for Versailles, or of abandoning the Court for the town; it was, of course, still possible to have a foot in both camps, but it was a precarious and fatiguing existence. . . . The clique which chose to cut Versailles and live in Paris was naturally a small one, for to join it involved giving unpardonable offence to Louis, which in turn presupposed an unassailable financial status and a total lack of ambition.[37]

The book was well-received by reviewers. *The American Historical Review* was typical, hailing the volume as "the work of a nonspecialist . . . written for the entertainment and edification of a generous cross-section of the reading public." Furthermore, the author's "flair for the picturesque is everywhere evident."[38]

This was followed in 1954 by *The Sunset of the Splendid Century: The Life and Times of Louis Auguste de Bourbon, Duc de Maine, 1670–1736.*[39] In the preface, Lewis wrote:

In a very loose sense this book might be regarded as a sequel to *The Splendid Century*, published in 1953. But as it is a story complete in itself, I should prefer to say that it is the France of Louis XIV seen from a different angle. In *The Splendid Century* I dealt with classes rather than individuals, with problems of government and policy rather than with private lives. Here, I have endeavoured to complete the picture by telling the life-

36 Lewis, 191-92.
37 Lewis, 217.
38 William F. Church, "Review of *The Splendid Century* by W. H. Lewis," *The American Historical Review* 60 (1954): 83-84. In his *Louis XIV in Historical Thought. From Voltaire to the Annales School* (New York: W. W. Norton, 1976) Church mentions Lewis as the author of works on Louis XIV that are "revealing and indeed fascinating," 69.
39 London: Eyre and Spottiswoode, 1955. References below are to the American paperback edition Garden City NY: Doubleday Anchor Books, 1963.

story of the Duc du Maine, Bastard of France, against a lightly sketched background showing the rise, triumph, and decline of Louis XIV, and the repercussions which followed on his death.[40]

Lewis's choice of the rather minor Duc du Maine as the focus of this book was deliberate: "I selected Maine precisely for his ordinariness" so as to give "a picture of the life of any typical rank and file member of Louis XIV's higher aristocracy." Indeed, "a more prominent figure would not have served my purpose so well."[41]

Reviewers found many of the same virtues of *The Splendid Century* in *The Sunset of the Splendid Century*. In *The Modern Language Journal*, William Marion Miller commented:

> The book gives a good picture of the social life of the last half of the seventeenth century and the first four or five decades of the eighteenth. . . . It is, I dare say, a welcome and useful addition to the vast amount of material that has already been written on this important period in the history of France.[42]

In 1958, Lewis published a third volume, *Assault on Olympus: The Rise of the House of Gramont between 1604 and 1678*. In 1959, he published *Louis XIV: An Informal Portrait*, which also drew skillfully on his previous studies. In 1961 and 1962, Warnie's two final monographs on French history were published – *The Scandalous Regent: A Life of Philippe, Duc d'Orleans, 1674-1723* and *Levantine Adventurer: The Travels and Missions of the Chevalier d'Arvieux, 1653-1697*. His work on *Le Grande Siècle* was rounded out in 1964 by his edition of *Memoirs of the Duc de Saint-Simon*, which took him all the way back to his original interest in *Le Grand Siècle*.

W. H. Lewis as Motor Boat Enthusiast

Warnie also wrote a series of articles for a boating magazine, *The Motor Boat* (subsequently, *The Motor Boat and Yachting*). In 1936, he had acquired a 20-foot two-birth motor boat, *The Bosphorus*, which had been specially built for cruising on Great Britain's extensive inland rivers and canals (The name *Bosphorus* derived from a schooner mentioned in the Boxen stories). Interestingly for a military man, Warnie was quite fond of the sea, writing in his diary in 1933 that "The only thing in the world which is for me associated exclusively

40 Lewis, *Sunset of the Splendid Century*, ix.
41 Lewis, *Sunset*, ix.
42 Wm. Marion Miller, "Review of *The Sunset of the Splendid Century* by W. H. Lewis," *The Modern Language Journal* 40 (1956): 365.

with happiness: of inanimate things I put the taste and sound and sight of the sea first of my possessions."[43] His "hobby" also enabled him to find a degree of freedom and privacy which was lacking at the Kilns.[44]

Though perhaps a minor genre, and, strictly speaking not really historical in nature, these articles are worth mentioning here because they reflect the historical/descriptive/aesthetic style and elements of his diary. In 1947, he had written that "the older I grow the more I come to think that 'scenery' is the champagne of the eye – delicious, but for special occasions. I should not like to live in a famous beauty spot, any more than one would want to marry a famous beauty. A countryside such as this (Ireland) gives me all I require for my aesthetic daily bread."[45]

These pieces, typically charming and picaresque, were generally only a few pages in length and accompanied by photos. A bibliography of all his known boating articles follows this essay.[46]

43 From the entry for June 25, 1933, in the *Warren Hamilton Lewis Diaries*, The Marion E. Wade Center, Wheaton College, Wheaton IL, Vol. 15, Folder 3, 137-140. Used by permission of the Marion E. Wade Center.

44 See the editors' comment in *Brothers*, 174.

45 Lewis, diary entry for July 24, 1947, in *Brothers*, 206. Used by permission of the Marion E. Wade Center.

46 Copies of these articles were made available to me at the Wade Center in Wheaton.

THE BOOKS OF MAJOR W. H. LEWIS:
A CHRONOLOGICAL BIBLIOGRAPHY

The Splendid Century: Some Aspects of French Life in the Reign of Louis XIV. London: Eyre and Spottiswoode, 1953. 320 pp. + 16 plates; American edition: *The Splendid Century. Life in the France of Louis XIV.* New York: William Sloane Associates, 1954 306 pp. + plates; American paperback edition: Garden City NY: Anchor Books, Doubleday and Company, 1957, viii + 304 pp. + plates; New York: Morrow Quill edition, 1978, xiv + 306 pp.

The Sunset of the Splendid Century: The Life and Times of Louis Auguste de Bourbon, Duc de Maine, 1670–1736. London: Eyre and Spottiswoode, 1955. 320 pp. + 16 plates; American edition: New York: William Sloane Associates, 1955, 320 pp. + plates; American paperback edition: Garden City NY: Doubleday Anchor Books, Doubleday and Company, 1963, x + 386 pp. + plates.

Assault on Olympus: The Rise of the House of Gramont between 1604 and 1678. London: Andre Deutsch, 1958, 240 pp.; American edition: New York: Harcourt, Brace, and Company, 1958, 240 pp.

Louis XIV. An Informal Portrait. London: Andre Deutsch, 1959, 224 pp. + plates; American edition: New York: Harcourt, Brace, and Company, 1959, 224 pp. + plates; German editions: *Ludwig XIV: Halbgott und Mensch*, translated by Robert Felix Tübingen: Wunderlich, 1959, 313 pp. + plates; *Ludwig XIV. Der Sonnenkönig*, translated by Robert Felix München: Wilhelm Heyne, 1981, 348 pp. + plates; *Ludwig XIV. Der Sonnenkönig*, translated by Robert Felix Stuttgart/Wien/Zürich: Verlag Das Beste, 1997, 468 pp. + plates.

The Scandalous Regent: A Life of Philippe, Duc d'Orleans, 1674–1723 and of his family. London: Andre Deutsch, 1961, 228 pp.; American edition: New York: Harcourt, Brace, and World, 1961, 228 pp.

Levantine Adventurer: The Travels and Missions of the Chevalier d'Arvieux, 1653–1697. London: Andre Deutsch, 1962, 232 pp.; American edition: New York, Harcourt, Brace

& World, 1963, 232 pp.

Louis de Rouvroy, Duc de Saint-Simon. *Memoirs of the Duc de Saint-Simon*. Edited by W. H. Lewis. Translated by Bayle St. John. London: B. T. Batford, 1964, xiii + 242 pp.; American edition and paperback edition: New York: Macmillan, 1964, xiii + 242 pp.

THE BOATING ARTICLES OF MAJOR W. H. LEWIS: A CHRONOLOGICAL BIBLIOGRAPHY

"Through the Oxford Canal: A Whitsun Cruise on a Secluded and Attractive Waterway." *The Motor Boat*, July 2, 1937, 5-7, and July 9, 1937, 54-55.

"Exploring the Wey: A Three Days' Cruise on a Tributary of the Thames." *The Motor Boat*, February 25, 1938, 198-99.

"Cruising in Ulster Waters: Sailing Directions for Strangford Lough." *The Motor Boat*, April 15, 1938, 364-65.

"The Great Ouse: A Week with 'Bosphorus' on Fenland Waterways." *The Motor Boat and Yachting*, August 12, 1938, 180-81.

"But What's It Going to Cost?" *The Motor Boat and Yachting*, November 4, 1938, 482-83.

"The Winter of Our Discontent: It Is Not So Bad, After All, Thinks This Ditchcrawler." *The Motor Boat and Yachting*, February 17, 1939, 158-59.

"A Ditchcrawling Discourse." *The Motor Boat and Yachting*, May 12, 1939, 485-86.

Two Different Lewises
in Barfield's "Pegasus" Poem

by Stephen Thorson

Stephen Thorson earned an MD from Pennsylvania State University and an MA in theological studies from Wheaton College. He has worked in Nepal since 1984 and has taught theology courses there since 1992. Dr. Thorson contributed most of the topical articles for the *Applied New Testament Commentary*, as well as those for *The Applied Old Testament Commentary*. He has published many medical research studies, theological articles, and essays on C.S. Lewis. His most recent book is *Joy and Poetic Imagination: Understanding C.S. Lewis's "Great War" with Owen Barfield and its Significance for Lewis's Conversion and Writings*.

Owen Barfield often stated his opinion that his friend, C.S. Lewis, was three, or even five Lewises. In 1977, Barfield proposed that there was a "combatively logical Lewis," a "gently imaginative Lewis," and a "Lewis of literary scholarship and literary criticism."[1] In 1988, he identified five Lewises, a "distinguished and original literary critic," a "highly successful author of fiction," a "broadcaster of popular Christian apologetics," as well as a pre-conversion and post-conversion Lewis.[2] Interestingly, Lewis himself recognized three Lewises in himself: "the imaginative man," and "the religious writer," and "the critic."[3]

In his "Introduction" to *Light on C.S. Lewis*, Barfield described his problem with the "two Lewises" he increasingly recognized after 1935. He "unload[ed]" his obsession with the two Lewises in a verse drama written, as he says, "about 1950." He claims that he "rarely lost sight of . . . the fact that two of the characters loosely and archetypically represented for me 'my' two Lewises." Indeed, he states that this theme "most effectively determined the structure of the whole poem."[4]

1 Owen Barfield, "Lewis, Truth, and Imagination," *Owen Barfield on C.S. Lewis*, ed. G.B. Tennyson and Jane Hipolito, 2nd ed. (Oxford, UK: Barfield Press, 2011), 96-97.

2 Barfield, "The Five C.S. Lewises," *Owen Barfield on C.S. Lewis*, 129-30.

3 C.S. Lewis, letter to the Milton Society of America, ?1954, *Collected Letters, Volume III: Narnia, Cambridge, and Joy, 1950-1963*, ed. Walter Hooper (New York, NY: Harper Collins, 2007), 516-17.

4 Barfield, introduction, *Light on C.S. Lewis*, ed. Jocelyn Gibb (New York,

The verse drama is yet unpublished. It exists in two typescripts, almost identical, with different titles: "The Mother of Pegasus" (housed at the Marion E. Wade Center at Wheaton College) and "Riders on Pegasus" (at the Bodleian Library in Oxford).[5] According to Barfield's biographer, the poem is "written stylistically and semantically in a kind of personal code which could prove fascinating to unravel, but places it beyond the scope of the present study."[6] He goes on, despite Barfield's own explanation, to call it the "most mysterious" of Barfield's writings.[7] However, with a better understanding of the so-called "Great War" between Barfield and Lewis, the poem becomes much clearer.

The "Great War" was a term Lewis used to describe his decade-long argument between Barfield and himself in the 1920s, calling it a "major turning point" in his life.[8] They argued in person, through letters, and in the long (English) treatises with Latin titles that they wrote to each other toward the end of the decade. The "Great War" letters from Lewis were published in 2007, while the treatises from both men and two surviving letters from Barfield were finally published in 2015.[9] The main issue of the debate was the degree to which (if at all) the imagination may be said to provide truth.

The argument began with Barfield's conversion to Anthroposophy. Its founder, Rudolf Steiner, taught that new knowledge could be obtained by trained meditation, specifically, a supersensible awareness of new knowledge about reality, including the truth of the evolution of the consciousness of humanity through repeated earth-lives. Barfield believed that his life-long aesthetic experiences of poetry (poetic Imagination) not only evoked certain subjective feelings, but also revealed new knowledge about reality.[10] Although Lewis regularly

NY: Harcourt, 1976), xii-xiii.

5 The Wade Center (corrected) typescript is titled, "The Mother of Pegasus." The almost identical typescript in the Bodleian Library is titled, "Riders on Pegasus." The latter is available at <http://www.owenbarfield.org/riders-on-pegasus/>. Quotations are given by permission from Owen Barfield, Jr.

6 Simon Blaxland-de Lange, *Owen Barfield: Romanticism Comes of Age*, a Biography (Forest Row, UK: Temple Lodge, 2006), 265.

7 Blaxland-de Lange, 333.

8 Lewis, *Surprised by Joy: The Shape of My Early Life* (New York, NY: Harcourt, 1956), 207.

9 Lewis, *Collected Letters, Volume III, 1596-1645*; Barfield and Lewis, *The "Great War" of Owen Barfield and C. S. Lewis: Philosophical Writings 1927-1930*, ed. Norbert Feinendegen and Arend Smilde, *Journal of Inklings Studies*. Inklings Studies Supplement, No. 1 (2015).

10 Barfield, *Poetic Diction: A Study in Meaning*, 2nd ed. (1928; Middletown, CT: Wesleyan University Press, 1967).

experienced a special kind of aesthetic longing (which he called "Sehnsucht" or "Joy" or "Desire," hereafter simply Joy)[11] through music, the world of nature, and poetry, he was unwilling to assign the label "knowledge" to what remained in his mind after these experiences faded. He argued that such experiences provided meaning, if true, but not knowledge of actuality or fact-hood.[12] For more details on the foundation for my subsequent analysis, see my book on Lewis and Barfield's "Great War."[13]

The "Riders on Pegasus" poem has seven cantos with 35-55 stanzas per canto. Each stanza contains eight lines of ten syllables, rhyming ABCBBDED. Although Barfield remembered the date of the poem as "about 1950," Lewis refers to the poem in an April 1949 letter to Barfield, in which Lewis humorously hopes that (in addition to being both of the two main male characters) he is not also the main *female* character, Andromeda.[14] Barfield himself refers to "The Mother of Pegasus" as early as May 1950 in a letter to Leo Baker (a mutual friend of Barfield and Lewis).[15]

For this work, Barfield combined two separate myths to bring his two Lewises together into one story. In separate Greek myths, Perseus and Bellerophon are said to have flown on Pegasus, the winged horse, but the two heroes meet for the first time in Barfield's poem. Perseus is famous as the slayer of Medusa, the Gorgon, as well as the rescuer of Andromeda from a sea-monster. In some later versions of his story, Perseus flew Pegasus while rescuing Andromeda. The lesser-known Bellerophon is the slayer of the composite monster Chimaera (a monster with the head of a lioness, the body of a goat, and the tail of a serpent), which was only possible because he was flying on Pegasus at the time. In Barfield's poem, Pegasus clearly becomes a symbol of soaring to the heavens through poetic Imagination (with a capital

11 Many scholars misunderstand this special experience of Lewis's. Joy was not simply aesthetic longing, but a recurrent momentary experience of sudden longing, which left him with a "longing to recover an old state of longing"; see Lewis, "'Early Prose Joy': C.S. Lewis's Early Draft of an Autobiographical Manuscript," ed. Andrew Lazo, *Seven: An Anglo-American Literary Review*, 30 (2013): 13-49. Barfield confirms the experience to be a "longing for a longing you have lost" in his "Lewis and /or Barfield," *Owen Barfield on C.S. Lewis*, 137.

12 Lewis, *Collected Letters*, 3: 1633-34.

13 Stephen Thorson, *Joy and Poetic Imagination: Understanding C.S. Lewis's "Great War" with Owen Barfield and its Significance for Lewis's Conversion and Writings* (Hamden, CT: Winged Lion, 2015).

14 Lewis, letter to Barfield, 6 April 1949, *Collected Letters, Volume II: Books, Broadcasts, and the War, 1931-1949*, ed. Walter Hooper (New York, NY: Harper Collins, 2004), 929-30.

15 Blaxland-de Lange, 303.

"I"). Canto I, titled "Andromeda," opens with a terrified Andromeda, now married to Perseus, asking her patron goddess, Aphrodite (the goddess of love), to help her discover what cold and frightful thing Perseus is hiding in his cupboard press. It is, of course, the slain Medusa's head in a bag, which Perseus has kept to use in battle against his enemies. Medusa, the evil Gorgon with serpents instead of hair, turned all who looked upon her into stone. Medusa's two equally evil sisters, Stheno and Euryale, also appear in Barfield's poem. Medusa was also the grandmother of the Chimaera that Bellerophon killed (in other myths), as well as the "mother" of Pegasus. Perseus was able to slay Medusa because he only looked at her reflection in the Shield of Athene, his patron goddess (of wisdom and war). Medusa's severed head retained the ability to turn those looking at it into stone.

Canto II, "Perseus," describes the present state of affairs in Ethiopia, and especially the mind of Perseus, using language that will be familiar to all those who know Barfield's "combatively logical" Lewis:

> He in a thought-well of divine reflection
> Saw truths, so mere they make mere glancers blind:
> So, when men wrangled fruitlessly, entangled
> In secondary thoughts, his sovran mind
> Dropped blessing on them, dancing round behind
> The parrot phrase, or pricking vested error
> With its own point – the little spot of light
> Then everywhere at once, the Sun's – his mind a mirror. (II.11)

Notice Barfield's reference to the "mere truths" this Perseus sees from his "thought-well."

> So slightly turned, it never lost the light,
> And with what ease! And not as having striven,
> But laughing like a boy – yet afterwards
> Men marveled at the strength they had been given,
> And told each other: "He came down from heaven . . ." (II.12)

But all is not well with Perseus. In Barfield's poem the Shield of Athene represents logical Reason:

> Perseus began to love the sacred shield
> Itself, its rimmed horizon; before long
> He needed it beside him everywhere.
> To use it made him feel so firm and strong;
> For in those depths he judged of right and wrong
> Aloofly, saw the Whole without infection
> Of contact with the part – his darting mind

Pierced all things, insulated from them by reflection. (II.15)

Notice, the whole and part comparison, so important for Barfield's philosophy.[16] And in the very next stanza, Barfield warns Perseus/ Lewis about this overuse of Reason: "high on the throne the King / Sat looking at them with his back to the Court!" (16).

Perseus eventually takes the Shield of Athene everywhere when riding among his people, even when talking to his wife, and asks his servants to address the mirror. Barfield describes this first "Lewis" in his "Introduction" to *Light on C. S. Lewis* thus: Perseus goes "through a great many difficulties arising out of a preference he had developed for dealing with the reflections of things rather than with the things themselves (the objective correlative here was the excessive use, for administrative purposes, of the mirror which had once enabled him to slay the Gorgon)."[17]

Ironically, the "reflection" imagery in this passage came from Lewis himself. During their "Great War," Lewis drew a series of pictures to warn Barfield away from "supersensible" experiences during Anthroposophical meditation. Even though he was not a Christian at the time, Lewis believed that these experiences were dangerous, confusing imaginative meaning with true facts. He explained that Barfield, like all humans, was restricted by the post of "finite personality" to seeing reality (behind the post) only in the mirror of phenomenon with the eyes of "explicit cognition." His final picture shows a man (clearly Barfield) having used "occult science, yoga, 'meditation'" to chip off the mirror in an attempt to find more of reality. The man does not find more reality but is now "shrinking in horror from the phantom he has created." On the mirror, "visible to his neighbors" is the feared end-result of all this, an "ambulance, asylum, [and a] cemetery."[18]

The second character representing Lewis is Bellerophon, a son of Poseidon. When we meet him, he has recently killed Chimaera, the monster daughter of a half-brother of his, Chrysoar, fathered by Poseidon from the very Medusa Perseus had killed (according to the version of the story that Barfield used). Bellerophon's story is similar to Joseph's in Genesis. While in exile in Argos, he had refused seduction by the queen, who then accused him of attempted rape. Her

16 Barfield, *De Toto et Parte [The Whole and the Part]*, in Barfield and Lewis, *The "Great War,"* 149. Again, refer to Thorson, *Joy and Poetic Imagination*, for more explanation.
17 Barfield, introduction, *Light*, xii-xiii.
18 Lewis, *Collected Letters*, 3:1602-4.

husband sent Bellerophon to Lycia with a sealed letter instructing the king of Lycia to kill Bellerophon. Reluctant to do so, the king sent Bellerophon off to fight Chimaera, mistakenly hoping that this would produce the same result.

In Canto II, we find a description of Bellerophon, and like that of Perseus, it is meant to remind us of one side of Lewis. This is Barfield's view of the Lewis that rejected experiences of Imagination as our highest spiritual life and embraced instead a moral duty to orthodox Christianity. Bellerophon is described by Athene. He:

> "Abhors proud men, and prizes simple worth
> Beyond nobility. His mind to earth,
> His heart turned to the Gods, he pricks, demure,
> Erect, the path of duty – whom all the beauty
> Of Argos' frail, pathetic Queen could not allure;
> . . . [nor Chimaera] wrest
> His will unwilling from his mind's behest." (II, 49)

Meanwhile, Phineus, furious at losing Andromeda as his bride, goes to war and is defeating Perseus's army. Medusa's sister gorgons have secretly helped Phineus to resist their sister's dead stare, described as an "unwilling tool / For fastening on impulse Reason's rule" (II, 52). Athene suggests to Perseus that he should seek out Bellerophon to help his cause.

Canto III, "Bellerophon," relates how Andromeda secretly follows Perseus, and joins him in time to catch up with Bellerophon. It is she who discovers that the fully draped "horse" of Bellerophon actually has wings. In Canto IV, "Pegasus," Bellerophon tells them of his former skeptical view of the world. He expounds on gods vanishing from the world and raw materialism, and then moves on to his inner skepticism:

> "And worse than a world forsaken, worse than all
> That mausoleum of mere earth and sky,
> The charnel stillness of the world within;
> Where impulse chocks at reason's bantering Why;
>
> Till will has put on mind's infirmity,
> And old man's languor settles unperceived,
> And lotus-rotted are the lips that mutter:-
> 'Naught can be felt or done, since naught can be believed.'" (IV, 3)

This is reminiscent of Lewis's darker poems from *Spirits in Bondage*. But then, this "desolate" Bellerophon "suddenly" began to experience what Lewis called Joy or Desire:

> "And in that instant I became aware
> Of goings on – some older tale than Reason's –
> Pirene's fountain streaming far above,
> And the lift and lapse of vapours in Earth's dance of seasons.
> [Then] . . . Eager sprang belief
> In the unbelievable" (IV, 8, 9)

Although he seemed to see something flying, at first he denied its existence:

> "'Imaginings!' / Said dull experience drily, 'You see what you
> wish.'"(IV, 9)[19]
> "And I looked up from the water, swift as thought!
> And found it was a phantom of my brain!
> But when, after some days, it gleamed again . . .
> . . . like a blessing, and this time
> Glassed in the Fountain Tarn I beheld a flying horse!" (10)

Pegasus had sprung from a few drops of Medusa's blood, but tempered from the direct sun by a tiny cloud. This resulted in a glorious winged horse, instead of a monster like Chimaera, the evil "niece" of Pegasus.

Several times, Bellerophon looked up, but, each time, the vision vanished:

> "Then raise again – poor cautious dupe – my eyes
> To rake with killing custom's pursy stare
> The iron crags and all the empty air." (IV,12)

Bellerophon was unable to capture this wonderful creature, just as Lewis could not retain his fleeting experiences of Joy. But Athene gives him a golden bridle that was finally able to subdue Pegasus. Then, flying on Pegasus, Bellerophon is able to slay Chimaera. Perseus and Andromeda request Bellerophon to use the head of Medusa while flying on Pegasus to defeat the army of Phineus, not knowing about the new armor Medusa's sisters have arranged. But Bellerophon refuses. He had already tried to fly to heaven and failed:

> "Forgive, but ask not of my flight toward Heaven.
> Enough, ye know I tried: the way is not that way!" (IV, 47)

Zeus had laughed at Bellerophon's presumptuous attempt.

> "Will thou, thou little blind
> Bellerophon, o' leap the law of kind

19 Lewis used the phrase "Christina dreams" for fantasy or wishful thinking throughout the 1920's in his *All My Road Before Me: The Diary of C.S. Lewis 1922-1927*, ed. Walter Hooper (London: HarperCollins, 1991). He explained more in his Preface to the second edition of his *Dymer* (New York, NY: Macmillan, 1950).

So easily? Great Prince! How thou wast born
Hast thou forgot so soon? Down, down to earth!" (48)

Finally, Bellerophon concludes that: "Quadrupeds, Mountant on wings, blaspheme the Zodiac" (49). Therefore, he has decided that he will only ride Pegasus on the ground, draping his wings. Barfield describes this Lewis (afraid of blasphemy) thus: "Bellerophon . . . after slaying the monster Chimaera, declined an invitation to ascend to heaven on the back of Pegasus, who had been his mount in the fateful contest, on the ground of impiety."[20] We learn the nature of the invitation in the next canto.

In Canto V, "The Gods," Aphrodite, Andromeda's patron goddess, advises her to get Perseus to ask an important question: "Will Bellerophon fly on Pegasus again, if his own goddess, Athene, requests it?" This is the invitation Barfield believes Lewis refused: "If Reason asks him to do it, will Lewis soar on Imagination to the heavens and see the supersensible realities that Anthroposophy sees?" Bellerophon answers: "I cannot say – She could not so" (V, 11).

At that moment, a messenger arrives to tell Perseus that Phineus has already conquered Ethiopia, bringing prosperity and such modern advances as birth control (including condoms), abortion, new materials that are light but hard (plastics?), and loss of faith. Bellerophon still refuses to fly "on the grounds of impiety," in order to follow moral duty instead:

> "Have I not said I may not fly?
> How shall the Gorgon make the lewd less lewd?
> Rather *His* levin purges! Therefore pray,
> Casting yourselves upon the Fatherhood
> Of Zeus, who giveth all. I have learnt that good
> Is not one man on wings, but such man's choice
> Instantly to obey: when lean wolves howl,
> The Mastiff cocks his ears up for this Master's voice!" (V, 37)

Ironically, Bellerophon ends by mocking Pegasus with the name of Pegasus's defeated enemy as "a glorified / Chimaera! Scorning his dear law of kind, / Twy-natured, dangerous! Chaos shall rule chaos / And pride shall cast out pride! Ye crazy fools and blind!" (38).

In Canto VI, "The Gorgons," Athene, having obtained Zeus's approval, does command Bellerophon to defend Ethiopia. But the gorgon sisters of Medusa block her words, and Athene gives up in disgust. Then Aphrodite by-passes the gorgons, trying through Andromeda. She requests that Bellerophon give Pegasus to Perseus,

20 Barfield, introduction, *Light*, xii-xiii.

but Bellerophon, stung by the gorgon sister's venom, also refuses this. "When I am thrown, / It shall be time enough. Let him, who can, / "Unhorse me!" (VI, 23).

The gorgons believe they have succeeded and leave the field to Aphrodite. Aphrodite changes Andromeda into a gadfly. She stings Pegasus, who throws Bellerophon to the ground, freeing his powerful wings. Pegasus (Imagination) tries to comfort Bellerophon, when Bellerophon clasps Pegasus good-bye:

> "Farewell, Beautiful!"
> He [Bellerophon] murmured, "Dost thou mind the Fountain Pool?"
> And, while he fondled, Pegasus' great wing,
> Like the strange love of woman, curved above
> His bruised shoulders, nervous, awful, sheltering. (32)

But this "sheltering" wing only brings fear to Bellerophon:

> But he, when first he felt its feathery touch,
> Stared, like a man remembering things; some old
> Horror came over him, as though he heard
> A stealthy serpent rustling to enfold . . . with its flesh. (33)

So Bellerophon leaves Pegasus (Imagination):

> [H]e ducked, loosing his hold,
> And passed in front, below the Horse's head,
> Hastening as best he might; then, turning not,
> Alone for ever down the mountain, limping, fled,
> Fled from his friends, who would have loved him well
> Over the mountain-shoulder, out of sight.
> So the Myth knows no more of him. (34)

A stanza later, Barfield describes Bellerophon's end:

> . . . And gossips told
> How with each added year they watched him grow
> More full of crotchets, how the children mocked him,
> How all things through the day must run just so
> As he was used to them, or he would go
> Grumbling to bed and blaming. Yet the Blest
> Received him when he died – no fiery stars
> Whirling, but steeped Elysium dowered his ghost with rest. (35)

In his "Introduction" to *Light on C. S. Lewis*, Barfield comments on this second Lewis, "He was thrown by Pegasus and ended his days in increasing obscurity as a kind of aging, grumbling, earthbound,

guilt-oppressed *laudator temporis acti* [one who praises times past]."[21] This was meant as a warning to Lewis not to reject the high view of Imagination he had held during the "Great War," and not to consider it "impiety" to use Imagination to fly to the heavens and discover "supersensible" truths there.

The final Canto VII, "The Temple," reveals more of Barfield's desire for Lewis. Perseus, who represents what Barfield called "Thinking" or "Willing" during the "Great War," is unable to fly Pegasus (that is, unable to soar in Imagination) without Andromeda. She represents what Barfield called "Feeling" during the "Great War" arguments, but in his "Introduction" to *Light on C. S. Lewis*, Barfield writes that she is Perseus's "creative Eros."[22]

Together then, Perseus and Andromeda fly to Aphrodite's temple. There, Aphrodite encircles Andromeda with a girdle of Love, and raises Athene's Shield over Andromeda's head; Athene crowns Perseus with an Olive Crown, and then raises Medusa's head above Perseus. The royal pair carefully gaze only toward each other, bursting into antiphonal praise:

"Thou [Perseus] are the Sword, the Saviour from the Beast!"
"Thou [Andromeda] are the Meaning of the Abstract Word!" –
"Thou are my Head!" –
　　　"And thou my Will released,
"The Glory round the Head!" –
　　　　　"Be it increased!
"Thou are my King!" she sang, and he:- "Thou art
"Mine Impulse freed, the self-warm Deed, my Soul!
"I will not break thy seal!
　　　　"I will not break thy heart!" (VII, 19)

The following stanza seems to be a poetical description of their physical (and spiritual) consummation.

Suddenly, Poseidon attempts to enter the temple, terrifying Andromeda with memories of his previous order to kill her. Aphrodite (Love) calls to Athene (Wisdom), and Athene calls out for a new god to defend the pair:

[S]ome God came across
The waste of waters, hasting to their need;
A sable-winged and youthful God he was,
Late-comer to Olympus – Thanatos

21　Barfield, Introduction, *Light*, xii-xiii.
22　Barfield, xii. See also Barfield, "Autem" in Barfield and Lewis, 149.

His name and, where he came, he stilled the waves,
Walking erect on them: where he passed by,
He poured on anger oil of the dear grace that saves. (22)

Who is this God? He is a youthful, late-comer god; he stills the
waves, walks on water, and his grace "saves." Could this be Barfield's
description of Christ? Rudolf Steiner, although his view of Jesus
Christ is not theologically orthodox, believed that the Incarnation
of Jesus represented the center point in history. In another work of
his defending Steiner, Barfield explains that there were actually two
children called Jesus, one eventually offering up his "very personality"
to the other to allow the Timeless to enter time.[23]

In the following lines, Medusa's face, changed by Andromeda's
"womanhood restored," becomes fixed in the Shield of Athene,
changing Medusa's solely destructive stare into one that depends on
the spiritual state of the person who looks at it. Now her image is said
"[t]o brace and strengthen whom she failed to kill" (24). In another
place, we are told that "[t]he Shield appalled true hearts to steel, and
false to stone" (25). Perseus uses this "revised version" of the Shield to
defeat the army of Phineus, and the kingdom returns to peace:

.... Freedom walked inviolate.
Whole in each household, total in the State
Harmony reigned through all that golden time,
Because, harmonious in everyman,
Body and soul and spirit rang a triple chime. (28)[24]

Pegasus soon leaves them, but returns many years later in order to
fly them to the heavens to constellate there. And thus the end of the
poem.

Later, Barfield summarizes this ideal Lewis in the poem thus:
Perseus "made peace with his creative eros (Andromeda) and was
ultimately constellated, along with Andromeda and Pegasus, in the
heavens."[25] This was indeed Barfield's goal for Lewis, that he keep
the high view of Imagination he had held during their "Great War."
By doing so, Barfield hoped that Lewis would ascend back up toward
Spirit while remaining an individual soul, that Lewis would learn to
retain more than mere "residue" of truth after returning to normal

23 Barfield, *Unancestral Voice* (Middletown, CT: Wesleyan University Press, 1966) 112-13.

24 Readers should note that, for Barfield, the word "spirit" here is not "contained within the body," but is the "encompassing spirit that persists and sustains . . . through the transformation that is life and death," a spirit that never dies, but is reincarnated over and over in the world (*Unancestral Voice*, 108).

25 Barfield, introduction, *Light*, xii-xiii.

consciousness from experiences of poetic Imagination or Joy; and that he would recognize the "supersensible" (but "objective") facts about reality that can only be known through the kind of systematic meditation that is learned through Anthroposophy.

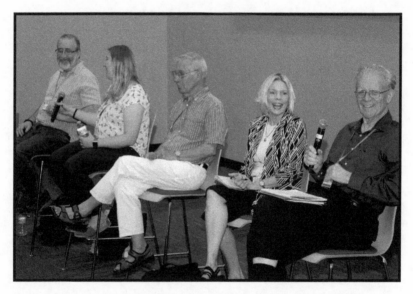

The Colloquium's keynote panel (left to right): Charlie Starr, Crystal Hurd, Stephen Prickett, Crystal Downing, and Joe Christopher.

IV. Essays on the Faithful Imagination

Mary, Martha, and the Faithful Imagination[1]

by Laura A. Smit

The Reverend Doctor Laura A. Smit is Professor of Theology at Calvin College in Grand Rapids, MI. She studied medieval philosophy and theological aesthetics at Boston University where she wrote her doctoral dissertation on aesthetic epistemology in the theology of Bonaventure. She is the author of the popular book, *Loves Me, Loves Me Not: The Ethics of Unrequited Love.* Her commentary on the book of Judges for the Brazos Theological Commentary on the Bible appeared in November 2018. In addition, from 2003 to 2008, Smit served as Dean of the Chapel at Calvin College. Her current research interests are focused on the thought of C.S. Lewis, particularly on Lewis as a medievalist, as well as her ongoing work on Bonaventure and theological aesthetics.

My purpose for this morning's "Centering" session is to consider the topic of "the Faithful Imagination and the New Testament." I propose to do that by focusing on one passage from the gospel of Luke.

> Now as [Jesus and his disciples] went on their way, he entered a certain village, where a woman named Martha welcomed him into her home. She had a sister named Mary, who sat at the Lord's feet and listened to what he was saying. But Martha was distracted by her many tasks; so she came to him and asked, "Lord, do you not care that my sister has left me to do all the work by myself? Tell her then to help me." But the Lord answered her, "Martha, Martha, you are worried and distracted by many things; there is need of only one thing. Mary has chosen the better part, which will not be taken away from her." (Luke 10:38-42)[2]

In keeping with the theme of this colloquium, "The Faithful Imagination," I want first to consider the role of the imagination in this story and second to look at an imaginative engagement with the story by the artist Fra Angelico. First, let's consider the passage.

1 Portions of this talk have been published on the blog of the Studio for Art, Faith, and History. My viewing of Fra Angelico's frescos at the monastery of San Marco in Florence was part of a summer faculty seminar sponsored by the studio. http://www.artfaithhistory.org/blog-1/2017/4/24/restoring-art-to-a-place-in-the-community-new-lessons-from-early-renaissance-italy-10.

2 Scripture references are from the New Revised Standard Version.

I want to enter the conversation about this scriptural text with the help of a 1946 essay by Dorothy L. Sayers, one of the authors collected and highlighted right here in the Center for the Study of C.S. Lewis & Friends at Taylor University (and, indeed, she was a good friend of C. S. Lewis, as well as being a very popular writer in the England in the mid-twentieth century). Sayers had a sharp sense of irony, even sarcasm, and she titled her essay, "The Human-not-quite-Human." About the Mary and Martha passage, she comments:

> I think I have never heard a sermon preached on the story of Martha and Mary that did not attempt, somehow, somewhere, to explain away its text. Mary's, of course, was the better part – the Lord said so, and we must not precisely contradict Him. But we will be careful not to despise Martha. No doubt, He approved of her too. We could not get on without her, and indeed (having paid lip-service to God's opinion) we must admit that we greatly prefer her. For Martha was doing a really feminine job, whereas Mary was just behaving like any other disciple, male or female, and that is a hard pill to swallow.[3]

I've always loved this little aside in Sayers's essay, since I share her experience when it comes to sermons about this story. I have also never heard a sermon on this story that has not attempted "to explain away its text." And when I was in seminary, more than thirty years ago now, I would have agreed with Sayers that the reason for this resistance to the clear teaching of Jesus in this story was sexism. I wanted so much to be allowed to study theology and the Bible in just the same way as my male colleagues, and I remember writing a rather scathing article in the seminary student journal saying that if other women wanted to remain in the church kitchen like Martha I would not interfere with them, but that I had no intention of letting them drag me back there with them. It was not the most tactful thing I've ever written, although I still think it was a legitimate reading of this story.

After all, this is actually what Paul promises in 1 Timothy 2:11, when he says, "Let a woman learn in silence with full submission." That word *submission* is widely used in the Greek world, not just for women, but in many situations. In the context of learning, it's the characteristic attitude that students are to have toward their teachers. Paul is describing what it is to have a teachable spirit. Since the rabbis said that it was better to burn the Torah than to teach it to a woman, this verse telling women to learn with submission is a revolutionary

3 Dorothy L. Sayers, "The Human-not-quite-Human," in *Unpopular Opinions* (London: Victor Gollancz, 1946), 120.

invitation. Women are not required to stay in the kitchen during times of theological discussion, hoping that later their brothers or fathers or husbands will tell them something of the ideas that were being taught. Not anymore. Mary is welcome at the feet of Jesus, where – like all the other disciples regardless of gender – she is learning quietly and submissively from the Master.

However, I no longer hear the story primarily that way. I've been in the ministry for more than half my life, and I no longer expend much energy defending my right to be there. Of course I'm allowed to learn; of course I'm allowed to sit at Jesus's feet. And yet, I still encounter people who try to explain away the clear teaching of this story: the teaching that Mary is right in what she is doing, and that Martha is wrong. Jesus is rather clear: "Martha, Martha, you are worried and distracted by many things; there is need of only one thing. Mary has chosen the better part, which will not be taken away from her." But just two weeks ago, my own pastor – unprompted by me, and with no knowledge of what I was working on – preached on this story, and he did indeed work very hard to "explain away" his text.

His motive was not sexist at all. There was nothing in his sermon to suggest that he found Martha more feminine than Mary. Quite the contrary. He identified himself as having a tendency to be more like Martha. Our congregation is small, and we all know each other, which may explain why my pastor thought it a good idea to go around and identify by name which people were more like Mary and which were more like Martha. There were both men and women in each group, and he presented both as equally important to the life of the church. In one respect I agree with my pastor. My experience suggests that the men of the church are just as prone to be busy about many things as are the women, and in many congregations that I know a serious devotional life is seen as women's work, whereas men do the more "real" work of serving on the property committee and managing the finances. So, Sayers has identified a phenomenon – a discomfort among contemporary Christians with privileging Mary over Martha – a discomfort that still persists in the churches that I know. But now, more than seventy years after her essay's publication, I no longer see her explanation as sufficient. Even among people for whom women in ministry are an accepted and normal part of church life, there remains a desire to undercut Jesus's preference for Mary in this story. Why?

One of my favorite books to teach is Josef Pieper's *Leisure, the Basis of Culture*.[4] Pieper presents the classic Aristotelian argument that

4 Josef Pieper, *Leisure: The Basis of Culture*, trans. Alexander Dru,

culture must be rooted in leisure, which is to say in activity that we pursue for its own sake, as opposed to being rooted in work, which is to say in activity engaged in for the sake of something other than itself, specifically activity engaged in for the sake of producing something. First published in 1947, just one year after Sayers's essay, Pieper's book was addressing the culture of post-war Germany. It was a time of rebuilding when there was a lot of work to do, so a focus on work made some sense. But Pieper thinks that what is happening is also a sort of hiding from the painful task of thinking deeply about what has happened in Germany, coming to terms with the complicity of regular Germans in the Nazi atrocities. Thinking about such things was so painful that it was easier to create a culture of total work, in which leisure was in the service of productivity. Rather than understanding work as a necessary responsibility that makes possible the truly human life of learning and art and imagination and worship, which is what leisure is supposed to be, the post-war world came to understand work as the point of life. Leisure came to be understood as the time off that was necessary in order to work more productively. Pieper reminds his readers that traditionally education is meant to be an act of leisure; that's why we talk about the *liberal* arts, that is study engaged in freely ("liberally"), for its own sake, not for the sake of productivity.

The culture of total work did not only dominate Germany; it has now come to dominate the western world. Those of us who are educators know that it dominates our schools, so that learning is supposed to be in the service of work rather than the other way around. And it dominates our churches. The culture of total work is the culture of Martha, not the culture of Mary, and so over and over again we come to this story of Mary and Martha and try our very best to make it mean that Martha had it right. As Sayers says, "we greatly prefer her [Martha]."

But Jesus says that Mary has chosen the better part. She exemplifies a life in which learning and worship join together as her source of purpose and meaning. Throughout this colloquium, we have repeatedly heard Lewis's well-known claim that imagination is the organ of meaning, and this is what Mary exemplifies in this story in Luke. She sits at the feet of Jesus, not in the spirit of constructive reason but in the spirit of receptive imagination. Jesus is teaching her what is true, and more than that He is Himself *the Truth*. By sitting at His feet, Mary is not trying to master truth; she is allowing truth to

introduction by T.S. Eliot (London: Faber & Faber 1952.) (First German edition, 1947).

master her, to order her life and make it meaningful. This, says Jesus, is the one thing that is needful. For all of us.

The imaginative, artistic response to this story that I would like us to consider this morning is Fra Angelico's fresco "The Agony in the Garden." Fra Angelico began life around the year 1400 in the farming town of Piero, north of Florence. His parents named him Giovanni, but most people called him Guido. When he was around fifteen years old, his father apprenticed him to a manuscript illuminator in Florence, which was the beginning of his life as an artist. He was a devout young man, active in one of the Christian communities for lay people that was popular at the beginning of the fifteenth century. But in 1421 he made the decision to take vows and enter the religious life, becoming a friar (or brother) in the Dominican Order. The Dominicans were and still are a preaching order. As a lay brother, Giovanni was not considered a preacher, but he advanced the Dominican preaching vocation by his painting. Because he was especially known for his paintings of angels, he came to be called Brother Angelico, or Fra Angelico.

The fresco we are considering today is from the Dominican monastery of San Marco in Florence. It was taken over by the Dominicans in 1440, and Fra Angelico, together with his team of assistants, was given the responsibility for communicating a Dominican way of life in frescoes throughout the building. Most remarkably, each friar's cell had one fresco painted in it, meant to contribute to the spiritual formation of the brother who lived in that cell. In his book *The Lives of the Most Eminent Painters*, Giorgio Vasari says this of Fra Angelico:

> He might have been rich, but to this he gave no thought; nay, he used to say that true riches consist only in being content with little. He might have ruled many, but he would not, saying that it was less fatiguing and less misleading to obey others. . . . He was most kindly and temperate; and he lived chastely and withdrew himself from the snares of the world, being wont very often to say that he who pursued such an art had need of quiet and of a life free from cares, and that he whose work is connected with Christ must ever live with Christ.[5]

Fra Angelico considered his own work to be connected with Christ, and he was intimately involved in planning the theological significance of his paintings, though no doubt other members of the

5 Giorgio Vasari, *Lives of the Most Eminent Painters, Sculptors, and Architects*, trans. Mrs. Jonathan Foster (London: Bell & Daldy, 1871), 2:34.

Dominican community also had a say. The frescoes that Fra Angelico painted in the brothers' cells of San Marco encouraged each brother, as he put it, to "ever live with Christ."

Mary and Martha figure prominently in the fresco from Cell 42, *The Piercing of Christ's Side*, in which they are pictured as witnesses, standing at his feet as he hangs on the cross. But the fresco we will consider today is from Cell 34 and is known as *The Agony in the Garden* (reproduced on page 293). The left side of the fresco illustrates a familiar story: Jesus is with his closest disciples – Peter, James, and John – in the Garden of Gethsemane. He has asked them to watch with him a little while, but they have all fallen asleep. The eyes of Jesus are fixed on the angel who is bringing him a cup, the very cup that Jesus has prayed might be taken from him. Fra Angelico has portrayed it as a communion chalice. Luke recounts this story this way:

> Jesus knelt down and prayed, "Father, if you are willing, remove this cup from me; yet not my will but yours be done." Then an angel from heaven appeared to him and gave him strength." (Luke 22:42-43)

By placing the cup of suffering in the hand of the strengthening angel, then portraying the angel as pointing insistently at the chalice, the fresco suggests that the gift of strength will come through the experience of suffering.

It is the right side of the fresco that is surprising, because Fra Angelico has placed Mary and Martha next to Jesus in his agony. We know these women are Mary and Martha because their names are helpfully inscribed in their haloes. Nothing in the gospel account, of course, links them explicitly with this moment in the garden, and the fresco refrains from placing them directly in Gethsemane. In this picture, they are with Jesus in spirit while apparently absent from him in the flesh. The little window in the separating wall suggests the link between them. They are doing what his male disciples have failed to do: they are watching with Jesus.

Martha is in prayer, her hands in the same position as those of Jesus in the opposite corner of the picture. Her prayer is joined with his prayer. Mary and Martha have already received strength through suffering in the experience of the death and miraculous resurrection of their brother, Lazarus. They have already seen their brother Lazarus pass through death and back to life. Now they are watching over Jesus, our elder brother, as he begins this same journey, though the death he faces contains the penalty for sin, and the new life he will win is a

permanent and glorified life.

After her brother's death, Martha's address to Jesus was very similar to Jesus's prayer here in the garden of Gethsemane. The gospel of John tells the story this way:

> When Martha heard that Jesus was coming, she went and met him, while Mary stayed at home. Martha said to Jesus, "Lord, if you had been here, my brother would not have died. But even now I know that God will give you whatever you ask of him." Jesus said to her, "Your brother will rise again." Martha said to him, "I know that he will rise again in the resurrection on the last day." Jesus said to her, "I am the resurrection and the life. Those who believe in me, even though they die, will live, and everyone who lives and believes in me will never die. Do you believe this?" She said to him, "Yes, Lord. I believe that you are the Messiah, the Son of God, the one coming into the world." (John 11:20-27)

Martha begins by affirming her confidence that even now Jesus could take this cup from her, that even now God would give him whatever he asked, but her faith in Jesus is not contingent on his willingness to raise her brother. She confesses that He is the Messiah, the Son of God, the one coming into the world. And she knows that even if she must drink this cup of sorrow now, she and her siblings may have confidence in the promise of the resurrection on the last day.

It is remarkable that Fra Angelico chooses to present Martha as a paradigm of prayer and contemplation rather than as a symbol of the active life, a common theme in medieval art. In this fresco he imagines for us a progression in Martha's life from the distraction of her domestic busy-ness, through the death and rebirth of her brother, to this moment of anguish shared with her Savior. She is now joined with Mary in choosing the better part. In the subsequent fresco of *The Piercing of Christ's Side*, Martha will be shown joining Mary literally at Jesus's feet, this time as he hangs on the cross in death.

Significantly, Martha is gazing intently not at an angel but at Mary. It is Mary who has been God's messenger, or angel, to her, showing her the one thing that is needful. Like Martha, Mary is also watching with her Savior; she has opened the Scriptures, which like him are given as bread from heaven. She is pointing insistently at the book, just as the angel is pointing insistently at the chalice. After his resurrection, Jesus met two disciples on the road to Emmaus and taught them from the Scriptures.

> Then he said to them, "Oh how foolish you are, and how slow
> of heart to believe all that the prophets have declared! Was it
> not necessary that the Messiah should suffer these things and
> then enter into his glory?" Then beginning with Moses and all
> the prophets, he interpreted to them the things about himself
> in all the scriptures. (Luke 24:25-27)

In this fresco, Mary also points to the Scriptures as the interpretive
key to Jesus's suffering and death.

This fresco is especially intimate because of the way that the cell
itself has been extended to include Mary and Martha within the friar's
own living space. The curved arches in the room in which Mary and
Martha sit echo the curved arches in the simple cells of the monastery.
The single window linking their room with the garden echoes the
single window in each cell. The walls are the same color and textured
in the same way. It seems that Fra Angelico intended for the brother
in this cell to understand himself as watching alongside Mary and
Martha. They are exemplars of the contemplative life that he is trying
to live. It is a life of both study and prayer. It is a life of union with
Christ.

The brother in this cell is also faced with the warning of the
sleeping disciples in the garden. Surely the friar knows this temptation.
The rhythm of the hours of prayer interrupts his sleep every night; he
never has what we would consider a full night's sleep. But as a friar he
is called to the contemplative way. This fresco daily calls him to stay
awake and watch with Jesus.

The life of prayer also interrupts his domestic work. In a
community of all men, the brothers are responsible for all the activity
of cleaning and cooking, of offering hospitality to travelers, care to
the sick, and aid to the indigent. The brother in this cell knows the
ever-present temptation to distraction that once snared Martha. The
domestic work must be done, but his life is meant to be ordered around
prayer and contemplation, with those other duties fitted in around his
primary work of life with God. Surely the friar knew the temptation,
even as we know the temptation, of reversing this pattern, of allowing
the busy-ness of our many tasks to control the rhythm of our day
and then trying to fit in times of prayer and contemplative reading
of Scripture around those tasks. The friar must keep his priorities in
order. This fresco daily says to him, "You are worried and distracted
by many things; there is need of only one thing."

Martha is the only figure in this image who looks out of the
frame into the life of the friar living in cell 34. Her focused gaze and

prayer posture remind him: "You have chosen the better part; it will not be taken from you." The better part is to be where Christ is, doing what Christ is doing, and listening to what Christ is teaching. As Fra Angelico said, "he whose work is connected with Christ must ever live with Christ."

Fra Angelico entered imaginatively into the full gospel teaching about Mary and Martha, and through his painting he invited the friar who lived in this cell – and now invites us – to do the same. By doing so we may all find a way to affirm what Jesus teaches in this story.

Let's consider our text one more time.

> Now as [Jesus and his disciples] went on their way, he entered a certain village, where a woman named Martha welcomed him into her home. She had a sister named Mary, who sat at the Lord's feet and listened to what he was saying. But Martha was distracted by her many tasks; so she came to him and asked, "Lord, do you not care that my sister has left me to do all the work by myself? Tell her then to help me." But the Lord answered her, "Martha, Martha, you are worried and distracted by many things; there is need of only one thing. Mary has chosen the better part, which will not be taken away from her."

Fra Angelico and his workshop, including Benozzo Gozzoli. c. 1443-1445. Agony in the Garden. fresco. Place: Museo di San Marco, Florence, Italy. http://library.artstor.org.lib-proxy.calvin.edu/asset/SCALA_ARCHIVES_1039614990.

Paradoxical Integrity in Job:
The Faithful Imagination in
the Hebrew Bible's Wisdom Literature

by Richard G. Smith

Dr. Richard G. Smith hails from Little Rock, Arkansas. He has been at Taylor since 2001 after earning his PhD in Divinity/Hebrew Bible at the University of Cambridge. He specializes in the study of the Old Testament with a keen interest in its poetic, wisdom, and prophetic literature. He is married to Jill and has four children.

To ask what constitutes a faithful imagination is to inquire about wisdom itself. While all of the wisdom literature in the Hebrew Bible exhibits concern in one way or another for what we are calling the faithful imagination, it is perhaps the book of Job more than any other that is actually *about*[1] the faithful imagination.[2] In the wisdom story of Job, no character's imagination goes unchallenged with respect to its faithfulness – not even God's. And so it is that the book of Job has been rattling imaginations for over two thousand years.

1 All italics in this essay are supplied by the author.

2 The expression "the faithful imagination" can have in view a number of different things depending on what we mean by the noun "imagination" and the adjective "faithful." For the word imagination, the Merriam-Webster dictionary lists three major fields of meaning with several subcategories. Imagination may designate the act or power of forming a mental image of something not present to the senses or never before wholly perceived in reality. The role of the imagination in discerning causation is of particular importance here. The word imagination may also refer to a creative ability or the ability to confront and deal with a problem. In this sense imagination has the sense of resourcefulness. The word imagination may also be used to designate the thinking or active mind, particularly in the sense that certain things may serve to fire the imagination, as we like to say. The word may also refer to that which is the creation of the mind, especially an idealized or poetic creation. Lastly, the word imagination can be used with pejorative connotations to designate a fanciful or empty assumption. When speaking of imagination in any of these ways as faithful one may also have a number of things in mind. We may be concerned with the extent to which an imagination is steadfast in affection or allegiance – that is, an imagination which is loyal to someone or something, perhaps even given with strong assurances and binding promises. Or the designation faithful may signal our interest in whether an imagination firmly adheres to promises or its observance of duty – such is to speak of a conscientious imagination. Finally, in considering an imagination as faithful we may have in view whether or not an imagination is true to the facts or to a standard – that is to be concerned with whether an imagination coheres with other evidence of reality.

I. JOB AND THE THEODICEAN IMAGINATION

Readers of the book have long recognized its preoccupation with what we moderns label as theodicy. This is an imaginative enterprise that usually seeks to acquit God of any evil befalling his servants.[3] There are three major theological principles that fuel the theodicean imaginations of Job and his friends in this story.[4] One is the divine retribution principle which imagines that the righteous experience blessing and well-being in this life while the wicked experience cursing and hardship. A second principle is that of innate human sinfulness which imagines that human beings are by birth and nature inherently morally flawed in God's eyes and therefore deserving of, and unable to avoid, God's punishment. A third is the divine discipline principle which imagines that suffering is educational discipline from God who seeks to correct any shortcomings in his creatures.

These three theological principles all have a legitimate place in the teachings of the Hebrew Bible and in Judeo-Christian biblical theology. However, in the story of Job, none of these three theological principles is able to account for Job's afflicted circumstances. This has profound implications for the subject of the faithful imagination in the story, as Yahweh eventually challenges Job to find solace for his imagination in an innovative poetic, almost fantastic, portrayal of God's relations with the non-human members of His creation.

II. JOB 1:1–5 AND THE TRADITIONAL ANXIOUS IMAGINATION

As the story of Job opens, the reader is introduced to a paragon of virtue, embodying the highest ideals of the wisdom tradition. Job is "blameless and upright," and, literally, "a fearer-of-God and a turner-from-evil."[5] What flows from this is seen in the narrator's ideal and

3 John Barton suggests that the author of the book of Job may even have partly sought to provide a "sampler" of stock positions on the theme of theodicy, see "Reading the Bible as Literature: Two Questions for Biblical Critics," *Journal of Literature and Theology* 1 (1987): 146.

4 Ernest W. Nicholson, "The Limits of Theodicy as a Theme in the Book of Job," in *Wisdom in Ancient Israel: Essays in Honour of J. A. Emerton*, eds. John Day, Robert P. Gordon, and H. G. M. Williamson (Cambridge: Cambridge University Press, 1995), 71–82. Other commentators also recognize these same theological issues at play in the Joban debates.

5 In Job 1:1 the expression *tām wəyāšār* "blameless and upright" (cf. Gen 17:1 [Abram]; Gen 25:27 [Jacob]) does not mean "sinless" in any absolute sense (cf. Job's words in 13:26; 14:14, 16) but rather refers to extreme integrity. In the expression *wiyrē' 'ĕlōhîm* the form *yərē'* is a construct of the participle *yōrē'*, thus "a fearer of God," that is, if the participle is to be taken as a substantive (cf. 6:14). The indefinite translation "a fearer" takes *'ĕlōhîm* as an indefinite common noun for deity

idyllic description of the social and material blessings traditionally considered to be the divinely bestowed products of such moral virtue born of the fear of Yahweh.[6] In the context of a thoroughly positive portrayal of Job's highly functional family,[7] the reader is given a glimpse inside Job's faithful imagination and shown what motivates his scrupulous practice of offering up daily sacrifices for each of his children, in addition to other sanctifying efforts. Job says, "Perhaps my sons have sinned and 'blessed' [meant as 'cursed'] God in their hearts."[8] The narrator then adds that Job "would act like this all the time."[9] In this way, Job seeks to forestall any retribution from the deity by carrying out proper atonement procedures on behalf of his children for any hypothetical sins of the mind that they might have committed. Here the narrator reveals Job's piety as driven by an anxious imagination. Faithful, to be sure, in its regularity and intentions, but anxious nonetheless.

So, what does all this tell us?

Prior to his suffering, Job held imaginatively to the retribution principle as an ordering concept for his life and for the lives of those around him. The reader should take careful note of this anxious version of Job's integrity and kiss it good-bye, because this version of Job will appear again in the story, and it will most certainly not characterize the restored Job at the end of the story. Ironically, it will be precisely Job's extreme moral virtue and the ethical sensitivity and integrity that goes with it which will cause problems for his theological imagination. Or to say it another way, if Job were not such a profoundly good man who feared Yahweh, then he would not have the sorts of problems that we will find him having as the story unfolds. It's what I call the *paradox of integrity*.

which thereby determines the indefiniteness of the entire chain.

6 That the fear of Yahweh is related to prosperity is well-rooted in the Hebrew wisdom traditions (Prov 22:4; 19:23; 10:27; 14:27; 16:6; Psa 31:20; 34:10; 34:10; 33:18–19; 112:2–3[1–2]). The sequencings of finite verbal forms in the main clauses of Job 1:1–5 are significant in the portrayal of states and the sequencing of events resulting from, or carried out in response to, those states.

7 The narrator's description of Job's ten children in 1:4 presents all of his adult sons and daughters regularly enjoying rounds of feasting with one another in their own homes.

8 Job 1:5. Hebrew verb *bērăḵû* "they blessed" is a euphemism for "they cursed."

9 The phrase *kāḵaʿ* is emphatically placed in the text of Job 1:5.

III. Job 1:6–2:13 and Competing Heavenly Imaginations

The narrative goes on to show how Job endured two cycles of affliction in which he lost his entire estate and all ten of his children on the same day, and then lost his health to a disease which laid him waste on the edge of town. Prior to telling about each cycle the narrator makes the reader privy to discussions about Job's integrity that took place in the heavenly realm between Yahweh and an edgy figure called *the Satan*. Job, of course, is never made aware of this.[10] Throughout the affliction narrative, the imaginations of Yahweh, the Satan, and Job are portrayed as dynamic in significant ways.

It is Yahweh Himself who first raises Job as an object of reflection, proudly imagining him as His servant, unique among humans, and, again, "blameless and upright, a fearer-of-God and a turner-from-evil" (1:8). This divine assessment buttresses the narrator's earlier assessment of Job *and then some*. However, the Satan challenges the faithfulness of Yahweh's imagination with respect to Job's motivations. He suggests that Yahweh Himself has failed to imagine how His own administration of justice on Job's behalf has actually created a duplicitous situation in which the deity gains loyal worshippers through protection services, bribes, and pay-offs. The Satan may even imply that Yahweh's blessing and protection of Job have been ecologically detrimental to the land.[11] In any case, the Satan imagines that neither Job nor Yahweh are wise and just and that Job's loyalty to Yahweh will evaporate into curses against God once the deity's blessings are removed. Thus, Yahweh sanctions the Satan to destroy all that Job has. Clearly the stakes are high for Yahweh's

10 In the human phenomenal world of Job and his community, Job's losses are understood as a direct action of God. Neither Job nor his herdsman imagine any intermediate spiritual agent like the Satan that might ameliorate notions of Yahweh's involvement. And even if they did, the narrator has already demonstrated through his portrayal of the heavenly discussion that allowances for any such agency would only make Yahweh one step removed from Job's affliction and thus do little to remove the theological problem of Yahweh's involvement in oppressing Job – as even Yahweh himself is portrayed as recognizing! Note that the servant in 1:16 refers to *'ēš 'ĕlōhîm* "fire of God" falling from heaven. Furthermore, third person masculine singular subject of *wayyak* in 2:7 is ambiguous but may refer to God's hand. See also the third person masculine singular subject of *wayyiga'* in 1:19, the antecedent of which cannot be the feminine *rûḥ gədôlâ* but instead must be God.

11 The notion of ecological injustice as a result of Yahweh's blessing and protection of Job could be suggested by *ûmiqnēhû pāraṣ bā'āreṣ* in 1:10, which one could legitimately translate "but his possessions have *burst forth* upon the land."

reputation for wise and just administration.

Prior to the second affliction cycle, Yahweh again broaches the subject of Job, but this time adds a moral assessment of the prosecutorial efforts conducted by the Satan thus far. Yahweh observes that Job "still holds fast to his integrity," and this leads Yahweh to protest to the Satan, "*and* so you have incited me against him to swallow him without cause."[12] Here Yahweh is portrayed as imagining that He himself has been roped into an unjust action against innocent Job. Apparently, Yahweh is sensitive to the sort of stains that can come upon one's character as a result of the ethical binds that may arise from attempting to establish justice. The Satan of course will have none of this. He imagines that Job is like an onion in which the layers need to be peeled back in order to expose the rotten core.[13] Thus Yahweh sanctions the Satan to attack Job's *body* short of causing death. This begins a major motif regarding how Yahweh relates to the very bodies of his creatures in the book of Job.

In response to the first affliction cycle, Job enters into formal and deliberate acts of mourning and says "Naked I came from my mother's womb, and naked shall I return. The Lord gave, and the Lord has taken away; blessed be the name of the Lord" (1:21). Here Job generates a coping sort of wisdom by reflecting on his experience according to the straightforward reality of his own existence. In the second affliction cycle, Job's response is set in the context of his response to his wife who urges him in 2:9 to give up his integrity and

12 The Hebrew line in 2:3 reads *wəʾōḏennû mahăzîq bəṭummāṯô wattəsîṯēnî bô ləḇalləʿô ḥinnām.* The verb *wattəsîṯēnî* is significant for its *wayyiqṭōl* form and for its collocation with the preposition *bə*. David J. A. Clines denies that the waw-consecutive here is used to express a logical necessity or consequence of that which immediately precedes in *Job 1–20,* vol. 17 of WBC, ed. David A. Hubbard (Dallas: Word, 1989), 5; cf. Samuel Rolles Driver, *A Treatise on The Use of the Tenses in Hebrew* (Oxford: Clarendon, 1892). However, his justification, that *ḥinnām* should not be linked with *wattəsîṯēnî* but with the immediately preceding infinitive *ləḇalləʿô,* seems overly facile. It is more likely that *ḥinnām* has been placed at the end of the sentence because it semantically relates to the entire verbal idea of "moving/inciting someone to swallow," *sît liḇlōaʿ* (cf. the collocation *wayəman liḇlōaʿ* in Jonah 1:17). This is quite Hebraic. For the use of the collocation sît bə with the idea of "inciting one against someone" cf. 1 Sam 26:19; 2 Sam 24:1; Jer 43:3.

13 Edward L. Greenstein, "'On My Skin and in My Flesh': Personal Experience as a Source of Knowledge in the Book of Job," in *Bringing the Hidden to Light: The Process of Interpretation. Studies in Honor of Stephen A. Geller,* ed. Kathryn F. Kravitz and Diane M. Sharon (Winona Lake, IN: Eisenbrauns, 2007), 63–77; N. H. Tur-Sinai, *The Book of Job: A New Commentary,* rev. ed. (Jerusalem: Kiryat Sefer, 1967), 22–25; Marvin H. Pope, *Job: Introduction, Translation, and Notes,* 3rd ed. (Garden City, NY: Doubleday, 1973), 20–21; Scott C. Jones, "Corporeal Discourse in the Book of Job," *JBL* 132 (2013): 847.

to curse God and die[14] – the very response that the Satan imagined for Job in the first place. Job says to his wife in 2:10, "You speak as one of the foolish women would speak (*kədabbēr 'aḥat hannəbālôt tədabbērî*). Shall we receive the good (*haṭṭôb*) from God, and shall we not receive the evil (*hārā'*)?" Job's imaginative characterization of his wife here as a *nəbālâ*-woman is thereby *an appropriately* serious charge of deeply perverse social behavior.[15] But what is more, Job apparently takes it as a given that God dispenses both good and evil and makes no issue of it. The narrator evaluates Job's responses by noting in the first instance that Job "did not sin or attribute moral corruption to God" (1:22) and in the second instance that he "did not sin with his lips" (2:10c).

What should we make of all this?

Job's responses to his sufferings reflect an imagination that is no longer governed by the retribution principle. Job does not blame himself for his misfortune. Job does not reject or rebel against God. Job does not try to acquit God of evil either. In other words, Job does not attempt to construct a theodicy to explain the relationship between the God he knows and the evil he has experienced from his hand. The notion of evil from God is, at this point, accepted.

We should also be mindful of how the narrator's gift to the reader of inside-information regarding the heavenly realm serves to restrain and provoke the imagination of the reader, thereby channeling it in the direction of the earthly debates yet to come. The reader knows of Job's innocence because the narrator has told him so. The narrator has also allowed the reader to hear Yahweh himself testify to Job's integrity on two occasions. This makes for a three-stranded cord of binding testimony from which the reader's imagination cannot responsibly break concerning Yahweh and Job. Although Job does not say so *explicitly* at this point, Job also recognizes he is suffering as an innocent man before God. But Job is able to know this because he happens to be one of those rare folks whose wisdom and virtue are so mature that he has a relatively accurate view of himself. In short, Job has a faithful imagination, at least when it comes to who *he* really is and what *he* has and has not done. Job, the text suggests, is not self-deceived.

So, Job's innocence is clearly established at the outset of the story, but, ironically, God's innocence is not necessarily so obvious.

14 Again in 2:9 *bārēk* "bless" is used in Hebrew as a euphemism for "curse."
15 See Gen 34:7; Deut 22:21; Josh 7:15; Judg 19:23-24; 20:6, 10; 1 Sam 25:25; 2 Sam 13:12; Isa 9:16; 32:6; Jer 29:23; Job 42:8.

At best, the first two chapters of the book of Job leave the reader with an image of Yahweh as an unwilling accomplice to Job's oppression. The narrative question that remains is what theodicy will replace the retribution principle which Job has abandoned. How long will Job remain in this state of theodic limbo? What theodicy will fill the vacuum previously filled by the retribution principle?

IV. Job 3–37 and Competing Earthly Imaginations

When it comes to the theme of faithful imaginations in the debate speeches of Job 3–37, there are three features that I would like to address. The first has to do with what the friends imagine they have to gain from challenging Job. The second concerns theodicy in the imaginations of the friends and Job. The third is the place of wild and mythic animals in Job's imagination.

A. What the Friends Imagine to Gain from Job

The narrative of Job 1–2 ends with Job surrounded in silence by friends whose imaginations have clearly failed to prepare them for the reality of Job's horrid state. This is in spite of their having met together beforehand to plan their mission of mercy. Their dramatic response contrasts with Job's deliberate and liturgical manner of mourning. Job's friends are overwhelmed and beside themselves in the face of his suffering. By the time the friends come to visit Job, he has nothing left for them: he has no wealth that can enrich them, no family or social standing that can enhance theirs by way of association, no power to exercise on their behalf or for their benefit. Neither does he possess any wisdom for them to appropriate, bereft as he himself now is of sapiential resources. It seems that the friends' visit is thoroughly altruistic. Theirs is a mission of complete charity. Or is it?

As the debate drama unfolds, it becomes clear that Job does have one thing of value left which the friends want from him, one benefit they can imagine deriving from being his friend – and that is his acknowledgement of their wisdom in correcting him. If they can correct and restore Job, who has corrected and restored others, then they can become the peers, even the betters, of this one who has been declared unique among humans and greater than all the men of the east.[16]

When the friends offer up their wisdom as a balm for Job's suffering and as a solution to his theodicy, they require Job to purchase

16 For Job's status, see Job 1:1–3; 4:3–4; 29:2–25.

it from them at the price of his own integrity by confessing sins which he knows, the reader knows, and God knows he has not committed. Therefore, Job refuses to submit his character to their imagination. That was the only thing left for the friends to gain from their friendship with impoverished Job, but he denied it from them. And their anger at him only serves to show that they were not offering their comfort freely and without expectation, or else they would have allowed Job the freedom to refuse it. Instead, the friends' truly traitorous colors start to show, and the imaginative name-calling begins as they work to define Job.

Of course, when the cursing and arguments start rolling out in chapters 3–37, the reader is in a position to critique the imaginations of the interlocutors. The reader knows that the rhetorical war waged by the friends against Job's character has no basis in reality, and so the reader is in a position to sympathize with Job, because he knows that Job is innocent and that Yahweh himself is not entirely in the clear. The reader is clearly empowered by the narrator to do this and, yet, to recognize still that some of Job's brutal characterizations of the deity go beyond the pale, in light of the inside-information provided about the heavenly debate.

B. Theodicy in the Imaginations of the Friends & Job

The friends press the *divine retribution principle* as a theodicy for Job far more than any other principle.[17] Job refutes it as a theodicy by focusing on the ample evidence of the welfare of the wicked.[18] He even denies the notion that God requites the wicked by punishing their descendants, since true justice is only rendered when the wicked themselves reap their own calamity.[19]

The *principle of innate human sinfulness* is also given extensive treatment in the Joban debates, and one sees it argued with increasing

17 The divine retribution principle is developed and refined in the debates. Eliphaz introduces it (4:7–11); Bildad develops it (8:8–22); Zophar develops it (11:6); Eliphaz refines it (15:4–6); Bildad refines it (18:5–21); Zophar refines it (20:4–29); Eliphaz hardens it (22:5–20); Job refutes it (10:3; 12:6; 21:1–16, 19–21; 31:1–40a); Elihu takes it up (34:10–30).

18 Job 10:3; 12:6; 21:7–34.

19 Job 21:19–21. This, of course, is a powerful argument that echoes major historical developments in Yahwistic ethics regarding notions of transgenerational punishment as seen also in Jeremiah 31:29–30 and Ezekiel 18 (contrast Exod 20:5; Deut 5:9). For a thorough study of Ezekiel on this point see Bernard M. Levinson, *Legal Revision and Religious Renewal in Ancient Israel* (New York: Cambridge University Press, 2008), 60–71.

intensity as talk goes on.[20] The friends' appeals to it are portrayed as eventually leading them to deconstruct the high theological anthropology of humans made in the image of God, to the point of humans being little more than worthless maggots before God.[21] Job refutes this, not by denying that humans are sinful, but by asserting that, in the case of his own undeserved suffering, God has irrationally and ruthlessly turned against his own divine handiwork.[22]

As for the *divine discipline principle*, it is not given very much

20 Eliphaz introduces the human sinfulness principle (4:17–19); Eliphaz develops it (15:14–16); Bildad develops it (25:4–6); Job refutes it (7:17–21; 10:1–17).

21 Eliphaz introduces the human sinfulness principle in chapter 4 when he relates the revelatory words of a wisdom instruction he received through a dream-vision revealing how "below reproach" all humans, as frail creatures, are before God. One should attribute these words to Eliphaz, as the received text of Job does, with some caution, because the possibility exists that 4:12–21 has been accidently dislocated from its place at the end of Job's lament in chapter 3. In that case the dream revelation would actually be Job's. Subsequent passages in Job seem to refer back to it (9:2; 15:12–16; 25:4–6). The dislocation of the passage is favored by several in Jewish exegetical traditions. Notice how Eliphaz (via quotation of the voice in the dream-revelation) first describes human creatureliness and frailty with imagery of "clay" and "dust" and "moth" (4:19). However, by the time he returns again to the human sinfulness principle in chapter 15 – and apparently echoing the earlier dream revelation of chapter 4 – we see Eliphaz describing humanity (and Job implicitly) in much more negative terms. Here Eliphaz refers to humans as being "abominable" and "corrupt" with a propensity for evil, "drinking iniquity" as naturally as one drinks water. The echoing of the previous dream revelation of chapter 4 only serves to emphasize the lowering of Eliphaz's theological anthropology. Just as Job's perspective on suffering is coloring his worldview, so too is Eliphaz's view of Job affecting his theological view of humanity. The friends' development of the human sinfulness principle as a theodicy reaches a climax in Bildad's final speech, which again seems to echo Eliphaz's original dream-revelation of chapter 4. Notice how humanity's inherent uncleanness in God's eyes is described as being such that they are counted as no more than "maggots" or "worms." Norman C. Habel well paraphrases the final phase of Bildad's development of the human sinfulness principle when he writes, "Mortals are not merely weak, sinful creatures, they are at the bottom of the order of creation. . . . The possibility of mortals like Job standing before God and being declared guiltless is preposterous." (Norman C. Habel, *The Book of Job: A Commentary*, Old Testament Library [Philadelphia: Westminster, 1985], 370). The human sinfulness principle is "the ultimate 'fall back' position among theodicies" (E. W. Nicholson, "The Limits of Theodicy as a Theme of the Book of Job," 76). When all other attempts to explain a person's suffering have failed in the face of the evidence for their innocence, one can always appeal to the belief that simply by being human a person is morally flawed and therefore deserving of divine wrath. However, as can easily be seen in Eliphaz's and Bildad's revisiting of the dream-revelation of chapter 4, this theodicy is prone to deconstruct human dignity and worth in order to sustain itself. In portraying how the friends developed a contemptuous view of humanity before God, the author of the book of Job may be attempting to criticize this theodicy as a desperate attempt to vindicate God and convict humanity.

22 Job begins to refute the human sinfulness principle as a theodicy in 7:17–21, a text which many scholars recognize as a parody of Psalm 8 with its high view of humanity as God's noblest creation. The point achieved through parody in

treatment in the debates.[23] In fact, the friends do not appear to take it up again after Eliphaz's introduction of it in chapter five. However, it is given extensive treatment by Elihu. Nevertheless, the appeals they make to the divine discipline principle are shown as failing to account for the sheer gravity of Job's suffering. It is not surprising, therefore, that Job trounces their use of the divine discipline principle as a theodicy by demonstrating that God's affliction of him is so grievous and devastating that it cannot possibly be construed as the loving father-like correction of a son but rather as child abuse.[24] This stinging exposé of the rank implausibility of the divine discipline principle as

Job is that in contrast to the psalm's high view of humanity as being just slightly lower than divine beings in the cosmic hierarchy, God relates to the human Job as a relentless fault-finder, treating Job as a burden rather than one "crowned with glory and honor." Yet in all this we note that neither Psalm 8 nor Job 7 make any reference to inherent human sinfulness as a fundamental component to being human. Job's complaint is that there is a glaring incongruence between the high anthropology represented in texts like Psalm 8 and the actual miserable lives of many humans like Job in God's world. Job continues to undermine the human sinfulness principle as a theodicy in 10:1–17 by arguing on the basis of creation theology that God's treatment of him is completely at odds with God having fashioned him in the first place, granting him life and showing him steadfast love. The issue, as he sees it, is not that Job as a human was inherently morally flawed in the making but that God in his treatment of Job has turned destructively against his own handiwork. With this Joban argument in mind, we may now be in a position to appreciate the wisdom narrative of Genesis 1–3 as a sapiential attempt to salvage human worth (as made in the image of God) without lessening or dispensing with the notion of human sinfulness. For instance, in Genesis 1–2 humanity is portrayed as having been created without any inherent moral corruption, i.e. they and all creation are "good." Of course, humanity does become corrupt in the so-called "fall account" of chapter 3 by acquiring the knowledge of good and evil through an illegitimate route, i.e. through disobedience to the divine prohibition. However, the sinful corruption of humanity is not presented there as something that originally was "natural" for humans or was inherent to their very creatureliness. In this light, the friends' development of the human sinfulness principle as a theodicy represents their own deconstruction of the high theological anthropology represented in Gen 1–3. Job's parodying of Psalm 8 shows that he himself recognizes this. Therefore, in portraying how the friends developed a contemptuous view of humanity before God, the author of the book of Job may be criticizing the theodic use of the human sinfulness principle as a desperate and misguided attempt to vindicate God and convict humanity, in as much as it is prone to deconstruct human dignity and worth in order to sustain itself. In other words, all suffering and evil are not due to the fact that humans are sinners by nature.

23 Eliphaz introduces the divine discipline principle (5:17–18); Job refutes it (6:4; 7:2–16); Elihu takes it up (33:13–17; 34:31–32; 36:7–13, 15–16).

24 As far as Job is concerned, the poison arrows of the Almighty are in him (6:4). He suffers from acute insomnia (7:4). His flesh is dirty, festering, and covered in maggots (7:5). He is hopeless and embittered (7:6–11). Nightmares torment him and make him long for strangulation (7:14–15). God's afflictions of Job may even be of such a severe nature as to suggest that God treats Job like his primordial enemy "the Sea" or "the Dragon" (7:12).

an explanation of Job's suffering, combined with the friends' growing confidence in Job's wickedness, may explain why none are really interested in trying to argue for it any further – except for the brash young Elihu, who all, including Yahweh, seem to ignore.

C. BEASTS IN THE IMAGINATIONS OF JOB AND THE FRIENDS

Wild animals and fantastic monsters traditionally associated in the ancient Near East with chaos and threats to world order figure prominently in the discourses of Job.[25] This aspect of Yahweh's rhetoric is extremely important to account for, because his speeches will be dominated by references to wild and mythic critters, the lives and creation of which he wants Job to reconsider.

Job tends to imaginatively reference wild and mythic creatures as a way of disparaging his now extremely marginalized existence. When he breaks his silence with his opening lament, Job longs to have those who can curse Leviathan curse his own birthday, so as to remove it from the cosmic calendar.[26] Job complains that he is being treated like he is *Yam*, the deity of primordial water-chaos and the sea, or like *tannin*, a chaos dragon or serpent who, like Yam in mythic tradition, has to be forcibly guarded and subdued.[27] Similarly, explaining why he himself has no chance of standing up to God, Job refers to God's destruction of *Rahab*, another name for the primordial chaos-dragon.[28] Job pairs *Yam* and *Rahab* together as objects of divine subjugation and destruction (26:12). When Job explains how his rash talk is driven by his desperate hunger to explain the turmoil of his own suffering, he points to how the wild donkey and the ox are silent when they have something to eat (6:5). Like them, Job's hunger for sapiential sustenance drives his complaints. Job argues that the wild animals know and can teach the friends that the true nature of his situation is that it is God's doing (12:7–9). Yet in the poem about wisdom's inaccessibility, it is claimed that neither birds of prey, like the falcon, nor beasts, like the lion, know the way to find wisdom (28:7–8, 21). Job likens the outcasts of human society to animals like

25 Job 3:8; 5:22–23; 6:5; 7:12; 9:13, 26; 12:7; 11:12; 26:12; 28:7–8, 21; 30:29; 35:11; 37:8.

26 Job 3:8. On Leviathan see Isa 27:1; Psa 74:14; 104:26.

27 Job 7:12. For references to *tannin* in the OT see Gen 1:21; Ex 7:9–10, 12; Deut 32:33; Is 27:1; 51:9; Jer 51:34; Ezek 29:3; 32:2; Psa 74:13; 91:13; 148:7.

28 Job 9:13. On *Rahab* see Isa 30:7; 51:9; Psa 40:4; 87:4; 89:10. *Rahab* is to be equated with the "twisting serpent" as Isa 27:1 does with Leviathan and as the Ugaritic Baal myth does with Lotan. Isa 51:9 also equates *Rahab* with *tannin*, the dragon/serpent, and the Sea.

the wild ass, who eke out their existence in the wilderness, exposed to the elements (24:5, 7–8). Job laments that in his suffering he has become a brother of jackals and a companion to ostriches (30:29). He describes himself as a defeated wild ox whose horn has been sunk into the ground (16:15). And Job complains that whenever he tries to stand up for himself, God hunts him down like a rogue lion (10:16).

The friends do not make many references to beasts in their rhetoric and this is probably indicative of where their minds live. However, Eliphaz does imagine the wicked person (like Job) as a roaring lion. According to him, God breaks their teeth and denies them prey, so that they starve and their cubs are scattered (4:10–11). Zophar imagines that an empty-minded person (like Job) has no more chance of obtaining understanding than a male wild donkey has of being born human (11:12). Elihu imagines in 35:11 that God teaches humans more than the beasts of the field and makes humans wiser than the birds of the heaven but that God does not at all answer the cries of wicked men (like Job). Finally, Elihu argues – in what is an obvious dig at Job's resolve to maintain his integrity in the face of divine affliction – that even the wild beasts have the sense to come in from the elements during the stormy blast of God (37:8).

Once all the human participants have had their say, it is evident that the moral characters of both Job and Yahweh are at stake. The situation is unfortunately imagined by all the human participants as something of an "either/or": either Yahweh is wise and just, or Job is. But not both. This cosmic Dodge City ain't big enough for the both of them. This is certainly how the three friends have perceived the situation, and so, as the self-designated posse of Yahweh, they try to run Job out of town. But Job will not be buffaloed. He reduces their arguments to ashes and steadfastly refuses to show partiality in judgment or to engage in flattery towards men or God (13:10–12; 32:21).

V. JOB 38:1–42:6 AND YAHWEH'S CHALLENGE TO REIMAGINE

Contrary to all expectations, Yahweh does indeed answer Job, and His stormwind theophany is not a divine weapon but a locus of revelation.[29] Through two cycles of interrogation that parallel the two earlier cycles of affliction, Yahweh peppers Job with questions designed both to rebuke him into dropping his charges against God as

29 For God's wind and storm as a weapon see Job 9:17; 13:25; 21:18; 30:22. On God's storm as possibly a locus of revelation see Job 28:25–28.

well as to affirm him for the integrity of his marginalized existence.[30] So these questions do not simply intimidate Job but involve him in Yahweh's thinking by answering questions with questions so that Job has some work to do in figuring out how to respond to Yahweh's sapiential imagination.[31] In these questions, Yahweh does indeed sanction Job's personal identification with the rural wilderness and with the extreme reaches of chaos where monstrous rejects dwell. However, Yahweh calls upon Job to reimagine what life is really like for the beasts in this wasteland. The poetics of this *re-imaging* process make Yahweh's speeches tantamount to an *extreme pastoral* or – to echo Aldous Huxley – a *brave new bucolic*, where all the wild beasts, with whom Job has negatively identified, not only laugh and play, but also scrap, claw, gouge, gorge, hunt, fight, cry, birth and die as a matter of course. And they do so by God's design, with integrity and without apology.[32] The centrality of bodily discourse in the book of Job becomes obvious in this passage. As Scott C. Jones has recently observed,

> Job's body is set into a large-scale dialogue with the body of God and the bodies of animals. Specifically, (1) Job's primary experience of God is in his body, and his descriptions of cosmic order from this intensely personal vantage point lead him to conclude that he is an object of shame. (2) Job imagines God's body as fighting against his body with an intent to destroy him, both physically and socially. (3) The divine speeches offer Job a new orientation to the cosmos and a grand vision of the bodies of animals through which he is to reimagine the

30 Yahweh's "rhetorical questions" function on two levels. One is on the level of the expected answer to the questions, which function to rebuke Job for his lack of knowledge and ability. The other is at the level of portrayal which functions to affirm Job on the basis of his previous identification with the beasts. The Hebrew verb *shq* "to play, laugh" is a key thematic word in Yahweh's description of animals and mythic creatures (39:7, 18, 22; 40:20, 29; 41:21).

31 On Yahweh as a sage in these speeches, see Norman Habel, "In Defense of God the Sage," in *The Voice from the Whirlwind: Interpreting the Book of Job*, eds. Leo G. Perdue and W. Clark Gilpin (Nashville: Abingdon, 1992), 33–37; Geller, "Nature's Answer: The Meaning of the Book of Job in Its Intellectual Context," in *Judaism and Ecology: Created World and Revealed Word*, ed. Hava Tirosh-Samuelson (Cambridge, MA: Center for the Study of World Religions, Harvard Divinity School, 2002), 123–24. For the way that Yahweh's questions involve the hearer with the speaker see Fox, "Job 38 and God's Rhetoric," 58. On the mental work of discernment that is placed on Job (and the reader) in figuring out how to respond see Dan Mathewson, *Death and Survival in the Book of Job: Desymbolization and Traumatic Experience*, eds. Andrew Mein and Claudia V. Camp, vol. 450 of *Library of Hebrew Bible/Old Testament Studies* (New York: T&T Clark, 2006), 156.

32 On the one hand, to describe Job 38:1–42:6 as a pastoral or bucolic is anachronistic. On the other hand, the dating of the book of Job is not at all certain.

nature of divine power, cosmic order, and the dignity of his own body.[33]

Job had imagined the "components" of his universe in one way which suggested that he himself was the object of divine attack and that God was unwise and unjust in His governance. Yahweh affects change in Job by reordering the components of Job's universe, so as to suggest the opposite, specifically that Job has become an elite object of God's special care and approval. Yahweh does not add any new "data" to Job's cosmos but rather appeals to a different order of understanding. It is critical to recognize here that Yahweh is portrayed as having condescended to become something of an *earthly* participant in this debate, in as much as He appears in the whirlwind and limits His own arguments largely to phenomenal categories. Or, to say it another way, God does not tell Job anything about His heavenly wager with the Satan or the testing nature of His afflictions. Instead, Yahweh redirects Job's imagination by appealing to evidence that is actually within Job's earthly purview and reasoning capacity.

The cast of beastly characters and the images associated with them in Yahweh's speeches have an impressive range. Yahweh speaks of birthing and corralling the sea (38:8–11), of the provision of prey for families of blood-thirsty lions and ravens (38:39–41), and of monitoring the gestation and birthing seasons of the ibex and deer when their young hit the ground running and never return (Job 39:1–4). He speaks of the wild ass who laughs at domesticated life (39:5–8) and of the wild ox who refuses to be domesticated (39:9–12), of the comic taxonomy and fearless parental habits of the ostrich who laughs at horse and rider (39:13–18), of the war horse who laughs at fear and craves battle (39:19–25), and of the ways of the hawk and eagle on high and on the hunt (39:26–30). Yahweh's discourse on these wild animals culminates in a picture of His provision for these birds of prey which experience a windfall of bountiful sustenance that most of us might find troubling – "His young ones suck up blood, and where the slain are, there is he" (39:30).

When Yahweh's discourse moves to the mythic monsters of Behemoth and Leviathan, the rhetoric really soars.[34] It is no accident that here, immediately after Job confesses his smallness and insignificance, Yahweh moves to instruct Job with images of these

33 Scott C. Jones, "Corporeal Discourse in the Book of Job," *JBL* 132 (2013): 845–46.

34 Yahweh's discourse on Behemoth is in 40:15–24 and on Leviathan is in 40:25–41:26 [41:1–34].

most corpulent, powerful, and exalted creatures.[35] Yahweh explicitly directs Job to consider Behemoth as his matched peer in creation (40:15; cf. Gen 1:24). He glowingly describes Behemoth's physical power (40:16–18) and presents Behemoth's dominance in the created order as the reason why God is the only one to subjugate him (40:19). Behemoth is served by the mountains, lotus, and willows (40:20a, 22), but is not a threat to any beast of the field (40:20b). His mouth is especially confident as the Jordan rages against it (40:23), and humans cannot capture him (40:24).

Yahweh's description of the watery Behemoth flows uninterrupted into His description of Leviathan. He directs Job to imagine the *impossibility* of even *trying* to capture, domesticate, commercially process, or successfully hunt Leviathan (40:25–41:2 [41:1–10]). Indeed, no one subjugates Leviathan (41:1–2 [41:9–10]). At this point Yahweh pauses to declare that He Himself owes nobody anything, because all creation belongs to Him (41:3 [41:11]). That being said, this declaration serves to load-up for Yahweh's rhetorical turn to praise Leviathan. Indeed, Yahweh declares that he will not withhold His own praise from Leviathan (41:4 [41:12]), thus emphasizing this as a speech-act of pure gratis on the part of the deity – the ultimate compliment to any creature. According to Yahweh, Leviathan is designed to dominate His created order (41:4–26 [41:12–34]). Leviathan is unskin-able and unbridle-able, because of his ferocious teeth (41:5–6 [41:13–14]), impregnable armored hide (41:7–9 [15–17]), and fire-breath (41:10–13 [41:18–21]). He projects bull-necked intimidation (41:14 [41:22]) with a hard body (41:15 [41:23]) and a hard mind (41:16 [41:24]). He frightens the gods (41:17 [41:25]), renders traditional weapons futile (41:18–21 [41:26–29]), has no soft under-belly (41:22 [41:30]), gives the deep its churning character (41:23–24 [41:31–32]), is unequalled in fearlessness (41:25 [41:33]), and rules over all the proud (41:26 [41:34]).

For someone who has negatively identified with these creatures as rejected, scorned, and mistreated by both humans and God, this is an *empowering rebuke* to the imagination, as Yahweh quite unexpectedly lauds all these creatures for their fierce independence and rugged individualism, and along the way makes it clear that "[s]ome animals were created in a way that preserves them from human exploitation."[36] To hear Yahweh tell it, these characteristics are the direct by-products of these beasts being the objects of God's personalized attention in

35 Jones, "Corporeal Discourse," 862.
36 Fox, "Meanings of the Book of Job," 13.

creating and equipping them to thrive in the wilderness amidst chaotic turmoil – which we should recognize as corresponding to the place of innocent suffering that defies all human theological explanation.

Yahweh both rebukes Job and proves Job's character by subtly demonstrating his solidarity with the most awesome and enigmatic creatures of God's creation. The images of Behemoth and Leviathan are constructed as caricatures of Job himself, not only to put him down as still beneath Yahweh, but also to comfort, console, and encourage him for the nobility of his place in Yahweh's order. The "independent" members of Yahweh's creation were made to be so by God himself, who has made them to thrive in wastelands as the objects of Yahweh's special care and admiration, which they experience far from the view of domesticated folk in their civilized towns. The thriving existence of these "rugged individuals" is actually a manifestation of the profoundly wise design of Yahweh's creation. Their extreme independence is the by-product of extreme integrity inherent in their creation by Yahweh, who alone subjugates them but also takes pride in them and does not slay them. Yahweh's character is thereby profiled and implicitly defended in the description of his relationship to creation, especially to those most individualistic, tenacious, and undomesticated members of his creation. In reality, such creatures have a sort of elite status, a special place, and even a special ruling function of their own within Yahweh's just order. Because of the integrity of their make-up they have no peers. All other creatures are below them, but none, except for humans, are terrified of them, and only God is above them.

Thus, just as Job had appealed to his own experience and character against the traditional wisdom of his friends, so too does Yahweh himself appeal to Job's experience and character, on the one hand to force him to drop his charges but on the other hand to affirm him for what he has become and for the place he has come to occupy in God's world. Job did well when he was defining himself and his integrity. Neither the narrator nor Yahweh have any problem with that. Job only ran into trouble when his pain moved him to define Yahweh – a move which is admittedly hard to resist in as much as one's own parameters are often constructed in response to perceptions of the identities of others. The friends, however, not only move to define God in their efforts to speak as His advocates, but they also move to define Job as his accusers. The friends fail badly in both ventures, as we shall soon see, while Job's final confession (42:2) suggests that he has finally come to "know" that God runs the world according to strategies that

he (a creature) could not have imagined.[37]

VI. JOB 42:7–17 AND THE PREVIOUSLY UNIMAGINABLE

In the epilogue, both Job and the friends are confronted with some images that were previously unimaginable to them. In the case of the friends, these images are particularly arresting. While the precise meaning of the Hebrew text of 42:7–8 is debated,[38] it seems relatively clear that Yahweh announces he has major problems with how the friends have spoken about Him and that their failure is not something Job has had a share in. Thus, it surely comes as a shock to the friends when Yahweh tells them that they are the objects of His wrath and that their only hope of pardon is not merely through offering sacrifices, but in fact their hope hangs on Job functioning prayerfully as their intercessory priest. In making this announcement Yahweh says something quite disturbing to the friends. Most English translations (e.g. NRSV, NIV, ESV) represent God here as saying, "for I will accept his [i.e. Job's] prayer not to deal with you according to your folly" (42:8). But the Hebrew text does not permit this lexically or syntactically.[39] A far more likely and straightforward rendering of the Hebrew would be "for I will have regard for him [i.e. Job] so as not to do *nebālâ* with you," or as the NJPS renders it, "for to him I will show favor and not treat you vilely." In the Hebrew Bible the word *nebālâ* is used for serious disorderly and unruly conduct, even sacrilegious acts. It designates the sort of crimes which threaten the sacred fabric of an ordered society, like rape and incest, and which are always punishable by death.[40] In threatening to do *nebālâ* to

37 At 42:2 I read the *qere, yāḏa'tî* "I know," over the *kethib, yāḏa'tā* "you know." The *qere* is supported by the versions and followed by most English translations.

38 The problematic line is *kî lō' dibbartem 'ēlāy nəḵônâ kə'aḇdî 'îyôb* which is usually rendered "for you have not spoken of me what is right (*nəḵônâ*), as my servant Job has." The main bone of contention is the meaning of *nəḵônâ* and to what words it refers.

39 As recognized by David J. A. Clines, *Job 38–42*, vol. 18B of *Word Biblical Commentary*, ed. John D. W. Watts (Nashville: Thomas Nelson, 2011), 1232. The Hebrew line in question in 42:8 is *kî 'im pānâyw 'eśśā' ləḇiltî 'ăśôt 'immāḵem nebālâ*.

40 See Gen 34:7; Deut 22:21; Judg 19:23, 24; 20:6, 10; Jer 29:22–23. Wolfgang M. W Roth, "NBL," *Vetus Testamentum* 10 (1960): 394–409; A. Phillips, "NEBALAH – A Term for Serious Disorderly and Unruly Conduct," *Vetus Testamentum* 25 (1975): 237–241; Richard G. Smith, *The Fate of Justice and Righteousness During David's Reign: Narrative Ethics and Rereading the Court History according to 2 Samuel 8:15b–20:26*, vol. 508 of *Library of Hebrew Bible/Old Testament Studies* (New York & London: T & T Clark, 2009), 150.

the friends, Yahweh is threatening to do things that the friends had refused to imagine God would ever do.

As for Job, he can hardly have imagined the way that his community is compelled to reorganize itself around him in 42:11, bringing him gifts and condolences "for all the evil (*'al kāl-hārā'ā*) that Yahweh had brought upon him (*'ăšer-hēḇî' yhwh 'ālâyw*)". In the description of how God restored Job's fortunes two-fold we see a man who is once again able to imagine some good things, particularly with respect to his daughters. The names of beauty that he gives them and the landed estates he sets up for them show Job to be a man who can now imagine good things and take steps to invest in them.[41] The only religious activity Job engages in is intercessory prayer, this time for known sins that have actually been committed by others. Gone from Job is that anxious sort of pious imagination that organizes life around the retribution principle.

VII. CONCLUDING REFLECTIONS

A philosopher friend of mine recently confessed half-jokingly that he had always struggled to imagine the ugly and repulsive hyena as part of God's creation. I tried to explain it from a Joban theological perspective. Yes, the hyena is ugly and repulsive, at least from the domesticated perspective of humans in their contrived little social and theological dog houses. But from the hyena's perspective, he is utterly and fiercely and unapologetically independent, and not the least bit interested in being domesticated, "cared for," or imagined by humankind. He is functioning in the way that God has made him to function and in the land that God has given him – far away from the pastoral gaze and grid of condescending humans. Such independent critters know like no one else the intimate and careful attention of God's providential care – with every bloated carcass they feast upon and with every muddy puddle they drink from. It may not seem like much to us, but it is to them, because it is *theirs*. Of course, when it comes to the problem of evil, accounting for hyenas is the least of our

41 Jemima (*yəmîmâ*) means "turtle-dove" (cf. Song 2:14). Cassia (*qəṣî'â*) is the name of an aromatic plant used in perfume (Exod 30:24; Ps 45 9[8]). Keren-happuch (*qeren happûk*) means "horn of antinomy," a black powder used for beautifying the eyes (cf. 2 Kgs 9:30; Jer 4:30; Isa 54:11; 1 Chr 29:2). The beauty of Job's daughters is presented not only as a public indication of special blessing (cf. Habel, 585) but also possibly as evidence of the efficacious nature of Job's naming of them. In terms of beauty the girls have all lived up to their names. Job continued a policy of justice and equity in his life that went beyond the normal practice of the ancient world. See chapter 31 where Job achieves the ideal, not the norm. On daughters' inheritance see Num 27:1–8.

problems. And Yahweh's speeches to Job are not really about wild animals and chaos monsters, any more than *The Chronicles of Narnia* is a series of stories about a lion.

Even though the character of Job is presented as unique, and his story is hardly that of an "Everyman,"[42] the book of Job still compels us to imagine whether persons of profound integrity, as we all hopefully aspire to be, can really imagine the true character of their friends or their God until there is absolutely nothing for their friends or their God to gain from being their friends or their God. And when faced with that, such persons of profound integrity have the opportunity to appreciate some things about themselves. Unfortunately, that kind of knowledge is not easy to come by. It seems to require that we possess some profound personal integrity to start with, and then experience some seriously undeserved and debilitating losses – the sort of losses which hurt us badly and make for dishonorable suffering in the eyes of the world. Perhaps only then are we in a position to faithfully imagine the axis upon which the imaginations of our friends and the creation of our God actually rotate.

However, even in such a school of hard-knocks, the wisdom which drives a faithful imagination remains anchored in the same fear of Yahweh that generates moral integrity on the sunny-side of life. Ultimately, one must dispense with being concerned about what other people think of one's undeserved suffering and pathetic mode of existence. This most profound bit of Hebrew wisdom literature suggests that those who chose to do so are able, like Job, to punch on through to experience God's unexpected revelation and care in ways they could not have imagined before – in fact, in ways that we are often too squeamish to contemplate or experience, because we eschew the life of radical integrity to which the fear of the Lord calls his creatures. In doing so, we lose the ability to faithfully imagine ourselves, our friends, and our God as they really are, and so we fashion ourselves into sycophants, our friends into talismans, and our God into an idol. All these things fail to excite Yahweh's faithful imagination in the wisdom literature of the Hebrew Bible. And the story of Job suggests that it is His faithful imagination that makes all the difference.

42 David J. A. Clines, "Why Is There a Book of Job and What Does It Do to You If You Read It?," in *The Book of Job*, ed. W. A. M. Beuken, vol. 114 of *BETL* (Leuven: Peeters, 1994), 20; Alan M. Cooper, "The Sense of the Book of Job," *Proof* 17 (n.d.): 231–232.

Teaching *Phantastes* to Today's Students

by John Pennington

John Pennington is a Professor of English at St. Norbert College in De Pere, Wisconsin, where he teaches specialty classes on fairy tales and science fiction and fantasy. He is the editor of *North Wind: A Journal of George MacDonald Studie*s. His most recent publications include an annotated, critical edition of George MacDonald's *Phantastes* (co-edited with Roderick McGillis) and an edition of critical essays, *Crossing a Great Frontier: Essays on George MacDonald's Phantastes* (both from Winged Lion Press).

In a review of Michael Ward's *Planet Narnia: The Seven Heavens in the Imagination of C. S. Lewis for Modern Philology*, Charles Ross remarks that "the Narnia novels may mirror religious truth, but they are not truth itself" (E132). To Ross, the Narnia books reflect what Christianity might be like in another, fantastical, world, filtered by a writer who recognized "the inadequacy of language" to capture such meaning in the real world. That is one reason, according to Ross, that Lewis liked George MacDonald, who attempted a similar approach to delineate the Christian world as a fantastic one. "One can now begin," concludes Ross, "to understand the joy Lewis derived from George MacDonald's *Phantastes* (1858), an enthusiasm not shared by many" (E133).

No shared enthusiasm for *Phantastes*? Oh, how Ross must be wrong. In fact, I have been assigning *Phantastes* in my Science Fiction and Fantasy class at St. Norbert College in Wisconsin for over seventeen years, and it is the first book they read during the semester, followed by H. G. Wells's *The Time Machine*. And, in truth, each semester the students consistently rate *Phantastes* as their least favorite novel of the semester. Wait, maybe Ross is right!

MacDonald's reputation generally – and *Phantastes*'s reputation specifically – owe a great deal to Lewis, who famously said that the fantasy novel "baptize[d]" (xxxiii) his imagination. "I have never concealed the fact," admits Lewis, "that I regarded him as my master; indeed I fancy I have never written a book in which I did not quote from him. But it has not seemed to me that those who have received my books kindly take even now sufficient notice of the affiliation. Honesty drives me to emphasize it" (xxxii). Lewis's comments have an ironic ring to them: as popular as Lewis is today, even he, it seems,

has not been able to translate his love of *Phantastes* to contemporary students, many of whom have grown up reading – and loving – the Narnia books and films. While I have yet to encounter a student who has read the Space Trilogy or even *The Great Divorce* (where MacDonald plays a pivotal role), I can rest assured that most of my students have an intimate knowledge of *The Lion, the Witch, and the Wardrobe* and other Narnia books.

If Lewis is such an important writer for students, then why is his exuberance for *Phantastes* not shared? I was determined to discover why students struggled with *Phantastes* in order to address those issues in the classroom. Quite simply, I discovered that students were confused by *Phantastes* and that their confusion led to boredom. Students were unwilling to heed Anodos's advice about Fairy Land: "But it is no use trying to account for things in Fairy Land; and one who travels there soon learns to forget the very idea of doing so, and takes everything as it comes; like a child, who, being in a chronic condition of wonder, is surprised at nothing" (24). The solution to this problem, I thought, would be to create a student-driven critical, annotated edition of *Phantastes*. My co-editor Roderick McGillis and I created such an edition for Winged Lion Press, one designed to address concerns students had when reading *Phantastes*.

McGillis and I published an annotated edition of *At the Back of the North Wind* for Broadview Press in 2011, so we have some experience creating such a beast. Rod also did an annotated edition of the Princess books for Oxford University Press in 1990. Sadly, that useful edition has been out-of-print for some time. While Broadview was pleased with the end result of the *At the Back of the North Wind* edition, one concern that external readers and the editors had was the breadth of the annotations we provided. Simply translated: Rod and I, some initial reviewers thought, had too many annotations, and our editor was constantly questioning whether we need an annotation here or there. We always answered, "Yes; trust us!" On one level, the concern was that the fantasy novel would look more like *The Waste Land* than a children's fantasy about North Wind and Diamond. On another level, our reviewers believed that we were providing readers with (too) obvious glosses for particular passages, the Catch-22 of any annotated edition of literature. In fact, Laurence Talairach-Vielmas mentions this concern in his *Marvels and Tales* review: "We may wonder, however, whether some of the notes do not overload the edition, in particular, the systematic citations of entire nursery rhymes, the comments on MacDonald's rhetoric, . . . and even the

names of the twelve apostles and references to contemporary novels.
. . . The explanation of the rise of the Metropolitan Police Force (75)
when a policeman appears on the scene is another example" (136).

Yet, George MacDonald himself provided his own guidelines
for annotations in his edition of *The Tragedie of Hamlet*:

> Doubtless many will consider not a few of the notes
> unnecessary. But what may be unnecessary to one, may be
> welcome to another, and it is impossible to tell what a student
> may or may not know. At the same time those form a large class
> who imagine they know a thing when they do not understand
> it enough to see there is a difficulty in it: to such, an attempt at
> explanation must of course seem foolish. (xii-xiii)

A contemporary case in point: Donald J. Gray's annotations
to the 3rd Norton Critical Edition of *Alice in Wonderland* (2013) are
quite different than Martin Gardner's for *The Annotated Alice: The
Definitive Edition* (2000), also published by Norton. In fact, Norton
has become the standard in critical editions (at least in the United
States). These editions are often inconsistent – the editors, usually
major scholars, often miss what the average student might need, either
providing notes that are too specialized or ones so obvious that they
verge on insulting the reader. Gray provides 45 annotations for *Alice's
Adventures in Wonderland*, whereas Gardner presents a whopping 125
annotations. Gray writes that Carroll was an esoteric writer – besides
being "a mathematician, logician, and student of language," he also
toyed with topics ranging from "existence, extinction, authority, and
the stability of meaning" to "axioms of Euclidean geometry and to
the governance of a providential deity" (viii). Carroll, Gray continues,
treats such serious topics that "continues to exercise the sensibilities
and intelligences of literary historians and critics, linguists and
psycholinguists, writers who are interested in the role of gender,
and writers who are interested in the motives and effects of Carroll's
imaginative constructions in print and of Dodgson's subjects and
compositions in photographs" (viii). Note that the word student is
never used. One might conclude that the annotated edition is not
necessarily geared to a student or novice audience, nor is its primary
goal to help students understand and appreciate Carroll's fantasy.

Ah, MacDonald's dilemma in *The Tragedie of Hamlet*. What is
an editor to do? For one, why not ask students what they need from
such an edition? This is precisely what we did. For two of my Science
Fiction and Fantasy courses at St. Norbert College, totaling over 70
students, I had them suggest annotations for each chapter. As such,

many annotations were student generated. Interestingly, the students were quite consistent with their suggestions, often flagging sections that Rod and I would not have annotated. Our annotations can be categorized in two ways:

CLARIFICATION NOTES

These notes, as you can imagine, provide definitions for obscure words – which to the twenty-first century student are many! We used the Oxford English Dictionary (OED) for our definitions since the dictionary provides a historical overview of a word's origin. In one instance, the OED quotes from MacDonald as an example: in chapter ten Anodos tells us of his love for a refreshing spring he encounters. "I drank of this spring, and found myself wonderfully refreshed. A kind of love to the cheerful little stream arose in my heart. It was born in a desert; but it seemed to say to itself, 'I will flow, and sing, and lave my banks, till I make my desert a paradise'" (68-69). In this passage "lave" is strange to students, the context suggesting that the word is perhaps an archaic variant of love. The OED, however, defines the word as a verb meaning "to wash or to bathe"; the word also can refer to something that is "leftover." The OED claims that the word is used primarily as a poetic expression, and it actually lists a passage from MacDonald's *Alec Forbes* to illustrate the definition over time.

CONTEXTUAL EXPLANATIONS

The second type of note provides contextual background information related to the nineteenth century, particularly in England, though we highlighted transnational connections with American authors since MacDonald was popular in America, where he completed a successful lecture tour in 1872 and 1873. Thus, notes were provided linking MacDonald to Hawthorne, Poe, Thoreau, and Emerson, for example. As you would expect, we also provide detailed notes for the quotations that function as epigrams to begin each chapter, in which MacDonald quotes from other literary works that students have little knowledge of, especially with the German writers. In addition, we provided notes on nineteenth-century issues that may not be familiar to contemporary readers – from exploring the impact of geological findings and Darwin's evolutionary theory to religious debates and even to the Victorian popularity of the vampire in literature.

But since Rod and I also wanted to appeal to the contemporary reader as much as possible, we included notes that highlight how

important MacDonald is to the development of modern and contemporary fantasy; consequently, we often provide connections to modern and contemporary writers, including Lewis and Tolkien, but also writers like Madeleine L'Engle, Philip Pullman, J. K. Rowling, and even Neil Gaiman (who in an informal discussion at a conference expressed to me the influence MacDonald had on him as a young reader of fantasy).

Here is an example of a note that captures the spirit of connecting with the past and the present. Two reviewers of our edition mentioned this note as reflecting the accessibility of the edition for students – they also mentioned the whimsy that might engage the reader. So who am I to disagree? The note is from chapter sixteen on Schiller's *Das Ideal und das Leben*, a work not exactly on the radar of today's students.

> 1. Johann Christoph Friedrich von Schiller (1759-1805) was a German writer, primarily known as a dramatist, poet, and literary critic. *Das Ideal und das Leben* (*Life and the Ideal*, 1795) is a philosophical poem. The *Oxford Reference* reports that the poem was "first published in 1795 in No. 9 of Die Horen, with the title 'Das Reich der Schatten'. Schiller changed this in 1800 to 'Das Reich der Formen', and adopted the present title in 1804." Edward Bulwer-Lytton (1803-1873), writer and politician, translated the poem in 1844 as *Ideal and Actual Life*. Bulwer-Lytton began his novel *Paul Clifford* (1830) with the lines: "It was a dark and stormy night," which is the name of the annual contest for bad opening lines. Madeleine L'Engle, who was inspired by MacDonald, begins her 1962 fantasy *A Wrinkle in Time* with these words, as does Snoopy when he plays the World-Famous Author in the comic strip *Peanuts*.

Our goal for these notes, then, was to connect to the students on an academic level, while also connecting to them personally, with a tone that is simultaneously serious (academic) and playful.

Another important way we wanted to bring *Phantastes* to the contemporary reader was by providing abundant material in the appendices that could be used in the classroom to focus students on a specific aspect of the novel. Our intent was to create small research units so students could do projects that directly engaged them in critical thinking and writing about *Phantastes*. Rod and I had approached our earlier edition of *At the Back of the North Wind* in a similar way, and we were pleased that reviewers noticed our approach. George Bodmer, for example, wrote that *North Wind* was "veritably a course in the Victorian fairy tale." U. C. Knoepflmacher wrote that

the edition was a "truly indispensable item" (from the back cover of the edition). Obviously, we were pleased when Bonnie Gaarden wrote the following about our *Phantastes* edition: "Any serious reader of *Phantastes* will find this edition to deepen his or her understanding and enjoyment of MacDonald's fantasy masterpiece, and MacDonald scholars will find it an invaluable resource" (from the back cover of that edition).

The appendices are as follows:

Appendix A: *Phantastes* and Novalis' Epigraph;
Appendix B: Reviews and Responses to *Phantastes*;
Appendix C: German Romantics and other Influences;
Appendix D: Fantasy and Realism in the Nineteenth Century;
Appendix E: Arthur Hughes Illustrations for the 1905 Edition of *Phantastes*.

Here are some examples of how one might use the material in the appendices. In the Reviews and Responses to *Phantastes* we include Edward Stanley Robertson's 1906 retrospective on *Phantastes* that was published in *The Academy* magazine. Robertson begins by asking, "How long is it since I first read '*Phantastes*'?" While rereading the novel he remarks:

> And now I find myself in possession of the most recent edition, issued by the author's son, Dr. Greville Macdonald, and illustrated by the author's friend, Arthur Hughes. I hope I am not ungrateful, but though I admire Mr. Hughes's illustrations, on the whole, I prefer my own plain copy. Methinks the reader should illustrate his '*Phantastes*' for himself; the mental picture is better than the material one. (209-10)

The appendix on Hughes's illustrations includes a short essay written by Jan Susina about Hughes's illustrations as a response to earlier illustrations by John Bell that the MacDonald family disliked. In his essay, Susina addresses the fact that *Phantastes* was not originally conceived as having illustrations. A teaching unit on Victorian fiction illustrations could be put together, addressing issues about the purpose and importance of illustrations and, more broadly, about the interplay between word and image in the nineteenth century. One thinks of George Cruickshank's early work with Charles Dickens and the eventual debate Dickens had with Cruickshank on the nature of fairy tales. That debate is reflected in Dickens's satiric "Frauds on the Fairies," which is found in our appendix on Fantasy and Realism in the Nineteenth Century. This, then, could lead to a discussion of the

so-called fairy-tale debate in the nineteenth century. While students are usually subjected to discussing a literary work primarily from a thematic approach that reflects the elements of literature, having them grapple with additional contextual issues beyond thematic or structural concerns may open the fantasy up to students.

A final example. *Phantastes* is primarily seen as an important Victorian fantasy that influenced Lewis (mostly) and Tolkien (partly) and paved the way for modern fantasy, particularly mythopoeic fantasy. Thus, the fantasy is read, if at all, in classes that are focused on fantasy literature. In the Fantasy and Realism in the Nineteenth Century appendix, we wanted to posit something more radical – that *Phantastes* is vital to the rise of the realist novel that came to dominate the Victorian age. In this appendix we connect Nathaniel Hawthorne's definitions of the romance from *The Scarlet Letter* and *The House of the Seven Gables* to *Phantastes*; in addition, we trace how Dickens in *Hard Times* flirted with the notion of the fantastic that he used in an interpolated tale in *Little Dorrit*. We also include George Henry Lewes's defense of the realist novel in a *Westminster Review* article from 1858, the year of *Phantastes*'s publication. When I teach the Nineteenth Century British Novel next, I will assign *Hard Times* and *Phantastes* as mid-century examples between the realistic and fantastic impulses in the Victorian novel.

On the copyright page of *Phantastes*, MacDonald includes a quotation: "In good sooth, my masters, this is no door. Yet is it a little window that looketh upon a great world." We hope that our edition of *Phantastes* will open the window a bit for students. When students begin reading *Phantastes* they play the game of the impossible, able to agree with Anodos that "it is no use trying to account for things in Fairy Land; and one who travels there soon learns to forget the very idea of doing so, and takes everything as it comes; like a child, who, being in a chronic condition of wonder, is surprised at nothing" (24). Students suspend their disbelief early on. But as the fantasy progresses, they become a bit more impatient and side with Anodos where he says, "You see this Fairy Land is full of oddities and all sorts of incredibly ridiculous things, which a man is compelled to meet and treat as real existences, although all the time he feels foolish for doing so" (183). We hope that the Winged Lion edition of *Phantastes* will help its readers understand that the fantasy requires both views, for it is about much more than a 21-year-old wandering in Fairy Land and making random associations. We think C. S. Lewis might like that. Now if we can just convince Charles Ross.

WORKS CITED

Gardner, Martin, editor. *The Annotated Alice: The Definitive Edition*. Norton, 2000.

Gray, Donald, editor. *Alice in Wonderland*, 3rd ed. By Lewis Carroll. Norton, 2013.

Lewis, C. S. Preface. *George MacDonald: An Anthology*, edited by C. S. Lewis. Macmillan, 1947, xxi-xxxiv.

MacDonald, George. *Phantastes. (1858) Annotated Edition*. Edited by John Pennington and Roderick McGillis. Winged Lion, 2017.

---. Preface. *The Tragedie of Hamlet*. Longmans, Green, 1885. vii-xiv.

McGillis, Roderick, and John Pennington, editors. *At the Back of the North Wind*. By George MacDonald. Broadview, 2011.

Ross, Charles. Review of *Planet Narnia*. *Modern Philology*, vol. 110, no. 2, Nov. 2012, E131-E138.

Talairach-Vielmas, Laurence. Review of *At the Back of the North Wind*. *Marvels and Tales*, vol. 27, no. 1, 2013, pp. 135-37.

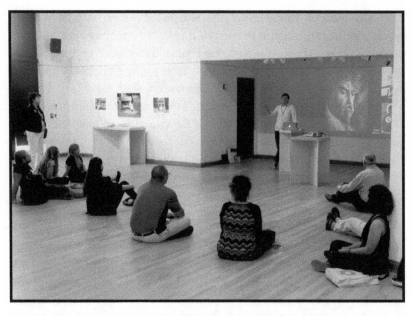

Jeremie Riggleman discusses his Inklings-inspired art exhibit, "At the Sea."

Warming the Wintry Heart: Redemptive Storytelling in "The Rime of the Ancient Mariner" and *Adela Cathcart*

by Abby Palmisano

Abby Palmisano is an English graduate student at Illinois State University. She graduated from Taylor University in 2017, where she was the student assistant at the Center for the Study of C.S. Lewis & Friends. Her research at Taylor has been published in *North Wind* and *Inklings Forever X*.

The curious thing about the season of winter is how often it represents not so much a particular emotion or feeling, but a lack of emotion. It is easy to imagine the biting, bitter cold as an apathetic or unfeeling heart. Many British authors have created characters typified by their wintry hearts. Characters such as Mary Lennox (*Secret Garden*), Edmund Pevensie (*The Lion, the Witch, and the Wardrobe*), and Ebenezer Scrooge (*A Christmas Carol*) come to mind. The hard and wintry hearts of these characters are often mirrored by their icy environments, which in turn melts into spring (as with Mary and Edmund) or the joy of Christmastide (as happens to Scrooge) as redemption transforms the heart. Two other works that participate in this literary tradition are Samuel Taylor Coleridge's "Rime of the Ancient Mariner" and George MacDonald's under-appreciated novel, *Adela Cathcart*.

The redemptive processes experienced by the title characters of these works have a fascinating similarity. Both warming redemptions are wrought through acts of storytelling. Storytelling, for the Mariner, is therapeutic and acts as a confessional so that he might be healed both spiritually and emotionally. Although Adela is not the one telling stories, the stories told to her inspire a world of feeling by awakening her imagination. The stories also equip her with a framework for understanding suffering and redemption as they acknowledge both the horrible and wonderful in the world. The stories make spiritual sense of suffering, bringing value to the hardship that she has experienced and revising her belief that the wretchedness she sees in the world is the "true way of things."[1] Instead, suffering becomes a process by which a person returns to God, echoing the opinion expressed by John

1 George MacDonald, *Adela Cathcart* (Whitehorn: Johanneson, 2000), 26.

Smith, Adela's storytelling uncle, that "darkness exists but by the light and for the light."[2] Winter, of both the heart and the world, exists but for the warmth of spring and Christmas.

Of course, the act of storytelling, or at least of effective storytelling, requires a good deal of imagination. Understanding the imaginative philosophies of MacDonald and Coleridge alike are in fact vital to an understanding of their redemptive visions. Both writers thought deeply about the imagination and its purposes and affects in human life. The imaginative philosophies put forth by both Coleridge and MacDonald are rooted in their Christian Neoplatonism. Although Christian Neoplatonists have used their philosophies to a variety of purposes, Coleridge and MacDonald particularly focused on the circular journeys of the individual, beginning with the initial departure from the One at the event of the Fall and the eventual reunification with God. Coleridge demonstrates his belief in the lyric poem, "The Eolian Harp":

> And what if all animated nature
> Be but organic Harps diversly frame'd,
> That tremble in thought, as o'er them sweeps,
> Plastic and vast, one intellectual Breeze,
> At once the Soul of each, and God of all?[3]

Multiety in the eventually achieved unity, as opposed to an undifferentiated monism, is an important element of Coleridge's Neoplatonism. Individual minds, that is, remain individual in the One. According to M. H. Abrams, "if irredeemable division is essential for evil, what Coleridge calls 'distinction' is not only redeemable but the necessary condition for progressive development, for to 'distinguish without dividing' is the only way to 'prepare for the intellectual re-union of the all in one.'"[4] MacDonald makes evident his Neoplatonist interests in his writings on the imagination, which are highly influenced by, and nearly identical with those of Coleridge. In a letter to his sister-in-law, Charlotte Powell, MacDonald wrote, "To be one with Him is the only Human perfection – to be one becoming one with Him, the only true Human History May

2 MacDonald, *Adela*, 6.

3 Samuel Taylor Coleridge, "Effusion XXXV" in *Coleridge's Poetry and Prose* edited by Nicholas Halmi, Paul Magnuson, and Raimonda Modiano (New York: W.W. Norton and Company, 2004), lines 37-40.

4 M.H. Abrams, *Natural Supernaturalism*, (New York: W.W. Norton, 1971), 267.

every year bring you nearer to God and nearer to men."[5]

Coleridge explained his unique philosophy of the Imagination extensively in his two-volume book, *Biographia Literaria*. Coleridge describes the imagination as "esemplastic" (as in his phrase "as over them sweeps / plastic and vast" from "The Eolian Harp"), meaning "to shape into one." The imagination, then, enacts Neoplatonic reunification on a microcosmic level, introducing higher forms of unity in its wake. In chapter thirteen, Coleridge draws a distinction between the three different powers of mind which are often lumped together as "the imagination" in common speech. He refers to these three divisions as the primary imagination, the secondary imagination, and fancy. The primary imagination is described as "the living Power and prime Agent of all human Perception," and as a "repetition in the finite mind of the eternal act of creation in the infinite I AM."[6]

The secondary imagination he describes as an "echo" of the primary imagination, "coexisting with the conscious will, yet still as identical with the primary in its kind of agency, only differing in degree, or mode of its operation."[7] Here Coleridge locates the "creativity" or imaginative endeavors of human beings who, after perceiving something of the imagination of God, consciously enact their own sort of creation.

In "The Imagination: Its Function and Its Culture," MacDonald defines the imagination as "that faculty which gives form to thought" and "is, therefore, that faculty in man which is the likest to the prime operation of the power of God, and has therefore been called the creative faculty."[8] From this we can see that MacDonald's encompassing view of the imagination, then, contains within it what Coleridge has divided into the primary and secondary imagination.

For both Coleridge and MacDonald, nature, being part of the ongoing creative activity of the great I AM, has an inherent connection to the human mind. M.H. Abrams, in *Natural Supernaturalism*, claims that "Coleridge's prime concern was to expedite a 'reconciliation from [the] Enmity with Nature' into which philosophy . . . had fallen."[9] This disunity with nature is deprecating for human beings since the mind was originally created to find Reason in nature. In "The Friend,"

5 Quoted in Roland Hein, *George MacDonald: Victorian Mythmaker*, (Nashville: Star Song, 1993), 95.

6 Samuel Taylor Coleridge, *Biographia Literaria* (New York: Everyman's Library, 1965), 477.

7 Coleridge, *Biographia Literaria*, 477.

8 George MacDonald, "The Imagination: Its Function and Its Culture" in *Dish of Orts* (Whitehorn: Johannesen, 1996), 2.

9 Abrams, 268-69.

Coleridge notes that "man sallies forth in nature, as in the shadows and reflections of a clear river, to discover the originals of the forms presented to him in his own mind."[10] This begs the question of how the mind might be reunited with nature. According to Coleridge, the answer is art. Art "is the mediatress between, and reconciler of, nature and man."[11] Such a unity with creation would naturally prompt an effort towards unity with the Creator. MacDonald similarly views nature as the form by which man may reveal his thought. He writes that "the world around him is an outlined figuration of the condition of his mind."[12] If art is the "mediatress" between man and nature, stories will hold redemptive and healing qualities, as seen in "Rime of the Ancient Mariner" and *Adela Cathcart*.

Both authors see human perception as a direct result of the imagination of God. For both of them, the imagination functions as a force that can awaken the self-conscious soul so that it may be reunified with God. The suppression of that mechanism is, therefore, disastrous to human flourishing. MacDonald believed that an unimaginative perception is stunted because it will "never lead . . . beyond dull facts – dull because their relations to each other, and the one life that works within them all, must remain undiscovered."[13] Just this sort of Gradgrindian perception appears to be killing young Adela.[14]

Adela, "dying of ennui," has fallen into such a stunted perception of the world that she is not sure she loves anything or anyone. She sees the world "with an overpowering sense of blackness and misery."[15] She cannot see "beyond dull facts." In response, her uncle tells her father that he "suspect[s] the cause of her illness is a spiritual one."[16] Her apathy, he believes, is related to her inability to see God in the world or her own place within it.

Adela's deadened perception is often rendered with wintry imagery, implying that her heart is frozen and, in MacDonald's view, must be melted by the "lamp" of the imagination in order to restore her right relationship with God, nature, and her own emotions. Smith, the novel's narrator, states that "the mind has its seasons four, with many

10 Samuel Taylor Coleridge, *The Friend* (London: Routledge and Paul, 1969), 509.

11 Samuel Taylor Coleridge, "On Poesy or Art," in *The Complete Works of Samuel Taylor Coleridge* (New York: Harper and Brothers, 1858), 328.

12 MacDonald, "The Imagination," 5.

13 MacDonald, 27.

14 Sir Thomas Gradgrind is an unimaginative and therefore villainous school superintendent in Charles Dickens's novel *Hard Times*.

15 MacDonald, *Adela Cathcart*, 25.

16 MacDonald, *Adela*, 52.

changes, as well as the world."[17] His statement associates emotional states of the mind which control our perceptions with the four seasons. The action of the novel (such as it is) takes place at Christmas time and continual reference is made to the weather and the snow. As such, the constant mention of Christ's birth in the winter undercuts the traditional connection between an icy perception and the winter. Early on, John Smith states, "I believe in the proximate correctness of the date of our Saviour's birth. I believe he always comes in winter."[18] This statement simultaneously acknowledges the bleakness implied by winter and the change of perception made possible by Christ's coming into the world.

Coleridge's Mariner, too, has an icy heart. In fact, the word "Rime" in the title may be a play on words, signifying both the rhyme in the poem and the literal meaning of "rime": a layer of frost on a cold object, here perhaps symbolizing the Mariner's cold perception of reality after experiencing the storm. As the Mariner begins his journey, the first landmark that he sails away from is the Kirk, the village church, implying a departure from God. Soon after experiencing a storm, the world around the Mariner becomes literally icy, a poetic embodiment of Coleridge's theory that in nature, man finds "the originals of the forms presented to him in his own mind."[19] The physical ice that surrounds the Mariner and his gloomy perception of it reflect the deadness of his own mind and soul. The Mariner has placed nature in "antithesis to the mind." Such an error is fatal since, as M.H. Abrams suggests, Coleridge "repeatedly describes all division as death dealing."[20] It is the Mariner's stunted perception of the world that leads to his failure to value the life that is before him when he shoots the numinous Albatross.

When the crew spots the Albatross, they hail it "as if it were a Christian soul,"[21] deserving love and respect. That the albatross "perched for vespers nine" further sacralizes the bird.[22] The Mariner, however, hardened in his perception of the world and, thus, at enmity with nature, does not value the life of the bird, leading him to commit his malicious crime. The severity of this crime is indicated through explicit comparison to the crucifixion ("with my cross-bow / I shot the

17 MacDonald, 312.
18 MacDonald, 5.
19 Abrams, *Natural Supernaturalism*, 269.
20 Abrams, 267.
21 Coleridge, "Rime," line 65.
22 Coleridge, 79.

albatross")[23] and by the crew's decision to hang the albatross around the neck of the Mariner "instead of the cross."[24] After the murder of the Albatross, the natural setting shifts from a world of ice to a world of fire. The Mariner's new infernal landscape, a reflection of "the originals of the forms presented to him in his own mind,"[25] is the objective correlative of the Mariner's realization of and experience of his own guilt.

The Mariner's newfound guilt brings feeling and suffering into his experience of the world, as opposed to the cold, unfeeling attitude he possessed previously, allowing him to become vitally aware of his own soul. This section of the poem is especially characterized by hellish and fiery imagery. The Mariner recalls "all in a hot and copper sky, / the bloody sun, at noon."[26] And he describes the landscape in a hellish manner: "Nor dim, nor red, like God's own head, / the glorious sun uprist,"[27] implying Divine judgement. This imagery matches the Mariner's realization that he "had done a hellish thing."[28] His attitude towards creation has likewise shifted from indifference to hatred, corresponding to his hatred of himself. In describing the creatures of the sea the Mariner complains that "slimy things did crawl with legs, / Upon the slimy sea,"[29] foreshadowing his later comment that "a thousand thousand slimy things, / Lived on; and so did I,"[30] implying that he is no better than the slimy things that have continued to live after the death of the crew. Despite the hellish horror of his inner and outer landscape, the Mariner has, at least, begun to perceive himself in relation to the natural world.

The ability to perceive – and to perceive correctly – figures prominently in Coleridge's thought. Ever concerned with the self-conscious mind, Coleridge developed a theory of mental powers that progresses from Sense to Intellect and is balanced with polarities that work together to create a unified mind, one that perceives its individuality and unity with the created order. "The Rime of the Ancient Mariner" is filled with such oppositional binaries which are eventually reconciled or balanced in the course of the poem. This suggests a correlation between the poem and Coleridge's "order of

23 Coleridge, 81-82.
24 Coleridge, 141.
25 Coleridge, "The Friend," 509.
26 Coleridge, "Rime," lines 111-12.
27 Coleridge, 97-98.
28 Coleridge, 91.
29 Coleridge, 125-26.
30 Coleridge, 238-39.

mental powers":

> Reason
> Imagination
> Understanding
> Understanding
> Fancy
> Sense

Key to human perception is the human "understanding," which, according to Owen Barfield, Coleridge defines as the "medial and mediate faculty, and has therefore two extremes or poles, the sensual, in which it is in St. Paul's carnal mind and the intellectual, or hemisphere, as it were, turned toward reason."[31] As a process of "awakening," the "understanding" in Coleridge's thought was the source of language. It is by the sensual or "passive" understanding that the human mind first abstracts itself from nature in order to judge it. Active understanding, or the understanding turned towards Reason, turns these judgments into language.

Each side of the gamut has a matching pole on the other end. This "evolution" of thought begins with the sense and sensory perception of nature. This perception is taken up by Fancy, which "plays with fixities and definites." The matter of Fancy is accompanied by instinct "where we are still united in nature"[32] and abstracted by the understanding so that judgements may be made. The pole of understanding turned towards reason takes these abstractions and judgements and turns them into language; this is the power of mind that is "awakened" to self-consciousness and is able to say "I Am." The Imagination, which is able to perceive the ongoing creative acts of God, then mediates between man and nature, re-creating the instinctual connection that had been "lost" in the act of abstraction. Lastly, the intellect, which takes what it perceives of transcendent reason by means of the Imagination is able to philosophize. This balance seems to be wrought with delicacy.

The Mariner becomes stuck in sensual understanding and is, initially, unable to progress along the gamut of mind. Owen Barfield, interpreting Coleridge, explains the danger of getting stuck in this phase of detachment:

> If therefore we make understanding an end in itself, we

31 Owen Barfield, *What Coleridge Thought* (Middleton: Wesleyan University Press, 1971), 97.
32 Barfield, 110.

become a race of animals . . . falling prostrate before lifeless images, the creatures of his own abstraction, [man] is himself sensualized, and becomes a slave to the things which he was formed to be the conqueror and sovereign.[33]

Stuck in such a state of division, the Mariner kills the Albatross, whom he cannot imagine in connection to himself or God. Fatefully, it is this act that is the beginning of the Mariner's eventual awakening to himself and to Reason, the first step in a process that will eventually lead to a synthesis of the visible and invisible in the world. Once the Mariner blesses the creatures of the sea, through the intervention of his kind saint, he is able to reunite with God through prayer, causing the Albatross to fall from his neck.

A similar process can be seen in some of the stories featured in *Adela Cathcart* such as "The Light Princess." Much like the Mariner, the Light Princess has lost the accuracy of judgement which understanding is meant to afford. Thus, the language used by the Princess to describe the physical world is inaccurate; when the prince pulls her out of the water, accidentally sending her floating into the air, she feels it as "falling."

She must be able correctly to judge gravity before it can be internalized and incorporated into her outward experience. The internalization of gravity (and the moment of synthesis) occurs through the internalization of water. The Princess must cry, and in order to do that she must be made aware of her soul. It is at this point that the imagination is activated to "pierce the understanding." When her evil aunt drains her beloved lake, which the Princess had begun to identify with her soul (thus re-unifying herself with nature), the Princess experiences suffering for the first time. The draining of the lake "haunted her imagination so that she felt as if the lake were her soul, drying up with her, first to become mud, and then madness and death."[34] It is her imagination that intervenes and allows her to feel and experience suffering.

The polarities of the understanding tap into metaphysical connection between mind, body, and heart – a concern that must be faced by the Mariner, Adela, and the Light Princess. Throughout both "The Rime of the Ancient Mariner" and *Adela Cathcart*, the supernatural elements presented in the stories force the characters to confront their own metaphysical misperceptions and eventually abandon them for a metaphysical knowledge that matches the realities

33 Barfield, 100.
34 MacDonald, *Adela Cathcart*, 92.

of their worlds. According to M.H. Abrams, Coleridge believed that "man's highest state is to experience his familial participation in the One."[35] This teleological statement implies that a separation from the One would be to avoid one's telos and be "betrayed by the wretchedness of division."[36] Such a way of living could not possibly be ideal or legitimately considered life, and therefore would be to live in death, as the Mariner does.

The Mariner's inability to recognize the Albatross as one of God's creatures demonstrates the Mariner's failure to participate in the unity between God and creation which Coleridge views as man's telos. The Mariner's actions of disunity, such as sailing away from the Kirk and his home country, as well as killing the bird, reveal the Mariner's metaphysical misperceptions – the belief that nature is separate from the mind and from God. The Mariner, Abrams suggests, has placed "nature in antithesis to the mind."[37] Abrams later observes that "killing 'the bird that loved the man' is an act which expresses the Mariner's prideful self-sufficiency, his readiness to cut himself off from the universal community of life and love."[38] It is the supernatural intervention in the poem that forces the Mariner to confront his own faulty metaphysics by showing him the consequences of disunity. By placing himself in opposition to the bird, he likewise places himself in opposition to the crew who "in sore distress would fain throw the whole guilt on the ancient Mariner: in sign whereof they hang the dead seabird round his neck" (139-42).[39] The crew, in reaction to the supernatural punishment for the albatross's death, place themselves in opposition to the Mariner, creating further disunity. However, it is also the supernatural intervention that brings the Mariner back into unity with nature, man, and God.

The seraph band that inhabits the bodies of the dead crew act as a positive supernatural element, helping restore the Mariner to unity with the One. The parallels in the sensory imagery of the poem demonstrate this return to unity. While the Mariner has still placed nature in antithesis to his mind, he finds either silence or frightening sounds in nature. While in the south pole, the Mariner observes that the ice "cracked and growled, and roared and / howled."[40] Nature,

35 Abrams, *Natural Supernaturalism*, 266.
36 Abrams, 266.
37 Abrams, 276.
38 Abrams, 273.
39 The quotation is from the marginal gloss corresponding to these verses in the text of "Rime".
40 Coleridge, lines 61-62.

through these sounds, is perceived as frightening, wild, perhaps monstrous. The seraph band that inhabits the bodies of the dead invert the Mariner's perception of nature. Instead of silence or threatening sounds, he hears "now it is the angel's song, / That makes the heavens be mute."[41] He now hears heavenly music and calming, pleasant sounds where he once heard stark silence or threatening noises.

The metaphysical beliefs promoted in *Adela Cathcart* differ from those of concern in "The Rime of the Ancient Mariner." Although both authors link the imagination to unity with God, where Coleridge emphasizes a unity between God, man, and nature, MacDonald emphasizes a unity of body, mind, and heart. Each story told in the novel, including the frame story of Adela and her illness, presents at least one character whose metaphysical beliefs emphasize the mind or the body, but not the heart. Each of the stories necessitates a recognition of the whole person in order for the needed resolution to take place.

At the beginning of the novel, Adela is ailing from some enigmatic illness and the local physician, Dr. Wayne, has been trying to treat her by physical means alone. Colonel Cathcart states that the medicines "certainly don't do her any good."[42] Body and soul are viewed as separate entities by Dr. Wayne. Smith suspects, in contrast, that "the cause of the illness is a spiritual one"[43] and proclaims that he "partly took the homœopathic system."[44] It so happens that a new homeopathic doctor, Harry Armstrong, has moved to Purleybridge. He is described by Smith as "a wonderful physician . . . a follower of some of the old mystics of the professions, counting harmony and health one."[45] In acknowledging the importance of a such a holistic approach, the company of the story-telling club endeavor to heal Adela mentally, spiritually, physically, and emotionally. The specific characters who make up the club – a doctor, a schoolmaster, a curate – underscore this point.

In "The Light Princess," the King and Queen ask two metaphysicians, Kopy-Keck and Hum-Drum, to propose ways to restore the flighty Princess's gravity. U.C. Knoepflmacher notes that "given the 'materialist' and 'spiritualist' affiliations of the two madmen, their names may suggest the absurd misapplication of the

41 Coleridge, 365-66.
42 MacDonald, *Adela Cathcart*, 13.
43 MacDonald, 52.
44 MacDonald, 13.
45 MacDonald, 45.

philosophical positions held, respectively, by Hume and Kant."[46] The solutions proposed by the two metaphysicians take only the mind (for Kopy-Keck) or the body (for Hum-Drum) into consideration, disregarding the heart altogether. The Light Princess, however, can only be healed by crying – something that would require a change of the heart. Once such a change has taken place in her heart, she cries, and a proper sense of gravity returns to both mind and body.

The suffering faced by both the Mariner and Adela are paramount to their return to God and the healing of perception, by virtue of the contingent awakening of the self-conscious soul. MacDonald utilized the spiritual journey of the Mariner in several of his fiction works, including *There and Back* and *David Elginbrod*. In both situations, the characters specifically mention the specters Death and Life-in-Death and their significance to the Mariner's journey. In *There and Back*, Richard and Barbara, neither of whom are Christians when their conversation about "The Rime of the Ancient Mariner" takes place, have trouble discovering the meaning of the two phantoms. Richard, who only places faith in the material world, is said to be "too close to the awful phantom to know that this was her portrait,"[47] implying that he is in a state of living death himself. Life-in-Death, in MacDonald's view, is synonymous with living in sin and envisioning the self separately from God. Therefore, the Mariner's being won by Life-in-Death is not, in fact, a result of a dice game, but a reflection of the state of his soul. This notion is later reinforced when Barbara exclaims, "But things oughtn't to go by the casting of dice. Money may, for that does not signify, but not the souls and bodies of men. It should not be the way in a poem any more than in the open world."[48]

In *David Elginbrod*, the title character David reflects on the respective fates of the Mariner and his crew as well. In doing so, he notes "sae Death got them, an' a kin' o' leevin Death, as she was a 'twar, an' in some respects may be waur than the ither, got a grips o' him, puir old body (So Death got them, and a kind of living Death, as she was, in some respects may be worse than the other, got hold of him, poor old person.)."[49] Here David finds that a living death may still be worse than death itself. A physical death may provide an end to

46 U.C. Knoepflmacher, introduction to *George MacDonald: The Collected Fairy Tales* (New York: Penguin, 1999), 344.
47 George MacDonald, *There and Back* (Whitehorn: Johannesen, 1995), 125-26.
48 MacDonald, 128.
49 George MacDonald, *David Elginbrod* (Whitehorn: Johannesen, 1995), 22.

suffering, but Living Death is a type of living hell, in which suffering is perpetual. It characterizes an absence of God in his perception of the world. However, as Barbara in *There and Back* observes, being won by Life-in-Death holds the possibility of eventual redemption. This would require a transition from one type of life in death to another; a living death towards life obtained through death.

When the Mariner awakes from his trance, it rains, a baptism of sorts, a sign of renewal. This change in the natural environment reflects the change that has taken place in the Mariner's heart. Upon awakening, the Mariner says that he "thought that [he] had died in sleep, / And was a blessed ghost."[50] The feeling of death and rebirth experienced by the Mariner signifies the spiritual rebirth that has taken place, taking the Mariner out of living in death and bringing him to a life through death.

Water in "The Light Princess" plays a particularly interesting role as well. The curse placed upon the Princess by her evil aunt is enacted through holy water at the infant Princess's christening. After John Smith has read this part of his tale aloud, the curate, Ralph Armstrong, remarks that "no such charm could have any effect where holy water was employed as the medium."[51] At this exclamation, Smith concedes that the curate must be correct in his observation, drawing the reader's attention to the specific use of water throughout the tale. It begs the reader to ask whether the curate might be correct, and if he is, why the charm does in fact bear effect on the Princess. It must be concluded that the power of the holy water is manifested in some other way. And it is; water itself becomes the sole means of restoration for the Princess. The holy water did not prevent the curse, but rather provided its cure. As the Princess grows older, she finds that "the moment she got into [the water], she recovered the natural right of which she had been so wickedly deprived – namely, her gravity."[52] The water restores her to her natural state – she is most like her true self in the water, so much so that she begins to associate the lake with her own soul. This is why the Princess must cry in order to break the curse. Crying is the internalization of water – a sort of baptism of the spirit. It is grief that makes such an internalization possible through the sacrifice of the Prince, who drowns (or seems to) in the water. Ralph Armstrong's sermon on Christmas morning conveys the same idea. In the sermon,

50 Coleridge, "Rime," lines 307-8.
51 MacDonald, *Adela Cathcart*, 61.
52 MacDonald, *Adela*, 75.

the curate states that "all man's winters are His."[53] Like the holy water in "The Light Princess" the difficult times in life belong to God, and it is God that will be the agent of healing and restoration in those difficult times.

The process of the storytelling itself is a vital aspect of both works. The act of telling the story, for the Mariner, is an opportunity to confess his guilt. The Mariner explains to the wedding guest:

> [T]his frame of mine was wrenched
> With woeful agony,
> Which forced me to begin my tale;
> And then it set me free.[54]

The Mariner is absolved through the telling of his tale, and it brings him spiritual and emotional freedom. Once the agony comes upon the Mariner, "This heart within [him] burns"[55] until his "ghastly tale is told."[56] The word "burns" is a return to the infernal imagery seen in Part II of the poem. The forced remembrance of things past and his sin not only provides a need for redemption through storytelling but prevents the levity that may occur through forgetfulness.

It is the Mariner's "glittering eye" that seems to keep the wedding guest entranced during the tale. In fact, throughout the poem, eyes become a symbol of empathy. After the crew dies, the Mariner remembers that "the look with which he looked on [him] / Had never passed away."[57] Although the crew is dead, their condemnation of the Mariner lives on in their eyes. In seeing the disapprobation in the eyes of the crew the Mariner begins to empathize with the dead men, generating a nascent state of unity despite the pain brought about by his empathy. It is a step towards the ultimate participation in the One eventually realized by the Mariner. The Mariner engages with the wedding guest through his eyes, which have a hypnotic effect on the wedding guest. The guest cries "that, which comes out of thine eye, doth make / My body and soul be still."[58] The Mariner is completely aware of the effect it will bear on him, stating, "Sadder and wiser thou wedding guest! / Thou'lt rise to morrow morn."[59]

The wedding guest is in need of the Mariner's tale; in need

53 MacDonald, 18.
54 Coleridge, "Rime," lines 578-81.
55 Coleridge, 585.
56 Coleridge, 584.
57 Coleridge, 255-56.
58 Coleridge, "Rime," 364-65; 1798 edition.
59 Coleridge, 368-69; 1798 edition.

because of his apparent levity at the beginning of the poem – "if thou'st got a laughsome tale, / Marinere! come with me."[60] The act of listening to the Mariner's yarn brings the wedding guest through the same process as the Mariner – the wedding guest progresses from a mental state of levity and disunity to one of fearful identification and a final one of empathy and unity. The wedding guest's reactions to the Mariner's tale prove his active involvement in the story. The tale pulls him away from the fleeting joy of an earthly wedding to the permanent joys of unity with the One found in the Kirk:

> O sweeter than the marriage-feast,
> 'Tis sweeter far to me,
> To walk together to the kirk
> With a goodly company![61]

The community emphasized in relation to the Kirk demonstrates a unity amongst humans in their relationship with God, thus intimating a Heavenly marriage between Christ and the Church. This Heavenly marriage presents a contrast with the earthly wedding feast that the wedding guest had wished to attend. Of course, the Mariner's new community involves much more than other humans, but all of creation.

In *Adela Cathcart*, empathy provided by Adela's friends is a key part of her healing process. They do not merely prescribe stories, they experience stories with her. Adela's friends take great care to ensure that their environment matches whatever story is being told, so that she can be fully involved in the imagination of the tale. Before he reads "The Cruel Painter," Harry insists that the story be told on a night with a full moon and asks the company, "May I arrange the scene as I please, for the right effect of my story?"[62] He then proceeds to place the members of the club in particular spots around the room and opens the curtains to reveal the full moon shining down on the snow. Harry's work pays off – "each window seemed to lie in a ghostly shimmer on the floor."[63] The external environment affects the character's perception of the tale and vice versa; the story and environment collectively produce the desired mood in the listener.

In his essay, "The Imagination: Its Function and Its Culture," MacDonald noted that:

> The fact that there is always more in a work of art – which

60 Coleridge, 11-12; 1798 edition.
61 Coleridge, 601-4.
62 MacDonald, *Adela Cathcart*, 379.
63 MacDonald, 379.

is the highest human result of the embodying imagination – than the producer himself perceived while he produced it, seems to us a strong reason for attributing to it a larger origin than the man alone – for saying at last, that the inspiration of the Almighty shaped its ends. [64]

This statement simultaneously acknowledges the active involvement of God in human subcreation (implying that truth is vital to the nature of art) and the multiplicity of interpretive possibilities held within any given work of human art. The conversation had by the members of the story-telling club and the variety of ways in which they respond to the stories being told demonstrate this idea. After John Smith finishes reading "The Light Princess," the members of the club discuss what the moral of the story may be, and each come up with a different answer, all of which may be correct in their own way. The varied number of interpretations highlights the individuality of the interpreter and, considering MacDonald's claim that "the imagination of man is the image of the imagination of God,"[65] implies a diversity of imaginative endowments inherent to the *Imago Dei*.

Adela's specific responses to each of the stories are also notable. Her reactions to the stories, after and during their telling, reveal her gradual healing and return to life. After the reading of "The Light Princess," Adela is an active participant in the discussion that accompanies the tale, contrasting her taciturnity earlier in the novel. When the schoolmaster points out a flaw in the logic of the tale, stating that the princess could not have rowed a boat without gravity, she readily responds "But she did. . . . I won't have my uncle found fault with. It is a very funny, and a very pretty story."[66] As the novel progresses, Adela grows more gregarious, contributing to conversation and even taking up reading (such as the works of Christian Neo-Platonist Henry More) related to the metaphysical explorations of the stories. With each new story told, her wintry heart melts a bit more, until she has come to see God and love in the world and in her soul. The stories help to heal Adela's perception of the world, melting her wintry heart and blooming into an emotional spring. The storytelling club has achieved its purpose.

MacDonald and Coleridge both use storytelling as a means of redemption and emotional healing. For both writers, stories are an effective means of healing – particularly the healing of perception –

64 MacDonald, "The Imagination," 25.
65 MacDonald, 3.
66 MacDonald, 103.

due to the inherent connection they believe the imagination to have to the mind of God and the soul of man. The stories told make spiritual sense of suffering and help the listener to come to clearer understanding of reality and their own place in the world. The stories also promote a sense of unity with God, nature, and others, as well as a unity of mind, body, and soul. In doing so, the stories create a realization of the need for unity in the listener, and a need for empathetic connection with others. Perhaps a quote from John Smith best demonstrates this point:

> How often we feel and act as if our mood were the atmosphere of the whole world! It may be a cold frost within us, when our friend is in the glow of a summer sunset: and we may call him unsympathetic and unfeeling. If we let him know the state of our world, we should see the rose-hues fade from his, and our friend put off his singing robes, and sit down with us in sackcloth and ashes, to share our temptation and grief. [67]

And, perhaps most importantly, active and empathetic storytelling leads the listener to seek not only a unified imagination but spiritual redemption. For both Coleridge and MacDonald, it is God and a return to divine unity that reorients the perception and initiates the ultimate healing.

67 MacDonald, *Adela*, 457-58.

Considering Joy:
Spiritual Centering and the Faithful Imagination

by D. Shane Combs

D. Shane Combs is a PhD student at Illinois State University. He teaches composition and life writing, and he is currently constructing a literary narrative course on Joy. His writing style blends traditional scholarly writing with life writing as a means of taking seriously both the theoretical and the experiential. His work has appeared in *Composition Forum, Writing on the Edge,* and *Assay: A Journal of Nonfiction Studies.*

THE S-WORD

If you were to have asked me in the spring of 2018, when I designed an English 125 course (Literary Narrative) around joy and the *Harry Potter* series, if what I was teaching was spiritual, I would have likely said "no." Perhaps partly because I have learned, after five years of teaching as a grad student, what it's like to step in the *s-word* in a secular space. People look at you sideways, sniff around, make funny faces, wonder about you.

Once, long before I shut off my Facebook account, I posted a comment about how I was considering teaching a unit on spirituality. Quickly, as if he'd been sitting at his desk all his life waiting for this very moment, the English 101 Coordinator, a fellow graduate student who wouldn't usually even say hi to me replied with, "In 101?" Meaning: "*Not* in 101." Meaning: "I don't think so." Meaning: "Just because I don't speak to you doesn't mean I'm not watching you."

I never taught that unit, and until I attended the 11th Lewis & Friends Colloquium at Taylor University, I would have imagined that I had put the concept of spirituality in pedagogy behind me. What I now realize, however, is that I had only put the *explicit saying of the s-word* behind me. Upon reflection, it seems I have been moving, rather rapidly, towards what Kristie S. Fleckenstein might call an integration of a spiritual centering in my classroom, one where students are understood as affective, spiritual beings, working towards "meaning [that] requires a participating, not an alienated, consciousness" (26). In Fleckenstein's concept of spiritual centering, as it was with my class on Joy, an affective emphasis requires giving legitimacy to "topics such as a writer's self-image, a student's personal history with

writing (including childhood and family experiences), and the writer's personal as well as rhetorical goals" (27). Beyond this, or alongside it, lies a duality and complexity always present in spiritual centering – the recognition that we are "creatures in whom spirit and flesh, chaos and order, feeling and rationality continually merge and re-form in a bewildering 'innerscape' of shifting boundaries" (32-33).

In this essay, I will explain why I chose to teach a class on Joy; and I will provide a variety of student responses from that class – some of which demonstrate the frustration students were having with education in general, some of which show the difficulty students had, especially early on, taking seriously a class on Joy and the *Harry Potter* series, and some that demonstrate what happens when student engagement meets content at a place of spiritual centering. Along the way, I will borrow from C.S. Lewis's *The Chronicles of Narnia* and *The Last Battle* as well as Devin Brown's *Bringing Narnia Home*, in order to demonstrate how effective pedagogy with a spiritual centering must convince students, at both an intellectual *and* affective level, that the course is worth the vulnerability and the commitment. In the final section of this article, I will suggest some ways of fostering a spiritual, pedagogical centering, as well as provide some final words to those who may wish to join me in the integrative work of doing academics from a spiritual center.

A PARADOX: STUDENTS ARE DISINTERESTED IN MODERN EDUCATION YET SKEPTICAL OF IMAGINATION

The realizations that follow are based on two sets of documents: a survey that students filled out on the first day of the Joy class and a written response document each student handed in with their final project at the end of the class. In the four-question survey, I asked, "Has Joy ever been an explicit conversation in your classes? If so, when and in what context?" Not one of the 27 students reported ever having a single explicit conversation about Joy in the classroom. A conservative calculation of the collective time spent by these students in school is *425 years*. That's 425 years of schooling without a single explicit narrative about Joy. How, then, I began to wonder, can students develop a sophisticated, educated framework for Joy? How can they develop a sophisticated framework for their passions, what they will pursue, what's worth pursuing? How will they develop a framework for a lifelong pursuit of the *Not-Yet-Ness* of Joy if we deprive them of any initial *Right-Here-Ness* of Joy?

Looking at this issue with the help of C. S. Lewis's Narnia Chronicles, consider the following: If Lucy, in *The Lion, the Witch, and the Wardrobe*, has to be considered a liar or an attention seeker because she claims to have been to Narnia, and the ones who *have to* see her like that, though she has never given evidence of being a liar, *have* to see her like that, even though they don't want to see her like that, the problem is not simply individual misperceptions. It is, at least to some degree, the structure. Or, rather, part of the problem is the *lack* of any existing structure for and about Narnia. Or Joy.

It is the same with the absence of Joy narratives. The students I encountered couldn't initially properly imagine a class on Joy, because they had not been given a single framework in the entirety of their lives for encountering and interpreting Joy. In fact, one of the students wrote of her embarrassment to her original answer to number 4 on the survey – "If you were to try to learn more about joy, where would you go to do so?" "I had absolutely no idea we were talking about the *feeling* [italics mine] of joy, so I put down the library because I thought joy might have been an author or book." You can't make this stuff up. Another student wrote that "Joy isn't something I've discussed with anyone in any area of my life in any context." The absence in this student's life of any framework for conceptualizing Joy only added to the urgency I felt to teach this material. This lack of awareness of Joy and its properties, as well as the lack of awareness of a need for it, is a twofold problem: students' lives are impoverished when they lack the necessary frameworks to even imagine a spiritual centering (and Joy as a component of that); also, students are ripe for indoctrination into cynical and reductive worldviews if they don't know that there are other ways of being in the academy and the world.

The second problem I faced was my students' initial inability to take seriously a course on Joy and the *Harry Potter* series. In my survey, I coded for what I call ESD (Early Semester Doubt). In fact, from 27 written responses, 17 students made statements that were obviously ESD. Among these were some of the following: "I was not excited to take this class"; "What kind of class am I in that we are going to focus on joy, and *Harry Potter* no less?"; "When I heard about [the content of the class] I thought it was some kind of mistake"; "It seemed like a bit of a joke to me"; "I honestly thought this was going to be the class I was going to drop"; "I laughed out loud a bit when I first saw . . . the required readings"; "My parents were a little bit confused when I told them that I was going to be reading the *Harry Potter* books as a requirement." Most of these same students later wrote about the class

being transformational.

While observing ESD, a second significant finding emerged. I began to see that many of these same students, so put off when they initially saw the readings and the subject matter, also wrote about how the educational system has failed to engage them for most of their lives. Students said things like: "School does not allow people to open up and be themselves. There is this standard that everyone seems to be living by in school but this class made us break that standard and I loved it"; "You changed what I think the potential of the classroom could be"; "I think this class should be given to students at least once in their schooling"; "It is the only gen ed class that has dealt with personal and real-life circumstances"; "Joy should be more heavily discussed in education because it is something that so many individuals lack because they do not truly know what Joy is." And my favorite: "I am not a huge fan of the educational system. I think it's too standardized Yet you created a little bubble that was our classroom, gave everyone their own voice, and let students be vulnerable and individual in a system that does not promote such activities."

In other words, students who were already disengaged and disinterested by the educational system, when first approaching a course outside of their disinterested expectations, had antecedent (educational) knowledge so ingrained that they rejected the learning material because of its difference, even though they did not support "business as usual" education. This demonstrates how difficult it is to combat the normalcy and expectations of the educational system, even when students experience that normalcy and those expectations as frustrating. In other words, although students are not impressed or engaged by *education as usual*, they still lend it credibility by seeing it as what they need in order to "get an education." This suggests teachers not only need to give students a space that is different, but we often first have to *convince them* of the worthiness of that space. It is my experience that students become convinced only when they are reached at both an intellectual and an affective, embodied place in their lives. Easier said than done.

THE ASLAN APPROACH:
ILLUMINATING LANGUAGE *AND* EXPERIENCE

The approach I am advocating takes a different approach to teaching – one including spiritual centering, modeled by vulnerability from the instructor in an attempt to reach the student at both an

intellectual and affective level. Let me put it in the form of a story about Aslan the Great Lion of Narnia.

Consider Peter, Susan, and Lucy, when dining with Mr. and Mrs. Beaver in *The Lion, the Witch, and the Wardrobe*. Consider their "introduction" to Aslan. When Mr. Beaver tells them that, "Aslan is on the move" (84), he is introducing them to a concept, a framework, every bit as much, if not more, than a lion. In fact, before it is even mentioned that Aslan *is* a lion, he will be called "King," "Lord," and the one who "will settle the White Queen" (85). So, it is necessary, in the story, to have both a space to talk about the name "Aslan," as well as an opportunity to talk about the worldview, the frameworks, the sophisticated life choices that can come through the narratives of Aslan. Further, learning *about* Aslan is not simply language-based and intellectual. It is affective and embodied. Susan is "nervous" about meeting Aslan. Peter is "longing" to see him, even if he is frightened (86).

In teaching Joy narratives, much like the Beavers teaching about Aslan, I found that when students got beyond the abnormality of the material, when they gave the ideas a chance, they were not finding the concepts easy. In fact, *easy* was not what these students were hungry for. Instead, they were hungry for potential educational applications that applied to their lives, their needs, and the hard work of figuring out of whom and how they might be. In the Joy class, we talked constantly about how you cannot separate talking about Joy from talking about death, sorrow, and suffering. In fact, many of the students discovered a Joy that provoked them to wrestle more directly with pain, with relationships, with risk, with the *Right-Here-Ness* of Joy, the absence of Joy, and the *Not-Yet-Ness* of Joy. In other words, when we, as a class, bought into the Joy narratives, we found ourselves answering the *Joy Question* much like Mr. Beaver answered the *Aslan Question*: "Is [Joy] safe? Who said anything about safe? 'Course it isn't safe. But it's good" (86).

VULNERABILITY AS THE MOVER TO TRANSFORMATION

Now that I've shared the general trajectory of the Joy class, it feels right to mention which specific activities and ideas led to student claims of transformation. Interestingly, many students reported an inverse relation between the parts of the course they most protested initially and the level of transformation they ultimately experienced.

Overwhelmingly, the part of the course that students found

most transformational was the unit which required that they use one of the Joy narratives to tell a compelling story to the rest of the class. Their story was to be about a personal/professional aspect of their lives that has been or needs to be transformed by the narratives we were wrestling with. Students seemed hesitant, if not petrified, to deliver such material to the class. Truth be told, towards the date when presentations would begin, I started to worry about their level of engagement (or lack thereof). For the introduction to this unit, I had written and delivered my own example, which was based on relational joy. In it, I talked openly about the fears I still have about some personal relationships in my life, based out of a negative script from my own childhood. This approach seemed to help, according to several students, including one who wrote, "First off, thank you for being vulnerable in front of a class full of college students, that takes courage and makes the difference in a class such as this one."

The students were most impressed, however, with the vulnerability among the class members. Their responses were overwhelmingly positive. "I thought you were kind of crazy when you introduced [unit 3]. I was nervous and did not know how I was supposed to get personal with a group of strangers. I feel like you knew we were going to feel this way, but you challenged us, and I appreciate that." "[The] presentations were so different than any presentation I've ever had to do, and I think that's what made them so special. Every single person had such a personal topic and no two were the same or even remotely similar." "I am definitely guilty of judging people before I get to know them, and I think the worst thing I do is assume that people haven't been through much in their [lives] and have it easy. I really don't like that I do that and this section of the semester . . . really opened my eyes to what other people go through."

On a similar note concerning vulnerability, students echoed how they engaged the course more deeply because class time was not just about note-taking but, rather, was about a continual, ongoing dialogue. One student put it this way: "The more one person opened up, the more someone else felt okay about speaking about their lives. . . . I felt this was especially important because we rarely ever walk into a college gen ed expecting to let the whole class know about some of the things that we have gone through. However, it happened in English 125, and I hope it continues to happen."

In this regard, the most significant aspects of the course, as reported by the students, were those aspect they were *least used to* in school, if not what they *most* feared. This includes continual

dialogue in every class, theoretical, practical, and personal, along with moments of deep vulnerability – a kind of vulnerability the students hadn't previously thought themselves capable of and that they had never imagined as a possibility in the classroom setting. In this way, there was a continual, reciprocal bearing witness in which students saw opportunities for learning more deeply when they witnessed their classmates being vulnerable, and, in return, the students who were witnesses became more vulnerable, with themselves and their classmates, as a way of paying back and engaging with what they witnessed.

ACTION OVER RHETORIC: FINDING CULMINATION IN THE ACT OF BEGINNING AND/OR ENDING

If vulnerability provided the possibility for transformation, this transformation, according to student testimony, was an opportunity for action, both beginnings and endings. It was only after teaching the course on Joy that I reread C.S. Lewis's *The Last Battle*. I noticed, in this book, that those who would do evil were almost always rhetoricians. Like the Ape, they were clever with their words, and they knew how to trot out a glimpse of hope that only *they* could provide, late at night and at enough of a distance that one never was quite sure what one was seeing. Too much of the academy has become the same. Those on Aslan's side, however, were action-oriented. They were convinced by frameworks they had *taken up* – spiritually, intellectually, affectively, and experientially. Somewhere in rereading that book, I coined a new phrase: Action over Rhetoric (AoR).

Though it was too late to introduce this term to the students, I went back and looked for this concept in their final responses. Like *spirituality*, which we never identified by a word, I found the concept of *AoR* in abundance, regardless of not mentioning the phrase explicitly during the semester. Students seemed to identify being moved to action as the ultimate marker of learning. This idea can be seen when students write statements such as the following: "This class really got me thinking and realizing that I'm in control of my own life and joy, and if I want to be joyful I need to take the steps toward living a more joyful life." "This class made me do things I would never do. It made me stand up in front of a group of people and talk about my personal problems." "I [now] know how others got through awful events and how they have found joy, so I know I will be able to do the same." "I will also try to pass on what I've learned about [joy] and try to

help people find the joy that they feel is missing in their lives." [Joy narratives] are not just something that I learned, but something I can apply to my life and better myself as an individual."

Another student demonstrated a sophistication with the Joy narratives, one that is a *Right-Here-Ness* of Joy that accepts its *Not-Yet-Ness* as well. The student writes that, "What I realized is I have a long way to go before I would consider myself joyful. I have not spent enough time on finding what makes [me] happy. I have been so concerned with trying to make others happy that I am neglecting myself." To this student and everyone else, I'd say, it's not your fault. This loss of a spiritually centered self is a product of our prevailing pedagogical structures. If, for example, some pedagogy in the 1960s-1980s was guilty of giving the individual a *Capital-T Truth* that excluded all social influence, too many pedagogies today are just as guilty of ideology that is so socially minded that it leaves no agency for/of the individual. Because of the extreme nature of this ideological shift, in the academy it is now, as in Narnia under the White Witch, always winter but never Christmas. We have stripped away the empowering of the individual. We have stripped away a spiritual and affective intrinsic interiority. We have located learning externally, all external and all a donkey covered in a lion mane of power. In the Joy class, however, I encountered students who wanted to be challenged where they are, so that they could take action to not remain in the same place. In regard to this striving, Devin Brown, in his book *Taking Narnia Home*, challenges us to live like it's always Christmas and never winter. Now, Brown's text doesn't say it will always *be* Christmas and never winter. (Indeed, even Narnia couldn't achieve the task of always Christmas and never winter.) What Brown's text does say is that we can live like it is. That is, rather than falling prey to cynicism that produces sorrow that confirms our cynicism, we can theorize and strive for a kind of "jollification" (45) that turns the miserable back to the joyful. As my students found, even if this understanding comes at the end of the semester, an ending, to those who have prepared both heart and mind, can be filled with new beginnings.

Examples of such endings and beginnings were frequent in final responses. Here I'll offer just a few of the examples. One student, who had struggled with social anxiety her whole life, reported that she entered into her first romantic relationship because of the class. Another student ended a five-year relationship because, after he learned to analyze our four Joy narratives, he realized they had rarely been present in his relationship. Several students reported that this

was the only class they talked about to their friends and family. One recommended the books to his friends. Another purchased the texts for a friend.

Thus students, when offered the opportunity, made their move toward action. The question now remains: how can *instructors* choose action over rhetoric? How might we theorize and act upon an opportunity to end the winter that has too-long reigned in too many academic spaces? I have a few suggestions.

In regard to spiritual centering: in a world where two extremes on any issue usually dominate every conversation, it is time for those more centered to become extreme about the unextreme. In other words, people who seek a centering, though seldom the loudest voices, actually seek a place where *most* humans want to be. If others can enforce their ideologies as if anything outside of their opinion should be heresy, those of a spiritual centering need to become *as* adamant about things that should be self-evident. This is me, now, being adamant:

1. It is not our job to indoctrinate our students to our belief system.

2. There should be a multitude of ideas in play that include a multitude of student-lived experiences.

3. There should not be a one-size-fits-all approach to educating no matter which approach is in fashion at this moment.

4. Despite educational practices that too often look like an ideological banking system, true learning involves contradiction, nuance, and paradox, rather than a mimicking of the instructor's worldview.

5. Our students are not simply lazy or privileged or non-caring because they have not let an instructor they've known for two weeks change every worldview they've held for two decades.

6. There is abundant evidence that indoctrination turns off more students than it turns on. Perhaps our first and most important move in teaching should be helping students find their own voice to explain and explore their lives.

These are the moves, I believe, that would allow the *Not-Yet-Ness* of Joy to have its moment in the *Right-Here-Ness*, because it's what we do right here, in every graceful incarnation of right here, that will determine whether we, as teachers/learners, are heading for more winter, or whether we might just see Christmas after all.

WORKS CITED

Brown, Devin. *Bringing Narnia Home: Lessons from the Other Side of the Wardrobe*. Abingdon Press, 2015.

Byars, Kathleen. "The Joy of Risk: What Cave Diving Taught Me." Kathleen Byars, 23 Oct 2016, https://kathleenbyars.com/the-joy-of-risk/. Accessed 4 Aug 2018.

Fleckenstein, Kristie S. "Creating a Center That Holds: Spirituality Through an Exploratory Pedagogy." *The Spiritual Side of Writing: Releasing the Learner's Whole Potential*, edited by Regina Paxton Foehr and Susan A. Schiller, Boynton/Cook Publishers, 1997, pp. 25-33.

Lewis, C. S. *The Last Battle*. HarperTrophy, 2010.

---. *The Lion, the Witch, and the Wardro*be. HarperTrophy, 2010.

Art, the Golden Rule, and
Lewis's *An Experiment in Criticism*

by Jim S. Spiegel

Jim Spiegel earned a BS in Biology and graduate degrees in philosophy at the University of Southern Mississippi (MA) and Michigan State (PhD). At Taylor University, he teaches ethics, history of philosophy, aesthetics, and philosophy of religion. He also coaches the highly successful Taylor Ethics Bowl team. He has authored numerous books and articles on issues in ethics, aesthetics, philosophy of religion, and popular culture, including the award-winning *How to Be Good in a World Gone Bad*. Jim lives in Upland, Indiana, with his wife and fellow author, Amy, and their four children.

Towards the end of *An Experiment in Criticism*, C.S. Lewis comments on a basic human impulse which perhaps helps explain our fascination with literature:

> We seek an enlargement of our beings. We want to be more than ourselves. Each of us by nature sees the whole world from one point of view with a perspective and selectiveness peculiar to himself. And even when we build disinterested fantasies, they are saturated with, and limited by, our own psychology. To acquiesce in this particularity on the sensuous level – in other words, not to discount perspective – would be lunacy. We should then believe that the railway line really grew narrower as it receded into the distance. But we want to escape the illusions of perspective on higher levels too. We want to see with other eyes, to imagine with other imaginations, to feel with other hearts, as well as with our own.[1]

Lewis's immediate concerns in this passage are mainly psychological and aesthetic, but this theme of self-transcendence through imagination has significant moral implications. Elsewhere in the closing pages of the book, Lewis gestures in a moral direction, but applications of this theme to the moral life are left largely unexplored. In what follows, I will pursue one such connection, specifically as related to the central Christian moral guideline – the Golden Rule. After laying some conceptual groundwork regarding the meaning

1 C.S. Lewis, *An Experiment in Criticism* (Cambridge: Cambridge University Press, 1967), 137.

and scope of the Golden Rule as a practical moral principle, I will revisit the main implication of Lewis's observations, especially as this regards the value of art for the moral life.

THE MEANING OF THE GOLDEN RULE

The biblical injunction to "do to others what you would have them do to you" (Mt. 7:12; see also Luke 6:31), popularly known as the "Golden Rule," originated in the Old Testament Levitical law (Lev. 19:18) and was emphasized by Jesus in the gospel narratives. Versions of this principle appear in most major religions, including Hinduism, Confucianism, Buddhism, Sikhism, Taoism, Jainism, and Islam.[2] That the Golden Rule deserves primacy of place in a Christian ethic is clear from Jesus's declaration that it "sums up the law and the prophets."

So, what does it mean to "do to others what you would have them do to you"? Consider this concrete situation. Al asks his co-worker Bob to cover for him at the office so that he can take care of a family crisis at home. Al's teenage son has been misbehaving, and his infant girl is sick, needing constant attention. Bob, however, is busy making final preparations for a conference presentation that he must deliver in Chicago next week and is concerned that he will not be adequately prepared if he doesn't use the afternoon to work on the presentation. What should Bob do? As a morally circumspect person, Bob decides to apply the Golden Rule to the situation. He asks himself, "How would I want to be treated if I were in Al's shoes?" Surely, he would want to be shown sensitivity and sympathy. He would also want his request to be granted or at least seriously considered. Ultimately, Bob offers a sympathetic ear and then consents to covering for his friend.

The first thing to notice about the Golden Rule is that it appeals to the concept of reciprocity. One's treatment *of* others ought to be guided by how one would prefer to be treated *by* others. When considering how to behave toward someone, one should consider what it would be like to be on the receiving end of that behavior. This suggests that a basic precondition for application of the Golden Rule is *knowledge*. One cannot treat others as one would be treated if one does not *know* how others would prefer to *be* treated. In our example, Bob must know the basic facts of Al's situation and something of his perspective. This might seem to be trivial or a matter of simple reflection, until one considers how one's own actual desires or

2 For a good discussion of the Golden Rule in world religions, see H. T. D. Rost, *The Golden Rule: A Universal Ethic* (Oxford: George Ronald, 1986).

preferences would be changed by one's being placed in the other's situation. This demands understanding what one's preferences *would be* within a certain specified context, a context that includes a range of specific circumstances, such as emotional states, cognitive states, personal relationships, physical conditions, economic factors, and so on.

The Golden Rule does not demand omniscience on these matters, of course, but it does require a basic understanding of such conditions, if only at the level of common sense. Awareness of the basic circumstantial facts is not enough. As we saw, Bob must somehow imagine what it is like to *be* Al and not just in a general sense but what it is like to be Al *in his particular circumstance*. In these cases, application of the Golden Rule proves especially challenging. But it is worth noting that this is the challenge of moral commitment in a general sense. As R. M. Hare notes, in any moral situation, involving persons A and B, person B:

> Must be prepared to give weight to *A*'s inclinations and interests as if they were his own. This is what turns selfish prudential reasoning into moral reasoning. It is much easier, psychologically, for *B* to do this if he is actually placed in a situation like *A*'s *vis-à-vis* somebody else; but this is not necessary, provided that he has sufficient imagination to envisage what it is like to be *A*.[3]

If Hare is correct, then this explains why versions of the Golden Rule are found in most world religions. All religions are fundamentally concerned with moral living, and the imaginative leap into the subjective viewpoint of others, as advocated in the Golden Rule, is foundational to any moral assessment. This means that much of my discussion can be extended not only to most religions but to all objectivist moral theories. Whether one aims to apply Kant's categorical imperative, Mill's principle of utility, a Rawlsian principle of justice, or any other moral principle, consideration of other points of view is essential.

What demands the work of imagination when applying the Golden Rule is the fact that it is presented as a counterfactual: "Do to others as you *would* have them do to you." Otherwise put, "Treat others in ways that you would want to be treated if you were they." Of course, when I consider this principle, I realize that presently I *am not*, nor presumably will I ever *be* other people. So, when applying this

3 R. M. Hare, *Freedom and Reason* (Oxford: Oxford University Press, 1963), 94.

principle, I necessarily entertain a scenario that is contrary to actual fact. But how does one go about considering such a thing? Obviously, as Hare suggests, the key is imagination. The only way I can apply the Golden Rule is if I have, in his words, "sufficient imagination to envisage what it is like to be" someone else.

There are some important qualifiers to the Golden Rule that deserve notice. First, the principle assumes the basic psychological health of the person applying it. In the hands of a sadomasochist the Golden Rule may be used to justify all sorts of abhorrent behavior. Such a person takes pleasure in being hurt and treated cruelly, so this principle would seem to counsel cruel behavior. But it is safe to assume that Jesus and other advocates of the Golden Rule would not condone cruelty, much less its justification via moral principle. Presumably, they would view sadomasochism as a psychological disorder. The peculiar applications of a person so disposed do not impugn the Golden Rule. This is but an instance of a general point regarding moral principles: abuses and misapplications do not undermine their reasonableness.

The need for another important qualifier becomes apparent when we consider an objection raised by nineteenth-century utilitarian philosopher Henry Sidgwick. Regarding Jesus's formulation of the Golden Rule, Sidgwick says:

> This formula is obviously unprecise in statement; for one might wish for another's co-operation in sin and be willing to reciprocate it. Nor is it even true to say that we ought to do to others only what we think is right for them to do to us, for no one will deny that there may be differences in the circumstances – and even in the natures – of two individuals, A and B, in the way in which it is right for B to treat A.[4]

The objection here has to do with the problem of relativity, specifically regarding moral predispositions among people. What are we to say of a situation in which a person wielding the Golden Rule is quite willing to act immorally, as many people in fact are? If I would like you to sin with me in some way, then by the Golden Rule, I should invite you to do so. After all, that is how I would prefer you to behave toward me. But surely we cannot sanction a moral principle that would advocate sinning and tempting others to do the same.

This problem suggests that the Golden Rule is not by itself an adequate moral guideline. That is, while it is a serviceable guide for testing our moral convictions, this principle is not the sole criterion

4 Henry Sidgwick, *Methods of Ethics* (Indianapolis: Hackett Press, 1981), 380.

for good conduct. Thus, Sidgwick concludes:

> Such a principle manifestly does not give complete guidance –
> indeed its effect, strictly speaking, is merely to throw a definite
> *onus propandi* on the man who applies to another a treatment of
> which he would complain if applied to himself; but Common
> Sense has amply recognized the practical importance of the
> maxim: and its truth, so far as it goes, appears to me self-
> evident.[5]

So then, what really is the use of the Golden Rule? In what sense
can Sidgwick maintain that it is of "practical importance" if it "does
not give complete guidance"? The answer lies in a simple distinction,
namely that between necessary and sufficient conditions for proper
moral guidance. The Golden Rule is not a sufficient condition, but
its observance is a *necessary* condition for discovering how to behave
morally. So its practical importance, to use Sidgwick's phrase, lies not
in its autonomy as a moral principle but in its usefulness for testing the
consistency of our moral convictions and actions. Harry Gensler puts
this point as follows:

> Properly interpreted, the golden rule [GR] doesn't say what
> specific act to do. Instead, it forbids inconsistent action-desire
> combinations. Thus GR doesn't compete with principles like
> "It's wrong to steal" or "One ought to do whatever maximizes
> enjoyment." GR operates at a different level. The golden rule
> captures the *spirit* behind morality. It helps us to see the
> point behind moral rules. It engages our reasoning, instead
> of imposing an answer. It counteracts self-centeredness. And
> it concretely applies ideals like fairness and concern. So GR
> makes a good one-sentence summary of what morality is
> about.[6]

Here someone might ask, "If the Golden Rule is not sufficient for
discovering proper conduct in all situations, then what is?" In response
I would say that this question is misguided if it aims to uncover a
single norm or criterion for moral living. But this is not to say that
there are not several principles or guidelines that are individually
necessary and *jointly* sufficient for living morally. When the Apostle
Peter says that God "has given us everything we need for life and
godliness" perhaps he has something like this in mind (2 Peter 1:3).[7]

5 Sidgwick, 380.

6 Harry Gensler, *Ethics: A Contemporary Introduction* (London: Routledge,
1998), 113.

7 *The New International Version of The Holy Bible* (Grand Rapids, Mich.:
Zondervan, 1973).

And, along these lines, we may find what we need in Scripture and careful interpretations of its essential moral teachings, as guided by philosophical reflection and Church tradition.

THREE PERSPECTIVES ON ART AND ETHICS

Having clarified the important but limited role of the Golden Rule in providing moral guidance, let us turn to the primary concern of this discussion. I noted earlier how proper application of the Golden Rule demands counter-factual analysis and the capacity to imagine what it is like to be in diverse life circumstances. Such skills are not typically regarded as essential to the moral life, but our analysis so far indicates that they are. Other things being equal, a good imagination gives a person a moral edge. But if this is so, then a question naturally arises: What does this imply regarding that domain of human activity most directly related to imaginative development, namely the arts? Could it be that aesthetic experience is not just relevant but vital to moral development? This is my contention, but it will take some work to elucidate this claim.

The first matter we must address – if only schematically – is the relationship between ethics and art. There are three basic perspectives on this issue. One of these is known as *aestheticism*, the view that art and the artist are insusceptible to moral judgment. According to this view, art and ethics never conflict because the creative artist is above moral prescriptions. Oscar Wilde declared that "there is no such thing as a moral or an immoral book. Books are well written or badly written. That is all."[8] And Benedetto Croce represents this perspective when he says, "The artist is always morally blameless and philosophically irreproachable, even though his art may have for subject matter a low morality and philosophy: insofar he is an artist, he does not act and does not reason, but composes poetry, paints, sings, and in short, expresses himself."[9] Another proponent of aestheticism, John Dewey, affirms that art is indifferent to ideas of praise and blame. Dewey notes that "this indifference to praise and blame because of preoccupation with imaginative experience constitutes the heart of the moral potency of art. From it proceeds the liberating and uniting power of art."[10] Thus, Dewey goes even further than Croce, suggesting

8 Oscar Wilde, Preface to *The Picture of Dorian Gray*, in the *Portable Oscar Wilde*, ed. R. Aldington (New York: Viking Press, 1946), 138.

9 Benedetto Croce, *Nuovi Saggi di Estetica*, 3rd ed. (Bari: G. Laterza & Figli, 1948).

10 John Dewey, *Art as Experience* (New York: Minton, Balch and Co., 1934), 349.

that morality is actually subject to art.

Those who affirm the view known as *moralism* take precisely the opposite stance, maintaining that art is wholly subservient to ethics. A well-known spokesman for this perspective is Leo Tolstoy, who penned his aesthetic treatise *What is Art?* many years after his conversion to Christianity. Tolstoy writes, "the estimation of the value of art . . . depends on men's perception of the meaning of life, depends on what they consider to be the good and the evil of life. And what is good and what is evil is defined by what are termed religious."[11] Arguing for a causal connection between religion and art, Tolstoy continues,

> if a religious perception exists among us, then our art should be
> appraised on the basis of that religious perception; and, as has
> always and everywhere been the case, art transmitting feelings
> flowing from the religious perception of our time should be
> chosen from all the indifferent art, should be acknowledged,
> highly esteemed, and encouraged, while art running counter
> to that perception should be condemned and despised, and all
> the remaining indifferent art should neither be distinguished
> nor encouraged.[12]

Thus, for Tolstoy, moral-spiritual value is the sole criterion for assessing art. The only relevant judgments of art are ethical in nature. As narrow and counter-intuitive as this perspective is, he was prepared to follow it to its absurd conclusions. While affirming many classics for their religious content, including Hugo's *Les Miserables*, Dickens's *A Tale of Two Cities*, Eliot's *Adam Bede*, and Dostoevsky's novels, Tolstoy rejected Dickens's *David Copperfield* and *The Pickwick Papers*, Moliere's comedies, and Cervantes's *Don Quixote*. He also rejected most chamber music and opera of his time, including Beethoven, Schumman, Liszt, and Wagner. Tolstoy's judgment was not that these are immoral works of art but that, because of their failure to endorse society's moral-spiritual values, *they are not truly art.*

The third perspective on the relationship between art and ethics, known as *ethicism*, falls between the aestheticist and moralist extremes. According to this view, advocated by Berys Gaut,[13] Mary Devereaux,[14]

11 Leo Tolstoy, *What is Art?* trans. Almyer Maude (Indianapolis: Bobbs-Merrill, 1960), 54.

12 Tolstoy, 145.

13 See Gaut's "The Ethical Criticism of Art" in *Aesthetics and Ethics: Essays at the Intersection*, ed. Jerrold Levinson (Cambridge: Cambridge University Press, 1998).

14 See Devereaux's "Beauty and Evil: The Case of Leni Riefenstahl" in *Aesthetics and Ethics: Essays at the Intersection*, ed. Jerrold Levinson (Cambridge: Cambridge University Press, 1998).

and Anne Eaton,[15] moral attributes of an artwork are relevant to but not wholly determinative of its aesthetic merit. Negative moral qualities may detract from a work's aesthetic quality, and positive moral qualities may enhance its aesthetic quality. But, at least for Gaut, positive moral qualities are neither necessary nor sufficient conditions for aesthetic excellence. A Monet painting of a hay bale may be aesthetically excellent though it is morally neutral. And a Cecil B. DeMille film may be aesthetically poor despite its morally admirable message. But the positive moral qualities of the latter do add to its aesthetic merit, just as the moral lessons in Shakespeare's *King Lear* or an episode of *The Andy Griffith Show* add to the overall aesthetic quality of these works. Similarly, on the negative side, poor moral qualities are neither necessary nor sufficient conditions for an overall negative aesthetic judgment of an artwork.

Unlike aestheticism, then, ethicism maintains that moral values are among the many considerations that should be considered when doing aesthetic evaluations – along with the usual non-moral considerations such as expressiveness, unity, originality, elegance, poignancy, and so on. The reason that works of art may be treated similarly to moral agents in this way is that they have the potential to impact moral agents for good or ill. Anne Eaton suggests, for example, that Titian's painting *Rape of Europa* could have "a morally corrupting effect by encouraging its audience to have erotic feelings toward rape, even inciting some to go so far as to commit acts of non-consensual sexual violence."[16] And Mary Devereaux notes how the Leni Riefenstahl documentary *Triumph of the Will*, a work of Nazi propaganda, is "morally repugnant" because "it presents as beautiful a vision of Hitler and the New Germany" and thereby inspires sympathy with the anti-semitism of the Nazis.[17]

I agree with these basic intuitions regarding the interface of art and ethics. Ethicism is a balanced position that recognizes both some autonomy and some interaction and mutual accountability between the moral and aesthetic spheres. Art and aesthetic experience are not morally indifferent, but neither are all judgments about art reducible to moral assessments. Rather, art may be evaluated both morally and aesthetically, and our moral judgments about art objects should inform our overall aesthetic judgments about them. Of course, there are no

15 See Eaton's "Painting and Ethics" in *Aesthetics: A Reader in Philosophy of the Arts*, eds. David Goldblatt and Lee B. Brown (Upper Saddle River, New Jersey: Prentice Hall, 2005).
16 Eaton, 64.
17 Devereaux, 227.

hard and fast principles for making such assessments; rather, there is a complex interplay of moral and aesthetic qualities in works of art.

MORAL IMAGINATION AND THE GOLDEN RULE

Assuming, then, that art and ethics are interactive domains, I want to discuss an oft-neglected dimension of this relationship within religious circles, namely the moral benefits of art and aesthetic experience. Monroe Beardsley has enumerated several public benefits of aesthetic experience, including the observations that aesthetic experience (1) relieves tensions and quiets destructive tendencies, (2) resolves lesser conflicts within the self and helps to create an integration or harmony, (3) refines perception and discrimination, (4) develops the imagination and along with it the ability to put oneself in the place of others, (5) is an aid to mental health, though more as a preventative than as a cure, (6) fosters mutual sympathy and understanding, and (7) offers an ideal for human life.[18]

Although I don't see this list as exhaustive, I do think Beardsley is essentially correct. Moreover, each of the benefits he cites deserves close attention. I will focus, however, on just two of these, namely the development of the imagination and the fostering of sympathy and understanding, as these qualities are pivotal when it comes to moral reasoning and, in particular, when applying the Golden Rule.

First, what is imagination? The mental activity of imagining is notoriously underexplored in the history of Western philosophy. As Calvin Seerveld insightfully notes, philosophers are probably uneasy with this function of the human mind because attempts to reduce it to one or more other mental functions have been categorical failures.

> We would do well to identify "imagining" as a mode of human functioning that is irreducible and to distinguish imagining from other kinds of human functioning, such as sense perceiving or image constructing or conceptual functioning. The confusion of imagining with sensing and imaging or concept-forming has obscured the specific, bona fide and particular glory of imagining in normal human life.[19]

Seerveld goes on to define imagining as "the reality of make believe," which may take the form of pretending, fancying, guising, or any other form of *as if* mental play. The child imagines when she pretends to be a tiger or some other animal. And the actor imagines

18 Monroe Beardsley, *Aesthetics: Problems in the Philosophy of Criticism* (New York: Harcourt, Brace and World, 1958), 573-76.
19 Calvin Seerveld, "Imaginativity," *Faith and Philosophy* 4:1 (1987): 46.

when he assumes the mental guise of Tom Sawyer or some other character.

In our earlier discussion of the Golden Rule, we noted the critical function played by the imagination when applying this moral principle. In order to effectively do to others as I would have them do to me, it is not enough simply to know my own situation, precisely because no one else but me is actually in my present situation. What the Golden Rule requires of me is that I imagine what it is like to be someone else. I must "make believe" I am the other persons with whom I interact. The *as-if* mental function of which Seerveld speaks, then, is not restricted to the recreation of children and the vocation of artists. Rather, the work of imagination is also essential to the moral life generally. And crucial to this function is the sympathy and understanding we gain through imagining. The more effectively I can make believe that I am another person, the more genuinely will I be able to feel what they feel and "get" their point of view. And to share another's feelings and perspective, if only imaginatively, is to go a long way in achieving the shared subjectivity that is demanded by the Golden Rule. Art and aesthetic experiences enhance one's ability to imagine and, thus, put oneself in another's place. As Lewis puts it, such experiences enable us "to see with other eyes . . . to feel with other hearts, as well as with our own.[20]

A few examples will illustrate this. To read Dostoevsky's *Crime and Punishment* or Camus's *The Stranger* is to learn something of what it is like to be a nihilist. These authors take the reader inside the heads of Raskalnikov and Mersault, respectively, enabling one to think their thoughts with them, to internalize their own anguish, to share their tortured subjectivity. Like so much great literature, these works draw the reader into the act of make-believe effortlessly and transparently. Great film directors accomplish the same end, though with different means, using not just words but cinematography, lighting, casting, staging, costumes, and musical scores. In *On the Waterfront*, Elia Kazan, with the help of an historic acting performance by Marlon Brando, enables the viewer to participate in Terry Malloy's internal struggle over whether he should risk his life by testifying against a mafia-infested longshoreman's union or turn the other way and allow the mob to continue their brutality amongst his friends and loved ones. In the realm of poetry, Dylan Thomas's "Do Not Go Gentle Into that Good Night" helps the reader feel some of the agony of losing a loved one who is willingly succumbing to death. And in the

20 Lewis, 137.

world of popular music the Beatles' "Yesterday" enables the listener to participate in the feelings associated with unrequited romantic love.

Each of these artworks, in its own way, acquaints the reader, viewer, or listener with the inner life of a particular (if fictional) person in a particular situation. Each provides a unique portal into certain psychological states, enabling one to identify with the thoughts, motives, or feelings of a person in circumstances quite different from one's own. Such experiences – particularly when compelling because of the beauty of their representation – contribute to one's personal awareness. "Artificial" as such experiences are, they add to the repository of contact points from which one may introspectively draw when trying to understand the concerns of other people. C. S. Lewis notes the moral relevance of this aspect of aesthetic experience, specifically in regard to the literary arts:

> Good reading . . . though it is not essentially an affectional or moral or intellectual activity, has something in common with all three. In love we escape from our self into one other. In the moral sphere, every act of justice or charity involves putting ourselves in the other person's place and thus transcending our own competitive particularity. In coming to understand anything we are rejecting the facts as they are for us in favour of the facts as they are.[21]

The special contribution of art to the ethical life is that it can instill understanding and sympathy that cannot be gained in any other way short of having the actual experiences. Of course, each person's life experiences are strictly limited. The only way to experience some things (thankfully) is to do so vicariously, via imaginative participation in the actions of fictional characters and events. In this way, aesthetic experiences endow the moral imagination with a greater repertoire of understandings and sympathies. Again, to quote Lewis, "My own eyes are not enough for me, I will see through the eyes of others. Reality, even seen through the eyes of many, is not enough. I will see what others have invented. Even the eyes of all humanity are not enough." When reading great literature, says Lewis, "I become a thousand men and yet remain myself. Like the night sky in the Greek poem, I see with myriad eyes, but it is still I who see. Here, as in worship, in love, in moral action, and in knowing, I transcend myself; and am never more myself than when I do."[22]

Works of art, Lewis argues, endow us with additional eyes –

21 Lewis, 138.
22 Lewis, 140-41.

new perspectives, which provide us with a deeper and richer stock of considerations to draw upon when facing novel moral situations. That is to say, they build the moral imagination and give one a better sense of what it is like to be someone else, thus improving one's ability to apply the Golden Rule and, generally, to be moral. So when applying the Golden Rule and engaging in the counter-factual analysis that this involves, the aesthetically sensitive person will have more resources to draw upon to do this well. Through art she becomes more adept at seeing things from different points of view, so when called upon to see a real-life situation from another's viewpoint she will be better prepared to do so than she otherwise would be.[23]

But there is a second and equally important moral benefit for the person who has frequent aesthetic experiences. By regularly engaging in imaginative exercises through encounters with art, she will be generally more inclined to employ this "as if" mental function in other circumstances. Since the Golden Rule involves imaginative work, she will be more naturally geared to use this principle when facing a personal conflict or moral challenge. Considering what it is like to be someone else is likely to become a sort of "moral reflex" for the person whose imagination is regularly nourished through art. The aesthetically developed person may be benefited in two distinct ways by her regular involvement in the arts. She will be better at applying the Golden Rule and she will be more inclined to consult this principle, if only reflexively, in the first place. As we all know, to be skilled in a particular area is of little value if one is not adequately motivated to go ahead and use that skill. Aesthetic development both improves the skill of moral imagination and motivates a person to use it.

One final implication of this discussion deserves emphasis. If the Golden Rule really is essential to morality and if aesthetic development is crucial to enhancing one's ability to apply the Golden Rule, then the person who ignores the arts will necessarily be morally handicapped. By this I do not mean that such a person will be necessarily *immoral* or completely stunted from an ethical standpoint. Rather, I mean that her moral development will be compromised. By ignoring the arts, she will necessarily be less able to exercise her moral imagination and

23 It is possible that some art forms are more effective than others when it comes to building moral imagination. Narrative art works, such as novels, plays, films, poems, and certain kinds of songs, for example, might have a greater capacity than other genres for nurturing this capacity. But all artworks – including the less narrative-oriented forms, such as painting, sculpture, architecture, and instrumental music – engage the imagination to some degree, so there are likely to be concomitant moral benefits for audiences of such works as well.

thus will be less morally mature than she otherwise would be. Or, put positively, the person who regularly exercises her moral imagination through aesthetic experience enjoys a distinct advantage in moral development. So the morally serious person will routinely engage in the arts, thereby developing her aesthetic sensibility and, in turn, her moral imagination. This is why the arts and aesthetic experiences are vital for the moral life and the religious life in particular.

WORKS CITED

Beardsley, Monroe. *Aesthetics: Problems in the Philosophy of Criticism*. New York: Harcourt, Brace and World, 1958.

Croce, Benedetto. *Nuovi Saggi di Estetica*, 3rd ed. Bari: G. Laterza & Figli, 1948.

Devereaux, Mary. "Beauty and Evil: The Case of Leni Riefenstahl." In *Aesthetics and Ethics: Essays at the Intersection*, edited by Jerrold Levinson. Cambridge: Cambridge University Press, 1998.

Dewey, John. *Art as Experience*. New York: Minton, Balch and Co., 1934.

Eaton, Anne. "Painting and Ethics." In *Aesthetics: A Reader in Philosophy of the Arts*, edited by David Goldblatt and Lee B. Brown. Upper Saddle River, New Jersey: Prentice Hall, 2005.

Gaut, Berys. "The Ethical Criticism of Art." In *Aesthetics and Ethics: Essays at the Intersection*, edited by Jerrold Levinson. Cambridge: Cambridge University Press, 1998.

Gensler, Harry J. *Ethics: A Contemporary Introduction*. London: Routledge, 1998.

Hare, R. M. *Freedom and Reason*. Oxford: Oxford University Press, 1963.

Lewis, C. S. *An Experiment in Criticism*. Cambridge: Cambridge University Press, 1967.

Rost, H. T. D. *The Golden Rule: A Universal Ethic*. Oxford: George Ronald, 1986.

Seerveld, Calvin. "Imaginativity." *Faith and Philosophy* 4, no. 1 (1987): 43-58.

Sidgwick, Henry. *Methods of Ethics*. Indianapolis: Hackett Press, 1981.

Tolstoy, Leo. *What is Art?* Translated by Almyer Maude. Indianapolis: Bobbs-Merrill, 1960.

Wattles, Jeffrey. *The Golden Rule*. Oxford: Oxford University Press. 1996.

Wilde, Oscar. Preface to *The Picture of Dorian Gray, in the Portable Oscar Wilde*, edited by R. Aldington. New York: Viking Press, 1946.

Keynote Panel
The Fantastic Imagination: Keynote Conversation

Crystal Downing, Crystal Hurd, Stephen Prickett,
Charlie Starr, and Joe Ricke
(transcribed and edited by Joe Ricke and Ashley Chu)

Joe Ricke: Good afternoon everyone. Thanks for coming. Let me introduce you to our panel: Joe Christopher, Crystal Downing, Stephen Prickett, Crystal Hurd, and Charlie Starr. I will begin by asking them some questions, but we will also make sure to reserve some time for questions from the audience.

First, I want to ask everyone on the panel a very simple question: how did you first discover or come in contact with our circle of writers we call "Lewis and Friends." It doesn't have to be C. S. Lewis; it might just as well be George MacDonald or Dorothy L. Sayers. We will start with Joe Christopher.

Joe Christopher: I was in junior high school; I was in the garage of my home reading science-fiction. I read an Asimov novel, a Lewis novel *Out of the Silent Planet*, and a Heinlein novel. And I thought when I read *Out of the Silent Planet*, "Hmm, that's a curious old-fashioned piece of science fiction!" I came back to it later.

Crystal Downing: I was assigned *Mere Christianity* when I was a sophomore in college, but I discovered Dorothy Sayers because, after my husband got his PhD at UCLA, we came back to the college where we met, and I was quite disturbed that there was no course in women's literature at this college. I had gotten a job as a secretary in the alumni office and, after a year, they fired my boss and made me the alumni director. I was 23 years old and the director of public relations was 24, and I think they just knew that we would work hard for little pay. So she and I decided we needed to offer a course in women's literature. We were willing to offer it for the January term (and they knew we couldn't hurt literature too much in three weeks), and we offered to do it for free. And my friend said, "Well, we need to include Dorothy Sayers." And I said, "Who is that?" because I was teaching the Brontës and George Eliot. So, she gave me a copy of *Whose Body* and that's how my involvement with Sayers started.

Stephen Prickett: I think you all know the answer to this

⌘ 364 ⌘

already. Lewis was giving the first-year lectures in Cambridge, and I was told I had to go to his lectures. So I went to his lectures. Full stop. End of story. [Laughter]

Joe Ricke: No, I'm going to press you on that one a little bit. Stephen, if I may, you are the president of the George MacDonald Society, are you not?

Stephen Prickett: Yes, I am.

Joe Ricke: I'd like to ask you because I think we would be interested in that – how did that come about? How did you get interested in George MacDonald and start reading his work?

Stephen Prickett: My mother read me *The Princess and the Goblin* when I was, I think, four years old. I didn't do *The Princess and Curdie* at that stage, but I remember *The Princess and the Goblin* very distinctly. Of course, I didn't remember the name of George MacDonald and, years later, I read it again and thought, "Hello! I know this story!"

Joe Ricke: Thank you. Crystal?

Crystal Hurd: I had graduated in 2001 from the University of Tennessee and was, like many English majors, taught all the fun mental gymnastics one must perform as an English major. I was looking for something that had the same depth but with a spiritual dimension as well. I was working at a soul-crushing job but someone (I don't even remember who it was, I wish I could; I would send them a fruit basket) said, "Have you ever read *Mere Christianity?*" And I'm like, "No, is it a Christian writer?" Well, I read two chapters of *Mere Christianity* and I'm like, "I want to buy everything this guy's written." And then I looked at Wikipedia and saw how much stuff he'd published and I'm like, "Crap. I'm going to need a third kidney to sell." [laughter]

Charlie Starr: Freshman year of college, my first semester required course in apologetics had a list of several books required reading for book reports. I think there were five books and one of the books was *Mere Christianity,* and it just went from there.

Joe Ricke: Very good. I want to ask something that's a little more personal. I hope that – given the makeup of this community – we will find this important and interesting. In relation to your personal life, what would you say that you owe this writer? Again, it doesn't have to be C.S. Lewis. It might be MacDonald, Sayers, Barfield. That would be fine. I am asking this because I know that a lot of these authors play a big role in our lives. So from your perspective now, what would you say has been really meaningful, even formative? I know it's hard, of course, to identify only one thing. But that is what I'm asking you to do.

Charlie Starr: Well, I attended college at a conservative Bible college in the Dallas area, and I can remember being taught the very important things that Bible-believing Christians were supposed to believe. When asked the question, "Is the Bible literal or figurative," you must answer "literal." So when Jesus says, "I am the door," I'm supposed to look for a knob. I had been taught an approach to truth that was not a biblical approach to truth. It was an enlightenment model of truth defended by conservative Bible-believing Christians in order to defend the Bible. Later, working on my Master's degree, I turned to the literature of the arts with a wonderful teacher, Louise Cowan. I still remember her opening lecture; she claimed that we must talk about the imagination as a mode of knowing. And this idea that imagination had epistemological significance was brand new to me. No one had ever taught me that. I could not comprehend it at first, and when I came to comprehend it, I found that there was a Christian writer who understood this, and his name was C.S. Lewis. And at one point I became utterly and completely hooked and I know exactly when: it was when I read *Till We Have Faces* in 1994.

Crystal Hurd: Like a lot of you, perhaps, I grew up in a pretty conservative situation. But I think when I read Lewis, he gave me a permission to doubt. Eventually, I had a kind of dark night of the soul experience (as I think a lot of us have had). And reading Lewis consoled me that it's okay, it's permitted, and that sometimes it's required to deepen our faith. So, Lewis told me that you can have intellect, faith, and imagination. And he gave me permission to ask questions.

Stephen Prickett: My experience, I think, is fundamentally different to a great many people's experience here. I had never met

a biblical literalist before I went to college. I was brought up in a Christian household. My father was a Methodist minister. My mother's father was a Methodist minister. My great-grandfather was a Methodist minister. I went to a Christian school as well, but it was assumed that modern science and Christianity fitted together. So, although many people going to university had sharp challenges to their religious faith, I did not. After all, my professors were Lewis and Basil Willey, (for whom I also have a huge respect), and so Christianity was intellectually respectable right from the start.

Crystal Downing: I as well grew up as a funda-gelical and went to a funda-gelical college. When I went on to grad school, I encountered people who told me, "Well, Crystal, you're the first Christian I've ever met who is the least bit intelligent." Wow, what a compliment. And at a wine and cheese party after a lecture by a religion professor at the University of California where I attended, I said, "Well, I believe in God." I wasn't even proclaiming Christ is the Son of God. Just "I believe in God." I remember he swirled his Chardonnay and said, "My, aren't you an anachronism!" And this was the 1980s and . . .

Stephen Prickett: I will remember to use that as an insult! [laughter]

Crystal Downing: . . . and I went to hear a lecture by the famous Marxist critic Frederick Jameson who was denouncing postmodernism because postmodernism called into question the truth claims of the linear progress of communism. And I remember he said, "The trouble with postmodernism is, it's just like fundamentalist Christianity." And I thought, "What? Yes!" And I thought, "I have to do research on this!" And so I got into postmodern theory, sometimes called the religious turn in philosophy, which insists that all truth claims are predicated on faith. And it was a challenge to the modernist idea that the scientists produce facts or objective truth and the rest are just "pseudo-statements," as I.A. Richards put it (which is why C.S. Lewis didn't like I.A. Richards). So that got me into my first book on Dorothy Sayers. I was claiming that, because she was a Christian at the height of a modernist worldview which was dismissing Christianity, she anticipated postmodern discourse. Not despite the fact that she was a Christian but because she was a Christian.

Joe Christopher: I guess Lewis's *Mere Christianity*. I got through

my years at University of Oklahoma partially because I read *Mere Christianity* and it gave me a structure of belief. I didn't have to agree with it, but at least I had to argue with it if I didn't. And it was good. It was valuable to me.

Joe Ricke: Let's switch gears to talk about specific books by our authors. What is the one book that is "your book" that . . . I'm trying to avoid the word *favorite,* but I can't seem to come up with a better word. But please, just focus on one book. And I want to say in advance, if you say *Till We Have Faces,* I'm just going to go to the next person. Crystal Downing?

Crystal Downing: *Mere Christianity* was important when I was a sophomore in college, for the same reasons that Crystal Hurd gave. In terms of my favorite book among the seven authors, it has to be *Gaudy Night* by Dorothy L. Sayers, especially the way it depicts how a woman negotiates the relationship between career and marriage. It is a very well-written book and I'm going to mention it tonight in my keynote address.

Joe Ricke: Thanks. Joe Christopher?

Joe Christopher: *Till We Have Faces* [laughter]

Joe Ricke: OK. Charlie?

Charlie Starr: Well, since I can't say *Till We Have Faces* . . . [more laughter]

Joe Ricke: You cannot.

Charlie Starr: . . . I will instead say that I was privileged several years ago to be able to sit down with a manuscript in C.S. Lewis's own hand. Right here at Taylor University. That was the first time I had ever held a Lewis manuscript in my hand. That was a true bucket list moment. The manuscript was called "Light." Four little pages and one of the most powerful stories, one of the strangest, most unusual stories that I've ever seen. And to hold something in my hands that Lewis had held got me hooked on Lewis manuscript work. I love the *Light* story itself, but I love the fact that I got to transcribe the story, that I got to compare it to *The Man Born Blind* version of the story, that I

got to travel to Oxford, that I got to have tea with Walter Hooper and then tell him that I thought he was wrong about something. And since then I have continued to find joy in being able to work with Lewis manuscripts. And it's Taylor University and the Brown Collection that made that possible.

Joe Ricke: And some of you saw the *Light* manuscript yesterday down in the Lewis Center . . .

Charlie Starr Otherwise . . . *Till We Have Faces.* [laughter]

Joe Ricke: Three of the five have already told me *Till We Have Faces.* That's why I said they don't get to say it. Crystal Hurd?

Crystal Hurd: I said *Till We Have Faces.*

Joe Ricke: I know.

Crystal Hurd: Since I cave to peer pressure so easily. . . . Being in an MFA has taught me about fiction writing from the inside, which has been interesting. And now seeing and analyzing Lewis in a new light as a fiction writer, I'm going to cheat and say the entire Ransom trilogy, because all of them are brilliant. And I mean "the empyrean ocean of radiance" (that's in *Out of the Silent Planet)*; that is just the most gorgeous passage in the English language.

Joe Ricke: The heavens versus space? Beautiful.

Crystal Hurd: Yeah, as he's looking out of the window . . .

Joe Ricke: The heavens declare the glory . . .

Crystal Hurd: Yes.

Joe Ricke: Stephen, we have more MacDonald scholars and fans than ever before at the conference this year, but still many of the Lewis and Tolkien fans don't really know a lot about George MacDonald. So which George MacDonald work would you most strongly recommend? If you were to say, "here's the one," which one would it be? I always tell people "The Light Princess" because I think it's the greatest fairytale ever written. But what do you recommend?

Stephen Prickett: *Lilith,* undoubtedly. I think *Lilith* is the most mind-blowing book, and I throw it at students at the beginning of a course and they come in sort of looking like *that* afterwards, but obviously *Phantastes* as well. The way in which *Phantastes* and *Lilith* bracket MacDonald's life really – the one from the beginning and the other from the end. And I'm glad to say that Lewis seems to have agreed with me on this particular judgment. I am not a great fan of most of the realistic fiction; I agree with Lewis again on that. In the realistic novels, I think MacDonald was squeezed into a form that did not really suit his genius. And I would also recommend *The Princess and the Goblin* and *The Princess and Curdie. At the Back of the North Wind* is not everybody's taste, of course, but I think it's a very, very interesting book and I can bore people for hours about *The Back of the North Wind,* if they are sympathetic. But I will not do so now.

Joe Ricke: Another question: Tell us what you have read recently *not* written by one of "our" authors that has been meaningful to you and that you would like to recommend to the rest of us? Crystal Downing, why don't we start with you?

Crystal Downing: I'll say *The Shallows* by Nicholas Carr. The subtitle is *What the Internet is Doing to Our Brains.* I've had several conversations over meals about our fascination with the actual object of a book. How it appeals to the senses on multiple levels and how future generations are not going to be able to read letters. I realize now that if I were going to respond to, "What is my favorite Dorothy Sayers text?" I would say her collected letters. I think she is more theologically profound and witty in her letters than any one of her single other texts. But we're not going to have letters anymore. People send emails and tweets. There is a loss. Nicholas Carr was an English major. He loves the Internet, but he says he felt his brain was changing. So he collected the research that suggests there is neurological damage happening due to the Internet. It's a very accessible book, and I tell all my students to read it.

Joe Ricke: Did he find any of his information on the Internet? [laughter]

Joe Ricke: Charlie?

Charlie Starr: I've been reading Jane Austen, and that's been very nice, but . . .

Joe Ricke: Well, that's nice. Crystal Hurd? Oh, you have more to say Charlie? [laughter]

Charlie Starr: Let me name a book that I have read, now probably a decade ago, which is one hundred pages, and it seems incredibly simple. But, while I was reading it, I was shaking with excitement and a little bit of anger, because he had written the book that I intended to write. And it's a little book by John Eldredge called *Epic: The Story God is Telling.* And he tells us what the monomyth is, what the one story is, the story that God is telling. And he uses film illustrations to point out that we keep telling this story too, because we can't help ourselves. As Lewis said in *Perelandra,* there's a society of mind, a web of interconnected minds. And that's how the higher myth of God comes down even among the pagans – because of that influence. Well then Eldredge proves the point by using movies that show us what the great four acts of the story are.

Crystal Hurd: I've been reading a lot of southern lit lately, so Faulkner's *As I Lay Dying.* Also, I don't know if you guys are book awards snobs like I am, but I just read *Sing Unburied Sing* by Jasmine Ward. It won the National Book Award. It's not for the faint of heart, but it's some of the most beautiful writing, I think, to come out right now.

Joe Ricke: The rest of you have to Facebook friend Crystal because she posts a picture of every book she buys.

Crystal Hurd: HarperCollins cuts me a check. I'm kidding.

Joe Ricke: Good. New question. What's happening in our world in terms of Inkling studies? One thing I could say is the Marion E. Wade Center has new co-directors and that's exciting. Let's hear it for Crystal and David Downing [applause]. That's one wonderful thing that's happening in our world. But what else is happening? What do you see happening out there? What's exciting and what do the rest of us need to know about? Stephen, why don't we start with you?

Stephen Prickett: Yes, I've been going to Romania for about the past five or six years now, almost on a yearly basis, to talk mostly about C.S. Lewis. There is a huge enthusiasm for C.S. Lewis in Romania. Twenty-five of his books have already been translated into Romanian, and I had the privilege a couple of years ago of a long coach journey sitting next to the woman who had translated the Narnia stories, and she told me the most remarkable story. She was walking home (this was during the Ceaușescu years) on a winter's evening. And the snow was brown around her, and she saw this shining light ahead of her. And I thought she was going to say she had a sudden conversion or something, but no. It turned out to be the British Council reading room, which had its own generator and was not relying on the main electricity system. And she went in there – it was warm, it was light, it was welcoming – and right in front of her was *The Lion, the Witch, and the Wardrobe*. And she started reading it and she said, "This is about Romania! Here is the wicked witch Madame Ceaușescu ruling with the rod of iron. Here we are living without Christmas and constantly being spied on by the Secret Police." And she said she bought her copy, she took it home, and she started translating it that evening. More recently, I have just had an invitation to go in November of this year to the opening of their C.S. Lewis Study Center at the University of Iasi. And Paul Michelson (another Colloquium participant), who goes to Romania probably even more than I do, is also involved. So, if anyone wants details about this conference in Romania, you would be enormously welcome. The conferences are in English, and the Romanians know how to welcome you. They're delighted to have visitors, and it's a quite extraordinary experience.

Joe Ricke: Crystal Downing?

Crystal Downing: My last book came out with Routledge, it's called *Salvation from Cinema,* and it is my opportunity to get "past watchful dragons," because I am talking about how cinema presents religious issues. And now the book is being taught at secular universities, but ultimately I am using secular theorist Jacques Derrida especially to argue that most religion is predicated upon what Derrida calls an economy of exchange. "You do this, you get that. You do this sacrament, you get salvation. You say these words, you are saved. You sacrifice yourself, you get seventy-two virgins in heaven." And what Derrida, an acknowledged atheist, says, is that anything to distinguish itself from generic religion must be predicated upon a gift. So, I argue

in the book (without doing a Christian apologetic) and say, "Well, this is interesting because Christianity seems to be the only religion in which salvation is offered as a gift. Where it's not because of works (*Lest anyone should boast*)." And that is exciting me, and it explains the topic of my speech tonight.

Joe Ricke: That's awesome. Do you use Levinas at all? Because I think late-Derrida is influenced by Levinas and is a much more religious atheist than he was earlier.

Crystal Downing: A lot of other people have, but I haven't.

Joe Ricke: We're going to switch the discussion now because we want to open it to the audience. So let's have some questions for our panel, please?

Question: Where do you think Lewis scholars or Tolkien scholars or MacDonald scholars go wrong in trying to convince the world that these stories are important?

Crystal Downing: I can respond right away to that. I have a problem with a chronological snobbery that I see among Lewis scholars. It's ironic that Lewis was indicting chronological snobbery, and yet so many people are writing books on C.S. Lewis without reading what has already been written about him, as though "I'm coming up with this," without paying attention to the fact that other scholars have expressed the exact same thing, perhaps more articulately.

Joe Ricke: Good one. Somebody else? What are we doing wrong?

Charlie Starr: I'll mention something that Donald Williams has pointed out, and it's not that Lewis scholars have gone wrong, it's that they have been seriously hampered by the fact that they can't quote as extensively as they would like to due to restrictions from the Lewis Estate. And then we end up paraphrasing in bad prose what Lewis says in perfect prose.

Joe Ricke: And thus creating material for William O'Flaherty to put on his blog about bad quotations. Somebody else? What are we doing wrong?

Question: I think we're doing a lot of things right, but I am worried that no one is reading nowadays. They're not even reading Lewis. When they do, they seem to love it, but they don't read.

Charlie Starr: I'll start by saying that one solution to the problem is evident right here in this audience. It's that two years ago and, for every conference that Devin and I have visited together probably for the last five or six years, we've been lamenting the lack of youth at the conferences. And when I showed up here this year, I was overwhelmed at the number of young people in this conference. And I thank you all so much for being here and being so excited. That must mean that there are a lot of teachers in here who are doing something right. [applause]

Joe Ricke: One thing I'll say is this: a lot of young people are actually quite bookish, and they're looking for someone who wants to encourage them in their bookishness.

Crystal Hurd: I agree with you, Joe. I think there actually are a lot of bookish young people in our culture. As an educator, I've noticed this. I am Gen X, so I'm the indicted generation that has supposedly fallen away from organized religion, orthodox church, etc. But honestly, I think that we are starved for spirituality.

Stephen Prickett: Can I comment quickly there?

Joe Ricke: Please do.

Stephen Prickett: I keep hearing this complaint about people not reading, students not reading. That simply has not been my experience. When I went to Baylor University, they asked me in advance to give the book list for a course I was supposed to be teaching. And I sent it in and I got a note back from the head of the department saying, "You have put in four or five big Victorian novels. You can't expect modern students to read the big Victorian novels." I wrote back and said, "Tough. This is self-selection. Let them come or let them stay away." My course was oversubscribed. The students wanted it. The faculty were trying to calm down the students from reading too much.

Joe Ricke: I just wanted to say, one thing we're doing here in the Lewis Center at Taylor is gathering together, and reading, and

reading aloud, and people want that. And we've discovered that they actually don't need to watch movies all the time. They can sit in a room with each other and drink tea and read aloud or read together. Last year we "discovered" a rather obscure book by Sayers titled *Even the Parrot*. Nobody seems to know this book. It's very rare. It is the funniest, wryest, most wicked parody of a children's book that has ever been written. And it's by our heroine, Dorothy L. Sayers. Since then, we have had a couple of sessions in which all we did was just read it out loud and laugh until we hurt. Anybody else?

Crystal Downing: Part of the problem is the demise of the humanities on college campuses, at least in America, and a lot of the problem is parents. They are saying, "If I'm spending all this money to send you to college, I want you to have a major where you can make a lot of money after you graduate." And, so, what this is doing is turning education into a meal ticket for the future rather than the one chance these four short years where you can develop critical thinking. Where you can read things that you would never have an opportunity to read elsewhere. So, I don't want to indict the students as much, as I get students who tell me, "I want to be an English major. My parents will not let me."

Joe Ricke: One more question? Christine Murphy, a student from Azusa Pacific. What's your question, Christine?

Christine Murphy: What's your advice for a young person who's interested in getting into Inklings scholarship?

Charlie Starr: I'll go on this one. One: read as many of the books as you can. If you're going to be a scholar, read all of them. And, then, find the ones that haven't been published yet and read them. Two: go to all the "Gracelands" around the world involving your particular writer. Since you mentioned Lewis, you've got to get to the Wade Center, you've got to get to the Bodleian, you've got to come here to Taylor, and to UNC-Chapel Hill. So, go to the great places. Even more important: get involved in a community. Like showing up to this conference and as many of the conferences as you can. Build relationships with the scholars that are already out there, because they want to help you. They want to give you ideas for work that could be done. And they just might say: "Well you know, here's this manuscript over here that nobody's touched" or "Here's an idea that I had that I'm

never going to get to." Emailing back-and-forth with those people could be a big help toward your own scholarly pursuits. Working in a scholarly community, especially one that's really friendly like ours, even when we disagree, is something that a whole lot of English major types aren't going to find elsewhere.

Joe Ricke: Somebody else?

Crystal Downing: I would add that you should start submitting your work to conferences. If you have conference presentations on your CV that will help you get into grad school. Go after a Lily grant. Valparaiso University has these grants for any student who would be willing to teach at a Christian college. And you can get scholarships that will pay for your graduate experience. Yes, jobs are fewer and farther between, but it is a smaller pool at a Christian college, obviously, because most Christian colleges want Christian professors.

Joe Ricke: Anybody else?

Stephen Prickett: Yes, I wanted to say that, as the international member of this group, think worldwide. Don't necessarily think of the U.S. or Canada, most universities have scholarships for overseas students especially set aside. I've helped two students from Texas come to work with me at the University of Kent in England. I remember recommending to a student who came to me in Glasgow, who wanted to go and work on Australian literature. And I said, "I know exactly where I can get a scholarship for you. Australia." And she looked at me and said, "But I'd have to leave home." And I said, "Yes." She went away sad like the rich young man in the gospels, but I only want to reinforce what's being said. Come and talk to all of us. In fact, the way to do it is through personal contacts. Find people you like, find people you want to work with.

Crystal Hurd: I was going to add to that, because my first year here was 2012, and I was green, fresh out of grad school. And I studied Lewis and leadership. Everybody, including my initial advisor, told me it was a terrible idea. So I switched advisers and got another one. So, don't give up on your ideas. And I love this community, this colloquium, these people. I made lifelong friends in 2012 here, and I'm just continually thankful for their support and friendship.

Joe Ricke: One final question. Bob Trexler?

Bob Trexler: If you are an undergraduate, and have written something well, and it's original scholarship, you can submit it to *CSL: The Bulletin of the New York C.S. Lewis Society*. It's published six times a year, and we are having our 50th anniversary weekend conference in New York. So, if you're in the New York area, it's a comparably inexpensive conference – like the Taylor one. It would be a great opportunity to mingle with other scholars.

Joe Ricke: Alright. It's officially time for tea. Thanks to all of you for being here. Please join me in thanking our panel one more time. [Applause]

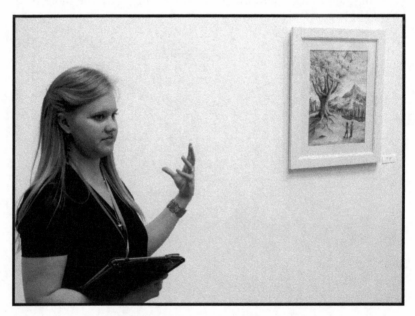

Emily Austin discusses her exhibit "Paintbrushes, Pubs, and Perelandra: Visualizing the Worlds of Lewis and Tolkien."

V. Creative Work
Inspired by C.S. Lewis & Friends

Mr Milton Tries to Read The Philosopher's Stone

by D.S. Martin

D.S. Martin's volumes of poetry include *Conspiracy of Light*
and *Poiema*. He has also edited the new anthology, *The Turning
Aside*, all available from Wipf & Stock. He is the Series Editor
for the *Poiema Poetry Series*. Visit his blog Kingdom Poets and
his website.

 For those who find the reading of footnotes
 leaves them at the gates of Milton's paradise lost
 & twice as alone imagine Milton tossed
 into a seventeenth-century annotated edition
 of *Harry Potter & the Philosopher's Stone*

Mr & Mrs Dursley of number four . . .
 Since the advent of a general postal system (for delivering
 epistles packages & rejected
 poems) homes have posted a numerical street address on or
 beside the front door

Privet Drive . . .
 In an odonym Drive is a synonym for Street Road or
 Avenue This particular
 designation arose with the increase of automobiles
 (motorized vehicles with a
 combustion engine which spins their wheels) which people
 are said to "drive"

were proud . . .
 Pride has gradually shifted in meaning through the
 centuries becoming a
 positive self image rather than one of the seven deadly sins

to . . .
 Here Milton reaches the end of line one
 & decides to read something simpler
 such as George Herbert or John Donne

"Mr. Milton Tries to Read *The Philosopher's Stone*" – plays with a comment (on page 62) in *A Preface to Paradise Lost* (Oxford University Press edition). "If Milton returned from the dead and did a week's reading in the literature of our own day, consider what a crop of questions he might bring you." The italicized words, when put all together, form the opening line of J.K. Rowling's novel *Harry Potter and the Philosopher's Stone*.

This poem is from D. S. Martin's poetry collection *Conspiracy of Light: Poems Inspired by the Legacy of C. S. Lewis* ©2013, Cascade Books.

The Sacred Fish

by D.S. Martin

You can't desire to catch the sacred fish
as much as he desires to be caught
& yet
he darts through the dim depths
with tail swerve & swish
laughs with the joy of glistening fins
at huge holes in your net
through which he swims

To get the shining coin from his mouth
is worth selling all you have
To get *him* even better
Everything you know about him
wavers in uneven light

Just below the surface
so it's barely wet
you let down your net
as he dives to the bottom
You seek the depths
as he leaps through waves
You search the shallows
as he heads for open water
& your tattered nets come up empty

If you let him
he'll repair them himself
trim knotted clumps & untie tangles
Selecting the right fibres
he'll tear & twist
the sinews of your heart into fine mesh
stretch them as thin as a pin
as wide as your whole being
a needle-shimmer piercing your soul

Better is one day in his boats
than thousands elsewhere

"**The Sacred Fish**" – are the last three words of chapter eleven "Scripture" in *Reflections on the Psalms* (page 100 in my Fontana paperback). Like several in this collection, this poem grows from extending Lewis's metaphor. This poem was first published in *Sojourners*.

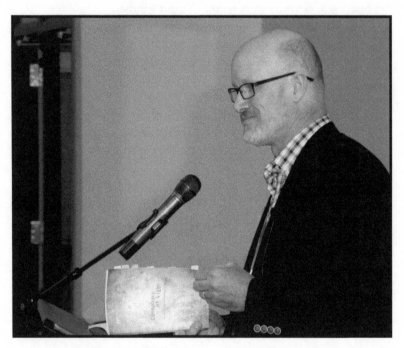

Poet D.S. Martin presents his plenary session
"A Poetic Look at C. S. Lewis."

C.S. Lewis, Poet

by Joe R. Christopher

A maker is what you were, a shaper of lines,
 Of stanzas, until the form the content girds;
With diction high or plain, as anodynes
 To shoddy thought, you chose your healthy words.

Success was yours in several different kinds:
 In narratives—as telling a queenly flight;
In metaphysical lyrics, intertwined
 In image and in passion's second-sight;

In serious light verses, ones that played
 With meter and with rhyme—these types and more:
Like the skilled Brisings who Freyja's necklace made,
 Brisingamen, of gold and amber—and lore.

First published in *The Lamp-Post* 29.1 (April 2007): 29.

The Taste of Deathtoll

by Bethany Russell

Bethany Russell's Midwestern childhood was characterized by a curiosity for the mysteries of the natural world and a fascination with the "plausible impossible" of speculative fiction. She now works at Tyndale House Publishers where she exploits her employee discount for *Adventures in Odyssey* CDs and Chuck Swindoll Study Bibles. She was an award winner in the Colloquium's creative writing competition in both 2016 and 2018. This story is affectionately dedicated to her brother, Joel.

Benedict had just consumed poison. Of this he was sure.

He lowered the cup from his lips. A drip trickled from the rim of his mouth, sliding down his chin and pausing midair for but a heartbeat.

Every soul seated at the royal table seemed absorbed into the suffocating silence. Every head was leaning in on him. From the glassy eyes of foreign slaves to the hard stares of her Majesty's officials, all in the grand assembly watched him and waited, frozen and breathless. Only the Queen herself, save for her usual irritability, seemed unconcerned. Despite the rumor that her wine had been tampered with by the conspiracy, the Queen saw the young cupbearer testing her drink each day as little more than a waste of time.

"Well, Benedict?" the Queen demanded.

The droplet of wine finally splattered onto the floor. But Benedict did not see it. His eyes looked upwards, where he beheld the paired arches extending from one side of the royal banquet hall to the other, like the roof of a giant mouth.

He gently placed the goblet of wine back onto its saucer, his gaze lingering on it with one final glance. The deep red pool could hide the poison, of course. But the root's bitterness was not so easily masked.

In fact, it was *almost* too strong for him. Already his stomach was churning, and he fought to keep down the sour tang of bile. The burning in his throat was all too familiar.

No, it really *was* too strong for him. He had not felt poison torment his body like this since . . . since the very first time he had ingested deathtoll.

"Mother," he whimpered, coiling inward and clutching his gut,

"Mother, I don't feel good."

She reached for the wooden cup, her green irises glinting in the glow of a lantern. "You aren't supposed to."

The pain sharpened, and he fell to his hands. His neck craned above the icy cellar floor. "I'm going to throw up."

His mother's tone became stern. "No! You must keep it down. You must!"

Yes. He must keep it down. He must. Today of all days he *absolutely must* keep it down. This glorious day. The day for which he had long suffered. The day the kingdom would be free.

Another stroke of pain nearly caused him to wince. But he didn't show it. He mustn't show it. Not even a twitch.

The executioner tore his bloody sword from the girl's chest. The peasant child collapsed with a sick thud.

"It is done, my Queen."

"Let it be known. Those who cannot afford their payments to me can neither afford to keep their children."

Perhaps the agony of poison was nothing compared to the sword. Benedict could not decide. All pain he had ever known had come from poison.

Her fingers grazed his open palm. She passed him a cluster of toxic herbs.

"You must build up resistance to everything, my son. Everything. I dread the thought of you dying the death meant for the Queen."

"Mother?"

She pressed her hand against his cheek. "As the Queen's cupbearer, I swore an oath that I would be trustworthy. I refused her nothing. Not even you." She grabbed his scalp in her two hands and kissed his forehead. Her tears fell on his own cheeks.

Yes. His pain came from poison.

Waves of it now pulsed with each heartbeat through his body.

His mother loved him. She never said so, but he knew it.

"You should feel honored by your mother, for she saved the Queen's life today. Deathtoll was in the royal cup," the official pronounced in a low rumble. "Now, you have the honor of taking her place."

Despite all her suffering and her talk of building resistance, she had died. But now he also knew the truth as she had. No one could ever be immune to deathtoll. Any amount more than a spoonful was fatal. He finally understood that she had tried to convince him that he could survive just to bring some hope into his bleak existence. Yes. That pain was the best gift she had ever given him.

"Have mercy on us! Have mercy on us! Mercy!"

Time and again, he had witnessed the Queen's answer to the people: The whip of slavery. The sword of mutilation. The sacrifice of infants to the fire.

Ah, though . . . at last he would be free from those wretched images of horror. After all these years, they were fading away, as in a foggy dream His mind . . . was the

But wait. It . . . it wasn't supposed to happen this way. He was supposed to have been able by now He should have been able to endure it. This was supposed to He was supposed to

"It is safe, your Majesty."

The saucer was lifted from Benedict's hands, and the official presented it to the Queen. She took the goblet to her lips and drank deeply.

Benedict smiled.

He had been wrong. His mother's hope was real.

The goblet slipped from the Queen's fingers. She shrieked but once, and her corpse collapsed next to Benedict's on the floor. In an instant, the slaves were overpowering her Majesty's officials.

He had just consumed poison. This he was sure. He had spit it into her cup.

Red Poppies

by Kendra Smalley

An undergraduate English student at Taylor University, Kendra Smalley enjoys writing poetry and fiction. Some of her work was published in the 2018 edition of *Parnassus*, the undergraduate literary journal for Taylor University. *Tsundoku* (piles of unread books) cover her shelves, and she enjoys adding to her collection in the hopes that one day she will be able to read all of the stories contained in those pages. She was one of the honorees in the student writing competition.

I inhale red poppies,
Their sweet scent
Spiced by something
Unknown, tingling.

I roll smooth stems between
Fingers calloused from
Years of gripping pens.

Bright crimson petals,
Delicate like tissue,
Stamp my vision.

My eyes burn from the weight
Of mingled salt and water,
Drawn from a cavernous well
Deep as generations.

Tears heavy enough to be
Wept for eons
Run down my cheek.

I remember a past I
Did not live, but
A past belonging to humanity,

Inherited memory of
Pain and loss and

Creative Work Inspired by C. S. Lewis & Friends

Fresh-turned soil among
Carved and crooked stones.

I inhale red poppies,
Tuck them behind my ear,
Slide them into my pockets,
Pin them on my breast.

Summit of Arthur's Seat, January

by Kendra Smalley

Draped over distant fields,
Silver and grey haze
Flickers white from the
Light knifing through
Clouds thick yet
Scurrying in thrashing gales.
Bursts and gusts catch
Breath from throat, snatch
Air from lungs.
Ravens toss and tumble above—
Level with human heads
Before they settle on rocks,
Feathers ruffling, revealing
White breasts, white
Hearts beneath
Feathery cloaks of black.

Oxford Visit

by Kendra Smalley

Green lawn bordered by
Trimmed and pruned hedges, neat
Rows of flowers, all encased in a
Stone wall broken by a single,
Black gate through which eyes peer
And glimpse Dodgson's white rabbit
Slipping down a hole.

Sneak back up the path, pass
Through the old ox-gate,
Wander beneath the green arms of trees
Until the tower of Saint Mary the Virgin
Rises, pointing, into the sky.

Beside the fine architecture,
Every stone measured and planned,
Grows a crooked, timeworn tree,
Its branches stretching
Over the fence to
Greet passersby, dangle
Leaves in their hair,
Caress the people, draw them
Into the overflowing churchyard.

A dark wooden door bears a
Diamond etched with the
Face of a lion, and
Two golden satyrs
Crouch in the corbels,
Glinting eyes watching congregants
Stream from the church and
Pass the lantern glowing nearby.

The Rabbit Room

by Kendra Smalley

I pay four pounds for a
Red transferware plate mounded with a
Round piece of sticky toffee pudding and
Melting vanilla ice cream that
Oozes down the dessert's moist sides.
Round soup spoon ferries bites until
Warmth and winter dance in my mouth,
Sweetness explodes.
I wipe syrup from my lips with a
Red paper napkin—the server told me to
Pretend it's white, and, with a wink,
"Not left over from Christmas."
It is January, yet not snowing or even
Slightly gnawing and cold, as I am used to:
In this place it is, perhaps,
Always Christmas and never winter.
We nibble our snack,
Chatter and giggle like children, in
Exuberant awe of the
Legacy of this place.
We drop into silence,
Pull out notebooks,
Scribble furiously before the
Ghosts and muses vanish into
Dark wood and dusty shelves.
Ink and imagination consume us until
More friends arrive, and
We slip away.

Kendra Smalley presents her paper
"George MacDonald, Shakespeare Scholar."

The Balrog captivated attendees during a balcony concert following the banquet. Members include Jane Heald (cello), Sean Ellsworth-Hoffman (violin), and John Renz (percussion).

VI. "Magic Moments": Reflections on the 2018 Lewis & Friends Colloquium

Why the Lewis & Friends Colloquium is Awesome
(It's the Students)

by Brenton Dickieson

I have just returned from what remains for me the best conference I have ever experienced, especially when it comes to engendering an atmosphere of support for emerging scholars while remaining critical on the material. Part of this is no doubt nostalgic. A few years ago, the C.S. Lewis & Friends Colloquium at Taylor University was my "coming out" as a Lewis scholar, and there I found a cohort of friends in my generation interested in these kinds of questions. Not just researchers, but a motley crew of broadcasters, poets, novelists, fans, collectors, gamers, theologians, critics, performers, musicians, renegade scholars, and folk that kick around archives. Since that conference, I have felt incredible support from senior and established scholars and artists. Now that I've come out of my shell, I am pleased that I was able to get to know about half of the students at this year's colloquium.

And these students are awesome. Whatever "kids these days" balderdash you might hear from media or so-called community leaders, I continue to proclaim that there is a quiet confederation of authentic, skilled, integrated millennials (and Gen-Zers) who carry with them a greater potential than my generation has been able to supply. Hashtag, *the kids are all right.*

Some of these students I knew were awesome going in. After all, there was a contingency of Signum University students, including one of my research methods students, Emily Austin. Emily, who designed the cover for *The Inklings and King Arthur*, was a kind of artist-in-residence for the weekend and gave a paper on central themes common to both *Lord of the Rings* and *Harry Potter*. I hesitate to put Josiah Peterson into the "student" category as he is a debate coach and teaches rhetoric and C.S. Lewis at The King's College in NYC. But Josiah took my C.S. Lewis class a couple of years ago and now is in the MA in cultural apologetics program at Houston Baptist University with Holly Ordway and Michael Ward. I was fortunate enough to hear Josiah's first paper, in which he enlightened us on Edwin Abbott's novella, *Flatland: A Romance of Many Dimensions* (1884), surprisingly significant to Lewis's intellectual development.

Beyond the Signum and King's College crowd, there are the

Taylor University superstars. I don't know if Taylor University is an elite college or not – their staff and faculty suggest it (as does the tuition cost) – but the school either invites or creates elite students. There are too many to name, but they are poets and scholars and organizers extraordinaire. Not wanting to highlight and exclude, I would still like to brag that I have the paper copy of the award-winning student short story by Bethany Russell. I may have to sell that one day to pay for my kid to go to Taylor.

I also got to have a great discussion with Kayla Beebout and Annalee Brantner, students of the intrepid Devin Brown from Asbury University. We had a discussion about whether Prince Edward Island was a real or a mythical place (it is both), and given their capacity for critical thought I would have loved to hear their papers on *Out of the Silent Planet*. The Asbury students were joined by students from Trevecca Nazarene with an eye for a great question, Torri Frye and Christian Mack (who won the award for best student critical paper).

Through serendipity or fate or the wisdom of conference grandmaster Joe Ricke, my own little paper on C.S. Lewis and L.M. Montgomery was in a session with not one but *two* papers on archival discoveries. Not unconnected, these are both students from Azusa Pacific where Roger White and Diana Pavlac Glyer excel in teaching and research. I had met Christine Murphy on the first day as she was talking to handwriting expert Charlie Starr about a piece she had discovered while haunting Azusa's C.S. Lewis archive. Christine used archival research to skillfully make a link through Lewis's literary critical work between 1930 and 1942. Sarah O'Dell is a little further along than most and doesn't fit in the same kind of "student category" as she is a rare PhD/MD researcher. She also is doing archival research worth noting, discovering the full, unpublished "Appendix" fellow Inkling Dr. Havard wrote for Lewis's *The Problem of Pain*. I can't wait to see the full paper for each of these pieces.

I got to chat with a half-dozen more students, many of them from the Taylor University superstar section of undergrads. After a reception on Saturday night, a large circle of us stayed up chatting about topics that ranged from C.S. Lewis's ridiculous use of money to the experience today of evangelical millennials to murdered and missing indigenous women and girls. It was a great night and highlighted for me the quality of mind and heart that millennials can bring to social conversations if we can be perspicacious enough – or humble enough? – to see it.

The Inklings and Gaming: A Workshop

by T.R. Knight

T.R. Knight is the Director of Academic Technology and an adjunct faculty member at Taylor University, teaching courses in Game Studies and Writing and Editing for Gaming. He is also an award-winning freelance editor working on tabletop games, RPGS, and fiction for various game publishers. He has a passion for the works of the Inklings, especially J.R.R Tolkien's Middle-earth, amassing quite a library of related books, media, and games. http://www.freelanceknight.com/published-works/.

What?! No Owen Barfield-inspired games?

And with that, you have an *inkling* of our discussion on the *Inklings and Gaming*. With all the scholarly discussion of C.S. Lewis, the Inklings, and the impact of their writing at the Lewis & Friends Colloquium, perhaps something a little lighter and more ... fun might garner some interest. After all, the game industry grows each year with sales of hobby games in North America topping $1.55 billion in 2017 ("Hobby Games"). With so much invested in the gaming hobby each year, how do the creative works of the Inklings influence or inspire game designers and publishers? How popular are tabletop and video games based on Narnia and Middle-earth? Or, perhaps of more scholarly interest, how accurate are these games to the worlds and works by which they were inspired?

To begin our journey down this path of the *Inklings and Gaming*, we first must gaze back into history and see how games influenced the authors themselves. Different books mention that the Inklings played chess at times, but I have found no mention of any of them playing other games or indulging in miniature warfare, such as H.G. Wells's *Little Wars* (1913). C.S. Lewis writes about chess in *The Weight of Glory*. "Like a good chess player, Satan is always trying to maneuver you into a position where you can save your castle only by losing your bishop." In our workshop at the colloquium, the audience and I did discuss the possibility that Tolkien and perhaps Lewis might have had some experience with war simulations in school, for it was not uncommon in England at the time to teach historical battles using miniature figures. One member of the audience offered to explore that subject afterwards; perhaps we will learn more at the next Colloquium.

But, more to our point today, how have the creative works of the Inklings influenced gaming over the years? One thing you realize quickly is that only C.S. Lewis's Narnia and J.R.R. Tolkien's Middle-earth have had any significant depiction in gaming. Neither other works by them nor any works by the other Inklings have spawned the kind of passion that the worlds of Narnia and Middle-earth have. Looking at this brief transmedia timeline of the book and cinema publications, you can start to see some interesting corollaries between the release of cinematic events and various games. Interestingly, those games most closely tied to the cinematic versions of the creative works have not fared well. On the other hand, the more recent games, building more obviously upon the foundation of the original written works, have been quite successful and are increasing in popularity and growth both in the game industry and Inklings community. Fandom remained strong for those worlds, and eventually game designers and publishers listened and returned with greater forethought, research, and design. Narnia faded from the gaming scene as the estate pulled back their licenses after the most recent movie, while games inspired by Tolkien's Middle-earth continue to be released into the market and to grow in popularity the more accurately they have depicted the world within the books.

As part of our workshop, we delved into the world of roleplaying games and a juxtaposition or irony between the first ever RPG, *Dungeons & Dragons*, and the world of Middle-earth. As the roleplaying hobby grew from those early days of *Dungeons and Dragons* being released by TSR, Inc., the Tolkien Estate took umbrage with some similarities in the games being produced and the world of Middle-earth. According to Gary Gygax, one of the original creators of *Dungeons and Dragons*:

> TSR was served with papers threatening damages to the tune of half a mil by the Saul Zantes division of Elan Merchandising on behalf of the Tolkien Estate. The main objection was to the boardgame we were publishing, *The Battle of Five Armies*. The author of that game had given us a letter from his attorney claiming the work was grandfathered because it was published after the copyrights for JRRT's works had lapsed and before any renewals were made. The action also demanded we remove balrog, dragon, dwarf, elf, ent, goblin, hobbit, orc, and warg from the D&D game. Although only balrog and warg were unique names we agreed to hobbit as well, kept the rest, of course. The boardgame was dumped, and thus the suit was settled out of court at that" (Archived discussion "Re: Bears and Hobbits").

Gygax continued to be confronted by fans about the similarity of the worlds depicted in the game and Tolkien's Middle-earth. He responded by pointing to a host of other influences. In fact, the same year that D&D was released, he sarcastically called himself a "foul blasphemer" because he refused "to consider Tolkien as the ultimate authority and his writings as sacrosanct" ("Fantasy Wargaming"). In that same 1974 article, he went on to answer the rhetorical question: "What other sources of fantasy can compare to J.R.R. Tolkien?"

> Obviously, Professor Tolkien did not create the whole of his fantasies from within. They draw upon mythology and folklore rather heavily, with a few highly interesting creations which belong solely to the author such as the Nazgul, the Balrog, and Tom Bombadil. All of the other creatures are found in fairy tales by the score and dozens of other excellent writers who create fantasy works themselves: besides Howard whom I already mentioned, there are the likes of Paul Anderson, L. Sprague de Camp and Fletcher Pratt, Fritz Leiber, H.P. Lovecraft, A. Merritt, Michael Moorcock, Jack Vance, and Roger Zelazny – there are many more, and the ommission [sic] of their names here is more of an oversight than a slight. . . . In general, the "Ring Trilogy" is not fast paced, and outside the framework of the tale many of Tolkien's creatures are not very exciting or different." ("Fantasy Wargaming")

In a later publication, Gygax claimed that "only a minute trace of the Professor's work can be found in the games" and that "there is no resemblance between the two" ("The Influence of J.R.R. Tolkien" 12-13). And over time, Gygax became tired of the comparisons:

> Though I thoroughly enjoyed *The Hobbit*, I found the "Ring Trilogy". . . well, tedious. The action dragged, and it smacked of an allegory of the struggle of the little common working folk of England against the threat of Hitler's Nazi evil. At the risk of incurring the wrath of the Professor's dedicated readers, I must say that I was so bored with his tomes that I took nearly three weeks to finish them. Considered in the light of fantasy action adventure, Tolkien is not dynamic. Gandalf is quite ineffectual, plying a sword at times and casting spells which are quite low-powered (in terms of the D&D ® game). Obviously, neither he nor his magic had any influence on the games . . . ("The Influence" 12-13).

From that point forward, there was a legal split between *Dungeons & Dragons* and Middle-earth. Over the years, many roleplaying games based in Middle-earth were released but each one faltered over time.

Many of the early RPGs based on Middle-earth were more standard fantasy gaming trying to set itself in Middle-earth, often with more traditional fantasy magic and spellcasters, which is not actually what the Middle-earth books depicted. The more recent release of *The One Ring* RPG has proven very popular as it truly feels like you are telling stories from the original books. During this same time period, *Dungeons & Dragons* has seen a renaissance with the release of its fifth edition. To that end, the irony comes full circle with the release of *Adventures in Middle-earth*, a D&D 5e based RPG set in the world of Middle-earth. After all these decades, Middle-earth and D&D are officially joined and admit they have commonalities. Roleplaying fans of Middle-earth are rejoicing with the opportunity to finally and officially be able to merge two of their passions at the gaming table.

Video games based on Inklings-inspired worlds have surprisingly struggled in the market. The Narnia-based games have not fared well, trying to ride the wave of fandom from the movies but then falling short from poor design or limited gameplay. Early Middle-earth video games never grabbed much market share either, but the two most recent games, *Shadow of Mordor* and *Shadow of War*, have done very well to some controversy and consternation of Tolkien fans. The games are based in the world of Middle-earth, but they encourage players to become fallen Rangers who use violence and dark powers to win the day. These games are very dark, and fans complain they do not properly capture the essence of the Middle-earth books, but that instead they exploit fans and focus on violence rather than depth of story.

Tabletop games inspired by the Inklings have fared much better among fandom. Many early games were simple but reflected the animated movies or BBC series. They focused more on the imagery of Narnia and Middle-earth as depicted rather than delving into the storylines and themes of the books. As the years progressed, game design improved, and designers returned to the worlds of Narnia and Middle-earth. Narnia saw some gain with the more modern movies, but the games did not grab as much market or fandom as the movies, so they quickly faltered, and game publishers shied away. Eventually, the licensing for Narnia games lapsed and no more games were released. Middle-earth games, on the other hand, continued to develop with designers listening to fans and passionately researching the original texts. Publishers released games that fans appreciated as they began to reflect the Middle-earth reader/gamers knew and loved. *The Battle of the Five Armies*, *War of the Ring*, and now *Hunt for the Ring* put players in the midst of some of the epic struggles within the books.

You feel the tension of the main characters from the books and have the opportunity to play out those famous events yourselves.

Success breeds success. As these Middle-earth games continue to remain popular, more publishers will seek out opportunities to release games based in that world. Could Narnia have similar success in the future? One problem is the issue of rights. What is the current status of the Intellectual Property (IP) of the Inklings as they relate to gaming? As for Narnia, Walden Media and Walt Disney own the movie IP while the Lewis Estate is currently withholding the IP rights for Narnia as negotiations are in process for a new movie and a possible series. Currently, no one has the right to produce new games based on the books or movies. Reprints might be possible for existing games, depending on original license. On the other hand, the IP rights to Middle-earth have become very distributed. Card Games are currently licensed by Fantasy Flight Games and Cubicle 7, board games and miniatures are licensed by Ares Games, RPGs have been licensed to Cubicle 7, while Monolith Productions/WB Games have the rights to the video games. Amazon Prime recently announced they have the rights to produce a new TV series which might spawn further interests in other games. At present, there does not seem to be any interest in games based on other works by the Inklings. Even Lewis's Space Trilogy does not seem to be garnering any interest among game publishers.

What about the future of *Inklings and Gaming*? News from the game industry shows that the Inklings, especially the Tolkien estate, have some good news upcoming. *The One Ring* and *Adventures in Middle-earth* are top-selling RPGs. Ares Games is planning more games to follow the successful *Hunt for the Ring*. Asmodee Digital and Fantasy Flight Interactive are releasing *The Lord of the Rings Living Card Game* as a digital card game. The upcoming *Lord of the Rings* series on Amazon Prime and *The Chronicles of Narnia: Silver Chair* movie begin production in late 2018, both of which could spawn interest in new games.

CHRONOLOGICAL INKLING GAMEOGRAPHIES

Narnia Tabletop Games (See www.boardgamegeek.com for more details)

1988, *The Chronicles of Narnia* (Out of Print)

2005, *Stratego: The Chronicles of Narnia* (Out of Print)

2005, *The Chronicles of Narnia: The Lion, the Witch, and The Wardrobe Game* (Out of Print)

2006, *Narnia Risk Junior* (Out of Print)

2008, *The Chronicles of Narnia: Prince Caspian Quest for the Throne Adventure Game*

Narnia Video Games

2005, *The Chronicles of Narnia: The Lion, the Witch, and the Wardrobe* (Out of Print)

2008, *The Chronicles of Narnia: Prince Caspian* (Out of Print)

Narnia RPGs (See www.rpggeek.com for more details)

2008, *Das Rollenspiel* (Out of Print)

Middle-Earth Tabletop Games (See www.boardgamegeek.com for more details)

1994, *The Hobbit Adventure Board Game* (Out of Print)

2004, 2012, *War of the Ring*

2011, *The Lord of the Rings: The Card Game* (Out of Print)

2014, *Battle of the Five Armies*

2015, *Hobbit Love Letter*

2018, *Hunt for the Ring*

Middle-earth Video Games

1982, *The Hobbit*

2016, *Middle-Earth: Shadow of Mordor*

2017, *Middle-Earth: Shadow of War*

Middle-earth RPGs (See www.rpggeek.com for more details)

1985, *Tolkien Quest* (Out of Print)

1984, *MERP*, First Edition (Out of Print)

1994, *MERP*, Second Edition (Out of Print)

2002, *Lord of the Rings Roleplaying Game* (Out of Print)

2014, *The One Ring*

2016, *Adventures in Middle-Earth (D&D)* 5e

WORKS CITED

Griep, Milton. "Hobby Games Top $1.5 Billion in 2017." *ICV2*, posted July 30, 2018. icv2.com/articles/news/view/41016/hobby-games-top-1-5-billion.

Gygax, Gary. Archived discussion "Re: Bears and Hobbits." *ENWorld: RPG News and Reviews.* July 24, 2003. web.archive.org/web/20121007050950/http://www.enworld.org/forum/archive-threads/57832-gary-gygax-q-part-iv-4.html#post1026737.

---. "Fantasy Wargaming and the Influence of J.R.R. Tolkien." *La Vivandière*, 1974.

---. "The Influence of J. R. R. Tolkien on the D&D® and AD&D® games." *Dragon*, no. 95, 1985, pp. 12-13. https://annarchive.com/files/Drmg095.pdf.

"A Fascinating Crash Course":
Reflection on the Gaming Workshop

by John Stanifer

I can't speak for everyone – maybe I just need to get out more – but when I attend a conference like the Lewis & Friends Colloquium, I mainly expect to hear papers presenting fresh interpretations of Narnia, Middle-earth, and Logres. You know, like . . . literary studies of literature. Things like that.

That's why I keep coming back. I like those papers.

But I have a confession to make. I am also a gamer. Maybe not as much as I used to be, when I was ten and felt like I could justify a six-hour Nintendo marathon. Still, to this day I have an affinity with the gamer crowd that I just can't seem to escape.

Imagine my surprise and delight to see the two overlap at this year's colloquium. I had little idea what to expect going into the "Inklings and Gaming" workshop, but, as I told one of my longtime colloquium friends, "I'm pretty much genetically obligated to go to this and see what happens." Judging by the size and the age range of the crowd in the room, I wasn't the only one who found myself curious about what T.R. Knight, Taylor University's Director of Academic Technology, had in store.

As it turns out, Knight presented us with a fascinating crash course in games based on the works of the Inklings, especially board games and video games featuring Middle-earth and Narnia (so far as we know, no game designer has had the nerve, the creativity, or the sheer insanity to turn Barfield's *Poetic Diction* or Charles Williams's *Taliessin through Logres* into a video game). From the outset, Knight admitted that he was only scratching the surface and was mainly interested in games that have had some level of critical and commercial success. One example is the second edition of *War of the Ring*, which was ranked at #14 on BoardGameGeek as of June 2018. Still, I learned a lot that I didn't know and found myself amazed yet again at the seemingly limitless impact that Lewis and Friends have had on our collective popular culture.

Among several intriguing insights Knight shared was that these games that exist primarily to tie in with the film adaptations – and have therefore had less direct connection to the texts – have for the most part come and gone in the blink of an eye. Those that

have delved more deeply into the world created by the texts have been more popular and lasting. Unfortunately, there haven't really been any Narnia games that fall into this category; on the other hand, as some in the room pointed out during the discussion that followed Knight's presentation, Lewis left us tantalizing hints of Narnia's history that a creative game designer could certainly pick up and run with. The history of Calormen, the giants in the north country, the Telmarine invasion, and so forth could all feed into a substantial role-playing campaign with relative ease.

The modern gaming industry owes a great deal to the likes of Lewis and Tolkien, whether they acknowledge that debt or not. Gary Gygax, co-creator of *Dungeons & Dragons* (D&D), didn't really care all that much for Tolkien, but you still see "halfings" (not "hobbits") showing up in D&D texts, and now there is even a book that uses the latest edition of the D&D rules to help players create their own role-playing campaigns based in Middle-earth itself (something else I didn't know before I attended Knight's talk).

I think we need more people like Knight who look not only at the works of the Inklings themselves but at all the books, games, movies, and other cultural by-products inspired by the Inklings. Yes, we readers and scholars who attend these colloquiums and other similar conferences around the world know that the texts themselves are wonderful and life-changing and important, but some of us are also secretly – or not so secretly – diverted by the nerdier creative endeavors those texts have inspired in others. Personally, I'm glad someone stood up at this year's colloquium and said, "Hey guys, let's celebrate our nerdiness!"

Count me among that crowd too. After all, it was the hippies that sparked a great deal of the revival of interest in Tolkien and Middle-earth in the 70s. Perhaps gamers will do the same thing now.

"Tune My Heart":
An Undergraduate's Colloquium Reflection

by Caleb Hoelscher

Caleb Hoelscher is a senior literature major at Taylor University from Fort Loramie, Ohio. Although he has been interested in C. S. Lewis since he first encountered his writings at an early age, he has recently developed an appreciation for the other Lewis & Friends authors through the Center at Taylor University, where he conducted research on George MacDonald's *Hamlet* manuscript during the summer of 2018.

When I personify imagination, I often think of him as a rule breaker, the student who cuts class for a day of whimsy and play, the musician who never ends his composition on the dang root note, the enthusiastic but unstable toddler who hobbles over to a white wall with sharpies and thinks *I wonder what would happen if.* Imagination blurs lines and frustrates fundamental assumptions. It is the daring spirit behind "to boldly go where no man has gone before," a testament to an imagination both strong enough to boldly dream and to boldly split the infinitive. But however you think of it, you can be sure that when imagination leaves the scene, you are either left with a new world to explore or, as with the toddler and her sharpies, a big mess to clean up. Or both.

On the other hand, when I think of the word faithful, I get a different picture. Faithfulness works overtime, remains loyal to one person, sticks to his principles even if the principles aren't popular or – for lack of a better way to put it – fun. I think of how Robert Hayden depicted his hard-working father in a poem: "Sundays too my father got up early / and put his clothes on in the blueblack cold, / then with cracked hands that ached / from labor in the weekday weather made / banked fires blaze. No one ever thanked him."

And when I think of the 2018 Lewis & Friends Colloquium, I think of those two characters sitting together on every program, sign, advertisement, whether digital or in print. I think of those two characters alive in me, fighting for space like two musical notes. They warble in the ear, the B and the C in a war of attrition, each demanding some sort of resolution. In other words, the theme of the 2018 Lewis & Friends Colloquium was, if you didn't already know, *the Faithful*

Imagination.

It was awe-inspiring to watch the dynamics of those two forces play out in almost every aspect of the colloquium: in the papers, the poems, the panels, the keynotes, the nerdy conversations at meals, the teatime discussions, the music, you name it. Out of that tension sprung new questions for me: Well, how shortsighted is faithfulness if the object of your faithfulness isn't imagined complexly? And how hopeless is imagination if it has no center, no purpose, no home? *All who wander aren't lost*, I thought, *but is it too presumptuous to assume that all who wander hope to return home eventually?*

But I am being too abstract. My subject is lively lectures about the Inklings and gaming – videogames, roleplaying games, computer games, board games. I am talking about keynote presentations brilliantly titled *Dorothy L. Sayers and the Wages of Cinema*. I am talking about an hour-long workshop on Lewis's handwriting, at least half of which was spent on the evolution of C. S. Lewis's letter f (I've been cautioned against writing with too broad a topic, but can one be critiqued for having a topic that is too narrow?). There were even several paper presentations that criticized our celebrated authors, helping fanboys and fangirls alike to see that their literary and scholarly heroes are people too.

There were also people like one of my biblical studies professors, Dr. Richard Smith, who talked about the faithful imagination in Job, a rather sobering presentation on an incredibly sobering book of Hebrew wisdom literature. But what he said in his presentation did not stick with me as much as what we talked about afterward – during the colloquium's banquet. We were having a fairly lively discussion about biblical interpretation, amidst sipping tea, waiting for the program to begin. Even after two years of Biblical Greek classes, I was still having trouble committing to the Biblical interpretation method of almost solely privileging authorial intent (in fact, I still am). With all the grace of an inexperienced and angsty English major, I just keep thinking "But what about the reader? What about reader response criticism? What about the reader, the text, and the writer coming together to create meaning?" My conversation with him took flight because of those questions. Without going into too much detail, Dr. Smith responded to a few of my concerns. And to conclude, he said, "As an English major, I'm sure you come across adaptations of Shakespeare that aren't exactly true to the text, don't you?" And I said, "Well, yes, but surely that's not always bad thing. Can't readers bring new meaning into a text?" He smiled, as if to say, *good question,* and then continued, "Well,

we seem to be getting at the theme of this colloquium, you think?" He went back to sipping his tea. I heard those two notes fighting for space in my ear.

And that question followed me as I walked to the Euler Center to go to the Saturday night reception. When I arrived, I walked into a glorious scene, bustling with activity. Italian sodas and chocolate-covered strawberries were being served in the corner. A band called *The Balrog* played music that called the fauns out of the forest to dance. Scholarly and creative discussions echoed across the room; ideas were refined and encouraged. And then – amidst all of this activity – Dr. Ricke, the Director of the Lewis & Friends Colloquium, walked up to the front with his ukulele and started singing the hymn "Come Thou Fount" with *The Balrog*.

> *Come, Thou Fount of every blessing*
> *Tune my heart to sing Thy grace*
> *Streams of mercy, never ceasing*
> *Call for songs of loudest praise*

Not everyone was paying close attention, but those who did were entranced. It was magical. It was honest. It was faithful and imaginative. Another woman, an Episcopal priest, who would perform the communion service the next day, came up and sang another verse.

> *Here I raise my Ebenezer*
> *Hither by Thy help I've come*
> *And I hope, by Thy good pleasure*
> *Safely to arrive at home*

Not all who wander are lost, I thought again, *but all who wander do hope to return home eventually.*

And now that I think back on it, that hymn really brought all of the papers, panels, poems, keynotes, and conversations together. It arranged them into an elegant musical composition, complete with tensions and resolutions. These weren't just scholars and creative people coming together to nerd out about philosophy, literature, gaming, C. S. Lewis's handwriting, the appendix to *The Problem of Pain*, Dorothy L. Sayers and Cinema, or even Job. It only seems so if you only look and don't listen closely, if you forget that these people came from all over America (actually all over the world) to talk about the authors, to talk about their writing, not for money or fame, but because of love – of the writing, of the writers, of the God behind it most of all.

Dr. Ricke returned to singing the last verse, repeating it multiple times, tagging the ending "Prone to wander" over and over again.

> *Oh, to grace how great a debtor*
> *Daily I'm constrained to be*
> *Let Thy goodness like a fetter*
> *Bind my wandering heart to Thee*
> *Prone to wander, Lord, I feel it*
> *Prone to leave the God I love*
> *Here's my heart, oh, take and seal it*
> *Seal it for Thy courts above*

So, ultimately, what was the colloquium about? At the risk of being overly sentimental (as I'm almost certain I will be), it was about Faithfulness. It was about Imagination. It was about what's good, what's evil, what's beautiful, what's ugly. It was those two notes fighting for space in the ear: the Imagination, which calls us to wander without being lost, and Faithfulness, which reminds us that what we love most always binds our wandering hearts.

If you look, you will see a bunch of nerds talking about nerdy things. But if you listen carefully, you will hear hearts being tuned. You will hear praise.

A Poet's Experience of the
C.S. Lewis & Friends Colloquium

by D.S. Martin

I had the privilege of being one of the keynote speakers invited to read at the 2018 C.S. Lewis & Friends Colloquium in Indiana. This would seem to be an unusual arrangement if you did not know about my book *Conspiracy of Light: Poems Inspired by the Legacy of C.S. Lewis* (Cascade Books). I wrote each of the poems in this book either about something that Lewis wrote or about some incident in his life.

As I said in the introduction to that book, "There was a time in my youth when I would buy and read any and every book I discovered by C.S. Lewis. What I had found was that he wrote in a way that engaged my mind like no other writer. He was respected in a variety of fields, and held passionately to his faith in Christ. Years later, when I began re-reading his books I was surprised to find many of the ideas I'd held as my own, had been planted by Lewis. . . . As I re-read Lewis I was also re-introduced to his exceptional skill at presenting ideas through analogy. Many of the poems in this book began with the poet in me taking a Lewis word-picture and pushing it in one direction or another until it took on a life of its own."

Joe Ricke, who generously invited me to the colloquium, asked if I would write "a reflection on the colloquium, perhaps especially from your perspective as [a] first-time visitor and poet." Those who know Dr. Ricke's delightful sense of humour will appreciate his response to my inquiry concerning the length of such a piece. He said, "14 lines, rhymed abbaabbacdecde. Or 500-1000 words, whichever would suit you." And so, although I rarely write sonnets or traditionally structured verse, here is my response.

A POET AT THE C.S. LEWIS & FRIENDS COLLOQUIUM

Some come to Indiana for the race
I came because of Lewis having read
such insights & such beauty & have fed
on his expressions of the Father's grace
With all these scholars gathered in one place
would any care at all of what I've done?
A poet shoves aside the clouds so sun

will strike the forest floor reveal a space
already there but hidden from our view
A scholar studies details seeks unknowns
like one holding a magnifying glass
These Lewis lovers also love what's true
A perfect audience to hear these poems
They caught subtleties knew just when to laugh

Of course, a gathering of those extremely familiar with C.S. Lewis would catch things in my reading that would be missed by a less-versed audience. As they delighted in such recognitions, and my twists of phrase, I had a lot of fun. As I attended other sessions, listening to people's insights into such as Lewis, Tolkien, Williams, Sayers, and MacDonald, I knew I was with my tribe. They love the books I love, and desire to glorify the God I worship.

Since returning home to Ontario, I have extended my experience of the colloquium by re-reading George MacDonald's *Phantastes*, which I had read so long ago that my memory of it was slight. I also followed a recommendation to read Dorothy L. Sayers's masterpiece, *Gaudy Night*, which (believe it or not) is one of the few Lord Peter Wimsey mysteries that I hadn't read. Both experiences I've greatly appreciated – even more so because they are shared with so many from the colloquium. Since returning home, thoughts of my time in Indiana have also inspired me to write a light-hearted poem entitled "Screwtape Visits Your Local Costco." Perhaps I'll have a chance to share it with you some time.

Since Joe Ricke's response made me laugh, I thought I might also add a pair of limericks to celebrate the occasion as well. I know that you know that a limerick never aspires to high art. In this case they merely aspire to doggerel, and so, to make you smile.

The Colloquium's own top banana
asked a poet to visit Indiana
Could this be a success?
Would it turn out a mess?
Would anyone shout out hosanna?

I wondered if it might be tricky
sharing verse Would these scholars be picky?
But once I was done
we had all had such fun
that I've just got to thank Dr Ricke

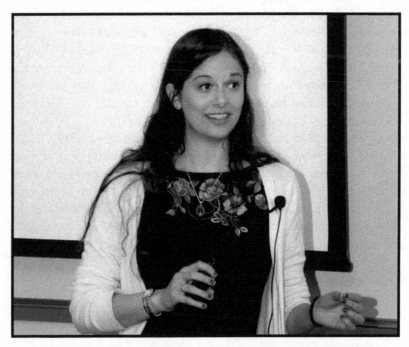

Sarah O'Dell presents her paper "The (Revised) Clinical Imagination:
An Unpublished 'Appendix' to *The Problem of Pain*."

Afterword: "A Place of Many Windows"

by Sarah O'Dell

Sarah O'Dell received an MA in English from Azusa Pacific University and is a medical student in the Medical Scientist Training Program (MD/PhD) at the University of California, Irvine. At Azusa, she studied with Inklings scholar, Diana Glyer.

The 11th Biennial Frances White Ewbank Colloquium was themed "The Faithful Imagination," and I am hard-pressed to find a more fitting description of the events of May 31–June 3, 2018. For where scholarship is governed by a community of faithful imaginations, there it becomes what it always ought to be: a kind of worship. This attitude of worship was deeply woven into the fabric of the colloquium, whose participants were united not only by their shared intellectual interests – a context which included the works of "C.S. Lewis and Friends" – but also their shared vision.

My experience of the colloquium (my first attendance of an event hosted by The Center for the Study of C.S. Lewis & Friends) was that of a communal feast of word and image, a place of intellectual and imaginative nourishment. I cannot completely express my gratitude for the conversations and learning that I experienced during this time or give full voice to the sense of wonder at the transformation of a meeting of academics, artists, and enthusiasts into such a locus of re-enchantment. However, I am able to map some of the contours of this "thin place" and recognize elements that enriched my own experience.

The work shared at the colloquium represented an impressive variety and depth of scholarship, the riches of which is well chronicled in this volume. It was a joy to interact with individuals I had previously only known as names on book covers – Charlie Starr, Stephen Prickett, Joe Christopher, David Downing, and Donald Williams, among others – and witness their discoveries firsthand. I was especially inspired by Charlie Starr's plenary "From the Faun's Bookshelf: Myth and Meaning;" in particular, his realization of myth as "concrete thought" was at once theoretically useful and personally enlightening. Reading his recent book has strongly resonated with my experiences in the Medical Humanities, in which experience also serves as a type of evidence.

The art exhibitions, poetry readings, and musical engagements scheduled alongside engaging plenaries and paper sessions made the colloquium a truly interdisciplinary experience. The enchanting art of Emily Austin and the poetry of D.S. Martin provided their own particular beauty, broadening the imaginative scope of the colloquium. I was also heartened by the openness with which the treasures of the Brown Collection were shared with colloquium attendees. The trust demonstrated in sharing a first edition of a much-loved volume or priceless manuscript was evident, as was the joy facilitated by this generosity.

Such excellent scholarship and creative work were matched by a strong sense of community. The richness of this community was evidenced in all aspects of the conference, from presentations to round table discussions, mealtimes to late-night gatherings, poetry readings to communal prayer. All were made welcome: scholars, artists, students, and non-academics who simply loved the subject matter. My impression of the colloquium was that of a multifaceted and holistic fellowship of mind and spirit.

Finally, one of the most striking aspects of the colloquium was the remarkable hospitality extended to young scholars. Not only did Taylor University demonstrate a clearly outstanding undergraduate research program of its own grown out of the treasures of the Brown Collection, but a concentrated effort was made at the Colloquium to include the next generation of Inklings scholars. While this welcoming atmosphere was evidenced by the whole of the scholarly community present, Joe Ricke, the Director of the Center and the Colloquium, especially went out of his way to highlight the work of emerging scholars. His warm initial response to my abstract made this support clear before the conference had even begun. While at the conference, I was deeply encouraged by his enthusiasm for my own work, including his promotion of my paper to other attendees and his special effort to attend my presentation. As this was my first formal presentation of my work on Robert Havard – and indeed my "coming out" as an Inklings scholar – I found such support particularly meaningful.

My own contribution to the colloquium represented a piece of a larger project, namely a book-length consideration of physician and Inkling Robert E. Havard. As both a medical student (MD/PhD) and a literary scholar, I am intrigued by Dr. Havard's role within the group, as well as keenly interested by his own (largely unpublished) writings. My conference paper, titled "The (Revised) Clinical Imagination: An Unpublished "Appendix" to *The Problem of Pain*,"

explored the differences between a previously unknown draft of Dr. Havard's "Appendix" to *The Problem of Pain* and the published version. The contrast between the two versions is stark, especially in regard to their respective perspectives on mental illness, and this difference is likely due to C.S. Lewis's own edits.

I had been working on my project for over a year without sharing it with a scholarly audience wider than a few people, including my mentor and friend Diana Glyer. I was curious to see how my ideas would be received, given the incomplete view of Robert Havard that one gleans from a thorough review of Inklings scholarship. However, my experience at the colloquium confirmed the deep need for careful research and scholarship regarding the lesser-studied "friends," and further fueled my enthusiasm for my project. Even more so, my experience sharing my recent research affirmed the power of words to heal: Dr. Havard's "lost" commentary on mental illness and depression proved powerful, inspiring conversations about mental health and emotional suffering, even as it "healed" a previous gap in the narrative surrounding *The Problem of Pain*.

During his plenary "Informing the Inklings: C.S. Lewis's Debt to George MacDonald," Stephen Prickett reminded us of the following passage from *The Weight of Glory*: "The books or the music in which we thought the beauty was located will betray us if we trust to them; it was not *in* them, it only came *through* them, and what came through them was longing" (30). This caution was well-realized over the course of the colloquium, where mythopoeic creations were not only deeply considered in their own right, but – crucially – recognized as a "series of windows, even of doors" (*Experiment* 138). As such, the 11th Biennial Frances White Ewbank Colloquium remains in my memory as a place of many windows, a Wood between the Worlds rife with the possibility of deep magic and even deeper growth. I am so grateful for its role in my own development as an Inklings scholar and look forward to attending and supporting the colloquium for many years to come.

WORKS CITED

Lewis, C.S. *An Experiment in Criticism*. Cambridge UP, 1961.

---. *The Weight of Glory*. HarperOne, 2001.

About the Center for the Study of
C.S. Lewis & Friends at Taylor University

The Center for the Study of C.S. Lewis & Friends is housed in the Zondervan Library of Taylor University in Upland, Indiana. With a mission to promote the integration of faith, scholarship, and the imagination, the Center serves the Taylor University campus, our regional community, and a worldwide academic and lay audience. As well as curating the Brown Collection (see below), we offer various programs to reach our many constituencies. For students, we hold seminar classes on the works of C. S. Lewis and other authors; host weekly teas which feature refreshments, fellowship, and scholarly and creative presentations in the spirit of the Inklings; and sponsor special one-off events such as concerts, films, and visiting speakers. Once a month we host a "Socratic Club" lecture, modeled on the Oxford Socratic Club founded by Stella Aldwinckle and presided over for many years by C. S. Lewis.

For our local community, we offer invitations to learn from local or visiting Lewis & Inklings scholars, tours of the center, opportunities to view the collections, as well as other events both educational and inspirational. On a larger scale, we organize and administer the biennial Frances White Ewbank Colloquium on C.S. Lewis & Friends, which has, since 1997, gathered hundreds of scholars, readers, and friends from across the United States and around the world. Several essays in this volume attest to the colloquium's value to its participants. The Center also sponsors Inklings scholarship in a number of other ways, primarily through funded undergraduate research opportunities for Taylor students and publishing a book series. In cooperation with Winged Lion Press, the Lewis & Friends book series features collections of essays from the colloquia (such as this volume), as well as monographs or other edited collections.

Our most important service is curating a fine rare book and manuscript collection, named after its original collector, the late Dr. Edwin W. Brown. The Edwin W. Brown Collection includes all first editions (English and American) of books authored, edited, or with prefaces by C.S. Lewis, published essays and lectures, over a hundred Lewis letters, and two very special Lewis manuscripts ("Light" – a previously unpublished short story and the *Summa* notebook).[1] The

1 Both manuscripts have been published in recent years: Charlie W. Starr, ed., *"Light": C. S. Lewis's First and Final Short Story* (Hamden, CT: Winged Lion Press, 2012); Norbert Feindendegen and Arend Smilde, ed., *The "Great War" of Owen*

collection also contains many other works by or about Lewis, as well as first editions of the works of W. H. Lewis, Charles Williams, Dorothy L. Sayers, and Owen Barfield. Since its relocation to Taylor University in 1997, the collection has more than tripled in size.

After C.S. Lewis, the author most prominently featured in the collection is the Scottish writer, preacher, lecturer, George MacDonald, whom Lewis called "his master." The MacDonald portion of the collection contains more than six hundred volumes, including first edition books, biographies, critical works, and many books with inscriptions and/or annotations by MacDonald. The collection includes over one hundred first or very early editions of MacDonald's work, a forty-six volume set of his complete works in a very fine series of reprints, and a collection of nineteenth-century periodicals containing the first state versions of many of MacDonald's works, including serialized novels, poems, and essays. The MacDonald holdings also include twenty books by MacDonald's wife and family and a wide variety of manuscripts, letters, and ephemera.

Some of the many unique treasures of the Brown Collection include:

- MacDonald's personal copy of Shakespeare's *Hamlet*, containing MacDonald's extensive handwritten notes;
- Several George MacDonald novels with handwritten notes by C.S. Lewis;
- Books from MacDonald's personal library, five of which include notes in MacDonald's hand;
- *Prince Caspian* inscribed by Lewis to its seven-year-old owner;
- Mary Neylan's copy of *George MacDonald: An Anthology*, inscribed to her by Lewis (as well as Lewis's many letters to Neylan and her portrait of Lewis, sketched on her final visit just weeks before his death);
- The letters written by C. S. Lewis and W. H. Lewis to Jill Flewett-Freud, who, as a school girl during World War II, lived with Lewis household at the Kilns;
- Signed copies of books by Barfield, Dorothy L. Sayers, and Charles Williams.

To facilitate our outreach work, the Center has added the Lewis

Barfield and C.S. Lewis: Philosophical Writings, 1927-1930 (Oxford: *Inklings Studies* Supplements, no. 1, 2015).

Room, just across the hall from the Brown Collection. The Lewis Room features hundreds of books, journals, visual media, and other materials, and is both a comprehensive collection of Inklings scholarship and reader's copies of books written by the authors. On-campus students, especially creative writers, find this a pleasant, welcoming space to gather and study. Small seminar classes sometimes meet here as well. Best of all, the materials in the Lewis Room are available for check-out, both locally and through inter-library loan, thus enriching the research opportunities for students, faculty and scholars alike. We encourage Inklings scholars to send us their most recent work to add to the collection. New books are generally displayed for several weeks before being shelved.

Individuals or groups interested in visiting the Center are welcome during the academic year, when we hold regular hours; special arrangements can also be made for other times. We are eager to share our collection with new friends and welcome your enquiries about how you can help support our work.

WINGED LION PRESS BOOKS IN PARTNERSHIP WITH TAYLOR UNIVERSITY

Inklings Forever: Volume X
Papers from the 10th Francis White Ewbank Colloquium on C. S. Lewis &
Friends
Joe Ricke and Rick Hill, editors

"The folks at Taylor University have done it again! This colloquium proceedings volume is a
rich and tantalizing mix of scholarly studies, reflections, and creative work."
 Charles Huttar, Prof. Emeritus, Hope College
 Editor of *Imagination and the Spirit*

Exploring the Eternal Goodness: Selected Writings of David L. Neuhouser
Joe Ricke and Lisa Ritchie, Editors

In 1997, due to David's perseverance, the Brown Collection of books by and about
C. S. Lewis and related authors came to Taylor University and the Lewis and Friends
Colloquium began. This book of selected writings reflects his scholarship in math
and literature, as well as his musings on beauty and the imagination. The twenty-one
tributes are an indication of the many lives he has influenced. This book is meant to
acknowledge David L. Neuhouser for his contributions to scholarship and to honor
his life of friendship, encouragement, and genuine goodness.

Light: C. S. Lewis's First and Final Short Story
Charlie W. Starr
Foreword by Walter Hooper

Charlie Starr explores the questions surrounding the "Light" manuscript, a later
version of story titled "A Man Born Blind." The insights into this story provide a na
ew key to understanding some of Lewis's most profound ideas.

"As literary journalism, both investigative and critical, it is top shelf"
 James Como, author of *Remembering C. S. Lewis*

"Starr shines a new and illuminating light on one of Lewis's most intriguing stories"
 Michael Ward, author of *Planet Narnia*

C. S. Lewis' Top Ten: Influential Books and Authors, Volume One
Will Vaus

Based on his books, marginal notes, and personal letters, Will Vaus explores Lewis'
reading of the ten books he said shaped his vocational attitude and philosophy of
life. Volume One covers the first three authors/books: George MacDonald, G.K.
Chesterton, and Virgil. Vaus offers a brief biography of each author with a helpful
summary of their books.

"Thorough, comprehensive, and illuminating"
Rolland Hein, Author of *George MacDonald: Victorian Mythmaker*

OTHER WINGED LION PRESS BOOKS OF INTEREST

C. S. LEWIS

C. S. Lewis: Views From Wake Forest - Essays on C. S. Lewis
Michael Travers, editor

Contains sixteen scholarly presentations from the international C. S. Lewis convention in Wake Forest, NC. Walter Hooper shares his important essay "Editing C. S. Lewis," a chronicle of publishing decisions after Lewis' death in 1963.

"Scholars from a variety of disciplines address a wide range of issues. The happy result is a fresh and expansive view of an author who well deserves this kind of thoughtful attention."
Diana Pavlac Glyer, author of *The Company They Keep*

The Hidden Story of Narnia:
A Book-By-Book Guide to Lewis' Spiritual Themes
Will Vaus

A book of insightful commentary equally suited for teens or adults – Will Vaus points out connections between the *Narnia* books and spiritual/biblical themes, as well as between ideas in the *Narnia* books and C. S. Lewis' other books. Learn what Lewis himself said about the overarching and unifying thematic structure of the Narnia books. That is what this book explores; what C. S. Lewis called "the hidden story" of Narnia. Each chapter includes questions for individual use or small group discussion.

Why I Believe in Narnia:
33 Reviews and Essays on the Life and Work of C. S. Lewis
James Como

Chapters range from reviews of critical books , documentaries and movies to evaluations of Lewis' books to biographical analysis.
"A valuable , wide-ranging collection of essays by one of the best informed and most accute commentators on Lewis' work and ideas."
Peter Schakel, author of *Imagination & the Arts in C. S. Lewis*

C. S. Lewis: His Literary Achievement
Colin Manlove

"This is a positively brilliant book, written with splendor, elegance, profundity and evidencing an enormous amount of learning. This is probably not a book to give a first-time reader of Lewis. But for those who are more broadly read in the Lewis corpus this book is an absolute gold mine of information. The author gives us a magnificent overview of Lewis' many writings, tracing for us thoughts and ideas which recur throughout, and at the same time telling us how each book differs from the others. I think it is not extravagant to call C. S. Lewis: His Literary Achievement a tour de force."

Robert Merchant, *St. Austin Review*, Book Review Editor

In the Footsteps of C. S. Lewis: A Photographic Pilgrimage to the British Isles
Will Vaus

Over the course of thirty years, Will Vaus has journeyed to the British Isles many times to walk in the footsteps of C. S. Lewis. His private photographs of the significant places in Lewis' life have captured the imagination of audiences in the US and UK to whom he has lectured on the Oxford don and his work. This, in turn, prompted the idea of this collection of 78 full-color photographs, interwoven with details about Lewis' life and work. The combination of words and pictures make this a wonderful addition to the library of all Lewis scholars and readers.

Speaking of Jack: A C. S. Lewis Discussion Guide
Will Vaus

C. S. Lewis Societies have been forming around the world since the first one started in New York City in 1969. Will Vaus has started and led three groups himself. *Speaking of Jack* is the result of Vaus' experience in leading those Lewis Societies. Included here are introductions to most of Lewis' books as well as questions designed to stimulate discussion about Lewis' life and work. These materials have been "road-tested" with real groups made up of young and old, some very familiar with Lewis and some newcomers. *Speaking of Jack* may be used in an existing book discussion group, to start a C. S. Lewis Society, or as a guide to your own exploration of Lewis' books.

C. S. Lewis & Philosophy as a Way of Life: His Philosophical Thoughts
Adam Barkman

C. S. Lewis is rarely thought of as a "philosopher" per se despite having both studied and taught philosophy for several years at Oxford. Lewis's long journey to Christianity was essentially philosophical – passing through seven different stages. This 624 page book is an invaluable reference for C. S. Lewis scholars and fans alike

C. S. Lewis Goes to Heaven:
A Reader's Guide to The Great Divorce
David G. Clark

This is the first book devoted solely to this often neglected book and the first to reveal several important secrets Lewis concealed within the story. Lewis felt his imaginary trip to Hell and Heaven was far better than his book *The Screwtape Letters*, which has become a classic. Readers will discover the many literary and biblical influences Lewis utilized in writing his brilliant novel.

C. S. Lewis Goes to Hell
A Companion and Study Guide to The Screwtape Letters
William O'Flaherty

A guide to *The Screwtape Letters* suitable for groups or individuals. Features include a topic index of major and minor themes, summaries of each letter, questions for reflection, and over a half-dozen appendices of useful information.

Joy and Poetic Imagination: Understanding C. S. Lewis's "Great War" with Owen Barfield and its Significance for Lewis's Conversion and Writings
Stephen Thorson

Author Stephen Thorson began writing this book over 30 years ago and published parts of it in articles during Barfield's lifetime. Barfield wrote to Thorson in 1983 saying, *""...you have surveyed the divergence between Lewis and myself very fairly, and truly 'in depth...'"*. This book explains the "Great War" between these two friends.

CHRISTIAN LIVING

Keys to Growth: Meditations on the Acts of the Apostles
Will Vaus

Every living thing or person requires certain ingredients in order to grow, and if a thing or person is not growing, it is dying. *The Acts of the Apostles* is a book that is all about growth. Will Vaus has been meditating and preaching on *Acts* for the past 30 years. In this volume, he offers the reader forty-one keys from the entire book of Acts to unlock spiritual growth in everyday life.

Open Before Christmas: Devotional Thoughts For The Holiday Season
Will Vaus

Author Will Vaus seeks to deepen the reader's knowledge of Advent and Christmas leading up to Epiphany. Readers are provided with devotional thoughts for each day that help them to experience this part of the Church Year perhaps in a more spiritually enriching way than ever before.

God's Love Letter: Reflections on I John
Will Vaus

Various words for "love" appear thirty-five times in the five brief chapters of I John. This book invites you on a journey of reading and reflection: reading this book in the New Testament and reflecting on God's love for us, our love for God, and our love for one another.

Jogging with G.K. Chsterton: 65 Earthshaking Expeditions
Robert Moore-Jumonville

Jogging with G.K. Chesterton is a showcase for the merry mind of Chesterton. But Chesterton's lighthearted wit always runs side-by-side with his weighty wisdom. These 65 "earthshaking expeditions" will keep you smiling and thinking from start to finish. You'll be entertained, challenged, and spiritually uplifted as you take time to breath in the fresh morning air and contemplate the wonders of the world.

"This is a delightfully improbable book in which Chesterton puts us through our spiritual and intellectual exercises."
 Joseph Pearce, author of *Wisdom and Innocence: A Life of G.K. Chesterton*

GEORGE MACDONALD

Diary of an Old Soul & The White Page Poems
George MacDonald and Betty Aberlin

The first edition of George MacDonald's book of daily poems included a blank page opposite each page of poems. Readers were invited to write their own reflections on the "white page." MacDonald wrote: "Let your white page be ground, my print be seed, growing to golden ears, that faith and hope may feed." Betty Aberlin responded to MacDonald's invitation with daily poems of her own.

George MacDonald: Literary Heritage and Heirs
Roderick McGillis, editor

This latest collection of 14 essays sets a new standard that will influence MacDonald studies for many more years. George MacDonald experts are increasingly evaluating his entire corpus within the nineteenth century context.

In the Near Loss of Everything: George MacDonald's Son in America
Dale Wayne Slusser

In the summer of 1887, George MacDonald's son Ronald, newly engaged to artist Louise Blandy, sailed from England to America to teach school. The next summer he returned to England to marry Louise and bring her back to America. On August 27, 1890, Louise died leaving him with an infant daughter. Ronald once described losing a beloved spouse as "the near loss of everything". Dale Wayne Slusser unfolds this poignant story with unpublished letters and photos that give readers a glimpse into the close-knit MacDonald family. Also included is Ronald's essay about his father, *George MacDonald: A Personal Note*, plus a selection from Ronald's 1922 fable, *The Laughing Elf*, about the necessity of both sorrow and joy in life.

A Novel Pulpit: Sermons From George MacDonald's Fiction
David L. Neuhouser
Each of the sermons has an introduction giving some explanation of the setting of the sermon or of the plot, if that is necessary for understanding the sermon. *"MacDonald's novels are both stimulating and thought-provoking. This collection of sermons from ten novels serve to bring out the 'freshness and brilliance' of MacDonald's message." from the author's introduction*

Phantastes by George MacDonald: Annotated Edition
John Pennington and Roderick McGillis, Editors

This annotated edition provides a wealth of information to better understand and enjoy this masterpiece. In addition to the text, there are 184 pages containing an authoritative introduction, life chronology, textual notes, book reviews, and comparative source materials. With 354 footnotes to explain obscure words and literary references, this enhanced edition will benefit any reader and will provide a solid foundation for future scholarship.

Behind the Back of the North Wind: Essays on George MacDonald's Classic Book
Edited and with Introduction by John Pennington and Roderick McGillis

The unique blend of fairy tale atmosphere and social realism in this novel laid the groundwork for modern fantasy literature. Sixteen essays by various authors are accompanied by an instructive introduction, extensive index, and beautiful illustrations.

Through the Year with George MacDonald: 366 Daily Readings
Rolland Hein, editor

These page-length excerpts from sermons, novels and letters are given an appropriate theme/heading and a complementary Scripture passage for daily reading. An inspiring introduction to the artistic soul and Christian vision of George MacDonald.

Shadows and Chivalry: Lewis and MacDonald on Suffering, Evil, and Death
Jeff McInnis

Shadows and Chivalry studies the influence of George MacDonald, a nineteenth-century Scottish novelist and fantasy writer, upon one of the most influential writers of modern times, C. S. Lewis—the creator of Narnia, literary critic, and best-selling apologist. This study attempts to trace the overall affect of MacDonald's work on Lewis's thought and imagination. Without ever ceasing to be a story of one man's influence upon another, the study also serves as an exploration of each writer's thought on, and literary visions of, good and evil.

The Downstretched Hand:
Individual Development in MacDonald's Major Fantasies for Children
Lesley Willis Smith

Smith demonstrates that MacDonald is fully aware of the need to integrate the unconscious into the conscious in order to achieve mature individuation. However, for MacDonald, true maturity and fulfillment can only be gained through a relationship with God. By exploring MacDonald's major biblical themes into his own myth, Smith reveals his literary genius and profound understanding of the human psyche. Smith interacts with other leading scholarship and in the context of other works by MacDonald, especially those written during the same time period.

Informing the Inklings: George MacDonald' and the Roots of Modern Fantasy
Michael Partridge and Kirstin Jeffrey Johnson, Editors
Preface by Stephen Prickett

In the summer of 2014, the George MacDonald Society held a conference at Magdalen, C.S. Lewis' old college in Oxford. Twelve papers from the conference were selected for publication, some written by established MacDonald scholars and others by a new generation of scholars who continue to mine the depths of the rich correlations between fantasy writers of the 19th and 20th centuries.

Pop Culture

To Love Another Person: A Spiritual Journey Through Les Miserables
John Morrison

The powerful story of Jean Valjean's redemption is beloved by readers and theater goers everywhere. In this companion and guide to Victor Hugo's masterpiece, author John Morrison unfolds the spiritual depth and breadth of this classic novel and broadway musical.

Through Common Things: Philosophical Reflections on Popular Culture
Adam Barkman

"Barkman presents us with an amazingly wide-ranging collection of philosophical reflections grounded in the everyday things of popular culture – past and present, eastern and western, factual and fictional. Throughout his encounters with often surprising subject-matter (the value of darkness?), he writes clearly and concisely, moving seamlessly between Aristotle and anime, Lord Buddha and Lord Voldemort.... This is an informative and entertaining book to read!"

Doug Bloomberg, Professor of Philosophy, Institute for Christian Studies

The Many Faces of Katniss Everdeen: Exploring the Heroine of The Hunger Games
Valerie Estelle Frankel

Katniss is the heroine who's changed the world. Like Harry Potter, she explodes across genres: She is a dystopian heroine, a warrior woman, a reality TV star, a rebellious adolescent. She's surrounded by the figures of Roman history, from Caesar and Cato to Cinna and Coriolanus Snow. She's also traveling the classic heroine's journey. As a child soldier, she faces trauma; as a growing teen, she battles through love triangles and the struggle to be good in a harsh world. This book explores all this and more, while taking a look at the series' symbolism, from food to storytelling, to show how Katniss becomes the greatest power of Panem, the girl on fire.

Myths and Motifs of The Mortal Instruments
Valerie Estelle Frankel

With vampires, fairies, angels, romance, steampunk, and modern New York all in one series of books, Cassandra Clare is exploding onto the scene. This book explores the deeper world of the Shadowhunters. There's something for everyone, as this book reveals unseen lore within the bestselling series.

Virtuous Worlds: The Video Gamer's Guide to Spiritual Truth
John Stanifer

Popular titles like *Halo 3* and *The Legend of Zelda: Twilight Princess* fly off shelves at a mind-blowing rate. John Stanifer, an avid gamer, shows readers specific parallels between Christian faith and the content of their favorite games. Written with wry humor (including a heckler who frequently pokes fun at the author) this book will appeal to gamers and non-gamers alike. Those unfamiliar with video games may be pleasantly surprised to find that many elements in those "virtual worlds" also qualify them as "virtuous worlds."

BIOGRAPHY

Sheldon Vanauken: The Man Who Received "A Severe Mercy"
Will Vaus

In this biography we discover: Vanauken the struggling student, the bon-vivant lover, the sailor who witnessed the bombing of Pearl Harbor, the seeker who returned to faith through C. S. Lewis, the beloved professor of English literature and history, the feminist and anti-war activist who participated in the March on the Pentagon, the bestselling author, and Vanauken the convert to Catholicism. What emerges is the portrait of a man relentlessly in search of beauty, love, and truth, a man who believed that, in the end, he found all three.

"This is a charming biography about a doubly charming man who wrote a triply charming book. It is a great way to meet the man behind A Severe Mercy."

Peter Kreeft, author of *Jacob's Ladder: 10 Steps to Truth*

Remembering Roy Campbell: The Memoirs of his Daughters, Anna and Tess
Introduction by Judith Lütge Coullie, Editor
Preface by Joseph Pearce

Anna and Teresa Campbell were the daughters of the handsome young South African poet and writer, Roy Campbell (1901-1957), and his beautiful English wife, Mary Garman. In their frank and moving memoirs, Anna and Tess recall the extraordinary, and often very difficult, lives they shared with their exceptional parents. Over 50 photos, 344 footnotes, timeline of Campbell's life, and complete index.

HARRY POTTER

The Order of Harry Potter: The Literary Skill of the Hogwarts Epic
Colin Manlove

Colin Manlove, a popular conference speaker and author of over a dozen books, has earned an international reputation as an expert on fantasy and children's literature. His book, *From Alice to Harry Potter*, is a survey of 400 English fantasy books. In *The Order of Harry Potter*, he compares and contrasts *Harry Potter* with works by "Inklings" writers J.R.R. Tolkien, C. S. Lewis and Charles Williams; he also examines Rowling's treatment of the topic of imagination; her skill in organization and the use of language; and the book's underlying motifs and themes.

Harry Potter & Imagination: The Way Between Two Worlds
Travis Prinzi

Imaginative literature places a reader between two worlds: the story world and the world of daily life, and challenges the reader to imagine and to act for a better world. Starting with discussion of Harry Potter's more important themes, *Harry Potter & Imagination* takes readers on a journey through the transformative power of those themes for both the individual and for culture by placing Rowling's series in its literary, historical, and cultural contexts.

Hog's Head Conversations: Essays on Harry Potter
Travis Prinzi, Editor

Ten fascinating essays on Harry Potter by popular Potter writers and speakers including John Granger, James W. Thomas, Colin Manlove, and Travis Prinzi.

Repotting Harry Potter: A Professor's Guide for the Serious Re-Reader
Rowling Revisited: Return Trips to Harry, Fantastic Beasts, Quidditch, & Beedle the Bard
Dr. James W. Thomas

In *Repotting Harry Potter* and his sequel book *Rowling Revisited*, Dr. James W. Thomas points out the humor, puns, foreshadowing and literary parallels in the Potter books. In *Rowling Revisted*, readers will especially find useful three extensive appendixes – "Fantastic Beasts and the Pages Where You'll Find Them," "Quidditch Through the Pages," and "The Books in the Potter Books." Dr. Thomas makes re-reading the Potter books even more rewarding and enjoyable.

Sociology and Harry Potter: 22 Enchanting Essays on the Wizarding World
Jenn Simms, editor

Modeled on an Introduction to Sociology textbook, this book is not simply about the series, but also uses the series to facilitate the reader's understanding of the discipline of sociology and a develops a sociological approach to viewing social reality. It is a case of high quality academic scholarship written in a form and on a topic accessible to non-academics. As such, it is written to appeal to Harry Potter fans and the general reading public. Contributors include professional sociologists from eight countries.

Harry Potter, Still Recruiting: An Inner Look at Harry Potter Fandom
Valerie Frankel

The Harry Potter phenomenon has created a new world: one of Quidditch in the park, lightning earrings, endless parodies, a new genre of music, and fan conferences of epic proportions. This book attempts to document everything - exploring costuming, crafting, gaming, and more, with essays and interviews straight from the multitude of creators. From children to adults, fans are delighting the world with an explosion of captivating activities and experiences, all based on Rowling's delightful series.

POETS AND POETRY

In the Eye of the Beholder: How to See the World Like a Romantic Poet
Louis Markos

Born out of the French Revolution and its radical faith that a nation could be shaped and altered by the dreams and visions of its people, British Romantic Poetry was founded on a belief that the objects and realities of our world, whether natural or human, are not fixed in stone but can be molded and transformed by the visionary eye of the poet. A separate bibliographical essay is provided for readers listing accessible biographies of each poet and critical studies of their work.

The Cat on the Catamaran: A Christmas Tale
John Martin

Here is a modern-day parable of a modern-day cat with modern-day attitudes. Riverboat Dan is a "cool" cat on a perpetual vacation from responsibility. He's *The Cat on the Catamaran* – sailing down the river of life. Dan keeps his guilty conscience from interfering with his fun until he runs into trouble. But will he have the courage to believe that it's never too late to change course? (For ages 10 to adult)